UNITED STATES HISTORY TO 1877

9th Edition

Light Townsend Cummins, Ph.D.
Austin College, Sherman, TX

John A. Krout, Ph.D.

Arnold S. Rice, Ph.D.

C. M. Harris, Ph.D.

Contributing Editor
Bartram Barbour, Ph.D.
Boise State University, Boise, ID

Collins
An Imprint of HarperCollinsPublishers

UNITED STATES HISTORY TO 1877. Copyright © 1933, 1935, 1946, 1955, 1962, 1971 by Harper & Row, Publisher, Inc. Copyright renewed 1961, 1963, 1968, by John A. Krout and assigned to Harper & Row, Publishers, Inc. Copyright © 1991, 2006 by HarperCollins Publishers, Inc. All rights reserved. Printed in the United States. No part of this book may be used or reproduced in any manner whatsoever without written permission except in the case of brief quotations embodied in critical articles and reviews. For information address HarperCollins Publishers, 10 East 53rd Street, New York, N.Y. 10022.

An American BookWorks Corporation Production

HarperCollins books may be purchased for educational, business, or sales promotional use. For information please write: Special Markets Department, HarperCollins Publishers, 10 East 53rd Street, New York, NY 10022.

Library of Congress Cataloging-in-Publication Data

Cummins, Light Townsend.
　United States history to 1877.—9th ed./Light T. Cummins ... [et al.] ; contributing
editor, Bartram Barbour.
　　p. cm.
　Rev. ed. of: United States to 1877 / John A. Krout. 7th ed. 1967.
　Includes bibliographical references and index.
　ISBN-13: 978-0-06-088159-7
　ISBN-10: 0-06-088159-3
　　1. United States—History—Outlines, syllabi, etc. I. Barbour, Bartram. II. Krout, John
Allen, 1896- United States to 1877. III. Title.

E178.2.C984 2006
973—dc22

2006043371

06 07 08 09 10 CW 10 9 8 7 6 5 4 3 2 1

Contents

Preface

This 9th edition of *United States History to 1877* revises the first volume of John A. Krout's popular and time-tested outline survey of American history, first published by Barnes and Noble in 1933. Professor Krout periodically updated this volume until the 1960s, when he retired from the faculty of Columbia University. Arnold S. Rice thereafter revised the 7th edition in 1971. The 8th edition was reworked and expanded by C. M. Harris in 1991.

Over the last seventy years in its various editions, this outline-based book has become a tried-and-true standard resource volume for over three generations of introductory-level history students in the United States and around the world. Much of the work of Professors Krout, Rice, and Harris remain in the pages of this current edition. Beyond that, however, every possible effort has been made to reflect in this 9th edition the most recent scholarship and current interpretations of American history. This edition contains new information about the history of women and of minorities, including Native Americans, African Americans, and Latinos. It also provides explicit emphasis on significant social and cultural developments while concentrating on the important political, economic, and foreign policy occurrences.

In addition to an expanded bibliography for additional reading, this edition contains study questions (and explanatory answers for them) designed for student use at the conclusion of each chapter. That is because this volume has been revised to meet more explicitly the requirements of Advanced Placement high school classes, along with the needs of college students enrolled in introductory United States history survey courses. The current author has taught the introductory American history course for thirty-five years at the university level while also serving for much of that time as a faculty consultant to the United States history section of the Advanced Placement program.

Note that this outline-style volume is a good place for readers to begin the focused study of United States history to 1877. On the other hand, this book most certainly does not exist in order for readers to believe that, in consulting this volume, they have conducted any sort of definitive analysis of the subject. For that reason, Professor Krout's admonition from earlier editions bears repeating here: This book is not a shortcut to knowledge about United States history, nor is it designed to save its users from additional reading, study, and critical thinking. This volume provides only the beginning for such efforts. A reasoned understanding and mastery of United States history will be gained only by additional reading in many of the excellent and special studies available, such as those recommended in the Appendix.

Light Townsend Cummins, 9th Edition

Europe and the New World

1000: Viking settlement established at "Vinland," believed to be Newfoundland

1275: Marco Polo reaches China

1418: Prince Henry the Navigator of Portugal founds school for navigators; Portuguese voyages of exploration begin

1469: Kingdom of Spain united by the marriage of Ferdinand of Castile and Isabella of Aragon

1492: Cristobal Colon (Christopher Columbus) discovers the new world, first landing at San Salvador (Watling) Island

1494: Treaty of Tordesillas divides western hemisphere between Spain and Portugal

1497: John Cabot explores North America for England

1513: Ponce de Leon reaches Florida; Balboa reaches the Pacific Ocean

1517: Protestant Reformation begins with the posting of Martin Luther's 95 theses in Wittenberg, Germany

1519–1521: Hernán Cortés conquers the Aztecs in Mexico

1519–1522: Magellan circumnavigates the globe

1529–1536: King Henry VIII of England clashes and breaks with the Pope and the Roman Catholic Church

1536: Publication of John Calvin's Institutes in Geneva

1540: Francisco Vasquez de Coronado explores American southwest for Spain

1558–1603: Reign of Queen Elizabeth I in England

1565: St. Augustine founded in Spanish Florida

1585: Roanoke Island settlement made by the English

(continued on next page)

1588: English defeat of the Spanish Armada

1598: Juan de Oñate founds Spanish colony of New Mexico

1603–1625: Reign of King James I in England

1608: Samuel de Champlain founds first French settlement at Quebec

1680: Pueblo Revolt of Native Americans in Spanish New Mexico

1682: French explorer La Salle reaches mouth of the Mississippi River

1685: La Salle founds French colony on coast of modern Texas

1685: Spanish settlements founded in Texas as response to La Salle

In terms of the North American continent and its peoples, the United States is but a recent develop-ment on the larger stage of history in the western hemisphere. The continent itself, the theater of human activity, took its modern form between 54 million and 2 million years ago.

A variety of indigenous native cultures developed in North America prior to the first European explo-ration and settlement in the fifteenth century. The discovery and conquest of a "new world" in the west-ern hemisphere was, from the European perspective, an heroic enterprise. From the Native American perspective, however, this process proved to be destructive of life (natural and human) as it had evolved in North and South America over thousands of years. Nonetheless, the historic contact between Europeans and Native Americans irrevocably altered the destinies of both civilizations as they came to coexist in the western hemisphere. This coexistence became a symbiotic process, as each profoundly affected the historical destiny of the other civilization in the unfolding history of the United States and the rest of the Americas.

■ NATIVE AMERICANS

The first inhabitants of the western hemisphere were themselves immigrants, nomadic hunters who began to migrate from Asia across the Bering Strait at least 15,000 to 20,000 years ago. Recent research indicates that this migration was not limited only to the Bering Strait; other Asian peoples may have come to other parts of the hemisphere by sea. By the time the Europeans discovered the western hemisphere, many different peoples and tribes inhabited what became known as the Americas. The Native American civilizations of this "new" world were new only from a European perspective. Like the Europeans, the original residents of the Americas had evolved relatively sophisticated societies from more primitive beginnings. These cultures had developed in isolation from contact with the rest of the globe.

Paleo-Indians

Today, anthropologists call the first Native Americans Paleo-Indians. These people were the descen-dants of the Siberian and Asian immigrants. They occupied most of the Americas by about 10,000 years ago. Existing as nomadic family units, they lived in almost every part of the northern and southern con-tinents, manifesting a Stone Age culture. They had no tribal identities, nor did they have any cultural attributes that would give them uniqueness from group to group. They were little more socially than hunters or gatherers. Little evidence remains today of their existence except for archaeological sites that have been found throughout the western hemisphere.

Modern research has determined that these early peoples survived by foraging and supplementing their meager diets by hunting small animals. They made simple stone tools and other small items such as utensils or rudimentary clothing. Some of them developed the technique of chipping arrowheads from flint and other types of hard stone. As time passed, the Paleo-Indians improved the quality of their weapons and, about 9,000 years ago, developed the spear with a sharpened obsidian or flint blade at its tip. This breakthrough enabled them to evolve more complicated hunting practices that focused on large game animals, which, in turn, motivated them to form more complicated societies beyond the family unit. Over time, at various places in the western hemisphere, the Paleo-Indians developed distinctive cultures based on regional conditions as they organized into larger social units. Over the subsequent centuries, this produced the various Native American societies that existed at the time of European contact. Several of these fifteenth-century Native American cultures had a profound impact on history and shaped the nature of the European historical experience in the Americas. In the case of United States history, that was certainly the case regarding the Mesoamerican and the North American native peoples.

Mesoamericans

The term Mesoamerican refers to the middle part of the western hemisphere, where two major Native American civilizations existed by the time Europeans arrived: the Mayas and the Aztecs. Both of these native societies had a larger impact on the history of the Spanish in the Americas than they did on the English, although their influence extended into what is today the southwestern United States. Most anthropologists believe that the vast central region of the hemisphere known as Mesoamerica was the location where complex Native American societies first developed from the Paleo-Indians. About 9,000 years ago, the fertile central valley of Mexico and the lush forests of the Yucatan saw their residents begin planting crops. The resultant organization of town life that flowed from this agriculture brought stability to the existence of these native peoples. This permitted them gradually to develop tribal societies that, at least analogously, had many of the same generic cultural attributes of European civilization itself; namely, Native American political structures of government, a trade economy, sophisticated social structure, a professional military establishment, a complicated religion based on theological concepts, and a material culture that included the existence of urban centers containing thousands of people. The Mesoamericans also understood much about the natural world, including the practice of herbal medicine and the mastery of complex astronomical observations.

Maya

The Maya civilization started developing in the Yucatan peninsula of Mexico about 1500 B.C. (in the European manner of time dating) and reached full flower by about 200 A.D. It dominated the geographic area that today includes southern Mexico, especially the Yucatan, and the northern parts of Central America. At its height, the Maya civilization included about 40 cities, some with as many as 50,000 people living in them. The Maya civilization may have had a total of two million residents. The Maya developed a written language of symbols, often carving their stories and legends on huge stone obelisks that remain today as important sources of scholarly knowledge about them. About 900 A.D., however, the power of Maya civilization began to decline as its residents left the cities; its society badly deteriorated for unknown reasons that modern scholars continue to debate. Isolated pockets of Maya, however, remained and proved to be a continuing difficulty for the Spanish colonizers.

Aztecs

The decline of the Maya prepared the way for the rise of the Aztecs, who existed as the most powerful Mesoamerican civilization encountered by the Europeans. Their own tribal legends hold that the Aztecs migrated to the central valley of Mexico sometime after 1000 A.D. from their original homeland called Aztlán, located somewhere to the north. They settled at Lake Texcoco, where they built a monumental island city, Tenochtitlán, which was connected to the shore by long causeways that could be closed for defense against enemy attack. The Aztecs developed sophisticated agricultural practices that included irrigation and crop rotation. Merchants and traders from the expanding Aztec empire traveled throughout Middle America plying their wares, some of which archaeologists have found as far north as the current southern part of the United States. The Aztecs also had a strong and highly organized army that eventually subjugated most of the surrounding tribes in what is today central Mexico. By the time the Spanish arrived in 1519, the Aztec capital city of Tenochtitlán had almost 150,000 residents, making it one of the world's largest cities, covering more than 5 square miles (13 square km) of island, much of which had been artificially expanded by dry land reclamation. The last emperor, Cuauhtémoc, ruled an empire with as many as 6 million people, many of whom belonged to almost 500 different tribes throughout the region that the Aztecs had brought into their realm by military conquest or commercial domination. The Spanish conquest (1519–1521), led by Hernán Cortés, subjugated this vast empire, providing the basis for the creation of the colony of New Spain with its capital, Mexico City, built on the ruins of Tenochtitlán.

North Americans

The Native American groups living to the north of the Aztecs, mostly in what is today the United States and Canada, were very different from the Mesoamericans and also had great variations among themselves. There are several ways by which these groups can be classified.

The easiest, of course, is by tribe, especially because this is the manner by which most native people identify themselves, such as Carib, Pequot, Creek, Shawnee, Apache, or Caddo. The historical problem with this method, however, lies in the fact that tribal structures can change drastically over long periods of historical time as groups die away, move from a given area, or assimilate into one another. The overwhelming pressures occasioned by contact with Europeans accelerated such alterations in tribal identification in many places throughout North America.

A second method of classification rests on language, because groups with a common linguistic heritage have clear-cut commonalities. Modern scholars have identified seven basic Native American language groups in the areas today comprehended by the United States and Canada. The difficulty with this method historically rests on the realization that speakers of particular languages did not always recognize their common bonds with each other.

A third method has become popular among historians because it employs classifying Native American groups by their social and cultural norms. For that reason, it is often called the anthropological approach because it combines Native American tribal and linguistic groups into larger categories based on a wide variety of common social practices, folkways, mores, political structures, economic practices, religious beliefs, and material culture. By this latter method of classification, it can be noted that there were two major anthropological groups of Native Americans encountered by the Europeans who came to North America in the colonial era: the Eastern Woodlands and the Anasazi-Pueblo peoples.

Eastern Woodland Native Americans

The Eastern Woodland anthropological classification is composed of three major groups: the Algonquin, the Iroquois, and the Muskogeans. These three groups most likely descended from a common prehistorical culture called the Mississippian, which existed from about 800 to 1500 A.D. The Mississippian culture spanned from the Mississippi River Valley eastward across the modern South of the United States, northward into the Ohio River Valley. These peoples were inveterate mound builders, which was the chief feature of their settlements. Such mounds can be found at thousands of locations in the eastern United States. Perhaps the most spectacular is located at Cahokia, Illinois, across the Mississippi River from St. Louis. One mound there covers over fifteen acres and rises over 100 feet from the surrounding plain. Archaeologists estimate that thousands of people lived at Cahokia, which existed as a ceremonial center for an extensive area.

Over time, the Mississippian culture declined to be replaced by the Eastern Woodland groups, some of whom continued to build mounds for ceremonial purposes.

Algonquians. These peoples lived at the time of European contact along the Great Lakes region, eastward along the St. Lawrence River, and the Atlantic coast from present-day New England north into Canada. The Abenaki, Penobscot, Pequot, and Chippewa were among the Algonquian tribes. These peoples mastered agriculture, growing corn as did other Eastern Woodland peoples. They were also hunters and fishers, excelling especially at the latter activity. They built sophisticated canoes and traveled easily throughout the region, using the bays and rivers as efficient highways. Because of the harsh winters, they developed innovative hunting techniques and woodland survival skills. This was especially the case in the hunting and trapping of fur-bearing animals. Because of their location, the Algonquians experienced European contact primarily with the French, whose Catholic missionaries worked very hard, but often unsuccessfully, to Christianize them.

Iroquoians. These groups included tribes such as the Seneca, Mohawk, Oneida, and Cayuga. The Iroquois inhabited the areas immediately south of the Algonquian regions, including today's states of New York and Pennsylvania, westward through the Ohio valley, into the Piedmont of the upper South. They shared the hunting and agricultural practices of the Algonquians, although they did not rely as much upon fish for sustenance. The Iroquois had permanent sites of habitation, often marked by structures that the Europeans called long houses because of their wood and bark construction. Some of these could be over 100 feet long, serving as ceremonial centers or as homes for several families. The Iroquois had a matriarchal society that afforded important tribal rights to women.

The chief distinguishing attribute of the Iroquois rested on their republican form of military organization. They were a warlike people whose tribes banded together into a loose confederation that provided for cooperation against common enemies, including the Algonquians. Because of this, the English found them to be powerful adversaries during the colonial period and, in some cases, Iroquois resistance to European colonization continued until the early nineteenth century. At times, in this process, the Iroquois engaged in political game-playing, balance of power politics, skillfully playing the English and the French against one another during much of the colonial era.

Muskogeans. The Muskogean peoples lived south of the Ohio River, along the Atlantic coast, and across the present day American South westward into eastern Texas. The major tribes included the Creek,

Chickasaw, Caddo, and Cherokee, along with other smaller ones such as the Natchez. They continued the tradition of mound-building that had been perfected by their Mississippian ancestors. It is clear that, in so doing, they had sophisticated religious beliefs that centered on sun worship. They engaged in extensive agriculture, especially growing corn, beans, and melons.

The Europeans found their form of social orgnization somewhat curious because their method of family organization was reckoned through the mother's family, meaning the family names and reckoning passed through the mother instead of the father. Females headed the family unit and owned property, although the male warriors had responsibility for hunting and warfare. For that reason, Muskogean chiefs were always male.

The tribal identity of these people proved to be very strong, and they successfully resisted European contact. Many Muskogean tribes still exist today, although a resettlement movement during the presidency of Andrew Jackson forcibly moved them into the present day state of Oklahoma. Over time, many Muskogeans intermarried with English and Scottish settlers, especially in the late colonial era. For that reason, many members of these tribes adopted Anglo last names.

The Anasazi/Pueblo Peoples

The Anasazi cultures grew from prehistoric peoples who lived in the American Southwest, mostly the modern states of New Mexico, Arizona, Colorado, and Utah as well as into northern Mexico. About 1000 A.D., they began to construct elaborate cliff dwellings, the ruins of which can be seen at places such as Mesa Verde and Canyon de Chelly. The Anasazi grew crops of beans, corn, and squash as they employed irrigation in order to boost their harvests. They also had an elaborate religion that involved the use of Kivas, round ceremonial chambers that existed as underground worship centers.

After a prolonged drought in the thirteenth century, the Anasazi culture declined. Its survivors moved to the fertile river valleys of the Southwest or sought protection by settling on the tops of the large mesas that dominate the region. There they built huge and complex adobe and stone cities such as the ones located at Taos, Acoma, and Pecos. When the Spanish arrived in the sixteenth century, they called these city dwellers the Pueblo, the Spanish word for town. The Pueblo cities, often containing hundreds of homes and thousands of residents, became centers for religion, trade, and agriculture. Pueblo people developed expertise as potters, as well as being outstanding basket and cloth weavers, while their merchants traded with Native American groups to the east on the Great Plains or southward into the Mesoamerican region.

Without the aid of the Native Americans, the first Europeans might not have survived in the new world. Many Native American vegetables, such as maize and potatoes, became important staples of the European diet. Yet the Native American ways were too strikingly different from those of the European colonists—and superficially too primitive—to gain their respect.

The Europeans' demand for land proved insatiable. In establishing their settlements, whether for purposes of extracting wealth or tilling the soil, they deprived the Native Americans of their hunting territories and forced them into the interior. The attacks and wars the Native Americans waged against the inward movement of settlers became excuses for European efforts to subjugate or eliminate these indigenous peoples of North America. Scholars now realize that European contact with Native Americas also resulted in the rapid and overwhelming spread of previously unknown diseases among the indigenous populations, who had no resistance to European germs. Some estimates hold that this Columbian

Exchange, as modern historians call this epidemiological disaster, may have killed over ninety percent of the Native Americans living in Mesoamerica, with almost as large a number of casualties in North America.

■ EUROPEAN DISCOVERY OF AMERICA

The European "discovery" of the western hemisphere came at the end of a major period of economic and political change in Europe at the end of the fifteenth century. Although various isolated individuals from Europe probably knew about the New World prior to late 1492, Europe as a society ventured into the Americas because it was ready to profit from the voyage of Columbus.

Early Voyages: The Norse

Fishermen of the North Atlantic were probably the first Europeans to see the North American continent, but they were not intent on discovery or settlement. Some of them were likely French or Basques from Spain. In the ninth and tenth centuries, the seafaring Norse mariners of northern Scandinavia established settlements in Iceland and Greenland. Some of these sites have been studied by archaeologists in recent decades. According to the Norse sagas and modern archaeological excavations at L'Anse aux Meadows, Leif Erickson, son of Eric the Red, discovered Vinland, possibly an area just south of Labrador, which is part of Newfoundland, Canada. His exploits were celebrated in the sagas but had no wider influence.

Medieval Europe

During the medieval period, or Middle Ages (600–1500 A.D.), Europe was fragmented into the many small political units that existed as the Feudal system. The lords of Feudal Europe were beset with internal rivalries and religious disputes, as well as being preoccupied with survival and subsistence. The economic and psychological effects of the plague epidemics of the fourteenth century, in which it is estimated that more than one-half of the people of Europe died, were widespread and long-lasting. Nonetheless, profound changes loomed on the horizon. By the late fourteenth century, four major motivations caused Europe to emerge from the Feudal era:

- The increase in geographic knowledge among educated Europeans
- The growing influence of capitalism as the dominant economic system
- The resultant research for new markets in Asia by capitalistic merchants
- The rise of powerful nation-states

These factors combined to create a new era of European expansion.

Early European Expansion

In the fifteenth century, a great movement began that, within several centuries, carried Europeans into every part of the world. This movement was marked by population growth and the consequent increase of wealth, much of which became concentrated in the cities where the merchants lived, thus reducing the power of the previously dominant Feudal lords. Demand for land and products caused prices to rise and trade to expand. This quickening of economic activity created a market for new and exotic items and

encouraged traders to extend their enterprises into new and more distant markets. An outward-looking, risk-taking mentality slowly overcame the inward-looking and relatively static outlook of the Middle Ages, with far-reaching implications for history.

The Lure of Asian Trade

The powerful merchants of Europe turned their attention to developing a trade with Asia. Travelers like the Venetian Marco Polo, who visited and wrote of the fabulous court of the Great Khan of China in the late thirteenth century, stirred the imaginations of Europeans. This created a great desire throughout Europe to learn more about the rest of the world. It also gave hope to many merchants for a profitable east-west trade with Asia.

By 1400 A.D., luxuries of Asia—silks, precious stones, silver, and gold—as well as necessities such as spices and drugs, came to Europe by several difficult trade routes. One went from Asia by sea to the head of the Persian Gulf, then by camel through Baghdad to the Mediterranean, and finally to Europe through the Italian city-states that had good ports. A second commerce, sometimes known as the caravan routes, brought Asian goods overland from China to the Caspian Sea, and then by road to the shores of the Black Sea. This growing European trade with the Near East and Asia was initially dominated by the Italian city-states, including Venice, Genoa, and Florence. The merchant princes who enjoyed monopolies as the middlemen in the trade accumulated great wealth.

Economic Motive for Exploration

During the fifteenth century, the costs and uncertain conditions of maintaining the largely overland trade routes with the Near and the Far East, especially after the Turks captured Constantinople (1453), encouraged the emerging European merchants in what would become the nation-states of Spain, France, and Portugal to find a shorter and more reliable (and thus less expensive) route to Asia. This, in fact, was the motive that first led European explorers to find new water routes to the east. It also caused Europeans to make important advances in new maritime technologies, including perfection of the Caravel sailing-ship, improved navigational instruments, and better techniques of map-making. The increases in capital wealth that came about as a result of a general expansion of trade with Asia disposed moneylenders and bankers to be more willing to make credit available for adventurous enterprises.

The Nation-State

The economic motive for developing new trade routes to the east was the first stimulus for the European voyages of discovery. But the funds required to support these ventures exceeded the means and the tolerance for risk of private investors and moneylenders. The organizing and outfitting of these overseas expeditions was an enterprise comparable to the launching of a space mission today.

Nation-states arose in part to meet this need. These larger governmental entities, usually created by Feudal princes whose fortunes had grown tremendously by conquest or commerce, combined the previously independent principalities of Europe into larger political units that could exercise power generated by great wealth. Portugal during the fifteenth century, for example, grew when the powerful monarchs of the Feudal house of Aviz combined Oporto, the Algarve, Lusitania, and Estremadura into one nation governed from Lisbon. A similar process took place as a unified Spain replaced various Iberian principalities, a consolidation completed by Ferdinand and Isabella in 1492. This process, known as the Reconquest in

Spanish history, involved the Catholic monarchs of Spain militarily reclaiming the Iberian lands previously conquered by Moorish armies in the late Middle Ages. This Reconquest later became a model for the Spanish colonization of the new world.

The centralization of power in enlarged monarchies and the competition among them provided the means and the will to sustain the great expense of exploring the unknown. Such a commitment, along with a powerful economic motive, encouraged both gathering of information about remote geographical areas and technological innovations in ship construction and navigation that would permit ambitious sea voyages. Nation-states became the basic catalyst for the age of European contact and colonization in the new world, an activity that took place in the name of the nation-states.

■ THE AGE OF EXPLORATION

The discovery and exploration of the Americas had far-reaching effects on the ideas and aspirations, as well as the economies, of Western Europe during the sixteenth and seventeenth centuries. Portugal and Spain were the first European nations to emerge from the process of becoming nation-states in the late fifteenth century. They launched the voyages of discovery and were the first to exploit the new lands and peoples they encountered. By the seventeenth century, most European nation-states were engaged in claiming and establishing colonial empires.

Portugal

Portugal was the first European nation to establish direct contact with Asia and the Indian subcontinent. Portuguese mariners, trained in the special school of navigation established at Cape St. Vincent by Prince Henry the Navigator (1418), pushed down the western coast of Africa, where the prince hoped to establish colonies and to find precious metals. In the years after the prince's death, Portuguese explorers went beyond Africa. Bartholomew Diaz rounded the Cape of Good Hope in 1486; twelve years later, Vasco da Gama reached India. The expansion of trade became Portugal's prime objective. By the early decades of the sixteenth century, its merchants had established lucrative colonial posts in Africa, India, China, Japan, and the East Indies, from which Lisbon reaped rich rewards. Brazil, accidentally discovered by Pedro Cabral in 1500, was brought under the control of Portuguese monarchs (1515–1570). The Portuguese seaborne empire, which had little direct impact on the colonization of the western hemisphere, did prove to be a powerful motivation to other nation-states for finding their own routes to Asia.

Spain in America

Spain, in contrast to Portugal, turned to the west and quickly surpassed Portugal in the extent of its voyages and discoveries. Because Portugal dominated the route around Africa, Spain took the risky step of supporting a sea captain and experienced mariner who desired to sail west into the unknown waters beyond the Straits of Gibraltar. The unanticipated discovery of a new hemisphere resulted from this gamble.

Early Explorers for Spain

In 1492, a Genoese mariner named Cristobal Colón, or Christopher Columbus as he is known in English, gained financial support from King Ferdinand and Queen Isabella of Spain to make a westward voyage in search of a new route to Asia. In this and three later voyages, he discovered parts of the Americas,

eventually recognized as a new world. Although Columbus's name would be used as a secondary name for the United States and for the independent nation of Colombia in South America, the two continents were soon known as the Americas, after Amerigo Vespucci, who in 1500 published an inflated account of a later voyage made by Columbus.

Soon other explorers were seeking either new lands or new routes to old lands. Spanish expeditions produced a series of rapid achievements and vast claims for the Spanish crown: Vasco de Balboa crossed the Isthmus of Panama to the Pacific Ocean in 1513; in the same year Ponce de Leon landed in Florida. Ferdinand Magellan reached the Philippines in 1513, and one of his ships completed the first trip around the globe, from 1519–1522. By the Papal Line of Demarcation (1493), modified a year later by the Treaty of Tordesillas between Spain and Portugal, Spain was given control over all "heathen lands" lying west of a line drawn from North to South poles, 370 leagues to the west of the Cape Verde Islands.

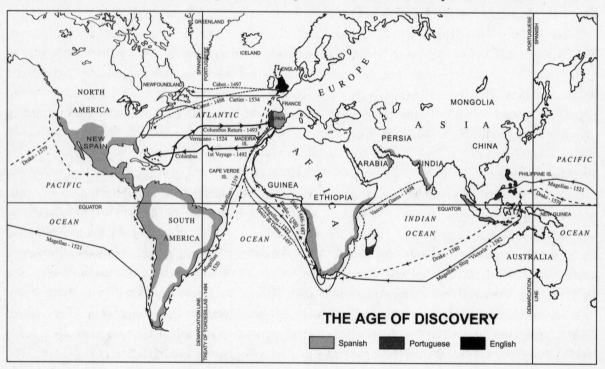

THE AGE OF DISCOVERY

Spanish · Portuguese · English

Spanish Conquests and Colonies

Spanish noblemen and gentlemen adventurers, known as conquistadores, quickly plundered and subjugated the newly discovered lands. Hernán Cortés, with an army of only 300 along with thousands of native allies, and assisted by disease among the Aztecs, vanquished the empire of the ruler Montezuma in Mexico (1520). This empire became the viceroyalty of New Spain, one of Spain's major colonies in the new world.

Hernán de Soto explored the Mississippi valley and Gulf coast (1539–1542) and Francisco Vasquez de Coronado led an expedition beyond the Rio Grande and Pueblo country into the Great Plains (1540) to expand the reach of Spanish territory into the American Southwest. Francisco Pizarro's conquest of the Inca Empire (1534) expanded the Spanish empire into South America. The Spanish crown, which licensed the private expeditions of these explorers and their many counterparts, received one-fifth of whatever riches

they found or colonies they planted. Spain thus gained an empire that, by the end of the century, extended from the southern regions of what is today the United States to Chile, at the southern tip of South America.

By 1575, approximately 175,000 Spaniards, organized politically into the viceroyalties of New Spain and Peru, were exploiting the resources of the Americas. The growth of Spanish colonies rested on an elaborate bureaucratic system directed from Spain, and also on the ecclesiastical organization of the Roman Catholic Church. Spanish priests established missions among the indigenous natives and set about the work of converting native peoples to Catholicism. The mission system eventually reached the present day United States. In 1565, Pedro Menendez d'Avila founded the town of St. Augustine in Spanish Florida. By the early 1600s, a chain of missions extended westward across northern Florida, all staffed by Spanish friars. Then, in 1598, Juan de Oñate founded the Spanish colony of New Mexico, which gradually prospered thereafter except for a ten-year interlude after 1680, when the Pueblos revolted against their colonial masters.

France in North America

By the time Spain had conquered New Spain and Peru, France had become a force in European power politics. Francois I (1515–1547) served notice that he would not permit Spain and Portugal to divide the new world between them.

France based its claims on the activities of French fishermen in American waters and the explorations of both Giovanni da Verrazano, who sailed along the coast of North America (1524), and Jacques Cartier, who tried unsuccessfully to establish settlements along the St. Lawrence (1534). It was not until 1608 that Samuel de Champlain, under orders from a monopoly granted by King Henry IV, founded the trading post of Quebec, which was to become the capital of New France.

French Canada existed primarily as a center for the fur trade. Despite the great extent of its territory, however, New France remained a group of small settlements, the most important of which were along the St. Lawrence River. French interest in the interior of the continent, demonstrated in the expeditions of Father Jacques Marquette (1673) and of Robert Cavelier, Sieur de La Salle (1682), eventually led to the establishment of a few settlements along the Mississippi River and Gulf coast in the colony of Louisiana. In 1685, La Salle settled the western Gulf coast at a location in the modern state of Texas. This colony caused the Spanish to react to the French threat. In 1690, Spain established the Texas colony as a buffer zone to protect New Spain from French encroachments.

Dutch Commercial Empire

The Dutch provinces of the Netherlands, which broke away from Spanish control (1581), preyed upon Spanish commerce with America and despoiled the Portuguese in their Asian and African trading posts. As Dutch commerce grew in the early seventeenth century, the New Netherlands Company and the Dutch West India Company sponsored settlements in South America (Guiana), the West Indies, and the valley of the Hudson River, which Henry Hudson had discovered in 1609. The first short-lived trading post in the Hudson Valley was established in 1614 and a decade later, Dutch settlers began to arrive on Manhattan Island, forming the port of New Amsterdam (later New York).

Swedes and Danes in America

Swedish commercial power in the Baltic countries grew rapidly in the seventeenth century. Sweden's merchants established a trading post on the Delaware River (1638), but it was not well supported. Its

struggle against great odds ended in 1655, when it was conquered by the Dutch. Greenland and the Virgin Islands, on the periphery of the North American continent, were colonized by Denmark.

English Settlement

Although much smaller on maps of Europe than its rivals, England nevertheless surpassed them in developing foreign trade. It possessed a great advantage in the economic strength of its rising commercial middle classes. After 1588, the English navy had no equal on the seas, and England's ambitions became expansive. The English came to the new world with the goal of making successful transplantations of their society.

England as a Nation-State

The English government did not participate in colonial ventures directly the way the governments of Spain and France did during the sixteenth century. The early Tudor monarchs deferred English interest in the new world in favor of domestic development at home in order to consolidate the power of their nation. Henry VII and Henry VIII concentrated on building the home economy, constructing a large navy to support trade, and consolidating their power as national rulers. After these goals had been achieved, subsequent English monarchs, from Elizabeth I to Charles II, gave encouragement to subjects willing to undertake overseas adventures that held promise for the nation.

Explorers and Elizabethan Seadogs

From the year 1497, when the Genoese captain Giovanni Caboto, or John Cabot, explored the coast of North America for King Henry VII, English mariners searched for the northwest passage, a route through America to Asia. Their achievements contributed to geographical knowledge and inspired writers such as Thomas More to imagine utopias in the new world. The English nation, however, remained preoccupied with domestic political, economic, and religious matters until the late sixteenth century. When war with Spain appeared inevitable, Queen Elizabeth gave encouragement to the daring deeds of Seadog Captain John Hawkins, who disrupted the Spanish slave trade, and to Sir Francis Drake, who raided Spain's colonies and ships carrying precious metals to Europe. The English navy's complete victory over the Spanish Armada in 1588 eliminated the threat of a Spanish invasion of Britain and made England preeminent on the high seas.

Raleigh and Gilbert

Queen Elizabeth also encouraged several colonization efforts made by brothers Sir Humphrey Gilbert and Sir Walter Raleigh, both of whom had been instrumental in the effort to subjugate and secure English settlements in Ireland in the 1560s and 1570s. Gilbert urged the queen to establish colonial bases from which the English could strike at Spanish possessions in the Americas. Raleigh and Gilbert claimed Newfoundland for the queen in 1583, but failed in their attempt to establish there the first English settlement in the new world. Raleigh, after his brother's death, sent out several expeditions with a similar goal, the most successful of which landed on Roanoke Island, off the coast of North Carolina, in 1587. The Lost Colony of some 120 persons, however, had disappeared by 1590, when English ships returned with supplies after the conclusion of the struggle with Spain.

Economic and Religious Motives for Expansion

During the reign of James I, who succeeded Elizabeth I, the English court became more supportive of projects to plant English colonies in the new world. The desire to weaken Spain and France continued to be a factor, but by this time, colonization had also begun to appear useful in resolving England's domestic problems, which derived from economic upheaval and growing religious strife. The seventeenth century proved to be a time of great turbulence in England, an era of civil strife, war, and unrest.

English Migration

The British government gradually recognized that colonies would provide useful outlets for large numbers of displaced farmers and laborers and for the growing numbers of religious dissenters who objected to the rites of the established Church of England and the authority of Anglican bishops and priests.

Most of the English settlers who migrated to the new world had strong motives for risking the known perils of sea voyages and the unknown perils of life in a remote wilderness. Some, like the Puritans and English Roman Catholics, wished to live free from dictated religious conformity and the threat of (or actual) persecution for their differing religious beliefs. They also wanted to insure religious conformity in their own settlements according to their own beliefs. Others who migrated to British America were victims of economic changes in England, such as the farmers and workers who were displaced by the enclosure process, by which farm land was increasingly given over to sheep-raising for the production of wool. Some were down-and-out debtors seeking a new chance for prosperity; others, including a few outlaws, had much to gain by escaping their predicaments in England. Whatever their backgrounds and circumstances, those who immigrated to the English colonies were universally attracted to America by the opportunities to own their own land and to start anew.

Investment Capital and Mercantilism

The growth of overseas trade (largely from exports of wool) increased the capital wealth of English merchants and encouraged many of them to become merchant adventurers, taking great risks to secure higher profits on their investments. They became increasingly interested in new enterprises after the collapse of the European cloth trade in the 1550s. The fact that private capital was available to fund colonial ventures in the new world helped convince English monarchs to make the land grants that were needed to begin settlements—the royal purse was not placed at risk. Many English merchants organized Joint Stock companies, which became the organizational mechanisms for British colonization.

In permitting new settlements to be established in America, the Crown was also influenced by the prevailing economic ideas that would later be defined as mercantilism, which preached the desirability of economic self-sufficiency within the borders of the nation. Mercantilism had four basic tenets as a national economic theory:

- National power was measured by national wealth.
- Such wealth was reckoned by bullionism, the amount of precious metal in the treasury.
- Increasing the amount of bullion on hand rested on maintaining a positive balance of international trade.
- The founding of colonies achieved a positive balance of trade by creating new sources of raw materials while creating new markets for goods produced at home.

According to this theory, it was highly desirable for England, an island nation, to gain its own sources of raw materials, without having to import them on the world market. By this pragmatic standard, the colonies became useful sources of raw materials, to be organized and governed primarily for the purpose of serving the economic needs of the mother country.

First English Foundations

Richard Hakluyt (the younger), a friend of Sir Humphrey Gilbert, developed and sustained popular interest in the colonization of America, despite such setbacks as the death of Gilbert (lost at sea) and the Lost Colony. Hakluyt broadened the mercantilist appeal, promising that colonists would get rich by supplying the natural products needed in the mother country. As for England, he wrote in 1584 that the establishment of colonies would be a worthwhile enterprise if only for "the hope of the sale of our wool."

The discovery and penetration of the Americas by the European powers marks the beginning of the early modern era. Intense competition among the new European nation-states caused them to see the new world as a source of wealth and strategic advantages in their struggles for power and domination in Western Europe. By exploiting the native populations and extracting treasure from the Americas, Spain set one pattern of colonization and became an international power. After restraining Spain's drive for domination, England began to colonize for a different purpose, establishing settlements in North America primarily for the purposes of transplanting English society and of expanding the English economy.

Selected Readings

Adair, James (Kathryn E. Holland-Brand, ed.). *The History of American Indians* (2005).

Axtell, James. *The Invasion Within: The Conquest of Culture in Colonial North America* (1985).

Bailyn, Bernard. *The Peopling of British North America: An Introduction* (1986).

Clendinnen, Igna. *Aztecs: An Interpretation* (1991).

Cronon, William. *Changes in the Land: Indians, Colonists, and the Ecology of New England* (1983).

Crosby, Alfred. *The Colombian Exchange: Biological and Cultural Consequences of 1492* (1972).

Eccles, W.J. *The Canadian Frontier, 1534–1760* (1969).

Games, Alison. *Migration and the Origins of the English Atlantic World* (1998).

Lang, James. *Conquest and Commerce: Spain and England in America* (1975).

Meinig, D. W. *Atlantic America, 1492–1800* (1986).

Meredith, Howard. *A Short History of Native Americans in the United States* (2001).

Morison, Samuel Eliot. *The European Voyages of Discovery: The Northern Voyages* (1971).

 The European Voyages of Discovery: The Southern Voyages (1974).

Nash, Garry B. *Red, White, and Black: The Peoples of Early America* (1982).

Nichols, Roger L. *American Indians in United States History* (2004).

Phillips, J. R. S. *The Medieval Expansion of Europe* (1998).

Richter, Daniel K. *Facing East from Indian Country: A Native History of Early America* (2001).

Starkey, David. *Elizabeth I: The Struggle for the Throne* (2001).

Washburn, Wilcomb E. *The Indian in America* (1975).

Weber, David. *The Spanish Frontier in North America* (1992).

Test Yourself

1) Which of the following was not a part of the Muskogean group?
 a) Seneca
 b) Creek
 c) Caddo
 d) Chickasaw

2) True or false: Spain founded the first colony in a territory that is now a part of the United States.

3) Which was not an important motive for British colonization?
 a) intercolonial rivalry
 b) profits from business
 c) Christianize Native Americans
 d) havens for religious dissenters

4) True or false: Mesoamericans had an unsophisticated social and economic structure to their society.

5) The first British colony in North America was founded by
 a) Sir Walter Raleigh
 b) the Puritans
 c) the Pilgrims
 d) Richard Hakluyt

6) Which nation never established a colony in North America?
 a) Spain
 b) England
 c) Portugal
 d) the Netherlands

7) The Mississippi River was first descended by the European explorer
 a) Balboa
 b) de Soto
 c) La Salle
 d) Cortés

8) True or false: The Dutch had a profitable colonial empire that stressed trade rather than colonies.

9) The Treaty of Tordesillas divided the known European world between:
 a) Spain and England
 b) Portugal and France
 c) France and Spain
 d) none of the above

10) The ancestors of the Native Americans are called
 a) Proto-Natives
 b) Paleo-Indians
 c) Pre-Natives
 d) none of the above

Test Yourself Answers

1) **a.** The Seneca were Iroquois. This tribe was the largest of those composing the Iroquois Confederacy. The other tribes of the Confederacy were the Oneida, Mohawk, Onondaga, Cayuga, and Tuscarora Indians. The Seneca lived in the Great Lakes region, especially concentrated in modern-day western New York. The Creek, Caddo, and Chickasaw tribes belonged to the Muskogean grouping of Native Americans, all of which lived in the present-day American South.

2) **True.** Spain established St. Augustine in Florida in 1565. It was founded as a naval station to protect the Spanish fleets sailing from the New World to Europe. The first English foundation in the present-day United States occurred at Jamestown in 1607. The first French colonies to be established within the modern boundaries of the United States did not occur until the early 18th century, with the settlement of Louisiana.

3) **c.** The English never had a mission system, as did Spain, in order to Christianize Native Americans. Religious conversion of the Native Americans was never as important to the English as it was the Spanish. For the most part, England entered the race for colonies due to the other reasons noted in this question, especially because of economic motives and for reasons of inter-colonial rivalry. Additionally, the English colonies— especially in New England and Pennsylvania—became havens for religious dissenters, including Puritans and Quakers.

4) **False.** Mesoamericans had a highly developed society and economy with many analogies to European civilization. Mesoamerican civilizations had urban centers, sophisticated trade systems, complex theological religions, highly developed technologies, refined concepts of mathematics and science, and complex forms of social organization. These were, however, different from their European counterparts. For that reason, Europeans who had first contact with Mesoamericans did not recognize or appreciate the fundamental complexities of the Native American societies that they encountered.

5) **a.** Sir Walter Raleigh and his brother Humphrey Gilbert established the first colonies in the 1580s, although these did not survive. The settlement at Roanoke, founded in 1585, became the most important all of these. Known as the Lost Colony, the disappearance of all the settlers at Roanoke became one of the great mysteries of the British colonial experience. Richard Hakluyt, who influenced Raleigh and Gilbert, never founded a colony in British North America. Instead, in the 1580s, he wrote an influential pamphlet (*A Design for Western Plantations*) that greatly influenced the beginnings of the colonial movement in England. The Puritans and the Pilgrims, both part of a religious controversy in the Church of England, did not found colonies in British North America until early in the second decade of the 1600s.

6) **c.** Brazil was the only Portuguese colony in the Americas. Spain, England, and the Netherlands all established colonies in geographical areas that would eventually become the United States. Portugal, however, founded most of her colonies in Africa and on the Indian subcontinent. In the 1520s, a group of Portuguese mariners were blown off course by an Atlantic storm and landed on the eastern tip of South America. They laid claim to that region, thereby affording Portugal the opportunity to found the colony of Brazil. Portugal never settled a colony in North America.

7) **c.** La Salle led the first European expedition to the mouth of the Mississippi in 1682. Balboa, de Soto, and Cortes were all Spanish explorers who expanded Spain's territorial settlements in the Caribbean and Gulf of Mexico region during the early 1500s. La Salle, a wealthy Frenchman, established a wealthy trading business in Canada during the 1660s and 1670s. He sought greater fame and fortune in the 1680s by traveling the Mississippi River and laying claim to the entire region through which it flowed, naming it Louisiana in honor of the French king, Louis XIV.

8) **True.** The Dutch primarily developed a trading empire rather than a territorial one. Other than the colony of New Netherlands, founded in 1624 in the Hudson River Valley of present-day New York, and a few isolated islands in the Caribbean, the Dutch never founded successful colonies in the New World. Instead, her citizens became accomplished sailors and merchants. Dutch merchants eventually dominated much of the commercial trade and shipping of the Western Hemisphere, trading with Spanish, French, and English ports throughout the Americas.

9) **d.** The treaty was between Spain and Portugal. By the time Columbus had sailed to the New World in 1492, the Portuguese had already established a successful seaborne colonial empire that had trading stations down the African coast and into the Indian Ocean. Two years later, the Pope by a Papal Bull, divided the unknown world beyond Europe between Spain and Portugal. Spain received all lands to the west of a line of demarcation drawn down the Atlantic Ocean beyond Canary Islands. Portugal received title to all unknown lands that fell to the west of this line. Representatives of Spain and Portugal met at the Spanish town of Tordesillas in 1494, where they signed a treaty that legitimized this agreement, which England and France never recognized and later ignored when they began to establish colonies.

10) **b.** The term Paleo-Indian is routinely used by anthropologists to identify the primitive peoples they have identified as the first human inhabitants of the Western Hemisphere. The word *Paleo* means ancient, primitive, or prehistoric. Hence, the Paleo-Indians were those human groups that appeared in the Americas before the more sophisticated and highly organized Native American societies that had distinctive cultures, languages, and civilizations. The other terms noted in this question, Proto-Natives and Pre-Natives, have no anthropological meaning and are not customarily used by those who study the historical origins of Native Americans.

English Colonization in North America

1607:	English settlement made at Jamestown, Virginia
1619:	House of Burgesses formed, and first Africans sold to planters in Virginia
1620:	Pilgrims (Puritan Separatists) settle at Plymouth, Massachusetts
1624:	Dutch settle New Amsterdam (New York City); Virginia Company's charter revoked, Virginia made a royal colony
1630:	Puritans settle Massachusetts Bay
1634:	Maryland settled
1642–1648:	Civil war in England
1649:	King Charles I executed; monarchy abolished and the Commonwealth proclaimed in England
1660:	Restoration of the monarchy and King Charles II; Navigation Act of 1660 (reenacting much of the act of 1651) passed
1662:	Connecticut organized by royal charter
1663:	Staple Act passed; royal charters issued to Carolina proprietors and to Rhode Island
1673:	Duty Act passed
1675:	King Philip (Metacomet's) War brings destruction to the New England frontier
1676:	Bacon's Rebellion challenges Governor Berkeley's authority in Virginia
1681:	Charter granted to William Penn for Pennsylvania
1684:	Crown revokes the Massachusetts Bay Company's charter
1685:	Accession of James II (formerly Duke of York)

(continued on next page)

1686: Dominion of New England absorbs New England colonies, and briefly New York and New Jersey

1688: The Glorious Revolution; James II deposed, succeeded by William of Orange and Mary

1691: Massachusetts receives new royal charter

1702: New Jersey united by royal charter

1702–1714: Queen Anne's reign

1714: George I of Hanover succeeds to British throne

1727–1760: Reign of George II

1729: North Carolina and South Carolina formed by new royal charters

1732: Georgia trustees receive charter from King George II

Between 1607 and 1732, permanent English settlements were established along the eastern coast of North America from New Hampshire to Georgia. The new colonies provided outlets for tensions and unrest in the mother country: lack of employment and available land, crowded cities and prisons, and religious and political dissent. They also motivated the development of new economic activities and, in colonies, the creation of African slavery. The peopling of wilderness environments in North America, the process by which the new settlements took hold and grew, significantly altered the development of the colonies and has had an enduring influence on the course of American history.

■ METHODS OF ESTABLISHING COLONIES

The English government employed two basic organizational agencies to promote the establishment of settlements overseas: the joint stock company and the proprietorship. The Crown created both by means of a royal charter. In some cases, such as Virginia in the 1620s, the monarch rescinded the charter and reasserted control, making the province a Royal Colony. The joint stock company and the proprietorship were well known forms of business and investment organization to the merchants and landholders of England and proved to be well adapted to the purposes of colonization.

The Joint Stock Company

Commercial joint stock companies began in the mid-1550s when they became a popular form of organizing businesses, especially in the city of London. They were composed of adventurers (stockholders), who pooled their assets in exchange for stock, thereafter sharing *pro rata* the company's profits and losses. Originally created to further overseas trade in commodities, the joint stock company became, during the reign of James I, the preferred method to undertake colonial ventures in North America. The Crown issued joint stock company charters that gave control of territory in British-claimed areas for the purpose of settling colonies, which from the viewpoint of the company existed for purposes of making a profit from settlement. Control of the colony was at first vested in the directors of the company, who were usually more interested in profits than in the settlers. Most charters provided that colonists should have all the rights and privileges of Englishmen and that their governing bodies should pass no law contrary to the laws of England.

Two of the most important colonies were established by the joint stock company method: the settlement at Jamestown, Virginia, by the London Company (1607), soon known as the Virginia Company; and the Puritan colony of the Massachusetts Bay Company (1630).

The chief characteristic that distinguished the joint stock company colony from others in English America was the large measure of self-government that it enjoyed. The stockholders of the Massachusetts Bay Company, for example, migrated to America with their charter, thus making the colony corporate or self-governing. The qualified voters in the colony chose the governor, the governor's council, and the legislative assembly. Massachusetts was a corporate colony until it lost its charter in 1684. Connecticut and Rhode Island, originally settled by dissident groups from Massachusetts, gained royal charters that conferred upon the colonists control of their own governments.

Non-English Joint Stock Companies

Two of the thirteen original colonies were initiated by non-English joint stock companies: New Netherlands, later New York, by the Dutch West India Company in 1623; and Delaware by a Swedish company in 1638. New York was captured by the English in 1664 and became a royal province when its proprietor, James, Duke of York, became king in 1685. Delaware fell under the proprietary control of the duke, who then sold it to William Penn, the proprietor of Pennsylvania. Hence, neither of these colonies retained much of their non-English heritage in terms of government or economics, although some colonists from those nations remained to live under the British.

Proprietary Colonies

Of the thirteen English colonies, seven were founded as proprietorships: Maryland to Lord Baltimore (1632); New Hampshire to Captain John Mason (1635); New Jersey to Sir William Berkeley and Sir George Carteret (1663); the Carolinas to a group of supporters of Charles II known as the Lords Proprietors (1663); Pennsylvania to William Penn (1682); and Georgia to a board of trustees headed by James Oglethorpe (1732). All except Pennsylvania and Maryland had become royal provinces before the Revolution.

The proprietary charters normally granted huge tracts of land to an individual or a group of persons on terms reminiscent of Feudal tenure. In the proprietorships, political control was put in the hands of those who received the royal grant, but in most cases it was delegated in part to representatives chosen by the colonists. The owners usually invested their personal fortunes in developing their lands and thus were placed in the position of having to attract new settlers to purchase or rent small holdings from them in order to reap profits.

Colonial Complexes

In addition to the type of founding charters that created a British colony, English provinces in North America can also be organized by geographical and economic similarities that historians call colonial complexes. There were three of these in number:

- The Plantation Colonies, which eventually included the colonies of the colonial Chesapeake (Virginia and Maryland) along with those of the south Atlantic coast (North Carolina, South Carolina, and Georgia). The Plantation Colonies developed a profitable staple crop economy, including production of tobacco, indigo, naval stores, and other agricultural products designed to be sold for commercial purposes. The institution of African chattel slavery developed in these colonies as a source of badly needed agricultural labor.

- Colonial New England, composed of the Massachusetts Bay colony, Rhode Island, Connecticut, and New Hampshire (Vermont was never a separate colony). Colonial New England turned to the sea, developing a maritime economy that also included ship manufacturing, food processing, and some subsistence agriculture.
- The middle colonies, including Pennsylvania, New York, New Jersey, and Delaware. The middle colonies, which probably had the greatest population diversity in terms of non-English residents, eventually specialized in the production of foodstuffs such as grain, vegetable produce, and livestock.

Cities in all three types of colonies, especially at Boston, New York, Charleston, and Philadelphia, became important commercial centers.

English colonies in North America were founded in two chronological waves, (1607–1644) and (1660–1732), and this also determined many of their distinctive characteristics. The first wave of colonial establishment took place during the reign of the first two Stuart monarchs, James I and Charles I. The English Civil War and Puritan Interregnum of the 1650s marked a period in which no new colonies were founded. With the restoration of the monarchy in 1660, a second wave of colonial founding marked the increased popularity of the proprietary colony as the preferred method of colonial government. In addition, with the passage of the Trade and Navigation Acts in the 1650s and 1660s, English colonies in the Americas came under centralized economic direction from the home ministries in London. This alone made the second wave, or restoration colonies as they are sometimes called, more efficient in their founding of new colonies than those established during the first wave.

Table of English Colonies							
Name (thirteen original states in Italic)	**Founded By**	**Date**	**Charter**	**Assembly**	**Made Royal**	**Status in 1775**	**Remarks**
Virginia	London Company	1607	1606-1609-1612	1619	1624	Royal	
Plymouth	Separatists	1620		1639	1691		Merged with Massachusetts in 1691
Massachusetts	Puritans of the Mass. Bay Co.	1628	1629	1634	1684	Royal	Only royal colony to have its charter restored (1691)
Maryland	Lord Baltimore	1634	1632	1634		Proprietary	A royal province, 1690-1715
Rhode Island	Roger Williams	1636	1663	1647		Self-governing	Frustrated Andos's attempt to take away charters 1686-1687
Connecticut	Emigrants from Massachusetts	1636	1662	1637		Self-governing	Frustrated Andos's attempt to take away charters 1686-1687
New Haven	Emigrants from Massachusetts	1638		1643			Merged with Connecticut, 1662 1686-1687
Maine	F. Gorges	1641	1639		1691		Bought by Massachusetts, 1677
North Carolina South Carolina	Eight Nobles	1663	1663	1669	N. 1729 S. 1729	Royal Royal	Informally separated, 1691; formally separated with different governors, 1729
New York	(Duke of York)	1664	1664	1683-1685	1685	Royal	Dutch colony of New Netherland, 1622-1664
New Hampshire	John Mason	1664	1639	1680	1679	Royal	Towns absorbed by Massachusetts, 1641-1679
New Jersey	Berkeley and Carteret	1664		1664	1702	Royal	Under the governor of New York until 1738
Pennsylvania	William Penn	1681	1680	1681		Proprietary	A royal province, 1692-1694
Delaware	Swedes	1638		1702		Proprietary	Conquered by Dutch, 1655; by English, 1664 Merged with Pennsylvania, 1682; Separate governor (1691) and assembly (1702)
Georgia	James Oglethorpe	1732	1732	1733	1752	Royal	

■ THE COLONIAL CHESAPEAKE

The colonies that were established on the Chesapeake Bay, in Virginia and Maryland, though quite different in organization and motives, developed along similar lines, shaped to a considerable extent by the bay itself and the many navigable rivers and streams that flowed into it.

Virginia

Jamestown, site of the first settlement (of about 100 men) in 1607, proved to be an unhealthy and dangerous place for human habitation. It would not have survived were it not for the able leadership of Captain John Smith and the strict order and communal discipline maintained by the first governors.

The Virginia Company made little progress, beyond survival and the development of tobacco as an export crop (by John Rolfe), during the first ten years at Jamestown. Tobacco became an important crop and created an economic boom for the colony. New incentives for prospective settlers were therefore announced. To increase the population and supply of laborers, the company enacted in 1618 a new system of land grants. Settlers were to receive a headright parcel for themselves and another fifty acres for each additional person whose passage they paid. (Private land ownership had been offered as an incentive a few years earlier.) Fulfilling a guarantee in its charter, the company sanctioned the formation in 1619 of the House of Burgesses, the first legislative assembly in the new world. Still, the company failed, in large part because 347 settlers had been killed in an Indian attack in 1622. James I revoked its charter and made Virginia a crown colony in 1624. Of the 8,500 settlers who went out to Virginia during the company's existence, only 1,300 (or 20 percent) survived.

Virginia as a Royal Colony

Under royal authority, Virginia expanded and grew. By 1650 there were 16,000 settlers; by 1660, 40,000. A distinct pattern unfolded in this expansion: The best land (initially in the tidewater region) was accumulated in large holdings by a small group of planters. This brought pressure from newcomers and have-nots for additional land in the backcountry and frequently led to the forced removal of native occupants and hostilities on the frontier.

Under Governor Sir William Berkeley, who dominated the politics of the colony for thirty years, the House of Burgesses (which received royal sanction in 1639) became an exclusive club of large landholders. The electorate was increasingly restricted and representation thereby heavily weighted in favor of the easternmost counties. Landholders in the interior and backcountry perceived the great inequity in this and became increasingly restive. When Governor Berkeley failed to respond forcefully to Native American uprisings on the frontier in 1676, those western settlers took matters into their own hands. Led by Nathaniel Bacon, they gained control of the colony for a brief time and even burned Jamestown. Although Bacon's Rebellion quickly collapsed after Bacon died of natural causes, it proved to be the most serious challenge to royal authority in the colonies until the American Revolution.

The Origins of Slavery

The chattel slavery of unwilling African arrivals in English America had its legal beginnings in colonial Virginia, largely because of the critical need for inexpensive labor that resulted from the tobacco boom set in motion by John Rolfe. The headright system, coupled to the frontier migration of arriving

English settlers, made it difficult for planters to find agricultural laborers in the colony. Planters initially turned to indentured servants to meet this need, and many did come to the colony. Many, if not most, of these indentured servants became settlers, and sometimes planters, upon being released from their indenture contracts after periods from five to seven years. Some historians estimate that between 75 and 80 percent of the 130,000 immigrants who came to the colonial Chesapeake from the British Isles during the seventeenth century were indentured servants. Nonetheless, these numbers could not supply the demand for labor. Slavery in the colonial Chesapeake evolved in response to this need.

African and Native American slavery had been practiced by the Portuguese and Spanish since the beginnings of discovery, although the institution was alien to British law and practice. In the late 1610s, Dutch trading vessels began bringing African captives to Virginia, whom the planters "purchased" under the existing laws of indenture. Unlike the case of European indentured servants, however, the planters customarily did not release the Africans from indenture contracts because, as one document noted, "they remained strangers to English law and custom." In 1682, a Virginia law provided for the enslavement of "Negroes, Moors, Mollatoes, or Indians" if their native country "was not Christian." The institution of slavery spread rapidly throughout the British colonial system, so that by the early eighteenth century, it existed literally everywhere English agriculture and planting flourished. Historians estimate that by the time of the American Revolution, more Africans had come to the new world in total number than did Europeans, although most of them went to the Caribbean or to Portuguese Brazil. The slave trade brought about ten million African people to the western hemisphere, with about 250,000 of them going to the British Atlantic colonies that eventually became the United States.

Maryland

Maryland was established by the Calvert family, the earls of Baltimore, who in 1632 gained a charter from King Charles I making them and their heirs "true and absolute lords and proprietaries" of the settlement. They intended it to be a refuge for English Catholics as well as a productive financial venture. The first settlers landed at St. Mary's, on the Potomac River, in 1634; they encountered friendly Indians who sold them land and provisions.

Although they possessed total authority over the colony and provided large grants of land to their relations and friends, the Calverts needed to attract settlers and laborers to make Maryland a successful venture and avoid financial ruin. They recognized that the colony had little hope of growth if it excluded non-Catholics and thus pursued a policy of religious toleration almost from the beginning. This policy notwithstanding, differences between English Catholics and Puritans troubled the colony in its first years. With the Glorious Revolution in England, Protestants gained a sympathetic royal governor from King William. They proceeded to pass laws in 1691 establishing the Church of England in the colony and denying Catholics the right to hold office. In 1715, the Calverts reassumed the proprietorship, and the charter of 1632 was restored under the fourth earl of Baltimore, who had been raised in the Anglican faith.

Although its charter and religious purpose were unique, Maryland grew much like Virginia. Many settlers from Virginia moved to Maryland, where they established a society and culture that was very similar. The land was soon organized into large farms or plantations, on which tobacco was the principal crop. In 1635, the proprietor permitted formation of a representative assembly, the House of Delegates, modeled on the English House of Commons. A few years later, faced with an acute need for laborers, the proprietors initiated a headright system of land grants, similar to that of Virginia, to encourage immigration.

■ NEW ENGLAND

New England, named by Captain John Smith, who had explored the area for the Plymouth Company, was first settled by Puritans and other Calvinists. Heavily influenced by the Massachusetts Bay experiment, the colonies east of the Hudson River shared a common religious heritage and adopted a social organization based upon the importance of the town.

Calvinism

The religious orientation known as Calvinism derived from the teachings of John Calvin, a Genevan (Swiss) theologian whose ideas became powerful, revolutionary forces for religious reform during the seventeenth century throughout Europe, including England. Calvinists believed in an all-powerful God and in the principle of predestination: that God had determined the individual's fate in advance of birth. Calvinism encouraged industriousness, good works, and piety. Calvinists believed that they should lead lives free from sin. The best way to accomplish this goal, they felt, was to live in communities of the elect, people who had been predestined not to sin. This enabled them to become saints in Heaven. The purpose of organized religion, therefore, was to create such communities, known as congregations, where such believers could live their everyday lives together following the teachings of the Bible and remaining free from the temptation to sin.

Calvinists appeared in almost every nation of Europe, except for Spain, in the seventeenth century. In France, they were known as Huguenots, in Scotland as Presbyterians, and in the lower countries as Dutch Reformed. In England, they were called Puritans because they desired to "purify" the recently created Church of England of its Roman Catholic practices.

Two types of Puritans emerged in England:

- Non-conformists who wanted to remain within the Church of England in order to reform it
- Separatists who thought the solution was to withdraw from the Church of England in order to live a godly existence apart

The majority of Puritans were non-conformists, and during the 1630s they grew in strength and number in England to the point at which they provoked a Civil War during the reign of Charles I. Their cause merged with that of the Parliamentary faction and eventually brought down the monarchy. For a brief period (1649–1660), Britain was a commonwealth or republic dominated by the non-conformist Puritan government of Oliver Cromwell, although King Charles's son was restored to the throne in 1660.

Plymouth Plantation

The second English settlement in North America, and first in New England, was made by a group of Puritan Separatists, originally from the small town of Scrooby, in East Anglia, who had suffered some persecution and gone into exile in Holland for their refusal to observe the practices of the established church. Led by William Bradford, this group of thirty-five believing "saints" (part of the elect), with sixty-seven "strangers," left England for America in September 1620 on board the ship *Mayflower.* They had been permitted to settle on lands claimed by the London (Virginia) Company, but they came ashore just outside its territory, on Cape Cod.

To govern their settlement, they subscribed to a covenant or agreement that set down a code of civil laws, known as the Mayflower Compact. They disembarked at Plymouth Rock to begin their settlement

on December 21, 1620. Plymouth Plantation remained small and poor, but its example led other Puritans to attempt similar settlements that would prosper. The colony was self-governing under the Mayflower Compact until 1691, when King William III placed the Plymouth settlement under the governorship of the colony of Massachusetts. The people who settled Plymouth called themselves Pilgrims, a name by which they are still known today.

Massachusetts Bay

Led by John Winthrop, a group of non-conformist Puritans, better organized and financed than those led by Bradford, left England in 1630. They had formed themselves into the Massachusetts Bay Company and secured a royal charter the previous year. By emigrating together, they were able to use the joint-stock company organization to achieve greater independence from royal interference. They cleverly extended that organization to structure their religious and political community. In a little more than ten years, in what is known as the Great Migration, the population of the settlement reached 20,000.

Because the Puritans who settled Massachusetts Bay were not separatists, they believed they had a special covenant with God to establish a true Christian community that would be an example to the world. As Winthrop put it, "we shall be as a city upon a hill, the eyes of all people are upon us." After a difficult first few years, their numbers grew dramatically, largely because of a steady migration of whole families.

The civil government of Massachusetts Bay reflected the importance of its churches—only full members of a Puritan congregation, those who had proved they were God's elect (saints), had the vote and held civil offices (as freemen). Significantly, the meetinghouse of each community was located in the center of the town and was used for both religious and civil gatherings. Still, even with the religious requirement, a significant proportion of the adult male population of the community was politically enfranchised (40 percent; a higher percentage than in England). The General Court, at first a meeting of the original stockholders, soon became a legislature, composed of a House of Deputies and a council appointed by the governor. In 1648, it issued the laws and liberties in the form of an alphabetized code, the first such code in English.

Although Massachusetts Bay was largely self-governed, the Puritans enacted laws no more tolerant of diversity than those that had been used to imprison and persecute their fellow Puritans in England. They in effect established their own churches in place of the Church of England, taxing all residents for their support and requiring universal church attendance. Unorthodox Puritan beliefs—such as those of Anne Hutchinson, who challenged the Calvinist doctrine of predestination by insisting that Christians might gain salvation and grace directly from God, and those of non-Puritan groups like the Quakers—were not tolerated and were, in fact, severely punished.

Rhode Island

Rhode Island was established by Roger Williams, a Puritan minister who disagreed with John Winthrop, and the followers of Anne Hutchinson. Hutchinson and her supporters left Boston and settled the town of Newport. Williams founded the town of Providence, and it soon combined with Newport to create Rhode Island. This colony was the first to separate church and state: "liberty in religious concernments" was recognized in the royal charter Rhode Island received officially in 1663 from the king (a charter had been granted by Parliament during the period of Puritan rule in 1644). In Rhode Island, taxes were not applied to the support of churches and no requirement of church membership was placed on the right to vote.

Connecticut

The desire for better lands and dissatisfaction with the rigidity of life in Massachusetts Bay led two groups to form new settlements in the rich Connecticut River Valley in the late 1630s. Under the leadership of Thomas Hooker, Hartford and two other local towns drafted the Fundamental Orders of Connecticut in 1639; this frame of government drew on the example of Massachusetts Bay but expanded political rights. The Hartford area colony gained a royal charter in 1662, with authority over another, more orthodox settlement on the lower Connecticut, at New Haven, which had framed its own Fundamental Articles.

New Hampshire

New Hampshire was organized as a proprietary colony but grew in population only after it was settled by Massachusetts Puritans looking for refuge or new lands. Although Massachusetts pressed its claims to the territory, New Hampshire gained its own charter in 1679.

The Dominion of New England

In an effort to assert royal authority over Massachusetts and to prevent violations of the Navigation Acts, advisors to James II secured the revocation of the Massachusetts Bay charter in 1684. Two years later, the king consolidated the colony and its neighbors into one government, the Dominion of New England. The territory of the Dominion was soon extended to include New York and New Jersey and placed under the authority of a single royal governor, Sir Edmund Andros. The elected assemblies of the settlements were abolished.

The Dominion collapsed when King James II, an advocate of divine right rule of kings and a Roman Catholic, was driven from the throne in 1688. Governor Andros was pursued by a mob and imprisoned. In England, the Glorious Revolution ended with Parliament elevating James's daughter Mary and son-in-law Prince William of Orange to the monarchy. Under their rule, Massachusetts Bay and Plymouth were made into a single royal colony. The colony's new charter (1691) restored the General Court and abolished religious restrictions on political rights.

■ THE MIDDLE ATLANTIC COLONIES

By the mid-seventeenth century, a new group of colonies took shape along the Atlantic coast between the colonial Chesapeake and New England. Some of the colonies had their roots in the British colonial heritage, while others did not.

New York

New York, originally the Dutch colony of New Netherlands, was captured by the English in 1664 and given by Charles II to his brother James, Duke of York (later James II). The Dutch resisted the English claim but lost the colony for good, after momentarily regaining it, ten years later. Under the duke's direction, the colony was ruled by his governor—without a representative assembly, but with recognition of the colony's multinational population and a new code of laws. The Dutch were allowed to retain their property, and the Dutch language and culture continued to flourish. Religious toleration was guaranteed by the Duke's Laws.

The extensive Dutch manorial estates known as patroonships were acknowledged and James himself reinforced this pattern by making large grants of land to friends and relations. This served to thwart

productive use of the land and remained a source of political discontent throughout New York's early history. New York City, strongly influenced by its Dutch origins and diverse European population, steadily grew as a port. The fur trade, especially with the Iroquois tribes west of Albany, on the Hudson River, was an important part of the colony's economy during the seventeenth century, but it declined rapidly in New York after 1715.

For a brief period, New York (with New Jersey) was merged into the Dominion of New England. When news of the Glorious Revolution arrived, the local militia seized power and Andros's lieutenant escaped to England. A New York City merchant, Jacob Leisler, took control of the colonial government; he was executed in 1691 after refusing to step aside for the appointment of a new governor, which eventually happened in spite of his opposition.

New Jersey

The area between the Delaware and Hudson rivers was part of the grant made by Charles II to the Duke of York. He, in turn, had given it to two of his political friends, Sir George Carteret and Sir John Berkeley (also proprietors of Carolina). When the latter sold his holdings to Quakers in 1674, the colony was divided into West and East Jersey. It was reunited in 1702 under a single royal charter.

New Jersey was sparsely populated and loosely administered throughout its early history. Contests over land and related claims of the early proprietors, which pitted the colony against New York, persisted, restricting development. Many settlers came from New York and reflected a similar pattern of diversity in origins; however, few brought or accumulated substantial wealth.

Pennsylvania

Pennsylvania (or "Penn's woods") was named by Charles II, who made a large grant of land on the Delaware River to William Penn in 1681 in order to repay a debt. Penn enlarged his proprietary holdings when he purchased the three lower counties of Delaware in 1682. His objective was to establish a settlement that would serve as a "holy experiment," to be organized in harmony with the beliefs of the religious Society of Friends, or Quakers (dissenters from the Church of England who had taken a different path than the Puritans). The city Penn planned as the center of the colony was named Philadelphia (from the Latin for brotherly love) to further proclaim the experiment's goals. Born to privilege, Penn had come to accept the Quaker belief that all possessed the "inner light," a divine spark by which one should be guided. This belief led the Society of Friends to be democratic in their worship and plain in their manners and dress. These practices and their pacifism had subjected them to persecution in England and in the New England colonies.

Like other idealistic proprietors, Penn needed to attract settlers in large enough numbers to offset the large sums he had invested to establish the colony. He encouraged Germans, Scandinavians, and other continental Europeans to emigrate to his province, creating a diversity that, with Pennsylvania's rich and well-irrigated lands, caused it to develop quickly. Penn's good faith in dealing with Native Americans allowed the new colony to enjoy good relations with the local tribes during its infancy. He even agreed to restrictions on his own powers in accepting the Charter of Liberties in 1701, which also authorized Pennsylvania and Delaware to elect their own representative assemblies. Despite the colony's success, Penn and his family were unable to collect the quitrents (Feudal levies) from settlers that had been provided for in the king's grant.

■ THE SOUTHERN RESTORATION COLONIES

The restoration of the monarchy in 1660 resulted in a new colonial foundation in Carolina that was eventually followed by the creation of Georgia in the 1730s as a buffer against Spanish Florida.

North and South Carolina

The two Carolinas were colonies settled soon after the restoration of Charles II to the English throne in 1660. They were originally granted as one colony by the king to eight of his friends, called the Lords Proprietor. They were wealthy and ambitious land speculators, who sought to make large profits by enticing new settlers from other American colonies to their proprietary lands. Interestingly, they attempted to do this by granting religious freedom and promising that laws would be made by an elected assembly. When few responded to these enticements, one of the proprietors, Sir Anthony Ashley Cooper (shortly the first earl of Shaftesbury), convinced the others to sponsor emigration from England. In 1670, an expedition succeeded (despite the loss of more than half its members) in forming a settlement at Port Royal, in the Sea Islands off the Carolina coast. Ten years later, the city of Charles Town (later Charleston) was founded at the confluence of the colony's two principal rivers, the Ashley and the Cooper.

Shaftesbury and the philosopher John Locke, who never visited America, drew up the Fundamental Constitution for Carolina in 1669. This document responded to England's social problems rather than to the realities of life in the new world, which explains why the well-ordered and highly structured aristocratic society they envisioned never took form.

The northern portion of Carolina, which became North Carolina, was settled by small farmers. Those who settled about the harbor at Charles Town, in the coastal lowlands, raised provisions for export, notably to the sugar planters of the West Indian island of Barbados. At the turn of the century, they began exporting rice, soon a valuable staple crop. Land grants in the form of headrights helped to attract a steady flow of new settlers (often with slaves) to the lowlands.

The Carolinas were ill-fitted as a single political and geographical unit and proved impossible to govern. The proprietors lost control of the settlers after Shaftsbury's death in 1719. In 1729, King George I abolished the proprietorship and divided the original grant into two royal colonies, North Carolina and South Carolina.

Georgia

As the last of the thirteen colonies established by Britain in America, Georgia was placed under the direction of General James Oglethorpe and a group of trustees in 1732 for a period of twenty-one years. The following year, Oglethorpe led the expedition that made the first settlement on the Savannah River. The colony was established primarily for military reasons, to serve as a buffer between the British colonies and Spanish Florida, from which the Spanish had launched attacks against English settlements in 1686. Anticipating future attacks from Florida, the trustees sought to people the colony with only the most reliable settlers and to concentrate the population rather than allowing it to spread out over large areas. The colony also had a social purpose—to serve as an outlet for unfortunate debtors (one could be imprisoned for owing a very small sum) and for the poor of Britain. Georgia prohibited Roman Catholics and black slaves from the colony, restricted the size of land holdings, and forbade the import of rum, fearing its possible effects on local Native Americans.

Events in Georgia failed to fulfill this idealized mission. Despite the trustees' active efforts to recruit settlers, only a small number of British debtors and paupers migrated to the colony. Land restrictions were soon eased, rum was tolerated and permitted, and the prohibition on slavery was eliminated in 1751. Recognizing the failure of their experiment, the trustees returned their colony to the Crown the following year. Thereafter, Georgia grew in the manner of the southern plantation provinces, as settlers from other colonies, especially South Carolina, came to raise rice and other staple crops.

The most successful of the English settlements in North America possessed strong communal purpose and organization in the first years of transplantation. After the settlements took hold, they faced an array of social problems and continuing threats to their survival, made worse by lulls in migration or declines in population. Massachusetts Bay benefited from a steady influx of Puritan settlers from England until the English Civil War. But most of the colonies, especially the proprietorships, had to abandon or ease their first, idealized plans for new communities to attract and keep settlers. They provided incentives in the form of land grants, political rights, and, gradually, laws to ensure religious toleration. As the colonies grew and new settlers pushed into the interior in search of unclaimed lands, conflicts with displaced Native Americans increased and new tensions emerged between the western (or interior) regions and the first coastal settlements.

Selected Readings

Andrews, Charles M. *The Colonial Period in American History* (4 vols., 1934–1938).

Berlin, Ira. *Many Thousands Gone: The First Two Centuries of Slavery in North America* (1998).

Engerman, Stanley L. and Robert E. Gallman, eds. *The Cambridge Economic History of the United States,* Vol. 1. *The Colonial Era* (1995).

Games, Alison. *Migration and the Origins of the English Atlantic World* (1999).

Gleach, Frederic W. *Powhatan's World and Colonial Virginia: A Conflict of Cultures* (2001).

Pulsipher, Jenny Hale. *Subjects Unto the Same King: Indians, English, and the Contest for Authority in Colonial New England* (2005).

Lovejoy, David S. *The Glorious Revolution in America* (1972).

Main, Gloria L. *Tobacco Colony: Life in Early Maryland, 1650–1720* (1982).

Main, Jackson. *Society and Economy in Colonial Connecticut* (1985).

Middleton, Richard. *Colonial America: A History, 1565–1776* (2002).

Morgan, Edmund S. *American Slavery, American Freedom: The Ordeal of Colonial Virginia* (1975).
 Roger Williams: The Church and the State (1967).
 The Puritan Dilemma: The Story of John Winthrop (1958).

Oatis, Stephen J. *A Colonial Complex: South Carolina's Frontiers in the Era of the Yamasse War, 1680–1730* (2004).

Reich, Jerome S. *Colonial America,* 5th Ed. (2001).

Salisbury, Neal. *Dominion and Civility: English Imperialism and Native America, 1585–1685* (1999).

Taylor, Alan. *The American Colonies* (2001).

Tate, Thad W. and Ammerman, David, eds. *The Chesapeake in the Seventeenth Century* (1979).

Tolles, Frederick B. *Quakers and the Atlantic Culture* (1960).

Walsh, Lorena S. *From Calabar to Carter's Grove: The History of the Virginia Slave Community* (1997).

Weir, Robert. *Colonial South Carolina* (1983).

Wood, Peter. *Black Majority* (1974).

Test Yourself

1) Which of the following was not a structure that England used for founding colonies?
 a) Joint Stock Company
 b) proprietorship
 c) land grant to a religious group
 d) royal charter granted by the King

2) Which was the economic asset of greatest value in colonial Virginia?
 a) tobacco as a cash crop
 b) free land for settlers
 c) agricultural laborers
 d) none of the above

3) Which of the following was a Restoration colony?
 a) Vermont
 b) Carolina
 c) Connecticut
 d) Rhode Island

4) True or false: Quakers were the largest group of people to settle in Pennsylvania.

5) True or false: Puritans in Massachusetts believed in religious freedom for everyone.

6) Slavery as a British colonial institution grew legally from
 a) international law
 b) Native American servitude
 c) indentured servitude
 d) all of the above

7) True or false: South Carolina developed the most diverse cash crop agriculture of the plantation colonies.

8) True or false: Georgia was founded partly as a refuge for debtors and other needy people.

9) The investors who founded the Carolina colony were called the
 a) friends of the King
 b) Carolingians
 c) Lords Proprietor
 d) none of the above

10) The first non-conformist Puritans to settle in Massachusetts were led by
 a) John Winthrop
 b) William Bradford
 c) George Calvert
 d) William Berkeley

11) The Middle Colonies became known for their production of
 a) cotton
 b) grain
 c) tobacco
 d) silk

12) England attempted to bring all of New England under one government when it created
 a) the Dominion of New England
 b) the Puritan Interregnum
 c) the Restoration
 d) all of the above

Test Yourself Answers

1) **c.** The British crown created colonies by issuing joint stock company charters, royal charters, or granting proprietorships. All British colonies in the Americas owe their founding to one of these three methods for establishing an English colony. Although some colonies, such as Puritan New England, had clear-cut religious motivations, the religious groups that founded such colonies never got a direct grant made to their denomination or religious organization in order to found a colony. England never made grants of land directly to a religious group in order to found a colony, although some of the colonies founded by joint stock companies or proprietors—including Massachusetts Bay and Pennsylvania—had strong religious motivations.

2) **c.** Labor was always at the highest premium in the plantation colonies. Tobacco, planted for the first time in large amounts in 1618, brought huge commercial profits to the colony of Virginia. In addition, many settlers came to Virginia in order to get land grants which, in some cases, made them wealthy. However, the greatest need in colonial Virginia was for labor to clear the land and plant tobacco. In that regard, labor was the most valuable economic commodity in the colony. By the early 1660s, for example, the institution of African slavery had been established in Virginia in order to meet this need. In addition, an increasing number of indentured servants also came to the colony in order to meet the ever-growing demand for labor.

3) **b.** Carolina was the restoration colony. The others either were never colonies (Vermont) or were chartered by the Puritan expansion of New England. Connecticut and Rhode Island grew from the expansion of Massachusetts Bay. Vermont, during the entire colonial period, existed as a part of the colony of New Hampshire. It did not become a separate state until much later.

4) **False.** More Germans and Scots-Irish settled in Pennsylvania than Quakers. Although William Penn was a Quaker who brought large numbers of his group to Philadelphia, they were relatively small in number. Most of them were merchants, artisans, and other skilled laborers who were attracted to the city life of the Pennsylvania capital. Starting at the beginning of the 18th century, however, large numbers of Scots-Irish immigrants began arriving in Pennsylvania, attracted to the rich farming and grazing lands to the west of the urban areas. They settled the lush river valleys of central Pennsylvania and came to constitute the largest group of people who settled in colonial Pennsylvania.

5) **False.** Puritans only wanted a religious haven for people who believed as they did. They did not wish to provide a haven for everyone else. In the early 1630s, the Puritan government of Massachusetts established strict requirements for those persons who wished to settle in the colony. People wishing to live in the Massachusetts Bay colony had to join a local Puritan church to get a land grant and become a citizen. There was little toleration for other

religious groups, including Quakers and anyone else who disagreed with the Puritan leaders. This also extended to other Puritans, such as Roger Williams and Anne Hutchinson, who questioned some of the religious practices of the colony's leadership. For that reason, Williams and Hutchinson were eventually expelled from the colony in the late 1630s. They and their followers founded colonial Rhode Island.

6) **c.** Slavery grew from the legal existence of indentured servants in British law. England traditionally had no system of law that legitimized slavery, an institution of bondage that was unknown in the British Isles. Unlike Spain and Portugal, English colonizers did not enslave Native Americans nor did British law—at least initially— recognize the international legal arguments that underlay Spanish and Portuguese slavery. The need for labor, especially in colonial Virginia, created a situation whereby legal slavery involved out of the institution of the endangered servitude. African arrivals, who at least initially became indentured servants legally, had their contracts extended indefinitely because there was a continuing need for their labor. In the 1660s, the Virginia assembly passed a law permanently indenturing African laborers, thereby creating the legal basis for the institution of slavery in British North America.

7) **True.** The colony of South Carolina developed a very diverse agricultural economy. The colony grew cotton, rice, tobacco, and indigo. It had more cash crops of greater economic importance than any other colony in British North America.

8) **True.** Georgia was founded partly as a refuge for debtors and other needy people. This was an important goal for General James Oglethorpe, who founded the first settlements in the colony. In the early 1730s, the time during which Georgia was being settled, many minor crimes carried harsh penalties in England. The founding of Georgia was seen as a way to rehabilitate petty criminals and others who needed a fresh start. In reality, most of the people who went to colonial Georgia in the 1740s and 1750s were not debtors, needy people, or minor criminals. Instead, they were independent yeoman and settlers drawn by the opportunity to plant crops and make a good living for themselves. By the 1750s, colonial Georgia had ceased to be a haven for debtors and other needy settlers. It became a royal colony.

9) **c.** Carolina was founded by a wealthy group of noblemen and investors who called themselves the Lords Proprietor. Many of them were strong supporters of King Charles II and received the Carolina grant for that reason. Many of them received large personal grants of land in the colony and hoped to reap great wealth from these holdings, which some of them did.

10) **a.** John Winthrop was the leader of the Puritans who founded the Massachusetts Bay colony. Winthrop was non-conformist Puritan, meaning that he favored remaining within the broad structures of English religious traditions. Another and much smaller group of Puritans, often called separatists, believed that they should not follow English religious organization or tradition. William Bradford was the leader of a group of separatist Puritans who founded the Plymouth colony, which later became a part of a larger and more prosperous Massachusetts Bay. George Calvert was a founder of Maryland, while William Berkeley served as royal governor of Virginia.

11) **b.** Pennsylvania, Delaware, New Jersey, and parts of New York became important producers of flour during the colonial period. Pennsylvania especially became the "bread basket" of British North America. By the time of the American Revolution, the vast wheat fields of the middle colonies produced a significant amount of the flour consumed in Great Britain.

12) **a.** The Dominion of New England was an attempt by King James II to combine Massachusetts Bay, Connecticut, Rhode Island, and New Hampshire into one colonial government. New York and New Jersey were later added to this governmental structure, which lasted from 1686 to 1689. It was unsuccessful, largely because the colonists in all of the involved colonies deeply resented the loss of self government. There were widespread protests and complaints, many of which were directed against Sir Edmund Andros, the royal governor of the Dominion. The Dominion of New England came to a quick end in 1689 when the Glorious Revolution in England removed James II from the British throne.

Provincial America

1611: Publication of the "authorized," or King James, version of the *Bible* in English

1619: First Africans imported into Virginia

1636: Founding of Harvard College in Cambridge, Massachusetts

1647: Massachusetts School Act passed

1649: Maryland Toleration Act passed; repealed 1654

1654: First group of Jews to settle in American colonies arrive in New Amsterdam; first American synagogue founded in New York in 1695

1662: "Halfway Covenant" introduced in Massachusetts Bay

1665: Freedom of conscience included in New Jersey proprietors' "Concessions and Agreements"

1678: Publication of John Bunyan's *The Pilgrim's Progress, A Christian Allegory*

1687: Publication of Sir Isaac Newton's *Principia Mathematica*, containing his laws of motion and theory of gravitation

1688: The Glorious Revolution; James II deposed, succeeded by William and Mary

1692: Witchcraft trials begin in Salem, Massachusetts

1693: The College of William and Mary founded; Spanish found Pensacola

1694: Thomas Smith plants first rice crop in Carolina Colony

1708: First regularly issued colonial newspaper, *The News-Letter,* published in Boston

1718: New Orleans founded by the French; San Antonio founded by the Spanish

1720: Cotton Mather urges inoculation against smallpox in Boston

1730s–1740s: The Great Awakening begins and spreads

(continued on next page)

1731: Organization of the Library Company of Philadelphia

1734–1735: Trial of John Peter Zenger for libel

1739: Stono uprising of slaves in South Carolina

1741: Reverend Jonathan Edwards gives sermon entitled "Sinners in the Hands of an Angry God"

1743: Founding of the American Philosophical Society for the Promotion of Useful Knowledge in Philadelphia

1747–1752: Franklin's experiments with electricity and lightning

1750: Iron Act passed by Parliament

1766: First Wesleyan or Methodist Church in America established in New York City

The immigrants from the old world brought English and European habits, customs, and outlooks to new and often harsh environments in the new world. To survive, they had no choice but to adjust to the new conditions of life in the American colonies, enforced by nature and by British governments. To prosper, they had to overcome great odds: the sheer distance between the settlers, a constant scarcity of labor, and the lack of liquid capital and a circulating currency. In the middle and northern colonies, these conditions encouraged diversity and innovation; in the South, the prospects of great wealth from large-scale staple-crop agriculture led white planters first to use and then to rely on the labor of African slaves. In cultural matters, the American colonists continued to look to metropolitan London for direction and examples, as did the people who inhabited areas in England that were distant from the great imperial capital. Colonial America was a region in which new identities formed. British colonials became American, while transplanted Africans formed new identities that also permitted them to survive the rigors of slavery as they became Americans.

■ COLONIAL ECONOMIES

Colonial America was largely a land of farmers and planters. Home or plantation manufactures (manufactured goods) flourished on a small scale. Large-scale manufacturing was restricted by imperial legislation and a lack of capital for investment. This was because British trade regulations, first passed in the 1650s and 1660s, required that the colonies operate as part of a colonial economic system based on mercantilism (the accumulation of precious metals through favorable trade balances). More fundamentally, the colonial economies were shaped by the magnet of British demand for staple exports to England and handicapped by labor shortages. These hindered the development of local and regional markets, although there was an active intercolonial coastal trade. At the same time, the colonists proved to be remarkably adaptable in fashioning a successful economy within the confines of the British imperial system.

New England

Severe winters and poor soil largely determined the economy of the New England colonies. With the exception of the rich Connecticut River Valley, where tobacco grew and which fit the pattern of the middle colonies, the region proved to be unsuited for large-scale agriculture and was thus shaped in its development by trading and the sea.

Harvesting the Land and Sea

Characteristic of the region northeast of the Hudson Valley was the diversified farming of small freeholds. Despite the handicaps of a short growing season and rocky soil, many crops were grown successfully for consumption or local trade. Among the chief products were corn, oats, rye, barley, and fruit such as apples and cranberries.

Fishing as a commercial enterprise was virtually confined to New England. By 1765, 10,000 persons were employed in catching, cleaning, and preserving cod, mackerel, bass, halibut, and other deep-sea fish, which had become an important Anglo-American trade item with Europe and the West Indies. By the eighteenth century, New Englanders were hunting whales in the Atlantic, from the Arctic to the coast of Brazil. Some 360 vessels were engaged in the whaling industry at the beginning of the American Revolution.

Manufacturing and Commerce

Domestic production in New England, as elsewhere, was supplemented by the output of small handicraft industries. Woolen textiles, leather goods, household utensils, and iron implements were important, but in the eighteenth century, the distillation of rum from West Indian molasses became New England's chief industrial activity. It was part of the profitable trade in molasses, rum, and slaves that brought gold and silver into the region. Along the New England coasts, industries related to seafaring and shipbuilding developed in response to the demands of domestic and foreign trade.

New York and the Middle Colonies

The middle region of English America possessed good soil and a moderate climate. Two of the continent's major river systems, the Delaware and especially the Hudson, permitted navigation into the interior. Like their southern neighbors, these colonies developed staple-crop agriculture; however, the region was characterized by the diversity of economic activity rather than by uniformity.

Diversified farming, not unlike that of New England, was more rewarding in the fertile valleys of the Middle Colonies. They were the principal supplier of wheat to New England and the southern colonies. Corn and other grains, animal products, vegetables, and fruits also contributed to the region's export trade. By the time of the American Revolution, the export of grains (especially white flour) dominated this commerce.

Early Industrialization

The wheat-growing areas of these provision provinces were dotted with flour mills. Pennsylvania and New Jersey attracted significant numbers of immigrant craftsmen and artisans, especially from Germany. What were called iron plantations and small furnaces spread in Pennsylvania and elsewhere in the region throughout the eighteenth century. The most ambitious enterprise, the American Iron Company of Peter Hasenclever, operated several furnaces and forges in New York and New Jersey. It employed over five hundred men in the 1760s before failing when its English backers went bankrupt. The skilled workmen in this region also produced textiles, paper, glass, and iron.

Southern Colonies

The economy of the Chesapeake region of the upper South was soon dominated by large-scale agriculture that produced staple crops. Land was organized into plantations and given over to the production of a

single staple or cash crop (at first, tobacco) and the generation of profits. This pattern also took hold in the colonies of the lower South.

Plantation Agriculture

Although fruits and grains were raised in the southern colonies, agriculture was dominated by commercial cash crops. Tobacco was raised in Maryland, Virginia, and North Carolina. Before the Revolution, Maryland and Virginia were raising 50 million pounds of tobacco annually. By the late 1600s, England was importing a total of 20 million pounds of tobacco each year from her American colonies.

Other cash crops also became important for the plantation colonies. In 1696, a Carolina planter named Thomas Smith began cultivating rice seed imported from Madagascar, although some historians believe that the idea for this crop actually came with the Africans who began arriving in Carolina as slaves. Nonetheless, South Carolina was exporting 500,000 pounds of rice each year by the end of the colonial era. The same success came with indigo, a highly prized blue dye used throughout Europe in that era. The planting of indigo owed much to the efforts of Eliza Lucas Pinckney. Born in 1722, at age sixteen she took over management of her father's plantation near Charleston, where she began experimenting with indigo planting, which to that date had only been successful farther south in Spanish America. She secured indigo seeds from the West Indies and, over a three-year period, blended them into a new strain that proved perfect for the Carolina lowland plantations. By the 1740s, South Carolina was shipping over 110,000 pounds of this valuable crop to England. Eliza married Charles Pinckney, and two of her sons became colonial leaders in the American Revolution.

In good growing years, when market prices were favorable, such large-scale agriculture could be immensely profitable. However, the promise of large profits encouraged overproduction. Consequently, there were periodic collapses in prices due to excess supplies; the risks of crop destruction from bad weather and various pests were also high. Further, the uninterrupted cultivation of cash crops, especially tobacco, exhausted the soil. By the mid-1700s, planters in the Chesapeake began to raise feed grains, especially because the price of tobacco began to decline. Feed grains became especially profitable when a series of crop failures caused the price of grain to rise on the European market, thus spurring the increased exportation of this crop to England.

Slavery and the Slave Trade

Plantation agriculture required large pools of labor. Driven by the desire to accumulate wealth, and often in debt, the first planters were limited in their ability to gain profits by the scarcity of labor. The more land they put under cultivation, the greater their profits; but they could profit only from what they could harvest. Their need and desire for labor, and the demanding nature of field work, led to solutions that dehumanized laborers and made them receptive to slavery. Nevertheless, the labor force of the southern colonies throughout the seventeenth century was chiefly recruited from the poor whites, both free and indentured.

The Eighteenth Century Growth of Slavery. By 1700, there were perhaps 25,000 slaves in all of the American colonies, with the great majority in the southern colonies. Thereafter, it is estimated that 250,000 people of African descent came to British North America in the eighteenth century. As the number of black slaves grew, southern colonies passed various slave codes that gave white owners almost complete control over the lives and persons of their slaves. Slaves, in fact, were defined for legal

purposes as chattel or animal property—this invited abuse and affected all aspects of the master-slave relationship. It also had an important effect on human relationships within the slave community. Despite these measures, there were outbreaks of resistance, such as the Stono uprising of 1739 in Carolina, that, while few in number, served to keep all aware of the possibility of armed insurrections.

Trade in human cargoes became the key to holding together the system of American slavery. Because mortality rates proved very high, planters throughout the hemisphere needed a steady supply of slaves during the seventeenth and eighteenth centuries. British residents along the south Atlantic coast preferred slaves who had first lived awhile in the West Indies instead of those who came direct from Africa, because the former would presumably be "seasoned" against new world diseases. Much of this commerce took place under the auspices of the Royal African Company, which had been founded in 1672. Although this joint stock company's charter expired in 1712, it can be credited with defining the character of the British slave trade.

The Middle Passage. The international commerce in slaves involved an Atlantic trade system that was somewhat triangular in nature: manufactured goods from England went to Africa to be used as barter for captives being forced into slavery; thereafter, these people would be brought to the West Indies in the infamous middle passage, to be traded for "seasoned" slaves or molasses for North America, from whence colonial products would be taken to England, where the whole process began anew with another circuit of trade. Disease, dehydration, starvation, and unsanitary living conditions below deck became regular features of almost every middle passage voyage between Africa and the West Indies. It is difficult, if not impossible, for historians to determine the number of Africans who died during the cruel middle passage to the Americas. It is clear, however, that a very high percentage of these unwilling immigrants succumbed to the harsh elements and treacherous shipboard conditions. The horror of this middle passage, with its high mortality rate, ranks as one of the most detestable aspects of American slavery.

The Africans who survived and eventually came to British North America soon developed new identities as coping mechanisms for their unanticipated lives as human property. They had formerly been residents from different parts of their home continent, including Guinea, Yoruba, and Senegambia, among other places. Once in the new world, they blended together over the generations into a home-grown culture that, although it retained much from their African origins, created common patterns of language, religion, and social customs among them. Many African agricultural skills, patterns of tending livestock, and material culture survived over time, although blended with those of the British, to create an enduring and unique culture in the United States. Before the slave trade was abolished in the nineteenth century, between eight and eleven million black captives had been brought against their will to all parts of the new world to live and work.

Southern Commerce

Because the cash crops of the South were grown for British markets, and most plantations were located near navigable rivers and streams, southern planters tended to deal directly with British merchants through agents known as factors, who resided in the port towns. The shipments of products they sent to British ports were credited to their accounts; they purchased finished goods and supplies against the balances (which usually favored the merchant). This practice limited the growth of local and regional commerce in British America.

Southern Manufacturers

The southern colonies had fewer manufacturing establishments than the other regions of the country. A small-scale iron industry emerged in Maryland and Virginia, but the work of blacksmiths, tanners, cobblers, and weavers was largely confined to the plantations and their immediate needs. The forests of the Carolina uplands furnished lumber for shipbuilding and naval stores—pitch, tar, and turpentine—for the British navy. In the eighteenth century, Carolina and Georgia traders did a thriving business in furs.

■ COLONIAL SOCIETIES

American settlers brought European traditions and patterns of living with them to their new homes, but they faced quite different environments in the new world. Life in colonial America was shaped to a great extent by the immensity of nature and the struggle to survive in demanding conditions.

Population Patterns

Most of the early immigrants from England were from the commercial and laboring classes; those from the upper classes were usually younger sons without means. The real dangers of the transatlantic crossing and survival in an alien and often hostile environment discouraged those without strong motivation for migrating to British America. More often than not, these immigrants were willing to risk a new life to avoid persecution, prison and punishment, business failures, or dim prospects for trade and work.

By 1700, the population of British America had dramatically increased due to new immigration throughout the century but also to increases in life expectancy and birth rate. In New England, those who survived childhood lived to an old age comparable to modern life expectancy—probably a testament to the healthfulness of the environment. The region's population reached 150,000 in 1700, having quadrupled since 1650, largely as a result of natural increase.

In the southern colonies, however, conditions were quite different. The average life expectancy was roughly forty years, reflecting high mortality rates among children, the persistence of malaria and similar diseases, and a significant disparity in the number of males to females. Nonetheless, the British North American colonies experienced a significant population growth, by virtue of both immigration and a high birth rate. Historians estimate that about 250,000 people lived in the English colonies of North America at the end of the seventeenth century while, by the time of the America Revolution, it had grown to 2.5 million, including both slave and free residents.

Social Conditions

The peopling of the English colonies began with a small migration from a few provincial areas of England and, after the first settlements took hold, increased dramatically. By both voluntary and involuntary means, Europeans and Africans came to North America in significant numbers. The great distances that separated the settlers and a general scarcity of labor had significant effects on the development of colonial societies.

Family and the Role of Women

The family was the basic unit of colonial society, sanctioned by religion and tradition. Marriages sometimes took place at an early age and families were large, particularly on the frontier, where each new

pair of hands counted. The family bond was strengthened in New England by the longevity of the population and by the cluster effect of the town pattern of settlement in New England and other northern communities. Families were less stable on the frontier and the plantation as a consequence of multiple remarriages, higher death rates, disease, and isolation.

Women

The social position of women, who had an almost completely dependent legal status under English common law, improved rapidly in English America, where their numbers were few. Although they possessed few legal rights and protections, women were often accepted by men as equal partners in the social and business affairs of the family. They played crucial roles on the farm, raising and producing salable items to augment the income from crops. They often worked side by side with men, in addition to maintaining their traditional roles in the domestic sphere.

Social Status

Although the primitive conditions of life along the frontier tended to make all men equal in wilderness environments, class distinctions were obvious in the seaport cities and the older village settlements. A relatively small upper class, having close connections with England, consisted of colonial governors, clergymen, wealthy merchants and planters, and professional men.

In Puritan New England, the highest social rank was at first reserved for those leaders (among the "visible saints") considered most pious and worthy of emulation. This later gave way to measures of personal wealth and influence. In the South, and to an extent in New York, wealth, social position, and political power were measured by the extent of lands (and servants or slaves) one held.

Much larger was a growing middle class of prosperous tradesmen, farmers, mechanics, and laborers. The gap between upper and middle classes was much smaller than in England and Europe, where such distinctions endured from generation to generation; in the new world setting, they proved far less fixed. In the Chesapeake and other southern colonies, however, social mobility diminished toward the end of the seventeenth century as ruling planter groups began to perpetuate themselves and slaveholding became more firmly identified with wealth and power. Of the two groups of servants, those under bond or indenture were decreasing in number late in the eighteenth century, while the number of slaves was increasing.

African slaves attempted to maintain family life under the difficult circumstances that slavery presented for them. More than 95 percent of African Americans in British North America were held in bondage. Many of them lived on farms or on larger plantations. Several colonies had very large slave populations, including South Carolina, where over half of the total number of people in the colony were slaves. Often, the circumstances of their bondage determined the nature of slave families. Some slaves lived as appendages of the white family, especially on small holdings and in the cities. On larger plantations, slaves sometimes had the option of maintaining the structures of family life. At times, they fashioned extended families based on friendship or distant bonds of kinship. This permitted family units to survive the loss of members separated by sale. Hence, the extended family most likely played a larger role in the reckoning of slave families than it did in the English model. Family life among slaves benefited from the personal economic liberties that some masters permitted them to engage in from time to time. For example, many slave families planted small gardens from which they sold produce on the open market, while other masters allowed their slaves to work for personal wages on Sundays.

Immigration

Non-English settlers came to American shores in substantial numbers, bringing ideas and traditions that steadily modified the predominantly English manners and mores. By the early eighteenth century, immigration from England had slowed and was actually being discouraged by the government. The forcible immigration of slaves, from Africa as well as the West Indies, increased throughout most of the eighteenth century. The principal sources of immigration from Europe to the English colonies after 1700 were the German states and Northern Ireland.

Germans

Many German settlers were hard-working peasants, dispossessed by wars or other reverses and often victims of religious persecution. Others had been trained as skilled artisans or professional men. Pennsylvania became the center of German settlement, but Germans also penetrated the Shenandoah Valley and the Piedmont region of Virginia and North Carolina. Probably 200,000 Germans were in the colonies in 1775.

Scots-Irish, Scots, and Irish

The largest group of new English-speaking immigrants to the colonies were the descendants of Presbyterians from the Scottish Lowlands who had colonized Northern Ireland (or Ulster) early in the seventeenth century. Shortly after 1700, these Scots-Irish, driven by religious and economic grievances, left Ulster in large numbers for Pennsylvania and the colonies to the south. Drawn westward along the fertile river valleys in search of cheap land, often resorting to violence to remove Indians and others in their way, they exhibited hard qualities that allowed them to adapt to the unstructured life of the colonial frontier. Perhaps 300,000 Scots-Irish came to America before the Revolution, settling in the rural backcountry of Pennsylvania and in the piedmont areas of the Carolinas. Many of the Scots-Irish became small farmers.

Immigration from Scotland and Ireland continued throughout the seventeenth and eighteenth centuries. Scottish and Irish merchants and shippers were active in a number of American ports. Some Scots Highlanders (largely Roman Catholics), defeated in the uprisings of 1715 and 1745, came to settle in the colonies, especially North Carolina. Scots Lowlanders immigrated in increasing numbers at the end of the century to escape poor economic conditions.

Other Immigrant Groups

Various groups fled Europe to escape religious or political persecution or economic hardship, but in significantly fewer numbers: Huguenots and other Protestants fleeing religious and political persecution in France after the Edict of Nantes was revoked in 1685; the Swiss in North Carolina; the Welsh Quakers in Pennsylvania and New England; and small groups of Jews from Spain and Portugal, who settled in several port cities. Along the Hudson River, the Dutch influence in speech, dress, and building construction persisted into the nineteenth century.

Social Patterns

The greatest part of the more than one million non-native inhabitants of America in the mid-eighteenth century lived in rural settings, reflecting the importance of agriculture to the colonial economies. In New England, however, the town emerged as the defining social unit; in the South, the plantation community.

Colonial Cities

The major colonial cities and large towns—Boston, Newport, New York, Philadelphia, and Charleston—were all ports. The largest and most developed as a cultural center was Philadelphia, which had a population of over 18,000 in 1750 (almost twice that number by 1775). Beginning as tiny settlements, colonial cities rapidly developed into commercial centers in which physicians, lawyers, merchants, artisans, and mechanics lived in much the same way they would have in England or Europe. As the increase and concentration of population continued, colonial cities adopted governments and regulations for public health and safety and developed cultural institutions for the most part modeled after those of London. Communication between the colonial cities was at first mainly by sea because roads were poor—for a time, the seaports were more closely in touch with England, six weeks away by sea, than they were with one another. As the production of feed grains grew in the late eighteenth century, both New York and Philadelphia became important ports for the shipment of these crops to England.

Plantations

In Maryland and the colonies to the south, and also to an extent in upstate New York, along the Hudson River, society was organized by the plantations and estates that were formed in the late seventeenth and early eighteenth centuries. The choicest locations were on rivers and navigable streams that permitted vessels to receive produce directly from the dock. The largest plantations were usually well-run and somewhat diversified enterprises, to a large extent economically self-sufficient; those in the South had slaves who were trained to perform skilled work and crafts as well as the support functions of the plantation community.

The term plantation did not mean a large and extensive holding during the colonial period. It was used for any farming operation that grew cash crops, with sizes ranging from small farms operated by single families to larger businesses. It was not until the early nineteenth century that the word plantation came to mean a large-scale, cash-crop operation that involved numerous field workers and a wealthy owner of great economic and political influence. Although most holdings were modest in size, the plantation pattern prevailed in the colonial era and thus had the effect of retarding village and town development.

New England Towns

The social pattern of New England reflected the agreements or covenants that the Pilgrims and Puritans subscribed to as congregations prior to or during the process of settlement. The civil life of the congregation took place within the town, a hybrid social and political unit Puritans adapted from the English parish, village, and borough. Members of the community lived in a cluster of houses, built about a common pasture that formed the town. They went out from this center to farm and work their portions of the community's fields and wooded lands. In the town center was the meeting-house, the locus of the community's spiritual and political life. The community was governed by its yearly town meeting, in which all men participated. As populations and pressures for land use rose in the second and third generations of the first town settlements, the town unit model was replicated in inland areas.

Although the town structure was efficient and well suited for new settlements, Puritanism proved incapable of resolving other challenges presented by economic and social changes. The practice of dividing land holdings among the next generation of sons, rather than passing a single estate on to the eldest son, had the effect of fragmenting holdings and dividing family members. The Puritan "saints" were

unable to adjust to New England's rapid maritime and mercantile development and the region's increasing wealth. Tensions relating to such changes may have contributed to the fears and accusations of witchcraft that appeared in the 1680s and 1690s.

The most significant of these witchcraft incidents occurred at Salem in 1692. Several young girls in that town contended that some older women had bewitched them. Additional accusers soon appeared to allege that others in the community had also been engaging in witchcraft. This resulted in a mass hysteria at Salem, during which the religious courts executed nineteen people for engaging in occult practices, while the authorities jailed over a hundred others on such suspicions. The excesses of the Salem witch trials, however, had the net effect of sobering many residents of Massachusetts, and such incidents declined greatly in number thereafter.

The Frontier

Compared to the relative comfort of the cities and towns, life on the frontier was rough and dangerous. The danger of Indian attacks was constant—families frequently moved westward in groups and, when beginning a new settlement, erected a stockade for protection before clearing the land. By the eighteenth century, the log cabin was the standard dwelling; clothing was often made from home loomed cloth or the skins of animals; food at first was obtained chiefly by hunting and fishing. Recreation usually took the form of useful community enterprises, such as logrolling, house raisings, and husking bees.

French Colonies. The late 1690s also saw an additional development on the western frontiers of British America that would eventually have a profound impact on the English colonies: the expansion of France into the Mississippi valley. Following the discoveries of La Salle and the establishment of Spanish Texas, France decided to colonize the southern reaches of the Mississippi River where it met the Gulf of Mexico. This became the Louisiana colony. In the late 1690s, the Le Moyne brothers (the Sieur d'Iberville and the Sieur d'Bienville) first planted the French colony on the Gulf coast near present-day Mobile, Alabama. This small colony at first grew slowly, but French investors soon decided to encourage its economic development. By 1718, the city of New Orleans had been founded and was the capital of Louisiana. This colony stretched from the lower Mississippi valley, northward up the great river, to the Illinois country into the western Great Lakes where it met French Canada. The French founded settlements at Baton Rouge, Natchez, Fort Chartres, and various other places into present-day Michigan. They conducted a trade between Canada and Louisiana that created what one historian called a French thorn in the western side of British America. By the 1720s, an increasing number of French immigrants arrived in Louisiana, including the famous casket girls who came as brides for male planters, called by this term because of the small casks they carried to hold their meager possessions.

Spanish Colonies. The Spanish also created new settlements along the edges of the British frontier starting in the late seventeenth century. Like the French colonies, these, too, eventually had an impact on British America, especially in Florida, where Spain had been developing a colonial presence before the first English immigrants arrived in Virginia. By the late 1600s, Spain had greatly expanded her military presence at St. Augustine, which lay less than a single day's ocean sail to the south of Carolina. They constructed a large fort there and stationed a naval force at the city. In 1693, Spain decided to establish Pensacola on the Gulf coast as a major naval station, created especially in response to the French interest

in the lower Mississippi valley. The eighteenth century also witnessed an expanded Spanish presence in Texas. After a failed attempt to place a chain of missions in eastern Texas along the border with French Louisiana in the 1690s, the Spanish established San Antonio in 1718. By the 1720s, the Marques de Aguayo had built a half dozen large missions nearby along the San Antonio River, including one around whose ruins the siege of the Alamo would later take place. By the mid-eighteenth century, the proximity of Spanish and French colonies on the western and southern fringes of the British colonies would have profound implications for intercolonial rivalry and warfare.

Religion

The lives of most American communities were shaped by the churches or religious sects that dominated their colonies, whether or not their citizens subscribed to religious teachings. Although many settlers had left England to escape the threat of religious persecution, a complete separation of church and state was achieved only in Rhode Island.

Established Churches

By the middle of the eighteenth century, nine of the original thirteen colonies had established churches, supported by colonial laws and general taxation.

The Church of England. This church was the official established denomination of Great Britain, popularly known as the Anglican Church. Virginia was the first of the English colonies to give legislative sanction to the Church of England. Prior to the Revolution, Maryland, New York, the Carolinas, and Georgia had also recognized the Anglican Church by voting to support its parishes with taxes. There was no resident bishop of the Church of England in colonial America, and the Anglican clergy, handicapped by difficulties of travel and communication among scattered settlements, never gained a dominant position. The parish structure and the vestry (the lay council or committee of the parish), nevertheless had an effect on the government and politics of Virginia and Maryland.

In 1701, King William established an Anglican organization with the rather ungainly name of the Society for the Propagation of the Gospel in Foreign Parts. As part of the Church of England, this organization had as its purpose to send missionaries and teachers to the American colonies for the purpose of meeting the colonists' religious needs. By the time of the American Revolution, the SPG (as it was called) had over 300 Anglican missionaries in British North America, mostly in the southern colonies. Although these individuals met a pressing need for Anglican churches, the Church of England never dominated in larger numbers anywhere in the colonies except in the plantation South, and even there it was sometimes eclipsed by other denominations.

Puritanism. Calvinism dominated all aspects of the Puritan experiment of seventeenth-century New England. It continued to exert a strong influence in the eighteenth century, although church membership declined and the individual congregations broke into different groups on the question of church government: Presbyterians recognized a central governing authority of Presbyters; Congregationalists did not.

The Puritan settlers believed that their members had been divinely "elected" for salvation. During the first two generations of their control in Massachusetts, only church members could vote. In order to become a church member, one had to have his spiritual worth approved by the minister and the congregation.

Conformity to such strict standards was not easy, and church membership requirements were relaxed by means of measures such as the Halfway Covenant of 1662 (extending provisional church membership to children of church members). The Massachusetts charter of 1691 removed the church membership as a requirement for voting. In the following century, the colony permitted the establishment of some Anglican chapels, adopted a policy of cooperation with Presbyterian Calvinists, and authorized such dissenting sects as Baptists and Methodists to use funds derived from taxes for the support of their own ministers. The New England Congregationalist and Presbyterian clergy nevertheless continued to exercise considerable influence in political matters.

Multiplication of Religious Sects

In the eighteenth century, thousands of European Protestants who were neither Congregationalists nor Anglicans came to America. Along the frontier particularly, Baptists, Presbyterians, Methodists, and Quakers flourished. Lutherans, Dutch Reformed, Moravians, and Huguenots found a haven in the Middle Colonies, especially in Pennsylvania and New Jersey.

Progress Toward Religious Toleration

Although the desire for freedom of worship had inspired many religious groups to move from England and the European continent to the new world, the English colonies only gradually adopted policies of religious tolerance. Still, the need to survive and to populate settlements worked to promote religious freedom in a way that was unknown in the old world. Pressed by the demands of the growing non-English population, Massachusetts Puritans, for example, made notable concessions to dissenters by the mid-eighteenth century.

The example of Rhode Island, which Roger Williams had founded on the principle of separation of church and state, was nevertheless unique. Despite such measures as the Maryland Toleration Act (1649), the freedom of conscience provision in the New Jersey charter (1665), and the broad invitation to all religious sects sent out by the Quaker William Penn in settling Pennsylvania, Roman Catholic and Jewish minorities were restricted in the practice of their religion and denied the right to vote and hold office (as had been the case in England).

The Great Awakening

During the 1730s and 1740s, a revival of religious fervor swept the American colonies, ignited by wandering evangelists who perceived a decline of piety in their congregations. The most prominent preachers in this movement were George Whitefield, an evangelical Anglican from England who attracted large crowds and often spoke out of doors, and Jonathan Edwards, a New England Congregational minister and theologian. Edwards entitled his best known sermon "Sinners in the Hands of an Angry God." The latter believed that all people were born into sin and could be saved from eternal damnation only by God's grace. In different ways, evangelists attempted to win converts with such emotional appeals, which had a powerful effect on their audiences.

The revival stirred folk in both towns and countryside but had its most lasting impact on those who populated the isolated backcountry of the South and West. It produced a split among Presbyterian leaders, into Old Lights, who condemned emotionalism and took a more rationalistic approach to theology, and

New Lights, who put evangelical fervor above church organization. Methodism, the movement founded by John Wesley that sought to reform the Church of England, and Baptist sects that derived from Calvinism also gained converts to the evangelical cause. By placing such emphasis on individual conversion and grace, the Great Awakening contributed to a democratizing trend—and to a questioning of traditional authority and institutions.

Education

Education was judged important by the English colonists, and it began in the home. Most Americans learned to read and compute numbers wherever they lived. The King James translation of the *Holy Bible* was often the only book they had and, as such, it also made an excellent language primer in the absence of anything else to read. Some families also owned one or more of the works of Shakespeare, a copy of John Bunyan's classic *A Pilgrim's Progress,* and sometimes collections of English literary essays or great speeches.

Elementary Schooling

In 1647, the Massachusetts School Law required every town of fifty householders to maintain a grammar school. Although not universally enforced, the law was the first to mandate public education in America. In the middle colonies, schools were dependent on religious societies, notably the Quakers, and on other private organizations. In the South, the families of the Tidewater employed private tutors or relied on the clergy to conduct secondary schools. Most elementary schools were for boys exclusively, but schools for girls were established in the eighteenth century in most cities and large towns. Despite the informal quality of most American schooling, by the mid-eighteenth century, the literacy rates in the colonies was probably equal to if not higher than those in most European countries.

In the crafts and mechanical arts, such as building and carpentry, training was provided under terms of apprenticeship.

For slave children, there was little opportunity to learn to read or write. By denying their slaves the ability to read and write, slave owners sought to prevent insurrections and resistance. Some masters wanted (or permitted) their slaves to improve themselves, but the slaves, and even the master, risked punishment if caught.

Colleges and Medical Schools

Before the American Revolution, nine colleges had been founded. Harvard (1636), William and Mary (1693), Yale (1701), the College of New Jersey, now Princeton (1746), Brown (1764), Rutgers (1766), and Dartmouth (1769) were established primarily for the training of ministers, although subjects other than theology and the classics were taught. Two had no religious affiliation or purpose: the Academy and College of Philadelphia (1755), which became the University of Pennsylvania, and King's College (1754), later Columbia University.

By 1720, the natural sciences were being taught and modern languages were considered worthy of study. The College of Philadelphia also offered courses in practical subjects such as mechanics and agriculture. At the end of the eighteenth century, medical schools were established there and at King's College.

Culture in the Eighteenth Century

Anglo-American cultural institutions founded on English models emerged in the colonies. The books, manners, and fashions of colonial America reflected those of the mother country and its great metropolitan center, London.

Language and Literature

On the eve of the Revolution, Americans were more predominantly English in thought and aspiration than the large numbers of continental Europeans in the population seemed to indicate. Except among the German groups in Pennsylvania, English was the language of the overwhelming majority in every community. American usage reflected regional differences and, to be sure, the quite new conditions that settlers encountered—but the literary standards of America were still set by the works of English writers in England. The only writer in the American colonies to gain notice in England was Benjamin Franklin, author of many practical-minded essays, notably *Poor Richard's Almanac,* which appeared annually from 1732 to 1757.

Effects of the Enlightenment

The European Enlightenment had a significant impact on eighteenth-century culture and thereby exerted influence on the American colonies. This broad movement of learning and ideas was in large part the cultural expression of the great scientific advances of the seventeenth century, particularly the discoveries of Sir Isaac Newton in astronomy. The mechanical laws that governed the motion of the planets seemed to prove the existence of a rational God, a benevolent mechanic or clock-maker deity, whose handiwork men could discover and understand by means of experimental science. Many Christians, especially those close to the world of learning, incorporated such views into their religious beliefs. These deists disputed the literal or fundamentalist interpretation of the *Bible* and looked on the world as God's creation rather than man's temptation.

Science. The great scientific advances of the eighteenth century encouraged experimental inquiries into all aspects of the physical world. In colonial America, where nature so dwarfed the human presence, scientific interests were almost exclusively devoted to practical subjects with technological promise such as electricity and health care. Benjamin Franklin's celebrated experiments with electricity and the lightning rod demonstrated the validity of such an approach and made him world-famous. His book *Experiments and Observations on Electricity* (1751) had a tremendous impact on the development of European science. In Boston, the smallpox epidemics of the eighteenth century caused medical innovation. Cotton Mather, an important Puritan leader, read in a British publication about the possible benefits of inoculation against this disease. Mather urged in the early 1720s that all Bostonians be inoculated, and of those who were, only 3 percent perished in the next epidemic.

Libraries and Learned Societies. During the eighteenth century, there was a large increase in the number of books imported to America and gradually in the number printed in the colonies. The first printing press had been put into operation in Massachusetts in 1639. Private libraries grew in size, and public subscription libraries were founded on the model of the Library Company of Philadelphia, begun by Franklin and others in 1731. As was the case in England and Europe, an interest in science, albeit of a more practical bent, united merchants, lawyers, farmers, and especially physicians. Organizations such

as the American Philosophical Society (1743) also formed under Franklin's leadership. Modeled after the Royal Society of London, these groups provided a formal structure for such investigations.

Expanded Role of Newspapers. In the great expanse of colonial America, newspapers quickly took on an essential role in communication and information. They printed laws of the colonial legislatures, official communications, news from London and Europe, advertisements and notices, and selections from books of all kinds. The colonial printer (Franklin began his career as one) became an important figure in the shaping as well as the dissemination of early American culture. By 1730, seven newspapers were being published in four different colonies. At the turn of the century, there were more than 180 in the United States. Proportionally, there was a larger readership of newspapers in the colonies than in the mother country.

Law and Politics. English law and governmental institutions gradually took hold, but the great distance that separated the colonies from the mother country, as well as the American setting itself, introduced important modifications to English traditions. The common law and English judicial procedures were adopted, but they were applied in ways that fit American circumstances. General legal ideas and language blended readily into colonial politics and speech, reflecting, it would seem, the frequency with which the colonists felt it necessary to define their liberties and standing within the empire. In general, however, knowledge of English law in the colonies was rarely precise or deep. An idea grew that law represented abstract justice or natural order, rather than the will of the king in Parliament. The decision in the libel trial of the New York printer John Peter Zenger in 1734 and 1735 pointed to an American perspective: Despite the court's refusal to admit Zenger's evidence proving the truth of the alleged libel, he was acquitted of the charge. The case, as historian Daniel Boorstin has pointed out, was significant for having "affirmed the power of juries in libel cases to decide the law as well as the fact."

By the mid-eighteenth century, life in the American colonies had been shaped by both cultural heritage and environment. Because the ethnic character of populations was not uniform and the landscape and climate of American geographic regions varied, the provincial societies of English America exhibited more diversity than provincial English society. Although they did not yet share a distinctly American outlook, there were elements in their work and customs, their language and education, and their laws and politics that made them resemble one another more than they did their English rulers. Beyond the cities and principal towns of the colonies, British authority and English culture were considerably diluted.

Selected Readings

Ahlstrom, Sydney. *Religious History of the American People* (1972).

Armitage, David and Michael J. Braddock, eds. *The British Atlantic World, 1500–1800* (2002).

Bach, Rebecca. *Colonial Transformations: The Cultural Production of the New Atlantic World, 1580–1640* (2001).

Bailyn, Bernard. *Voyages to the West: A Passage in the Peopling of America on the Eve of the Revolution* (1986).

Berkin, Carol. *First Generations: Women in Colonial America* (1997).

Boorstin, Daniel J. *The Americans: The Colonial Experience* (1958).

Bond, Bradley. *French Colonial Louisiana and the Atlantic World* (2005).

Breen, Timothy. *Colonial America in an Atlantic World* (2003).

Bridenbaugh, Carl. *Cities in Revolt* (1955).
 Cities in the Wilderness (1938).
 Myths and Realities: Societies of the Colonial South (1963).

Bumsted, J.M. and Van de Wetering, John E. *What Must I Do to Be Saved? The Great Awakening in Colonial America* (1976).

Cannay, Nicolas and Anthony Padgen, eds. *Colonial Identity in the Atlantic World, 1500–1800* (1989).

Coclanis, Peter A., ed. *The Atlantic Economy during the Seventeenth and Eighteenth Centuries: Organization, Operation, Practice, and Personnel* (2005).

Curtin, Philip, ed. *The Rise and Fall of the Plantation World* (1998).

Foote, Thelma Wills. *Black and White Manhattan: The History of Racial Formation in Colonial New York City* (2004).

Green, Jack P. *Money, Trade, and Power: The Evolution of Colonial South Carolina's Plantation Society* (2001).

Griffon, Patrick. *The People with No Names: Ireland's Ulster Scots, America's Scot Irish, and the Creation of a British Atlantic World, 1689–1764* (2001).

Hofstadter, Richard. *America at 1750: A Social Portrait* (1971).

Isaac, Rhys. *Landon Carter's Uneasy Kingdom: Revolution and Rebellion on a Virginia Plantation* (2004).

Jordan, Winthrop D. *White over Black: American Attitudes Toward the Negro, 1550–1812* (1968).

Klooser, Wim and Alfred Padula, eds. *The Atlantic World: Essays on Slavery, Migration, and Imagination* (2004).

Lewis, Thomas A. *West from Shenandoah: A Scotch-Irish Family Fights for America, 1729–1781, A Journal of Discovery* (2003).

Lambert, Frank. *Inventing the Great Awakening* (2001).

May, Henry. *The Enlightenment in America* (1976).

McCusker, John M. and Menard, Russell, eds. *The Economy of British America* (1985).

Morgan, Edmund. *The Puritan Family* (1966).

Merrell, James H. *Into the American Woods: Negotiators on the Colonial Pennsylvania Frontier* (1999).

Risjord, Norman. *Representative Americans: The Colonists* 2nd ed. (2001).

Shannon, Timothy J. *Atlantic Lives: A Comparative Approach to Early America* (2003).

Ulrich, Laurel Thatcher. *Good Wives: Image and Reality in the Lives of Women in Northern New England, 1650–1750* (1991).

Wood, Peter H. *Black Majority: Negroes in South Carolina from 1670 Through the Stono Rebellion* (1974).

Test Yourself

1) What prominent colonist advocated smallpox inoculation?
 a) Benjamin Franklin
 b) Cotton Mather
 c) Eliza Lucas Pinckney
 d) Thomas Smith

2) The _____ settled the Pennsylvania and Carolina frontier.
 a) Germans
 b) Scots-Irish
 c) Moravians
 d) Quakers

3) The first colony to pass a law funding public education was
 a) Virginia
 b) Pennsylvania
 c) Massachusetts
 d) South Carolina

4) Which of the following was not a reason for population growth in the British colonies?
 a) importation of slaves
 b) immigration of new settlers
 c) a high birth rate
 d) trade and navigation laws

5) True or false: As the Puritan church died away, religion became less important in Massachusetts.

6) True or false: Most British colonists lived in rural areas during the eighteenth century.

7) Indigo production was introduced into South Carolina by
 a) Anne Hutchinson
 b) Thomas Smith
 c) Eliza Lucas Pinckney
 d) none of the above

8) True or false: There was greater equality between men and women in the colonies than in England.

9) French Louisiana was successfully colonized by the
 a) Count Frontenac
 b) the Le Moyne brothers
 c) Marques de Aguayo
 d) none of the above

10) One of the most significant preachers of the Great Awakening was
 a) William Bradford
 b) George Whitefield
 c) Daniel Boorstin
 d) Peter Hasenclever

Test Yourself Answers

1) **b.** Cotton Mather became a leader in the movement to popularize inoculation against smallpox, which was considered very dangerous in the early 1700s. The son and grandson of important Puritan ministers, Cotton Mather was a clergyman who also had an interest in science. In 1721 he advocated that all citizens of Boston be inoculated against the disease, which resulted in his wide-spread condemnation to the point that he even received death threats. Nonetheless, several hundred people chose to follow his advice and, in a smallpox epidemic the following year, over 98 percent of them survived. Within just a few years, inoculation for smallpox became routine due to the efforts of Cotton Mather.

2) **b.** The Scots-Irish settled in both Pennsylvania and Carolina, mostly along the western frontier of both colonies. By the 1730s, they had become the largest and most dominant group along the Appalachian frontier from the middle colonies southward to the southern Piedmont. For the most part, German, Moravian, and Quaker settlers confined themselves to Pennsylvania only.

3) **c.** Massachusetts was the first colony to pass a law requiring that its children receive a basic education. Puritans believed that everyone should read the *Holy Bible,* so literacy became a public responsibility and resulted in the first school laws. A Massachusetts law in 1642 required that all parents teach their children to read and write. Five years later, in 1647, the colony passed a public school law that required towns with more than 200 people to maintain grammar schools.

4) **d.** The navigations laws did not directly result in population increase. The size of the colonial population grew largely for three reasons: (1) a high colonial birthrate; (2) immigration of new settlers; (3) the importation of slaves. The commercial regulations as noted in the Trade and Navigation Laws did provide for some measure of economic growth, but they did nothing that directly encouraged population increase.

5) **False.** The residents of Massachusetts Bay remained very religious throughout the Colonial period. Starting in the 1660s, the popularity of Puritanism began to decline. Membership in new denominations, however, increased to replace the former dominance of Puritanism. In 1662, an agreement in Massachusetts Bay known as the Halfway Covenant increased toleration of other denominations in the colony. By the 18th century, the Congregational and Presbyterian Churches had eventually replaced Puritanism as the largest religious denominations in Massachusetts, where religion remained important.

6) **True.** The colonies were based on agriculture and most people lived in rural areas. Historians estimate that, even as late as 1790, some 90 percent of all Americans earned their living from the land or from the processing, sale, or shipping of agricultural products.

7) **c.** Thomas Smith introduced rice into Carolina, thereby giving the colony one of its most lucrative agricultural products. Eliza Lucas Pinckney, also from Carolina, introduced indigo to the region, thereby giving the colony another important cash crop. Anne Hutchinson, of course, had nothing to do with agriculture or the Carolina colony. She was a Puritan who helped to establish a Rhode Island colony.

8) **True.** Women had greater independence in the colonies than in England. Although women had the same legal rights in the colonies and England, they worked side by side with men in America. They had much to contribute to an agricultural society. In addition, some of them became business people and operated shops in the cities. A few women, including Abigail Adams, played important historical roles during the colonial period. As the wife of John Adams, Abigail influenced many significant social and political developments during her lifetime.

9) **b.** The Le Moyne brothers founded the Louisiana colony. They are better known by their individual royal titles, the Sieur d'Iberville and the Sieur d'Bienville. Iberville established the first French settlements along the Gulf coast, especially at Biloxi in 1700. His brother, Bienville, founded New Orleans in 1718, a city that quickly grew to be the capital of French Louisiana. The Marques de Aguayo was a governor of Spanish Texas who founded missions in the area of San Antonio during the 1720s. The Count Frontenac served as governor of French Canada from 1672 to 1682.

10) **b.** George Whitefield was the best-known preacher of the Great Awakening. Although based in England, he made numerous trips to the American colonies between the 1730s and the 1760s in order to preach. He was a friend of John and Charles Wesley, the founders of Methodism. Whitefield was known for the stirring emotional sermons, sometimes preaching to thousands of listeners in huge outdoor assemblies. The other three choices noted in this question were not preachers during the time of the Great Awakening, although some were indeed ministers.

American Colonies in the British Empire

1649–1660: Commonwealth governs England

1600: Restoration of the monarchy and King Charles II; Enumerated Commodities (Navigation) Act of 1660 (reenacts much of the act of 1651)

1663: Staple Act passed

1673: Duty Act passed

1685: Accession of James II (formerly the Duke of York)

1686: Dominion of New England formed

1688: The Glorious Revolution; James II deposed, succeeded by William and Mary

1689–1697: King William's War; concluded by the Treaty of Ryswick

1696: Board of Trade and Plantations established; Parliament passes Enforcement Act

1702: Anne, daughter of James II, becomes queen of England

1702–1713: Queen Anne's War

1707: Union of England and Scotland, forming Great Britain

1714: George I (first Hanoverian) assumes the throne

1745–1748: King George's War; concluded by Treaty of Aix-la-Chappelle

1754: The Albany Congress meets, Plan of Union fails; Battle of Fort Duquesne begins the final chapter in the conflict between the British and the French in North America

1754–1763: The French and Indian War (Seven Years' War in Europe); concluded by the Peace of Paris

1760: Accession of King George III

1763: Proclamation Line of 1763 enacted

(continued on next page)

1764: Sugar Act and Currency Act passed

1765: Stamp Act and Mutiny Act passed; Stamp Act Congress meets

1766: Stamp Act repealed and Declaratory Act passed

1767: Townshend Duties introduced

1768: Non-importation agreements implemented

1770: The Boston Massacre occurs; repeal of the Townshend Duties

1772: Attack on the *Gaspée*

1773: Tea Act passed; Boston Tea Party staged

1774: Parliament passes the Intolerable Acts (March–May); Continental Congress convenes (September)

During the first 150 years after Jamestown was settled, British governments put in place a mercantilist system of imperial regulation and made repeated efforts to strengthen royal authority over the colonies. However, struggles and conflict between Parliament and crown, wars in Europe, and the great distance that separated the colonies from the mother country prevented officials in London from gaining firm control of the American colonies. The majority of the colonists in the meantime became quite determined about claiming their rights as Englishmen, particularly in matters of taxation. A new attitude and policy toward taxation emerged in Britain after the victorious conclusion of the Seven Years' War in 1763, prompted by the great increase in the national debt that had been required to wage that worldwide conflict. The end of that war saw a significant change in British policy regarding the American colonies, as the government in London attempted to redefine how the colonies functioned in the imperial system. This caused growing dissention in British North America. Writing years later, after the American Revolution, John Adams recalled the period of the 1760s and early 1770s as the true era of revolutionary thought, because it was during those years that the colonials laid the seeds of revolt. By the end of that era, Adams noted that revolution was "in the minds and the hearts of the people."

■ EARLY IMPERIAL ADMINISTRATION

Governmental institutions evolved for the British colonies across the seventeenth and eighteenth centuries.

Royal Administration Under the Stuarts

James I, who regarded America as an extension of the royal domain, created administrative agencies that he hoped would maintain the Crown's authority over the colonies. He appointed a Council of Trade (1622) to see that English laws were enforced in America, and he revoked the charter of the London Company (1624), thus making Virginia a royal colony. His successor, Charles I, gave large powers over the colonies to a commission of twelve members of his Privy Council (1634).

The Puritan Commonwealth

The activity of the Privy Council in colonial affairs was cut short by the Puritan revolt (1642) against Stuart authority, which resulted in the execution of Charles I and the establishment of a commonwealth.

Although Parliament tried to maintain continuity of control by naming a special board of six noblemen and twelve commoners (1643), little was accomplished during the period of parliamentary rule. The colonies were, in the main, left on their own and allowed to govern themselves in local matters.

The Restoration

Charles II returned from exile to take the throne (1660) and sought the advice of favorites among the nobility and the wealthier merchants in colonial matters. He named two advisory bodies: a Council for Foreign Plantations and a Council for Trade (1660). These were merged in 1674 into a standing committee of the Privy Council for Trade and Foreign Plantations. Preoccupied by domestic strife and foreign wars, the king's advisors finally resorted to a radical scheme to curb the progress toward self-government they detected in Massachusetts and neighboring provinces. They secured the revocation of the Massachusetts charter and persuaded James II to merge the several settlements of the region into the Dominion of New England. The creation of the Dominion was represented as a measure necessary for military defense, but Americans generally regarded it as a device to impose royal authority on the colonies. The Dominion collapsed when James II was driven from the throne by the Glorious Revolution (1688).

Parliament and Empire

Although Parliament imposed new constitutional limits on the authority of the Crown, it continued to believe that colonial affairs could be guided by its commercial regulation.

Mercantilism

English parliamentarians generally accepted the prevailing theory of mercantilism—that a nation's prosperity depended upon the amount of precious metals it could accumulate through favorable trade balances. Colonies were judged valuable as suppliers of raw materials and consumers of finished products. The Crown had specific reasons for regulating the trade of the colonies—it needed (sometimes desperately) the revenues that flowed from duties and fees. British merchants embraced the regulation of colonial commerce as a means of excluding foreign competitors, principally the very active Dutch merchants.

The Navigation Acts

Mercantilist ideas provided the rationale for Parliament to pass a series of trade acts in the second half of the seventeenth century. These were designed to enhance the benefits of the colonial trade for the mother country and to restrict trade by colonials with Dutch and other foreign merchants. This trend in legislation continued after the Restoration.

The Navigation Act of 1651

Parliament decreed that all goods entering England must be carried in ships owned by, and in major part manned by, British subjects, including colonials, or in ships of the country producing the goods. By this arrangement, the Spanish could bring to England their olives and the Portuguese their wines, but Dutch ships carrying such products were barred. The Netherlands retaliated with war (1652–1654), the result of which was to further increase the prestige of England's navy and merchant marine.

The Enumerated Commodities Act (1660)

In this legislation, most of the restrictions of the original Navigation Act were reenacted. The colonies were forbidden to export certain commodities such as tobacco, sugar, cotton, indigo, and dyes to any country except England or the other English colonies. The list was made to include rice, molasses, and naval stores in 1706. In 1722, it was further extended to copper, ore, and skins. Because the commodities enumerated were much in demand in England and the colonies had been established to serve the mother country, English political leaders held that the act was justified.

The Staple Act (1663)

Designed to protect English merchants against foreign competition in American markets, this act provided that all European imports into the American colonies, with a few exceptions, had to first enter English ports. Such goods could be reshipped only after the payment of a duty.

The Duty Act (1673)

To prevent colonials (especially New Englanders) from exploiting flaws in earlier legislation designed to thwart their participation in direct trade with Europe, Parliament levied a plantation duty to be paid in colonial ports. Provision was also made for the appointment of resident customs collectors in the colonies, who were made directly responsible to the commissioners of customs in England.

The Enforcement Act (1696)

The American colonists, who considered the Navigation Acts both inconsistent with their rights and destructive of their growing commerce, found many ways to evade them. Customs officials, notably Edward Randolph in Massachusetts (1680), could get little help in carrying out their duties. As a result, the law of 1696 contained stringent clauses to break up smuggling: It required that all English and colonial ships be registered, and it authorized customs officials to search ships, wharves, and warehouses and seize unlawful goods. Admiralty courts to handle enforcement proceedings were established in all the colonies—such bodies could proceed without the accused having benefit of common law protections, notably a jury trial. In the same year, King William III created the Board of Trade and Plantations to oversee colonial commerce.

Enforcement of the Navigation Acts

After the Glorious Revolution, the victorious Whig faction, which had set constitutional limits on the monarchy, did not repeal the legislation that had extended imperial control over the colonies. Between 1682 and 1752, eight colonial charters were annulled, and the number of royal officials increased in all the colonies. The royal veto was exercised to overturn acts of the colonial legislatures; attempts were made to regulate certain colonial industries (including wool and iron manufacture) so as to reduce competition with those of England; the issuance of colonial currency was closely supervised; and the right of appeal from decisions of the colonial courts to the Privy Council in London was extended. Nevertheless, particularly under the long ascendancy of Sir Robert Walpole as first lord of the treasury and Chancellor of the Exchequer (1721–1742), the enforcement of these measures was not particularly vigorous and at times purposely lax in order to stimulate trade. Dealing with inconsistent and often inept enforcement of the regulations became as much a part of colonial economic life as the printed provisions of the Navigation Acts.

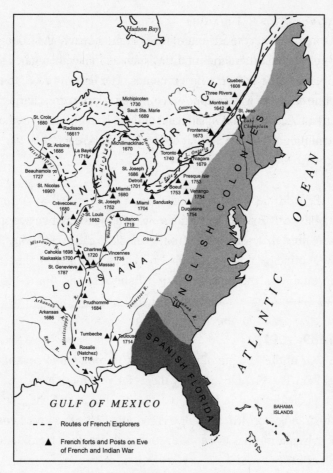

THE ENCIRCLING FRENCH

■ THE STRUGGLE FOR CONTROL OF NORTH AMERICA

From the Glorious Revolution of 1688 to the Peace of Paris (1763), the development of British America was in large part determined by the contest for power waged by England and France in every part of the world. Early in the eighteenth century, royal officials in the colonies, as well as in England, came to believe that French forts and trading posts might encircle the English settlements along the Atlantic coast.

French Policy

France's goals in North America were ambitious, if at times subordinate to its worldwide struggle with Britain. From settlements at Quebec and Montreal on the St. Lawrence River, the French pushed toward the Great Lakes and down the Mississippi Valley to the Gulf of Mexico. But, in fact, beyond Montreal, New France consisted mainly of a series of trading posts, missions, and forts strung along the route of the fur traders—the total population of New France was only 75,000. To maintain their authority over this great extent, the French formed alliances with the Algonquians and other nations (particularly the Hurons) and other tribes who were threatened by the English settlers or their sometime Indian allies, the Iroquois.

The Encircling French

In 1673, Father Jacques Marquette, the adventurous Jesuit missionary, and Louis Joliet, a successful fur trader, explored Lake Michigan and the tributaries of the Mississippi. They then sailed southward on that great river to the mouth of the Arkansas. The Count de Frontenac, then governor of New France, realizing the strategic importance of control of the Mississippi, gave strong support to a daring expedition of Robert Cavelier, Sieur de La Salle. In 1682, La Salle's small band of French and Indians reached the Mississippi delta and the Gulf of Mexico, claiming the whole valley for France. The French then began to erect a series of forts to bar the English from the region.

Colonial Wars

The military conflict between Britain and France in America was but one aspect of a worldwide struggle between the two nations that was waged from Canada to the West Indies, on the high seas, and through Europe and Asia. Of principal concern for the English and French colonists in America were control of the fur trade, supremacy in the North Atlantic fisheries, and possession of the great Ohio-Mississippi basin.

King William's War (1689–1697)

The outbreak of the War of the League of Augsburg in Europe led to hostilities in North America known as King William's War. The French, aided by their Native American allies, the Hurons, launched a series of raids from Canada. Settlements at Dover, New Hampshire, and Schenectady, New York (1690), were destroyed. The English took Port Royal (today Annapolis Royal), Nova Scotia, in 1690 but failed in a later attempt with their Iroquois allies to capture Quebec. Hostilities formally ended with the inconclusive Treaty of Ryswick (1697).

Queen Anne's War (1702–1713)

The French king Louis XIV's desire to place his own candidate on the throne of Spain precipitated a general war in Europe, known in America as Queen Anne's War. In 1710, France lost the province of Acadia (Nova Scotia), long a source of attacks against New England. On European battlefields, the brilliant leadership of the Duke of Marlborough was decisive for the British. By the Treaty of Utrecht (1713), Great Britain secured the Hudson Bay region, Newfoundland, and Nova Scotia. Spain yielded to British merchants (in the Asiento) a monopoly on the slave trade to Spanish America.

Troubled Truce

For thirty years after the Treaty of Utrecht, the French and British competed for advantage in establishing trading posts, building strategic forts, and arranging agreements with the Indian tribes most active in the fur trade. Spanish raids on British settlements in South Carolina during earlier conflicts eventually led to the founding of Georgia in the early 1730s, primarily as a buffer colony.

King George's War (1745–1748)

The bitter Anglo-French rivalry again erupted, first in Europe in the War of the Austrian Succession (1744). There, as well as in America, the conflict was inconclusive. New Englanders captured the fortified town of Louisbourg on Cape Breton Island, but to the colonists' dismay, it was returned to France under

the terms of the Treaty of Aix-la-Chapelle (1748). After the war, skirmishing continued on the frontier, particularly in the Ohio Valley, as both nations competed for control of the region and of the fur trade.

The French and Indian War (1754–1763)

The contest for empire reached its climax in the war that was known in Europe as the Seven Years' War. In Asia and America, as well as on the European continent, Britain finally prevailed over France and her allies. The war in America was bitterly fought.

Early Difficulties

Although the British American colonies had almost twenty times the population of New France, the war went badly at first for the British cause. General Braddock's army regulars, supported by Virginia militiamen under Colonel George Washington, were routed while on an expedition against Fort Duquesne (today, Pittsburgh). The French captured Fort Oswego (in upstate New York), while in Europe, Russia, Austria, and Sweden joined France to defeat Britain's ally, King Frederick of Prussia. The demands in other theaters (locations of the conflict) limited Britain's ability to commit troops to North America. Thus, the early fighting against the French in the American theater was largely assigned to the local militia of the individual colonies. The coordination of these groups proved difficult, giving France and its Native American allies a temporary military advantage.

William Pitt's Leadership

At the low point in British fortunes, William Pitt brought a new spirit into the war. As England's prime minister, he established effective control of military forces and foreign policy. In 1757, in an attempt to strengthen British forces in America, he initiated impressments (forcible inductions) of colonists into the British army. He also authorized seizures of their produce and possessions and approved the quartering of soldiers in their homes against their wills. These measures were so resisted by the colonists that Pitt issued new directives the following year. The colonial assemblies regained responsibility for raising troops, and compensation was stipulated when goods and other support were requisitioned by the army. Pitt enlarged the force of British regulars stationed in America and moved toward a total footing in what was, in fact, a world war.

British Victories

In 1758, a colorful army of Englishmen, Scots, and Americans, led by British generals Jeffrey Amherst and James Wolfe, stormed the French fortress of Louisbourg. Later that year, General John Forbes's troops cut their way across Pennsylvania and blew up Fort Duquesne, erecting Fort Pitt on its ruins. In 1759, Wolfe lost his life in the spectacular capture of Quebec, the capital of New France. The following year, Montreal fell to the British, and the war in America came to an end.

The Peace of Paris (1763)

The treaty that concluded the conflict redrew the map of the world. Britain ended the influence of France in India and gained Florida as compensation from Spain for the return of Cuba and the Philippines, seized during the conflict. In America, the boundaries of British colonies were extended to include Canada and all of France's territory east of the Mississippi River, except New Orleans. France

ceded to Spain the port of New Orleans and the rest of Louisiana that lay west of the Mississippi. The French empire in America was reduced to the small islands of Martinique and Guadeloupe and half of Hispaniola (Haiti), in the West Indies.

Consequences of Britain's Triumph

The defeat of France was secured at great expense to the British government—the national debt soared, restricting Britain's financial resources. With this constant reminder of the high cost of victory, the British government, believing the American colonists had not contributed sufficiently to the war effort, quickly concluded that the colonial system needed to be changed and new regulations implemented.

Intercolonial Cooperation

The removal of the French presence in Canada was of considerable significance for English America. It made the colonies less dependent on Great Britain for military defense, and it opened the eyes of the colonists to many defects in the imperial system. The wars with the French finally convinced many colonial leaders, at least in theory, of the usefulness of intercolonial cooperation in dealing with military matters, relations with Native Americans, and commercial issues although there was, in reality, little practical cooperation prior to the crisis of the American Revolution.

The Albany Congress (1754)

Even before the opening clash of the French and Indian War, delegates from seven colonies met in Albany to discuss the possibility of a closer union among the English provinces. The congress accepted Benjamin Franklin's suggestion that a federation be formed, to consist of a federal council chosen by the colonial assemblies (which were to retain their powers) and a president-general appointed by the Crown. The council was to provide for common defense, guide negotiations with Native Americans, and levy taxes for general purposes. The Albany Plan was rejected by the British government and received no meaningful support in the colonial assemblies.

Strength of Colonial Legislatures

The Anglo-French conflict dramatized the rise of the colonial legislative assemblies. Their responsibility for raising troops and their power to levy taxes within their borders had been indirectly acknowledged (if not directly approved) by Pitt in 1758. His decision to ask the colonial assemblies to raise taxes to pay for the war in America was interpreted by the colonists as recognition of their authority to tax themselves.

■ THE REORDERING AND EXTENSION OF IMPERIAL CONTROL

With the Peace of Paris, the British Empire virtually doubled in size. The great increase in the extent of British territory resulted in new thinking about the purpose of empire. The administration and control of the new lands had to be dealt with immediately. The pressing problem of the national debt caused royal officials and parliamentarians alike to devise ways to raise additional revenues.

OWNERSHIP OF THE CONTINENT, 1682 - 1783

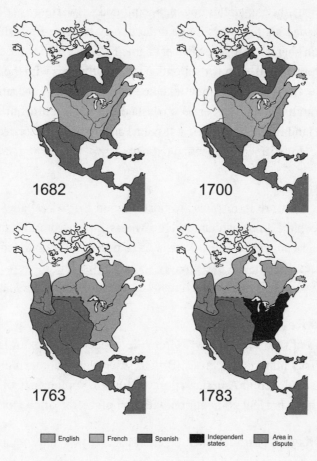

1682

1700

1763

1783

English French Spanish Independent states Area in dispute

The New Colonial Policy

In 1763, the young and, at times, mentally unstable King George III designated William Pitt's brother-in-law, George Grenville, Chancellor of the Exchequer, to be the prime minister. Faced with the need to significantly raise revenues and to gain control of a vastly enlarged empire, Grenville set out to reinvigorate the mercantilist system. The general goal of his colonial policy was to secure tighter control over the colonies in imperial matters and to gain greater returns from them for the benefit of the mother country.

Pressures of British Public Opinion

British merchants complained that the American colonists had long evaded the Navigation Acts with impunity, and that colonial merchants had made handsome profits during the French wars by trading with the enemy. They pressed Parliament to strictly enforce the commercial regulations in the colonies. Merchants and landlords in Parliament demanded that the burden on British taxpayers be lessened by compelling the colonies to bear a larger share of imperial expenses. Great Britain's debt had doubled between 1756 and 1764, while the cost of maintaining the civil and military establishments increased greatly. Although a few of the American colonies had met the requisitions imposed by the British government, most had contributed little to the costs of the wars with France.

Pontiac's Rebellion

The western frontier of the American colonies exploded in warfare in 1763 when a chief of the Ottawa tribe, Pontiac, formed his followers into a confederacy to drive English settlers out of the Ohio Valley. A Native American shaman (religious leader) named Neolin, who was called the Delaware Profit by the English, assisted Pontiac in these efforts. Pontiac forged alliances with the Hurons, Chippewas, and Mingoes. Together, under his leadership, they attacked the British fort at Detroit, along with smaller posts in the region. Although this attack was soon crushed, it had a significant effect in setting the new British policy on western lands in North America. It seems also to have convinced the British government that a permanent standing army in America was necessary.

Proclamation Line of 1763

Initially a temporary measure in response to hostilities in the Ohio Valley, the Proclamation Line reserved the region between the Appalachians and the Mississippi—from Florida to 50° north latitude—for the use of Native American tribes. The colonists were ordered to remain east of a line drawn along the crest of the Alleghenies. Those who had already settled in the region were ordered to withdraw, so, of course, the new policy was protested by American traders, frontier settlers, and land speculators.

Grenville's New Trade Regulations

By tighter enforcement of the trade laws, Grenville expected to obtain larger revenues from the American colonies to defray imperial expenses. British ships were stationed along the American coast and customs agents were deployed in American ports to force compliance. Colonial exports of finished goods were restricted so as to prevent competition with manufacturers in the mother country.

James Otis and the Writs of Assistance. These general search warrants, against which James Otis of Boston had made his famous plea in 1761, were used ever more frequently to locate illegal shipments and to collect customs duties formerly lost through smuggling.

Otis also wrote an important pamphlet called *The Rights of the British Colonies Asserted and Proved.* As a clear-minded attorney, young Otis set forth complicated arguments that eventually came to consume those who disagreed with British policy. For example, he noted that it was impossible to criticize the various policies found objectionable by some colonials without questioning the power of Parliament itself. "Let the Parliament lay what burden they please on us," he wrote, "it is our duty to submit and patiently bear them," but only to a point. That would come, he believed, when Parliament failed to extend to the colonists all of the rights and privileges enjoyed by those living in Great Britain.

The Sugar Act (1764). An enlarged customs service was charged with enforcing the Molasses Act of 1733. It set almost prohibitive duties on rum, spirits, sugar, and molasses imported into the colonies from foreign sources. In 1764, the duty on foreign molasses was reduced and new taxes on wines, silks, and other luxuries were imposed. This Sugar Act also provided for the rigorous collection of the tax. In so doing, it stipulated that charges of smuggling were to be decided in vice-admiralty courts (effectively denying the accused of a trial by jury). Although the Sugar Act did, in fact, lower the tax rate on molasses, the colonials had earlier become used to ignoring the high duties imposed by the 1733 act. They thus opposed this new legislation, not because of its slightly lower duties (which in theory was beneficial) but because in reality it contained strong enforcement provisions that attempted to end smuggling.

The Currency Act (1764). At the solicitation of British creditors, Parliament forbade further issuance of paper money in the colonies, thus preventing colonial debtors from settling their accounts in depreciated currency.

The Stamp Act (1765). Grenville hoped to secure considerable revenue by requiring that all official and legal documents, newspapers, almanacs, and pamphlets that were circulated in the colonies bear stamps showing that a tax on them had been paid. Unlike the Sugar Act, which revised previous duties on similar products, the Stamp Act was clearly a new form of tax, not a measure to regulate trade and raise revenue. A Stamp Act Congress of representatives from nine colonies gathered in New York in October 1765. It recognized Parliament's authority, but asserted that taxes could be levied only by the colonies' elected representatives.

The Quartering, or Mutiny, Act (1765). An attempt was made to reduce the cost of the military establishment by compelling the colonists to quarter, or furnish lodging and supplies for British troops if colonial barracks were inadequate.

Colonial Protests

Opposition to Grenville's laws was much more widespread and violent than the British government had anticipated. This in itself demonstrated how effectively they were being enforced—revenues collected in the colonies increased tenfold. The new measures were implemented at a time when the American colonial economies were in a postwar downturn. They extracted hard money from every class, region, and area—in cities and towns, on plantations, and on large and small farms.

Americans particularly objected to the new pattern of taxation and enforcement. By empowering British officials, troops, and courts to collect revenues, some colonial leaders believed that Parliament had circumvented the traditional authority of the colonial assemblies to pass tax measures. The new measures were thus perceived to be threats to the rights of the colonists as well as to their prosperity.

Boycotts and Mobs

Aroused by the threat to their lucrative West Indian trade implicit in the Sugar Act, some colonial merchants supported the signing of intercolonial non-importation and non-consumption agreements. These grew in effectiveness after the passage of the Stamp Act. In Boston, New York, and other ports, more radical opponents of the measures, often calling themselves the Sons of Liberty, held public demonstrations, terrorized stamp collectors, and destroyed stamps.

Reaction to the new British policy served to unite disparate elements of the American colonies in a common cause. It blunted, for example, the strong differences that set the interior and western regions in opposition to the eastern seaboard. (Such differences had earlier produced Bacon's Rebellion in Virginia; they caused the rising of the Paxton Boys in Pennsylvania in 1763 and would also lead to a revolt known as the Regulator movement in North Carolina in 1771.)

Retreat From Grenville's Policy

Although colonial resistance was noticed in London, it was the perception of a sharp decline in the colonies' trade with Great Britain that persuaded the new ministry of the Marquis of Rockingham to

repeal the Stamp Act and to reduce the duties imposed by Grenville in 1764. The fruits of concerted action were not lost on the colonists. At the same time, however, Parliament also passed the Declaratory Act, reasserting its right to tax the colonies as it saw fit.

The Townshend Program

Under the new ministry of the aging William Pitt, Charles Townshend, Chancellor of the Exchequer, persuaded Parliament to make a new attempt to increase revenues from America through comprehensive regulation of trade.

Townshend's Duty Act

In 1767, Parliament passed a Duty Act imposing duties on glass, lead, tea, paper, and paint pigments, to be collected by British commissioners in America. Enforcement of the existing laws was given further emphasis—the New York Assembly was suspended for refusing to comply with the mandatory Quartering Act. In 1768 the Massachusetts legislature was dissolved for issuing a circular letter that called for united resistance to Parliamentary taxation, and the Virginia House of Burgesses was dissolved for endorsing the letter.

Renewed Colonial Protests

The imposition of the Townshend duties revived non-importation and non-exportation agreements in the colonies. British finished and luxury goods were boycotted; American homespun products were worn defiantly.

The Boston Massacre (1770)

When members of a new board of customs officials for the colonies were threatened, four regiments of British troops were quartered in Boston. Soon thereafter, a slight brawl between the redcoats (British soldiers) and a group of liberty boys (colonists) developed into mob action. The British troops fired at the shouting civilians, killing five and wounding several others. The incident was purposely distorted and exaggerated by American dissidents, anxious for a dramatic issue to use in building resistance to the new British policy.

Efforts at Conciliation

When King George's favorite minister, Lord North, took over the control of governmental policy, he promised to heal the breach that had been developing between the colonies and the mother country. In 1770, Parliament was persuaded to repeal all duties on colonial imports except a small tax on tea. Lord North's conciliatory attitude strengthened the conservatives in the American colonies, who wished to avoid trouble. But the radicals, who distrusted North, prepared to meet any new infringement of their political and economic rights. Incidents such as the attack organized by merchants of Providence, Rhode Island, on the customs schooner *Gaspée* in June 1772 and the unsuccessful attempt by customs officials to send the accused to England for trial rekindled animosities.

The Tea Act

In 1773, Lord North and his colleagues attempted to help the British East India Company sell its surplus tea in America and thereby save itself from financial disaster. Parliament relieved the company

of the duty that it had paid to import tea into England and granted it a monopoly on the transport of tea to America, specifying that it could be sold in the colonies only by company agents (thereby undercutting colonial merchants). Prices for tea fell, but colonial consumers boycotted the product, reacting to the principle in the legislation, which they identified as yet another example of Parliament's attempt to levy taxes on them without their consent.

The Boston Tea Party

In Boston in December 1773, some 150 men disguised as Native Americans boarded three of the East India Company's ships and dumped cargoes of tea into the harbor. In other colonies, the company was either refused permission to unload its tea or prevented from selling it.

Coercion and Resistance

Parliament passed four Coercive **Acts,** known in America as the Intolerable **Acts,** to punish the residents of Boston and Massachusetts. The Boston Port Bill closed the city's harbor to all commerce until the province of Massachusetts had paid for the destroyed tea. The Massachusetts Government Act suspended the charter of 1691, making all colonial officials appointees of the Crown and forbidding town meetings without permission from the royal governor. The Administration of Justice Act permitted British officials charged with capital offenses in enforcing the law to be tried in England. The Quartering Act ordered Massachusetts to provide lodging and food for British soldiers stationed there.

The Quebec Act of 1774

The Quebec Act was carried in Parliament at the same time as the Coercive Acts. It placed the area west of the Alleghenies and north of the Ohio River within the province of Quebec, to be governed directly by British officials. The law also recognized the authority of the Roman Catholic Church in Canada. This act antagonized several colonies that had claimed lands in the region.

The First Continental Congress (1774)

The Intolerable Acts roused the colonies to again take cooperative action to defend what they regarded to be their liberties. In answer to the many calls for a Continental Congress, representatives from all of the colonies but Georgia met in Carpenters' Hall, Philadelphia, in September 1774. They were chosen by Committees of Correspondence, Committees of Safety, provincial mass meetings, and county conventions.

Petition of Grievances and the Suffolk Resolves

The Continental Congress narrowly defeated Joseph Galloway's proposal for a colonial union along the lines of the Albany Plan (with a congress that would accept or reject legislation enacted by the British Parliament). It drafted a Declaration of Rights and Grievances in the form of a petition to "His Most Gracious Sovereign," the king, in which document they demanded the repeal of the parliamentary measures that had produced their grievances since 1763. The representatives moved closer to asserting their continuing authority when they endorsed the resolves of Suffolk County, Massachusetts, which declared the Intolerable Acts unconstitutional, and made arrangements for a second meeting of the congress the next spring.

The Continental Association

The most important action taken by the Continental Congress was to urge the American colonies to join in an agreement, the Association, to boycott both import and export trade with Great Britain. Detailed methods were worked out for the enforcement of such an agreement in all the colonies.

The Navigation Acts imposed duties and penalties for smuggling on the colonial trade; but they were not (and could not be) enforced consistently, given the great extent of the American coastline. Their effectiveness depended on the compliance of the colonists. This was grudgingly given as long as the commercial system was loosely enforced, which, despite periodic intervals of zeal, proved to be the case until 1763. By then, colonists had developed sufficient independence of mind that new and more aggressive legislation by Parliament designed to increase tax revenues and punish evaders took on the distinct appearance of purposeful oppression. The policies of the British government in this regard, which bypassed the colonial governments and assemblies, strengthened this perception. By 1774, many colonial leaders had concluded that the objective of Parliament's colonial laws was to restrict or diminish what they had come to believe were their fundamental rights as Englishmen.

Selected Readings

Bailyn, Bernard. *The Ideological Origins of the American Revolution* (1967).

Breen, T. H. *The Marketplace of Revolution: How Consumer Politics Shaped American Independence* (2004).

Christie, Ian R. and Benjamin W. Labaree, *Empire or Independence, 1760–1776* (1976).

Colbourn, H. Trevor. *The Lamp of Experience: Whig History and the Intellectual Origins of the American Revolution* (1998).

Dickerson, Oliver. *The Navigation Acts and the American Revolution* (1951).

Ernst, Joseph. *Money and Politics in America, 1755–1775* (1973).

Gipson, Lawrence Henry. *The British Empire Before the American Revolution* (15 vols., 1936–1970).

Ketchum, Richard. *Divided Loyalties: How the American Revolution Came to New York* (2002).

Knollenberg, Bernhard, ed. *Origin of the American Revolution: 1759–1766* (2002).

Labaree, Benjamin W. *The Boston Tea Party* (1964).

Maier, Pauline. *From Resistance to Revolution: Colonial Radicals and the Development of American Opposition to Britain, 1765–1776* (1972).

Miller, John C. *The Origins of the American Revolution* (1943).

Morgan, Edmund S. and Helen M. *The Stamp Act Crisis* (1953).

Nash, Gary B. *The Unknown American Revolution: The Unruly Birth of Democracy and the Struggle to Create America* (2005).

Pares, Richard. *Yankees and Creoles: The Trade between North America and the West Indies before the American Revolution* (1956).

Parkman, Francis. *France and England in North America* (9 vols., 1865–1892).

Peckham, Howard R. *The Colonial Wars, 1689–1762* (1963).

Strum, Richard. *Causes of the American Revolution* (2005).

Raphael, Ray. *The First American Revolution: Before Lexington and Concord* (2002).

Sydnor, Charles S. *American Revolutionaries in the Making: Political Practices in Washington's Virginia* (1965).

Test Yourself

1) Which was the most important motivation for the Trade and Navigation Acts?
 a) to curb the power of France and Spain in the new world
 b) to increase the profits of British Joint Stock Companies
 c) to implement the economic theory of mercantilism
 d) none of the above

2) True or False: Parliament repealed the Stamp Act of 1764 because it listened to colonial protests about this law and agreed with those colonists who complained about it.

3) Which of the following was one of the Intolerable or Coercive Acts of 1774 that resulted in the meeting of the First Continental Congress?
 a) the Sugar Act
 b) the Townshend Duties
 c) the Boston Port Bill
 d) the Writs of Assistance

4) Which of the following British leaders initially had a conciliatory attitude toward the colonists and sincerely tried to help them by repealing all duties on colonial imports except for a small tax on tea?
 a) George Grenville
 b) Lord Rockingham
 c) Lord North
 d) Charles Townshend

5) True or false: The first discussions of colonial unity occurred at the Albany Congress, where Benjamin Franklin presented a plan of federation.

6) Which of the following was not one of the wars fought in North America during the period of European intercolonial rivalry?
 a) King William's War
 b) the French and Indian War
 c) Queen Anne's War
 d) the Thirty Year's War

7) Which of the following was the British Prime Minister during the French and Indian War, whose strong leadership and emphasis on military preparedness won the conflict for Great Britain?
 a) George Grenville
 b) Robert Walpole
 c) William Pitt
 d) Lord Rockingham

8) True or false: The Proclamation of 1763 was greeted with approval by the American traders, frontier settlers, and land speculators of the British Atlantic colonies.

9) The First Continental Congress took all of the following measures, except for
 a) declaring a Continental Association to boycott British goods
 b) drafting a Declaration of Rights and Grievances for the King
 c) passing the Suffolk Resolves to declare the Intolerable Acts unconstitutional
 d) adopting a plan of colonial union as presented by delegate Joseph Galloway

10) True or false: King James I viewed the government of the colonies as part of the extension of his royal domain and thus implemented governmental agencies primarily designed to maintain his authority in British America.

Test Yourself Answers

1) **c.** The Trade and Navigation Acts were first passed in the 1650s to implement the economic doctrine of mercantilism. All European colonial nations during the 17th century implemented mercantilism in order to strengthen their home economies. Although the desire to curb the power of France and Spain as rivals did relate to England's desire to dominate the New World economy, international rivalry was not a major motive for the passage of these Acts. In similar fashion, the specific desire to increase the profits of British joint stock companies was not a motive for the Trade and Navigation Acts, although such companies would benefit indirectly from economic prosperity created by the Acts.

2) **False.** Colonial protests did not cause Parliament to cancel the Stamp Act. Parliament cared little about colonial protest in 1765. The Stamp Act was repealed because of a decrease in tax revenues that it caused. Moreover, Parliament continued to pass additional tax legislation that produced additional protests and condemnation from the American colonies during the ten years after the repeal of the Stamp Act.

3) **c.** The Boston Port Bill was legislation passed by Parliament in 1774 that sought to punish the citizens of that city for having participated in the protests against the tea tax. This legislation became one of the so-called Intolerable Acts that resulted in disaffected colonists calling for the meeting of the first Continental Congress. All of the other pieces of legislation noted in this question were also acts passed by Parliament during the colonial crisis of the 1760s and 1770s, but they came before the Intolerable Acts.

4) **c.** Lord North became Prime Minister of Great Britain in 1770, initially adopting a sympathetic and conciliatory attitude towards the American colonies. He repealed some of the Townshend Duties and hoped for better relations with the colonies. The excesses of the Boston Tea Party changed his attitude, and he adopted a much harsher view of colonial protest. North served as prime minister during most of the American Revolution, resigning his office in 1782. George Grenville, Lord Rockingham, and Charles Townshend were also all British leaders of the era as well, but none of them ever had a conciliatory attitude toward the colonies, as did the Lord North prior to the Boston Tea Party.

5) **True.** The Albany Congress was the first time American colonists ever discussed uniting into a federated group of British North American colonies. This Congress met at Albany, New York, during 1754 for the purpose of discussing unified relations with the Indians. In the end, these discussions produced nothing. The Congress was notable in retrospect because one of the delegates, Benjamin Franklin, introduced a plan of the Union that provided for the election of a colonial assembly that would have delegates from each of the British North American colonies. Nothing, however, came from Franklin's proposal, and the various representatives to the Albany Congress returned home without acting on it.

6) **d.** The Thirty Year's War was not one of the inter-colonial wars. Instead, there were four major inter-colonial wars from the 1680s until the 1760s fought between Britain and her American colonies on one side and Spain, France, and their respective colonies on the other. These were: King William's War 1689–1697; Queen Anne's War 1702–1713; War of Jenkins' Ear, 1739–1742; and French and Indian War 1754–1763)

7) **c.** William Pitt, known later as Lord Chatham, was the successful architect of the British victory in the French and Indian War. George Grenville later served as Chancellor of the Exchequer. Robert Walpole and Lord Rockingham both served as prime minister, but not during the French and Indian War.

8) **False.** American colonials disagreed bitterly with the closing of the frontier as required by the Proclamation of 1763, and many of them ignored its provisions. Many British colonials, including George Washington and Benjamin Franklin, had invested heavily in the purchase of western lands beyond the proclamation line. This Proclamation negated their land titles. In addition, some colonial investors had formed land companies that sought to encourage migration into the new western areas. For that reason, many westward-moving frontier folk ignored the provisions contained in the Proclamation of 1763.

9) **d.** The Congress considered Galloway's plan of union but rejected it. The Continental Congress, however, did act on all other measures. It declared a boycott of British goods. Congress wrote a Declaration of Rights and Grievances to the King, setting forth its concerns. Finally, it declared the Intolerable Acts unconstitutional.

10) **True.** King James I thought there was no need for many governmental institutions in the colonies, because his authority provided for that through the colonial charters. James I was one of the last divine-right monarchs in English history. For that reason, he viewed colonial governments as a direct extension of his royal prerogative. The English Civil War of the 1640s, which came several years after the end of his reign, began to lay the foundations of the British constitutional monarchy, thus rendering his views of colonial government increasingly obsolete.

The American Revolution and the Confederation

1774: First Continental Congress assembles in September, adjourns October 26; Continental Association forms (October)

1775: Battles at Lexington and Concord, Massachusetts (April); Second Continental Congress convenes (May); American forces capture Fort Ticonderoga and Crown Point (May); fail to take Montreal; Washington appointed commander-in-chief (June); British win costly Battle of Bunker Hill (June 17)

1776: Thomas Paine's *Common Sense* published (January); British depart Boston (March); British occupy New York City (September); Congress votes to declare independence (July); supply of rebel troops begins at Spanish New Orleans (summer); Washington crosses the Delaware to surprise the Hessians at Trenton (December)

1777: Defeat of General Burgoyne at Saratoga in October foils British invasion plans; British occupy Philadelphia (September); Articles of Confederation formally adopted (November), but not ratified until March 1, 1781; Washington's troops go into winter quarters at Valley Forge, Pennsylvania

1778: Treaties of alliance and commerce with France concluded (February); British take Savannah, begin southern campaign (December)

1779: Spain declares war against Great Britain (June 21)

1780: British take Charleston, win Battle of Camden, South Carolina (May, August); Benedict Arnold's treason exposed (September); passage and ratification of state constitution of Massachusetts

1781: Fierce fighting in the Carolinas causes Lord Cornwallis to reposition his troops in Virginia (January–May); Spanish victory at Pensacola, Florida (May 10); decisive Franco-American victory at Yorktown results in Cornwallis's surrender (October)

(continued on next page)

1782: Impost tax rejected in Congress

1783: Last large contingent of Loyalists (7,000 of some 100,000) evacuated with British forces from New York (April); Treaty of Paris confirms American independence (September); soldiers' march for compensation causes Congress to leave Philadelphia (June)

1785: Land Ordinance of 1785 passed (May)

1786: Annapolis Convention meets (September); Shays' Rebellion rises in western Massachusetts (August–December)

1787: Northwest Ordinance passed (July)

In taking up arms, American colonists believed they were defending fundamental political rights conferred on them by the British constitution. Since 1763, they had protested, resisted, and now were defending themselves against a series of measures Parliament wished to impose on their communities without their consent. By 1776, many had come to believe that an anti-American conspiracy existed in the highest circles of the British government. After the Battle of Yorktown, a new British ministry would offer to restore imperial relations to conditions pre-1763. By that time, however, the Revolution had produced more ambitious aims.

■ FROM PROTEST TO RESISTANCE

In 1775, few Americans thought that the mounting quarrel with the British government would lead to independence for the colonies. As reluctant "rebels," they hoped for a modification of imperial regulations that would satisfy their demand for a greater measure of self-government.

The Appeal to Arms

After the adjournment of the First Continental Congress, the radicals among the colonial leaders created Committees of Safety to enforce the non-import and non-export features of the Continental Association agreement (see Chapter 4). After Massachusetts had been declared to be in a state of rebellion in February 1775, Lord North offered a plan of conciliation on the issue of taxation in the House of Commons: Parliament would temporarily not tax the colonies (beyond those measures intended for trade regulation) if the colonial assemblies would vote taxes to support royal government within their boundaries. This overture was offset by Parliament's passage of the Restraining Act (March 1775), which required New England to trade only with the mother country and the British West Indies, a measure also applied to middle and southern colonies after they joined the Continental Association.

Lexington and Concord

Before the Second Continental Congress assembled in Philadelphia in the spring of 1775, the Massachusetts Minutemen had fought the British regulars at Lexington and Concord. The clashes occurred when General Gage ordered his troops to destroy military stores in the hands of Americans and arrest such colonial leaders as John Hancock and Samuel Adams. The famous skirmishes at Lexington and Concord took place during the early morning hours of April 19, 1775. The British suffered over a thousand casualties. Militia from all the New England provinces, some 16,000 in arms, promptly surrounded Gage's

regiments in Boston, while Massachusetts leaders appealed to all other colonies for aid. In May 1775, colonial militia under Benedict Arnold and Ethan Allen took two strategic garrisons on Lake Champlain in upstate New York: Fort Ticonderoga and Crown Point.

The Second Continental Congress

In response to the appeals of Massachusetts, the Second Continental Congress, while sending a final **Olive Branch petition** to the king, took steps to raise and equip an army, appointed Washington commander in chief, issued a *Declaration of Causes for Taking up Arms,* and began seeking alliances with France and other European nations.

In July 1775, Congress rejected the North plan for reconciliation. In November, news was received that the king had not considered the Olive Branch petition, instead declaring the colonies to be in open rebellion. Parliament was sending an additional 25,000 troops to join the force of 15,000 already in the colonies. In December 1775, the king issued a proclamation and Parliament passed the Prohibitory Act to close all American ports.

From Moderate to Radical Consensus

In the months after Lexington and Concord, hundreds and then thousands of men (including colonial militia units from throughout New England) gathered in the environs of Boston while the British barricaded themselves in the city. Organized into a rough-hewn army, this rebel force fought the Battle of Bunker Hill against the British on July 17, 1775. The British suffered heavy losses, but still won this first major battle of the Revolution. The Congress appointed George Washington as Commander of the Continental Army. Arriving in Boston after the fighting at Bunker Hill, he worked diligently to mold his men into a serviceable army.

Even with the start of fighting, the movement for political separation grew slowly, but it mounted steadily among Americans in response to London's punitive actions. The colonists continued to believe that they had taken up arms to defend themselves and asserted that they would lay them down when their grievances were redressed. They did not need to be reminded that Britain possessed the world's finest naval and military forces. The brutal suppression of previous risings against the Crown, especially those in Ireland and Scotland in the eighteenth century, also gave American colonists pause—the penalty for rebellion was death.

Reluctance to Declare Independence

Fighting in the colonies had been going on for more than a year before the Continental Congress decided in favor of independence. There were several reasons for this delay:
- The sentimental attachment of most of the colonists to the mother country as well as strong connections of language and culture
- The fear that either anarchy or despotism might take the place of British authority
- The hope among colonial leaders that, as had previously occurred, there would be a change in the British ministry and a softening of policies
- The reluctance of colonial merchants to give up trade privileges they enjoyed under the British flag
- The inertia of many colonials, their failure to give specific instructions to their delegates in the Continental Congress, and the lack of effective apparatus for building a national or intercolonial consensus for such a dramatic move

The Logic of Political Separation

Colonists were pushed further down the road to a decision for independence by British actions, which suggested that compromise and accommodation were no longer possible.

Common Sense. Although King George III had no sympathy for the colonials' cause, the Continental Congress, which was not fully aware of this, persisted in asserting that it was resisting the "tyranny of irritated ministers" and Parliament rather than taking up arms against the Crown. The arguments presented by the English radical Thomas Paine in his pamphlet *Common Sense: Addressed to the Inhabitants of America,* published in Philadelphia in January 1776, exposed the faulty logic of British policies.

Paine identified as the source of the colonists' grievances the aristocratic society created by the monarchy—an unnatural and arbitrary system. "Of more worth is one honest man to society and in the sight of God," he wrote, "than all the crowned ruffians that ever lived." He argued for independence as a means of establishing a new republican order, free of the absurdities and follies of artificial distinctions. Indicting George III as the "Royal Brute," he suggested that if "earthly honors" were required, America should proclaim that the "Law is King." "Everything that is right or natural pleads for separation," he observed. "[T]here is something very absurd in supposing a continent to be perpetually governed by an island. In no instance hath nature made the satellite larger than its primary planet."

Paine wrote with great power in a plain style, calculated to reach the widest possible audience. That he had succeeded in his intentions was quickly evident. More than 100,000 copies of the pamphlet were bought less than three months after the first printing. The extent of Paine's influence is best measured by the events that followed. He cut the ground out from under the moderate position, creating a logic for declaring independence (and revolution) that made more sense to the common man than talk of "attachments" and tradition.

Lord North's Provocations. Americans were universally incensed by the North ministry's decision to pay foreign mercenaries, especially the Hessians (soldiers from the German state of Hesse) to fight in America, which they interpreted as evidence of an intention to use brutal means to suppress the resistance. Equally revealing of the ministry's closed-mindedness about reconciliation were reports that British agents were inciting Native American tribes against settlers of the western regions of the colonies and the extraordinary action of Lord John Dunmore, royal governor of Virginia, who had offered freedom to black slaves if they would join British forces in the fight against their masters.

The Irrevocable Step

During the spring of 1776, several colonial legislatures instructed their delegations to the Continental Congress to work and vote for independence. South Carolina set up a republican constitution; Rhode Island eliminated the required oath of allegiance to the king. It was also felt that a decisive act on the part of the Continental Congress would help inspire American troops in the field.

Richard Henry Lee's Resolution

Throughout the spring, the Continental Congress became more assertive. It sent an agent to Europe to procure military supplies, proclaimed that the ports of the colonies were open for trade (but not with Great Britain), and gave sanction to American privateers preying on British shipping.

On June 7, 1776, delegate Richard Henry Lee of Virginia moved that "these united colonies are, and of right ought to be, free and independent states." After debate and delay, Congress on July 2 formally approved Lee's resolution by a unanimous vote, with New York abstaining.

The Declaration of Independence

A committee appointed on June 11 to draft a declaration—consisting of Thomas Jefferson, Benjamin Franklin, John Adams, Roger Sherman, and Robert R. Livingston—had reported a draft document on June 28. Although amended in committee and on the floor of Congress, the Declaration of Independence was largely the work of Thomas Jefferson, who "turned to neither book nor pamphlet" in composing it, but rather sought to reflect the sense of Congress and the people. The document was signed by most of the delegates on July 4, 1776, and communicated to the colonial capitals. New York's approval enabled the Congress to prepare a "unanimous declaration" for a formal signing ceremony that took place the following month.

The Declaration falls logically into two parts. In the first, a preamble contained a statement of the natural rights philosophy, developed by John Locke and the English liberal thinkers of the late seventeenth century, with whose writings Jefferson and his colleagues, as well as most educated Americans, were well familiar. Jefferson was thus able to refer to "self-evident" truths, "that all men are created equal, that they are endowed by their Creator with certain unalienable rights; that among these, are life, liberty, and the pursuit of happiness." He then stated the Lockean tenet that governments were formed "to secure these rights" by means of a contract and derived "their just powers from the consent of the governed." When "any form of government becomes destructive of those ends, it is the right of the people to alter or to abolish it."

In the second part of the Declaration, Jefferson listed the "repeated injuries and usurpations" that led the colonies to declare that the "political connection between them and the state of Great Britain" to be "totally dissolved." This was the evidence offered to justify the breach of contract. His indictment was leveled at the king, who he accused of establishing "an absolute tyranny over these States." Because the king (not Parliament) was sovereign under the British constitution, the breach had to be made with the monarchy, even if the measures listed by Jefferson had been passed and largely advanced by Parliament. Paine's *Common Sense* had prepared the way for such an indictment.

The Effect of the Declaration

The Declaration was composed as an announcement and explanation to the world of the colonists' reasons for dissolving the union with Great Britain. It had the additional responsibility for stating a clear purpose and objective, with justifications, for making a revolution, and of convincing the undecided to join the patriot cause. It was not written for abstract or academic purposes. The language of the Declaration was, and remains, powerful, at the same time universal and concrete—the French Revolution of 1789 was inspired by it and the course of American history has been continuously shaped by it. The Declaration continues to exert influence in the world. When published in 1776, it had the additional effect of sharpening the lines between Whigs and Tories (that is, patriots and loyalists) and forcing individual Americans to make difficult choices.

■ THE WAR FOR INDEPENDENCE

With but three million people, the colonies confronted a world military power with a population of nine million. Poor strategy on the part of the British army, as well as Washington's skillful and economical use of the Continental Army, prevented superior British troops from destroying American forces. In time, French, Spanish, and other European assistance, as well as the size of the continent itself, proved decisive.

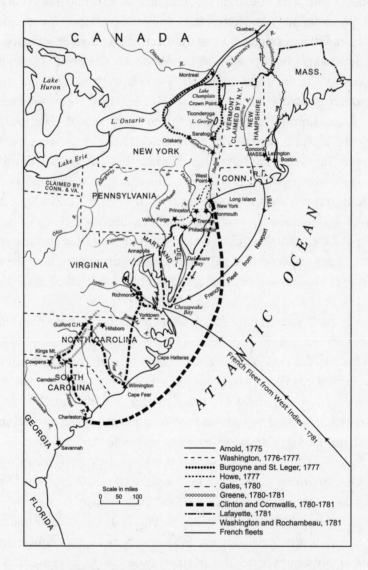

THE REVOLUTIONARY WAR ON THE ATLANTIC SEABOARD

Mobilizing for the Revolution

The need to obtain the materials of war—guns, cannon, horses, ammunition—and to pay for clothing, food, and housing to keep armies in the field posed enormous problems for the revolutionary patriots. Unlike the British government, which had the constitutional authority and well-established procedures to obtain what it needed to wage war, the Continental Congress lacked the power to tax and had no treasury or stream of revenue upon which to rely. It resorted to various devices to raise monies.

Many of the early efforts to supply the American troops revolved around the activities of Oliver Pollock, an Irish-American patriot who resided at Spanish New Orleans, where he operated a merchant house. During 1776, Pollock began shipping badly needed military supplies up the Mississippi and Ohio Rivers to Fort Pitt, from whence these materials made their way to the Continental Army. The Congress appointed Pollock as its official supply agent at New Orleans in 1777, as he continued to provide significant amounts of supplies to the rebel armies, including the gunpowder that won the American victory at Saratoga. In the process, Pollock "invented" the dollar sign used for American currency, which came from the way clerks at the Continental Congress interpreted his handwriting as they read the bookkeeping records of his supply accounts.

Financing the Revolution

In 1776, the economies of the thirteen United States were overwhelmingly agricultural and cash-poor. The few commercial centers were dominated by British merchant houses, the principal sources of credit for colonial Americans. The lack of hard currency resources, purchasing power among consumers, and available credit made it necessary for Congress and the state governments to issue scrip or paper money, which was backed by no other resource but the government's promise to make it good.

Paper Money. By 1780, almost $192 million had been issued in paper money, or Continentals. More than $60 million in additional bills of credit and certificates was pledged for quartermaster's compensation, loans, and soldiers' pay. The paper money depreciated rapidly, contributing to a rapid inflation; about $120 million was finally redeemed at one-fortieth of its face value. Many American merchants (notably those in Philadelphia during the winter of 1777–1778) refused to accept payment for provisions in Continentals. The Congress directed requests for specific sums to the states in the form of requisitions. Despite the urgency, the states were inclined to ignore them; they contributed only $6 million to the Continental treasury during the war.

Financial Management. Congress assigned financial administration to several committees and treasury boards before selecting Robert Morris as superintendent of finance in February 1781. He persuaded them to charter the Bank of North America as a means of establishing order in the financial system. Morris also instituted a contract system for army purchases, which had previously been managed by means of requisitions on the states.

Foreign Loans. Although loan certificates similar to modern bonds were sold through loan offices in the various colonies, the war effort could not have been sustained without foreign loans. These amounted to approximately $8 million and were placed in France, Holland, and Spain.

Organizing Military Forces

It took all of General George Washington's political as well as military skills as commander in chief to keep American forces intact and in fighting form once the war began in earnest. Early victories, which led to overconfidence, made the task of raising a regular army more difficult.

The Continental Army

The Congress relied upon the state militias until October 1776, when they finally yielded to Washington's pleas that a national army be created. He raised about 10,000 volunteers, initially to serve until the end of 1776, and was given control of some 7,000 more militia troops. This nucleus of Continental troops was augmented by volunteers who joined temporarily as the locations of battles and skirmishes changed.

Washington's forces, including most of his American officers, were for the most part inexperienced and poorly trained. The local militia were the least reliable in the field, but they did operate effectively in checking Loyalist activities and in denying the British much of the behind-the-lines cooperation that their hard currency would otherwise have purchased. Washington's command of the Continental Army was weakened by political jealousies and disputes over the conduct of military affairs. The war effort was further impeded by negligent and incompetent officials.

American Naval Forces. Although Captain John Paul Jones won several naval engagements and for a time terrorized the North Sea, the rebellious colonists had no sea power worthy of the name until the French navy came to their aid in 1780. Some two thousand privateers (in effect, licensed pirates) and thirty-four commissioned ships of war constituted the naval force in the early years of the war. American privateering significantly disrupted British merchant shipping, sending insurance rates soaring.

Early Military Encounters

Having evacuated Boston after the skirmishes that began in Lexington and Concord, British forces under General Sir William Howe captured New York City. Some 32,000 regular troops and over 100 ships were deployed about the harbor.

The Battle of Long Island

On August 26, 1776, the British defeated a division of Washington's army (of perhaps 19,000 men) on Brooklyn Heights, but failed to prevent the escape of the American forces. Howe leisurely followed Washington northward, content to fight light skirmishes at Harlem Heights and White Plains. Believing that most Americans did not support the rebellion, he failed to press the attack to destroy the Continental Army. Washington retreated across New Jersey into Pennsylvania, while Howe distributed certificates of loyalty to more than 3,000 inhabitants who were willing to swear loyalty to the king.

Trenton and Princeton

On Christmas night, 1776, Washington crossed the Delaware River and surprised Hessian detachments of the British army at Trenton, taking almost a thousand prisoners. He also surprised the British at Princeton early in the new year before moving into winter quarters at Morristown, New Jersey. These encounters were not in themselves significant, but they clearly demonstrated that the British army, despite its great superiority and advantages, was not invincible.

British Strategy in the Middle Colonies

In 1777, the British tried to execute a plan to capture the state of New York and split the colonies. Three British armies were to meet near Albany: General John Burgoyne to move southward from Canada

via Lake Champlain; Colonel Barry St. Leger to advance eastward from Lake Ontario by way of the Mohawk Valley; and General Howe to lead an army north from the port of New York.

Capture of Philadelphia

Howe failed to carry out his part in this campaign, having decided to pursue Washington's forces instead. He took the rebel capital with little difficulty. After overcoming Washington's stubborn resistance at Germantown, he quartered his army comfortably in the Pennsylvania capital, while the Americans went into winter quarters at Valley Forge (1777–1778).

Saratoga

During the summer of 1777, Burgoyne had quickly retaken Fort Ticonderoga, and then begun a slow march south. When St. Leger's advance eastward in the Mohawk Valley was checked, he found himself cut off from aid and reinforcements. Bands of New York and New England farmers harassed and slaughtered his regiments. On October 17, 1777, at Saratoga, New York, he surrendered the 5,000 men who remained in his army to General Horatio Gates.

The Turning Point: The French Alliance

The French government, under the influence of the able foreign minister the Comte de Vergennes, saw opportunity in an alliance with the Americans against its archenemy Great Britain. However, France withheld formal recognition of the United States until events demanded it.

Secret French and Spanish Aid

The American cause, aided immeasurably by the presence of the celebrated Benjamin Franklin as ambassador, was popular in France from the outset of the Revolution. By several means, including the use of secret agents (notably the versatile playwright Caron de Beaumarchais) and the creation of a phony trading company, the French government secretly aided the American war effort. Most of the gunpowder and other military supplies required at the outset of the war came through these channels. Ammunition, clothing, shoes, and other supplies were shipped from France in a steady stream during 1777. New Orleans and Havana also became important Spanish ports for the trans-shipment of supplies to the American army.

The Treaty of Alliance of 1778

The news of the great American victory at Saratoga, and the report that the British were readying a new peace initiative, induced the French government to make a decisive diplomatic move. On February 6, 1778, France recognized the independence of the United States and signed a military alliance and a treaty of commerce with the new nation. Spain and Holland followed France in declaring war on Great Britain.

The Military Conclusion (1778–1781)

British forces pursued and inflicted much damage on Washington's army in Pennsylvania and New Jersey, but failed to take steps to destroy it. Continuing in the belief that loyalist sentiment was strong, the British command, under General Henry Clinton after Saratoga, turned its attention to the South, where the bitterest fighting of the war occurred. Washington skillfully executed a defensive strategy, avoiding a decisive battle and attacking only when he had the advantage.

Spanish Participation

The Spanish court proved more hesitant than France to join the struggle against Great Britain, because Spain still had important colonies in the Americas. A colonial revolt against the authority of a monarch was not a prospect that found approval at the Court of Spain. Nonetheless, the Spanish king and his ministers badly wanted to employ the revolt in British America as a weapon to damage the British Empire, which had been their colonial rival for several centuries. Spain, therefore, adopted a cautious policy that provided for sending secret supplies to the Americans. In 1778, the Spanish merchant Diego de Gardoqui had organized a dummy trading company that served as a front for sending supplies to the rebels. Spain also loaned money to the Continental Congress. By 1779, however, the Spanish king decided that the Americans had a good chance of winning their rebellion, so he declared war on Great Britain on June 21. However, in so doing, Spain did not recognize the independence of the United States or formally ally with the struggling young nation. Nonetheless, the military campaigns of Spanish General Bernardo de Gálvez proved a valuable assistance for General Washington, because the British had to open a second front on the Gulf coast and along the lower Mississippi valley to fight the Spanish. General Gálvez captured British posts at Natchez, Baton Rouge, and Mobile. His conquest of Pensacola on May 10, 1781 constituted a major victory that swept the British Navy from the Gulf of Mexico and generally weakened overall military effectiveness of Great Britain in the crucial months before Yorktown.

The War in the West (1777–1779)

American victories in the interior helped to relieve the gloom cast by the military stalemate in the mid-Atlantic states and the discovery of General Benedict Arnold's treasonous plot to help the British take West Point. Virginia's outpost, Kentucky, had been ravaged in raids by Native Americans, and the Kentuckians were eager to strike the British posts northwest of the Ohio River. George Rogers Clark led American troops against Kaskaskia and Vincennes (1778–1779) and broke British power in that area. Supplies sent to Clark from Spanish New Orleans permitted him these victories.

Native Americans and the Revolution

In 1775, the Second Continental Congress sent an address to all Native American tribes noting that the conflict was a quarrel between family members, and that they should not become involved. The Oneida became one of the few tribes to support the Americans. Most tribes, however, were not easily deceived and many of these allied with the British against the colonials because of many grievances related to decades of frontier expansion. One such tribe, the Cherokees, led by Chief Dragging Canoe, attacked colonial settlements in the Virginia and Carolina backcountry. Additional raids against the American rebels also occurred in the Ohio valley and along the Mississippi. The Chickasaw, led by a chief with the English name James Colbert, attacked various rebel posts, including Fort Jefferson in present-day Kentucky. Joseph Brant, a Mohawk chief, became perhaps the best known Native American ally of the British during the Revolution. His warriors fought at the Battle of Oriskany in 1777.

Women and the Revolution

Many colonial women assumed traditionally male duties during the revolt, especially as their fathers, brothers, and husbands left home for war service. Abigail Smith Adams, wife of the Massachusetts leader

John Adams, proved to be the best known of them to history, largely because of the terms of partnership manifested in their marriage. Abigail and John engaged in an extensive correspondence while he served at the Continental Congress, and she maintained their farm at Quincy. She wrote to him in a famous March, 1776 letter: "In the new Code of Laws which I suppose it will be necessary to make, I desire you would Remember the Ladies."

Thousands of women took very active roles in the revolt as they supported the American and British armies as cooks, laundresses, and seamstresses. Historical records indicate that some of them even fought alongside men in battle, although such instances were rare. One of the most celebrated of these female soldiers was Deborah Sampson, who enlisted using a man's name, in order to join the army. She served for over three years and was twice wounded before her ruse was discovered. Other women provided valuable service as spies. Lydia Barrington Darragh monitored British activities at Philadelphia and passed through the battle lines several times in order to bring intelligence to General Washington.

The War in the South

Expecting support from the loyalists of the Carolinas and Georgia, the British captured Savannah (December 1778), occupied Charleston (May 1780), and soon after won a brilliant victory under Lord Cornwallis at Camden, South Carolina. Although they managed to hold the seaport towns in the Carolinas, they failed to maintain control of the countryside and could not subdue the guerrilla leaders Francis Marion, Thomas Sumter, and Andrew Pickens. After a decisive defeat by Carolina frontiersmen at King's Mountain (North Carolina) and a few costly victories, the British commander Lord Cornwallis withdrew north to receive supplies and reinforcements.

Yorktown

When Cornwallis took up a position at Yorktown on the James River, in Virginia, Washington organized a bold attempt to entrap him. Late in the summer of 1781, Washington and the Comte de Rochambeau, commanding newly arrived French troops, marched southward and joined forces under the command of the Marquis de Lafayette in Virginia. Additional troops were deployed by a French fleet under the command of the Comte de Grasse, who closed the trap by sealing off the Chesapeake Bay. On October 19, 1781, Cornwallis was compelled to surrender his army of 7,000. British troops remained in control of the port cities of New York, Savannah, and Charleston, but launched no new offensives.

The Peace of Paris (1783)

Pressed by enemies in Europe, Britain was eager to make peace with its American colonies, initially on terms of a restoration of imperial relations as they had existed before 1763. An extended period of diplomatic negotiation and intrigue ensued in which the various belligerents explored several solutions. American representatives in Paris (Benjamin Franklin, John Adams, and John Jay) were instructed by the Congress to insist on the recognition of the independence of the United States.

The Treaty with Great Britain

In the final version of the treaty, signed September 3, 1783, Great Britain recognized the independence of the United States and its claim to the territory westward to the Mississippi and from the Canadian

border to Florida (which was returned to Spain by a separate treaty). The Americans were confirmed in their fishing privileges off Newfoundland and adjacent territories; their efforts to obtain Canada, however, went unrewarded. From the United States, the British government secured pledges that:

- No legal impediments would be placed in the way of British creditors seeking to collect sums owed by American debtors
- Congress would urge the states to restore to the loyalists their confiscated property
- Navigation of the Mississippi from source to mouth would be open to subjects of Great Britain and the United States

Social Effects of the Revolution

The Revolution had its origins in political protest but also fed on tensions within the colonial societies. It generated social and economic as well as political changes but worked no great upheaval in the structure of American society as the French Revolution would effect in the 1790s. Class-related grievances against colonial elites did emerge, but the disputes varied from colony to colony and were frequently geographical (east west, upland, lowland) in nature. Furthermore, the distance from the top of the social ladder to the bottom in America was, by European standards, relatively slight.

The Loyalists

Between one-fifth and one-third of the inhabitants of the American colonies actively worked for or favored the British cause. It is difficult to generalize about their economic and social backgrounds, but their numbers included well-to-do imperial officials and agents, most of the Anglican clergy, and merchants and farmers more directly linked to British interests, as well as many Americans of quite modest means. Many of these Tories were city-dwellers, although the isolation of others probably accounted for their loyalty to British rule. Ethnic backgrounds also played a role in determining loyalties: Scottish immigrants, for example, were largely Tory, but the Scots-Irish settlers from Ulster and Northern Ireland were overwhelmingly rebels (or "patriots" after Yorktown).

Exodus of the Loyalists

By using state militia and vigilante groups, the rebel or patriot state governments effectively controlled the countryside and towns. They constantly menaced the Loyalists, imprisoning thousands, tarring and feathering or banishing many others. It is estimated that about 100,000 of them left America voluntarily or fled to Canada or England. Their lands and other property were confiscated and only rarely returned after the war.

The New Social Order

The Revolution itself and the Articles of Confederation formulated by the Continental Congress eliminated the monarchy and its authority from the American states. Because the political aims of the Revolution were eventually embraced by most of the wealthy and powerful in the colonies, and a large proportion of the adult male population held property, revolutionary fervor was directed almost exclusively to the institution of the monarchy and the trappings of royalty and aristocracy, not to economic status. Many

Americans, in fact, openly pursued economic opportunities presented by the cutting of imperial ties and the confiscations of Loyalist properties. Those who made fortunes in privateering, speculation, and profiteering in army contracts during the Revolution were seldom condemned.

Other Effects

Although the rhetoric of liberation and freedom had broad social implications, the revolutionary movement in America made use of such language for specific political rather than general purposes. Patriots might speak and write with passion about Britain's plot to "enslave" them, but the only significant emancipations of the Revolution were made by the British army, which freed captured black slaves, notably in Virginia, in the hope of disrupting the colonists' war effort. Most of these blacks were transported to Britain, where they met with neglect and misery.

■ THIRTEEN STATES

Although the conflict with Great Britain had forced the thirteen colonies into united action, most Americans still regarded themselves as citizens of the particular state in which they lived. Nationalism was to grow slowly.

The State Governments

In May 1776, the Continental Congress recommended that the colonies form new frameworks of government. Their new status as free and independent states, proclaimed by the Declaration, required fundamental adjustments. By the following year, twelve of the states had adopted new constitutions.

A Decade of Constitution-Making

Following colonial rather than British precedents, the new compilations of fundamental laws were in each case written documents. All eliminated the monarchy and established republican governments, deriving the authority to govern from the will of the corporate citizenry as expressed through their elected representatives.

The First State Constitutions

The colonists' grievances against the mother country had a strong impact on the first state constitutions. The separation of legislative, judicial, and executive powers was carefully worked out, leaving little to interpretation—the legislatures were given the greater powers, the executive or governor quite deliberately weakened; in two states, Pennsylvania and Georgia, the executive was eliminated.

Participation in government continued to be confined to male property holders, although by a series of measures, notably the elimination of primogeniture and entail (traditional methods of preventing the division of estates), property ownership was widened. Still, universal suffrage was not enacted. And although eight states eventually incorporated declarations of the "natural rights" of the governed in their constitutions, establishing a precedent that later contributed to the passage of the Bill of Rights, slavery was abolished only in the New England states and in Pennsylvania.

Despite the fact that women played a role in the struggle, notably the writer Mercy Otis Warren and the almost mythical Molly Pitcher, only one state, New Jersey, gave them the right to vote (repealed in 1807). The legal status of married women remained one of complete subordination to their husbands.

The Massachusetts Constitution of 1780

Massachusetts was the last of the states to enact a new constitution, but the document and the convention process that produced it proved to be the most influential. In general, the first state constitutions, written and passed by state legislatures, proved to be inadequate to the practical needs of governing. During the years before the Federal Convention, many states turned to the Massachusetts model, which provided for a bicameral legislature and a governor (directly elected), who was given the power to veto bills passed by the legislature.

The Articles of Confederation

As soon as the colonies decided on independence, the Continental Congress, which served as an intercolonial steering committee for the war, authorized a committee of thirteen to draft articles of more permanent union. The colonies had made tentative ventures toward federation in the New England Confederation, the Albany Congress, and the First and Second Continental Congresses.

Structure of the Confederation Government

The Articles of Confederation provided for a league among sovereign states and reflected deep suspicions of power. Each state had one vote in the federal Congress, and unanimous consent was required to amend the Articles. The Confederation Congress was empowered to borrow money, regulate the currency, establish a postal service, regulate Native American affairs, and settle interstate disputes. It assumed all financial obligations of the Continental Congress.

The weakness of the Confederation became apparent soon after the Articles were ratified. In seeking to prevent concentrations of power, the Continental Congress limited the new national government's capacity to govern. The most serious omissions were the absence of a federal executive and judiciary; and the failure to give Congress power to levy taxes, to regulate foreign and interstate commerce, and to enforce its laws.

Creation of a National Domain

Congress approved the Articles of Confederation in November 1777, but ratification of the instrument was delayed until 1781. Maryland refused to agree to the federal arrangement until the states claiming western lands consented to cede them to the central government. The resolution of this difficult issue removed a significant obstacle to formation of the union.

Western Land Claims. The sea-to-sea colonial charters of six of the states had granted them a theoretically limitless westward extension. When the Revolution wiped out the Proclamation Line of 1763 and the Quebec Act of 1774, some of these states expressed ambitions to extend their authority to the Mississippi. However, a growing awareness of the impracticalities of governing territories of such great extent led Virginia and other landed states to assign their western claims to Congress in 1781; the other states followed, although the last cession was completed only in 1802.

Jefferson's Ordinance of 1784. As soon as the Treaty of Paris had confirmed the title of the United States to the region between the Alleghenies and the Mississippi, the Confederation Congress adopted an ordinance, drafted by Thomas Jefferson, guaranteeing that the territory would be divided into ten new states, each to be admitted into the union as soon as it had a population equal to that of the least populous state in the Confederation. This measure, which also provided universal suffrage for adult white males, was superseded by the ordinance of 1787.

Land Ordinance of 1785. Eager to secure revenue from the public domain, Congress authorized surveys to divide the land northwest of the Ohio River into townships—each township was divided into thirty-six sections of 640 acres to be sold at public auction for a minimum price of $1.00 (hard currency) per acre. One section in each township was set aside for the support of public schools. Demand for parcels remained weak until Congress agreed to take wartime government loan certificates at full face value in payment for the land, a measure that favored speculators but also those veterans and other original holders who had retained the depreciated paper.

The Northwest Ordinance (1787). Responding to requests from the land companies, notably to those of Manasseh Cutler, who had secured a grant of six million acres for his company, Congress assumed a greater degree of control over the government of the Northwest Territory and its inhabitants, revising the previous ordinances. There were to be not less than three nor more than five states carved out of the area northwest of the Ohio River, as soon as 60,000 inhabited the territory. An assembly (to be elected by property holders when 5,000 had settled) was provided for in the interim, but an appointed governor was given a veto over its acts. (The states of Ohio, Indiana, Illinois, Michigan, Wisconsin, and part of Minnesota would be formed from the region, soon referred to as the Old Northwest.) The ordinance banned slavery from the Northwest Territory, made provision for public education, and guaranteed to the settlers civil rights and freedom of religion. The status of the new states to be formed from the territory (as full equals of the original states) was also specified.

The western region below the Ohio River was never organized in such a systematic way. There the process of settlement was uneven and confused by conflicting speculative claims of competing land companies and endless lawsuits. The populations of Kentucky and Tennessee grew dramatically during and immediately after the Revolution.

Uncertainty in Foreign Affairs

The American government under the Articles of Confederation was ineffective in dealing with foreign nations. Restrictions placed on Congress's powers led foreign diplomats to believe that Britain's former colonies now constituted thirteen states rather than one nation.

Hostility of Great Britain

The British government, citing the failure of Americans to indemnify the Loyalists and to pay the debts owed to British merchants, refused to withdraw British forces and abandon its fur trading posts along the southern shores of the Great Lakes (which it had pledged to do in the treaty of 1783). Britain refused to open her West Indian ports to American ships and declined to send a diplomatic representative to the United States until 1791.

Spain's Western Intrigues

From their colony in Florida, the Spanish made attempts to gain the loyalties of American frontiersmen and settlers of the interior. Because Spain held the mouth of the Mississippi and thus controlled the principal highway and lifeline of American settlers of the interior, its intrigues posed a serious threat to the new nation. John Jay, as Secretary of Foreign Affairs, tried to settle these difficulties in negotiation with the Spanish diplomat Diego de Gardoqui. The agreement they reached in 1786 would have required the United States to relinquish claims to navigation on the Mississippi in return for commercial privileges. Congress rejected these terms, and settlers in Kentucky and Tennessee threatened either to leave the union or to wage war on the Spanish.

Gardoqui granted liberal permission for settlers from the United States to found communities in Spanish territory if these new inhabitants agreed to take a loyalty oath to the King of Spain. Many settlers did so, including Moses Austin and George Morgan. They, and others who took the oath, founded settlements in Spanish Missouri and Louisiana in the 1780s and 1790s. In some ways, these English-speaking communities planted seeds that came to fruition in the Louisiana Purchase.

Economic Disruption

The artificial prosperity of the war years disappeared within a year of the treaty of peace. The first years of American independence brought severe economic problems caused by a postwar deflation, increasing national debt, and the changes in commerce and business brought about by the loss of economic participation within the British colonial system.

Government Finances

Lacking the power of taxation, Congress had to rely upon requisitions, which the state governments frequently failed to meet. The national debt steadily increased, as soldiers and foreign creditors went unpaid. The credit of the American government was so poor that loans required to meet its operating expenses could be obtained only with great difficulty and at exorbitant interest rates. Two attempts (in 1781 and 1785) to keep the government solvent by means of a national impost or tax on imports were defeated. Congress's efforts to gain the help of the states in retiring largely devalued Continental paper money issued during the war were unsuccessful; the individual states further compounded the currency problem by issuing paper money of their own.

Impediments to Economic Recovery

Lack of a uniform national currency severely hindered economic transactions. Specie (hard currency) was scarce and made up of a bewildering variety of coins. Heavy importation of European goods immediately after the war drained hard currency from the country. The means of replenishing it were lacking, because Great Britain barred American ships and many American products from its ports in the West Indies and in Europe. (Spain and France also closed their West Indian islands to American ships.) Paper money was uncertain in value and easily counterfeited. Tariff barriers between the states discouraged trade.

With economic depression came a fall in prices and a rise in the value of scarce hard money. Debtors found it increasingly difficult to secure funds with which to pay interest, settle mortgages, or meet tax assessments, and they pressed for the issue of paper money for these purposes.

In 1786, a group of disgruntled Massachusetts debtors, led by former Continental Army officer Daniel Shays, organized to prevent the courts from issuing judgments against debtors, collecting debts, and conducting foreclosure proceedings. Shays' band of farmers and veterans was quickly suppressed, but the incident dramatized the dangers of weak and unstable government and convinced many that drastic changes were required to preserve the republican experiment.

Americans achieved their independence as reluctant revolutionaries. They had resisted and protested a series of taxes and imperial regulations and taken up arms as their last available means to stop what they believed to be London's calculated usurpation of their liberties. In protest and in arms, they invoked their inherited rights as Englishmen rather than a new standard of rights and citizenship. Victory could be savored only temporarily. Its fruits proved to be bitter by everyday standards, as depression set in after the war had ended. The first independent state governments and the national confederacy created by the Articles of Confederation proved incapable of dealing effectively with post-war problems. These governments, largely deprived of executive power and authority, reflected the former colonists' belief that an oppressive and distant central government had been the source of their troubles. After the war, Americans found that by depriving their governments of the powers to govern effectively, they had also restricted their ability to carry out the people's will.

The sacrifices of war and pride in victory contributed to a new sense of nationalism, but the experience had not yet created a nation. However, the frustrations and disappointments that emerged during what has been called the Critical Period of American history, 1781–1787, did produce a growing recognition of the importance of union to the survival of the republican experiment and a sense of urgency among those who wished to strengthen it.

Selected Readings

Bailyn, Bernard, ed. *Pamphlets of the American Revolution, 1750–1776* (1965).

Calhoon, Robert M. *The Loyalists in Revolutionary America* (1973).

Cummins, Light Townsend. *Spanish Observers and the American Revolution* (1992).

Ellis, Joseph. *Founding Brothers* (2000).

Ferguson, E. James. *The Power of the Purse: A History of American Public Finance, 1776–1790* (1961).

Fischer, David Hackett. *Washington's Crossing* (2004).

Fiske, John M. *The Critical Period of American History, 1783–1789* (1883).

Foner, Eric. *Tom Paine and Revolutionary America* (1976).

Freeman, Douglas Southall. *George Washington* (7 vols. 1948–1957).

Higginbotham, Don. *The War of American Independence* (1971).

Isaacson, Walter. *Benjamin Franklin* (2003).

Jensen, Merrill. *The Founding of a Nation: A History of the American Revolution, 1763–1789* (1968).

Ketchum, Richard M. *Victory at Yorktown: The Campaign that Won the Revolution* (2004).

Main, Jackson Turner. *The Sovereign States, 1775–1783* (1973).

McCullough, David. *John Adams* (2001). *1776* (2005).

Middlekauff, Robert. *The Glorious Cause: The American Revolution, 1763–1789* 2nd Ed. (2005).

Morris, Richard B. *The Peacemakers: The Great Powers and American Independence* (1965).

Nash, Gary B. *The Unknown Revolution: The Unruly Birth of Democracy and the Struggle to Create America* (2005).

Norton, Mary Beth. *Liberty's Daughters: The Revolutionary Experience of American Women, 1775–1800* (1980).

Raphael, Ray. *A People's History of the American Revolution: How Common People Shaped the Right for Independence* (2001).

Patterson, Benton Raid. *Washington and Cornwallis: The Battle for America, 1775–1783* (2004).

Quarles, Benjamin. *The Negro and the American Revolution* (1961).

Shy, John. *A People Numerous and Armed: Reflections on the Military Struggle for American Independence* (1976).

Wood, Gordon S. *The American Revolution: A History* (2002).

Wilson, David K. *The Southern Strategy: Britain's Conquest of South Carolina and Georgia, 1775–1780* (2005).

Test Yourself

1) Which of the following was not a reason why the Second Continental Congress delayed declaring independence for over a year after the start of the Revolution?
 a) The colonists had strong sentimental, cultural, and language ties to Britain.
 b) The colonists feared that anarchy or despotism might result from independence.
 c) Colonial leaders hoped that a change in British ministries and cabinet leadership might end the fighting.
 d) Wealthy colonists feared that British authorities would seize their bank accounts and other assets located in England.

2) True or false: Richard Henry Lee of Virginia was the author of the document passed by the Continental Congress that made the United States of America an independent nation in July of 1776.

3) The American commander who conquered the British territories in the west, including Kaskaskia, Vincennes, and the Ohio and upper Mississippi River valleys was
 a) Henry Hamilton
 b) George Rogers Clark
 c) Francis Marion
 d) Andrew Pickens

4) Which of the following was a major weakness of the government created by the Articles of Confederation?
 a) The government had limited diplomatic powers.
 b) The government lacked national judicial and executive branches.
 c) There was no national money or currency.
 d) The government had no ownership of western land.

5) The official Congressional Agent at New Orleans who shipped large amounts of supplies to the Continental Army and who invented the dollar sign as the symbol of U.S. currency was
 a) James Willing
 b) Nathaniel Green
 c) Oliver Pollock
 d) Horatio Gates

6) France decided to negotiate the Treaty of Alliance of 1778 with American envoy Benjamin Franklin in Paris when the French government heard news of
 a) the determination of Washington's army to survive the hardships of Valley Forge
 b) the American victory at the Battle of Saratoga
 c) the British capture of Philadelphia
 d) the pressing need the Continental Army had for supplies and munitions

7) Which of the following states adopted a Constitution that, although one of the last enacted during the Revolution, later served as a model for many others, because it provided for a bicameral legislature and a directly elected governor?
 a) Virginia
 b) New York
 c) South Carolina
 d) Massachusetts

8) American diplomat John Jay unsuccessfully attempted to negotiate a 1786 treaty with Spain and its representative, Diego de Gardoqui, for the purpose of
 a) settling war debts owed to Spain by the American Congress occasioned by supplies sent to the Continental Army during the Revolution
 b) giving control of the upper Mississippi valley around St. Louis to Spain
 c) not having the United States renounce its right of free navigation on the Mississippi in return for commercial privileges
 d) none of the above

9) Shays' Rebellion of 1786 occurred because of frontier unrest caused by
 a) high land prices in Massachusetts
 b) inability of the Massachusetts government to pay bonuses to Revolutionary war veterans
 c) the desire of farmers to prevent Massachusetts State courts from issuing judgments against debtors and from conducting foreclosure proceedings
 d) all of the above

10) True or false: Parliament's Restraining Act of 1775 sought to control New England trade and punish that region by prohibiting its trade with Great Britain and the British West Indies.

Test Yourself Answers

1) **d.** Although Great Britain never threatened the assets of colonial leaders, most of them were prepared to commit their own assets to the colonial cause. In all other matters, colonial leaders did manifest various opinions that slowed their decision to seek independence. They had a strong cultural attachment to England, feared anarchy that might result from independence, and hoped that a change in the British political leadership might end the fighting of the American Revolution during its early stages.

2) **True.** Richard Henry Lee wrote the Article of Independence. The Declaration of Independence, authored primarily by Thomas Jefferson, was passed by the Congress two days later. The latter did not explicitly provide for independence, but instead explained why such has been declared. The Articles of Independence were adopted by Congress on July's 2, 1776. Two days later, the Congress passed the Declaration of Independence, an open letter to the world that fired the imaginations of many people who read it. For that reason, the Declaration has remained one of the enduring documents of United States history.

3) **b.** George Rogers Clark conquered the territories of the Ohio and Mississippi River valleys for the young republic. He is known as the Conqueror of the West. Henry Hamilton was the British commander whom Clark defeated. Andrew Pickens and Francis Marion were South Carolina rebel leaders.

4) **b.** The Confederation government had no executive or judicial branches. Under the Confederation, all governmental activities rested in the Congress. Many of the powers of government were reserved to the respective states, and were not fully enjoyed by the national government under the Confederation. The national government did have control over the money supply of the country, enjoyed limited diplomatic powers, and did hold title to the unsettled lands in the West.

5) **c.** Oliver Pollock served as the agent of the United States at New Orleans, which belonged to Spain during the era of the American Revolution. He was assisted, at times in these efforts, by Captain James Willing, who led an expert addition against British forts in nearby West Florida. Nathaniel Greene and Horatio Gates, however, were both colonial generals. Gates commanded American forces at the Battle of Saratoga. Greene commanded rebel forces in the Carolinas.

6) **b.** The French had been awaiting news of a rebel victory that might show that the colonies were militarily viable. French ministers in Paris worried during 1775 and 1776 that Great Britain might defeat the rebel colonies. Should France have allied with the Americans and that happened, the full force of the British military machine would then have been turned against France. The American victory at Saratoga convinced the French

that the infant United States had a real possibility of winning the war. Saratoga, therefore, caused the French Foreign Minister to negotiate an alliance with the Continental Congress.

7) **d.** The Massachusetts state constitution became a model for many of the other state constitutions written during the revolt, in spite of the fact that New Hampshire was the first state to enact a constitution in April of 1776) Indeed, by the time of the drafting of the Articles of Confederation, most of the states had their own constitutions.

8) **a.** John Jay had two major motivations in his negotiations for a treaty with Spain: (1) to settle war debts owed by the United States to the Spanish, and (2) for the United States to gain control of the area around St. Louis. He was willing to renounce free navigation of the lower Mississippi River by United States citizens in return for commercial privileges. Many Americans in the west wanted free navigation of the Mississippi River.

9) **d.** This rebellion in western Massachusetts occurred because of all of the reasons noted in this question. Daniel Shays, a leader among the farmers in that region, and his followers had a number of grievances. They wanted to Revolutionary War service bonuses, a lowering of high land prices in the state, an end to foreclosure proceedings in the Massachusetts for nonpayment of debts.

10) **False.** The Restraining Act provided for the opposite, as they attempted to restrict trade only to ports in Great Britain and the British West Indies. The British government hoped that restricting trade and commerce in this manner would be economically beneficial to the colonies. That was not the case.

Framing and Implementing the Constitution

1787: Constitutional Convention gathers in May, document adopted and published in September; first number of *The Federalist Papers* appears in New York newspapers (running to April 1788)

1787–1788: Ten states ratify the Constitution; ratifications by Virginia and New York (June, July 1788) were considered crucial

1788: *The Federalist Papers* issued in book form (March–May)

1789: First election for president under the Constitution (January–February); first federal Congress meets (March 4); outbreak of the French Revolution (July); Bill of Rights passed (September), from which first ten amendments ratified (December 1791); passage of Judiciary Act of 1789 (September); North Carolina is twelfth state to ratify the Constitution (November)

1790: Rhode Island ratifies the Constitution (May); Hamilton's plan for disposing of national and state debts approved (July); national capital fixed at Potomac River site from 1800, at Philadelphia until then (July)

1791: Congress legislates the Bank of the United States, the president signs bill (February); Congress passes whiskey tax (March); Vermont admitted to statehood in the union

1792: President Washington reelected unanimously (December); design competitions for the capitol and president's house held; Kentucky admitted to statehood in the union

1793: President Washington announces the Proclamation of Neutrality (April); Jefferson resigns as Secretary of State (December)

1794: Whiskey Rebellion in western Pennsylvania rises and is suppressed (July–November); Jay treaty signed (November)

(continued on next page)

1795: Hamilton resigns as Secretary of Treasury (January); terms of Jay treaty made public in March, resulting in political turmoil; Pinckney's treaty with Spain is signed (October)

1796: Washington's Farewell Address (September); John Adams elected to succeed Washington, defeating Jefferson, the new vice-president (December); Tennessee admitted to statehood in the union

1797: Episode of the "XYZ Affair" in France (October)

1798: News of "XYZ" is made public in April and embroils the nation; establishment of Navy Department (May); Congress passes the Alien and Sedition Acts (June–July); Congress repeals treaties with France (July); Kentucky and Virginia resolutions passed (November–December; second set of Kentucky Resolutions issued November 1799)

1798–1800: Incidents in the Quasi War with France

1799: Death of George Washington at Mount Vernon (December)

1800: Convention of 1800 (Treaty of Mortefontaine) signed with France (September; ratified December); presidential election results in large popular victories for Jefferson in a sufficient number of states to win in the Electoral College (December)

The struggle to thwart, circumvent, and defeat the colonial policy of the British government in the years 1763–1776 had guided the American lawmakers in drafting the Articles of Confederation and the first state constitutions. The objective of these documents had been to keep decisions in the hands of the people and to diffuse power so as to prevent its concentration in a central authority. In practice, most of the new governments were quickly revealed to be poorly designed instruments for the new demands of self-government.

In the first years of independence, government under the Articles of Confederation and the first state constitutions proved incapable of dealing with sizeable postwar problems. A growing sense of crisis contributed to a broad movement led by advocates of reform in the individual states who projected a bold nationalist vision of the future. By means of intelligence, persuasion, and clever maneuver, these nationalists succeeded in gaining popular support for a new constitutional order, which introduced a far stronger central government to the federal system. The emergence of two distinct models for the nation's growth and development sharpened political differences over the proper powers of the national and the state governments. The wars that raged in Europe, although distant, continued to menace the new nation.

■ THE GRAND CONVENTION

The political, economic, and diplomatic difficulties of the first critical years of independence contributed to the strength of a growing movement to place the national government on an entirely new basis. The refusal of the state legislatures to approve amendments designed to give Congress larger powers over national commerce and finance demonstrated the weaknesses of the postwar union and made it clear that the Articles of Confederation would have to be revised if the American people were intent on forming a new nation.

Weaknesses of the Confederation

Even before Shays' Rebellion in 1786, which gave dramatic emphasis to the consequences of weak government, there was clear evidence that the relationship between the thirteen states and the Congress was flawed. The dissenting vote of a single state had prevented the national government from raising adequate revenue to deal with the national debt. The individual states continued to have their own legal tender—several issued paper money, knowing it was valueless. Lack of adequate checks on the power of state legislatures encouraged majorities to overlook or ignore minority interests.

The powerlessness of government contributed to a growing sense of crisis. In March 1783, when discontent among officers of the Continental Army encamped at Newburgh, New York, began to take a conspiratorial tone, General Washington had to intervene personally. The following year, Spain indicated it would ignore the boundary between the United States and Spanish Florida set down in the Treaty of Paris. With the clear intention of alienating western settlers from the United States, the Spanish government announced that Americans would no longer have access to the lower Mississippi River. The political instability contributed to the postwar economic depression, which deepened through the end of 1786.

Coalition of Interests for Change

The desire for reform was strong not only among those who feared the consequences of social disorder but also among groups that depended on stable government policy or who required a uniform standard, such as a single national currency, to conduct their businesses or gain their living. These included

- Holders of government securities
- Army veterans seeking back pay and the funding of their pensions
- Manufacturers advocating protective tariffs to allow them to dominate the home market
- Merchants with interstate or international business, who required an intelligible and credible financial order
- Creditors who wanted debts repaid at face value or better
- Investors and financiers, in fear of the inflationary schemes of state legislatures
- Settlers and land speculators, who wanted the government to suppress Native American hostilities on the frontier and open western lands to settlement

The Campaign for a New Fundamental Law

By the mid-1780s, many prominent Americans desired changes in the functioning and structure of the national government as embodied in the Articles of Confederation. Some wanted to amend the existing document, while others began to consider replacing it with a new constitution.

Preliminary Conferences

In March 1785, committees from the Maryland and Virginia legislatures met at George Washington's Mount Vernon estate to discuss navigation of the Potomac River and the Chesapeake Bay. They decided to invite all the states to confer on commercial problems of the Confederation. The Annapolis (Maryland) Conference held in September 1786 was attended by delegates from five states, who adopted a report by Alexander Hamilton calling for a convention of all the states to meet in Philadelphia in May 1787, to "render the constitution of the Federal government adequate" to the needs of the union. The Confederation Congress endorsed this call, which, following the example of the

Massachusetts Constitution of 1780 was made directly to the people (requesting them to send delegates) rather than to the state legislatures or other established bodies.

The Constitutional Convention

The fifty-five men who attended the meetings at Philadelphia in the summer of 1787, the lawgivers or framers of the American Constitution, formed a remarkable assembly. They were mostly practical men of affairs who had been active in the patriot cause: merchants, lawyers, planters, farmers. Although many delegates were familiar with the ideas of political philosophers such as John Locke and the Baron de Montesquieu, and some had read more deeply in political theory, most shared the view of John Dickinson of Delaware, a lawyer and respected political thinker, who remarked during the deliberations, "Experience must be our only guide. Reason may mislead us."

Leadership of the Convention. The delegates to the *Grand Convention* were all prominent figures in their home states. Benjamin Franklin was preeminent among them in age (eighty-one), fame, and knowledge of the old, European world. Many had held offices in their respective states, but only a few, notably Franklin and John Jay, possessed diplomatic experience. Hamilton brought exceptional ability in financial matters; James Madison, extensive study of ancient and modern governments. Others contributed legal knowledge and experience in drafting legislation, notably James Wilson of Pennsylvania and George Mason of Virginia (the latter of whom who would not sign the final document). George Washington presided over the sessions, which by agreement were conducted in secrecy, without official record. Conspicuously absent were the more-radical revolutionary leaders Thomas Paine, Patrick Henry, and Samuel Adams, as well as Thomas Jefferson, then minister to France, and John Adams, minister to Britain. James Madison played a significant role and is, therefore, sometimes called the Father of the Constitution.

Plans for Reconstituting Government. A consensus quickly emerged in the convention on the need to strengthen the central government, but not on the means by which this should be accomplished. The delegates agreed, however, that a new government had to be given adequate powers to levy taxes, regulate commerce, protect private property, pay the national debt, coin and borrow money, and provide for the national defense. All agreed that the Articles of Confederation were beyond salvage by amendment.

Two major plans were presented. The first, upon which most of the discussions proceeded, was submitted by Virginia, then the largest of the states in area and population. It called for a new "national government" composed of "a supreme Legislative, Executive, and Judiciary," and proposed that population determine representation. The smaller states countered with the New Jersey Plan, which called for a federal government with a single-house legislature—in effect a proposal to strengthen the existing Articles of Confederation.

Resolution by Compromise. Differences on questions of representation were particularly difficult to resolve, owing to the problem of how to count slaves in the slave states. A sense of the urgency as well as of the importance of their work made it possible for the delegates to reach compromises.

The convention eventually accepted a proposal, worked out by a grand committee, which became known as the great compromise. The lower house of the national legislature would represent the states according to population; the upper house would be based upon equal representation, with two members

for each state. In calculating population, each slave would be counted as three-fifths of a person. Other compromises were made on matters relating to slavery in order to retain the support of the southern states—for example, the new government was prohibited from levying taxes on exports and from making any restrictions on the slave trade for twenty years.

The Constitution

The delegates at Philadelphia concluded their secret deliberations on September 17, 1787, and promptly published the completed document, the first words of which declared a new basis for the fundamental law of the nation. "We the People of the United States do ordain and establish this Constitution for the United States of America." The Preamble, modeled after the opening sentence of the Massachusetts Constitution of 1780, clearly stated that the new fundamental law derived from the authority of the people themselves. The Articles of Confederation had been the creation of the individual states.

The Structure of Government

As James Madison, its principal architect, would observe, the new Constitution established a political system that was a composition of national and federal government. The new federal system accommodated the thirteen state governments, derived from the colonial tradition, while establishing new bodies and powers designed to deal with national questions. The national government created by the union of states stood above the state governments in specified national matters, while it acknowledged the role of the states or shared power with them in others. State officials were required to take an oath to support the Constitution, state courts to recognize the Constitution and the laws and treaties made under it as the supreme law.

The Constitution greatly increased the power of central government but carefully divided its functions into three distinct branches—executive, legislative, and judicial. The principle of separation of powers was applied throughout the document. Carefully measured checks and balances were inserted to prevent usurpation or concentration of power in any one branch and for the purpose of protecting minority rights from the potential tyranny of the majority. In their powers to amend the Constitution and to elect the president and members of the Senate, the states also gained a role in applying checks and balances.

The chief executive, the president, who would be chosen by a college of electors in such fashion as the legislatures of the states would direct, was designated commander-in-chief of the armed forces and given the veto over legislation and the power of appointment.

The national legislature, the Congress, was to consist of two houses: the lower house, the House of Representatives, to be elected directly by popular vote; the upper house, the Senate, composed of two senators from each state, to be chosen by the state legislatures. Congress was given the powers to tax, to regulate interstate and foreign commerce, to control the army and navy, and to oversee foreign relations.

The judiciary was to consist of a Supreme Court and such lower courts as Congress might create, the judges appointed for life by the President, with the consent of the Senate. The House was assigned the power to impeach the president and members of the judiciary; the Senate the role of trying and judging such charges.

The Campaign for Ratification

Because most of the delegates had come to the convention with instructions to amend the Articles of Confederation, there was immediate and sharp reaction to the decision to draft a new Constitution (which only thirty-eight of the designated fifty-five delegates had, in fact, signed). An intense campaign was

required in several states to secure its ratification. By calling for special conventions in the states to ratify the document, the framers were able to avoid the amendment process specified in the Articles of Confederation, which required unanimous approval of the thirteen states through their legislatures. They gained important rhetorical advantage in the contest by calling themselves the true Federalists (or supporters of a federal system of national and state governments) and casting defenders of the status quo system as the anti-Federalists. The fact that they avoided representing themselves as nationalists, which, in fact, they were, suggests that they perceived public opinion to be a formidable obstacle to the changes they proposed.

Criticism of the Constitution

Critics and opponents believed that the Constitution concentrated too much power in the central government and suggested it would ease the way to despotism. They identified a retreat from the principles of the Revolution, citing that

- The document had been drafted in secret, by representatives of a propertied elite class.
- The delegates had gone beyond their powers in writing a new framework of government.
- The states would be reduced to dependent provinces.
- The document contained no "bill of rights" to protect the citizen against tyranny.
- The rights of property and not the rights of man were emphasized in the Constitution.

Strengths of the Federalists

The Federalists were able to mobilize powerful forces in the struggle for ratification. They enlisted most of the business and financial interests, the professional classes, and many influential newspaper editors. They had money, they were well organized, and they counted among their numbers many of the most prominent men in the country, most notably Washington and Franklin.

The Federalist Papers

Under the pen name Publius, Alexander Hamilton, James Madison, and John Jay wrote eighty-five essays that appeared in New York City newspapers during the debate over ratification in that crucial state. These essays were written with an immediate purpose, to persuade contemporaries to support the new Constitution and to allay fears raised by the Antifederalists—but were soon acknowledged to be classic works in western political thought.

Of particular importance was *The Federalist No. 10,* written by Madison, which dealt with the argument that republican (or representative) government could survive only in small geographic areas. It was generally believed that the ancient Roman republic had declined as the Roman Empire expanded; the more sophisticated reading public knew the works of the influential French writer the Baron de Montesquieu (1689–1755), who had demonstrated the tendency of central power to become more despotic as the distance between the rulers and the people grew. Madison effectively countered the conventional view. "The smaller the society, the fewer probably will be distinct parties and interests composing it and the smaller the compass within which they are placed, the more easily will they concert and execute their plans of oppression. Extend the sphere," he argued, "and you take in a greater variety of parties and interests; you make it less probable that a majority of the whole will have a common motive to invade the rights of other citizens; or if such a common motive exists, it will be more difficult for all who feel it to discover their own strength, and to act in unison with each other."

Ratification

The contest over ratification in the thirteen states was prolonged and often bitter. The lines of debate, however, were not clearly drawn, and local and regional factors were significant. Support for the new Constitution came from those whose work and interests were tied to the commercial life of the country; those more in control of their circumstances, such as farmers who had few commercial contacts, tended to oppose a change in the status quo. Residents of the small states, feeling their interests could only gain by the strengthening of the national government, were overwhelmingly in favor.

Delaware, New Jersey, Georgia (all by unanimous votes), and Connecticut promptly ratified the Constitution by January 1788, and victories for the Federalists in Maryland (April) and South Carolina (May) were also decisive. But in Pennsylvania, Massachusetts, Virginia, and New York, the margins were narrower and the contests tough and often bitter. Although nine states (sufficient to implement the Constitution) had ratified by June 1788, it was not certain that there would be a new government until the next month, when both Virginia and New York had ratified. North Carolina and Rhode Island had not decided when Washington took the oath of office on April 30, 1789 (they ratified, respectively, in November 1789 and May 1790).

■ ESTABLISHING AUTHORITY AND PRECEDENTS: THE WASHINGTON ADMINISTRATION

The Constitution provided a framework and outline for the executive, legislative, and judicial branches but no specific instructions for setting up the new government. It was left to the first officeholders to interpret the terse language of the Constitution and to set precedents.

The First Federal Congress

The first Congress to serve under the Constitution was elected in early 1789 and convened in September of that year. The members of the new Senate and the House of Representatives completed the work of the Constitutional Convention—filling in the framework of the federal government and setting it in motion. Members quickly passed legislation to establish departments within the executive branch, to create federal courts, and to raise revenues.

Having decided to secure most of its revenues through customs duties, Congress passed the Tariff Act of 1789, which placed a five percent duty on all imports. It then created the executive departments of state, treasury, and war and other administrative offices. In passing the Judiciary Act, it established the Supreme Court (with six justices) and federal circuit and district courts. The act also assigned the Supreme Court the authority to determine questions concerning the constitutionality of state laws. John Jay was appointed first chief justice of the Supreme Court.

The Bill of Rights

From the more than one hundred proposed amendments to the Constitution urged by the state conventions, the first Congress, following Madison's recommendations, approved and referred twelve to the states for ratification in September 1789. Ten of these amendments, which became known as the Bill of Rights, had been ratified by 1792. The first nine protected the citizen against the possibility of tyranny or

infringement of civil rights by the federal government. By declaring that powers "not delegated to the United States by the Constitution, nor prohibited by it to the States" were reserved to the states or the people, the Tenth Amendment further emphasized the federal nature of the document.

Washington as President

George Washington, the hero of the American Revolution, was elected the first president of the United States by a unanimous vote of the Electoral College. His role was the most controversial in the new government and his actions and demeanor had much to do with establishing the tradition of a strong and independent executive branch in America. Some proposed titles such as "His Elective Majesty" for the president and compared him to a king. Washington discouraged such talk while carefully establishing the authority of the presidency. He succeeded in this by merging his personal dignity with his public role as chief magistrate and by making effective use of formal ceremony.

The President's Cabinet

President Washington named Thomas Jefferson the Secretary of State, Alexander Hamilton the Secretary of the Treasury, and Henry Knox the Secretary of War. For his legal adviser, he chose Edmund Randolph, making him Attorney General. These four executive officers supervised departmental offices that, with the General Post Office, were run by only 130 employees in 1801.

During the course of his first term in the presidency, Washington gradually came to rely on private meetings with the four executive officers in cabinet, or behind doors, to gain advice on policy and legislation. In August 1789, he visited the Senate to ask its advice and consent on matters pertaining to a treaty that was being negotiated with the southern Native Americans. But after the Senate responded with hesitation and offered its own suggestions, in his opinion going beyond the legislative to infringe on executive power, he made a practice of communicating with that body only in a more formal way, after obtaining advice from within the executive. Thereafter, he sought the advice and consent of the Senate only by written messages.

Hamilton's Financial Plan

The financial chaos that confronted the new government posed a serious challenge to the credibility, and even the survival, of the republic. The reports and legislation that Alexander Hamilton prepared for Congress sought to bring order to the nation's finances but were also intended to establish the supremacy of the new national government over the states.

The brilliant Hamilton, who had served as General Washington's personal aide and secretary during the Revolutionary War, was a political realist who viewed the world from a commercial perspective. Born on the sugar island of Nevis, in the British Windward Islands, he had grown up under difficult circumstances on St. Croix, in the Danish Virgin Islands. As a boy and young man, he had worked as a clerk in the store of a St. Croix merchant (providing for himself from the age of twelve); with the help of friends he had been sent to study at King's College (Columbia University) in New York at the age of seventeen.

Hamilton wrote two important reports that set forth his beliefs and a plan of legislative action. He believed the republic could survive and prosper in its infancy only by enlisting the support of the wealthy—the merchants, capitalists, and investors—and harnessing their interests to those of the national

government. Similarly he thought it folly for the young republic to challenge British economic and military supremacy, whatever the provocation. Like most Federalists (and many Republicans), he believed that pure democracy would lead to mob rule. He looked to the "mixed government" of the British constitution, at least in theory a perfect balance of democratic (House of Commons), aristocratic (House of Lords), and monarchical (king or queen) elements, for useful models.

The National Debt

In his first report to Congress, Secretary Hamilton estimated that the national debt was $54 million, that of the states some $25 million. He proposed to fund the national debt, incurred during the Revolution and the Confederation period, by paying the full face value of all federal obligations, those held by foreigners as well as by citizens of the United States. This was judged unfair by many, especially Revolutionary War veterans, who had been forced to sell the paper money or certificates the Congress had issued (often their pay to speculators) at large discounts. Hamilton argued that it was more important for the new government to gain financial credibility abroad and to signal its good faith to investors, so that they would be encouraged to keep or put their money in the United States.

Hamilton also persuaded Congress to assume payment of the debts of the several states, on the ground that such indebtedness had been incurred chiefly during the Revolution by colonies fighting in a common cause. Although those states that had paid back most of their debt (notably Virginia) objected, Hamilton stressed that this measure would establish the supremacy of the national government in finance and further strengthen the new nation's credibility.

Congressional opposition to Hamilton's proposals was led by the influential Madison. The assumption and funding measures passed the House of Representatives (in July and August 1790) only after extensive debate and much legislative maneuvering. Hamilton's willingness to support a Potomac River site for the new national capital seems to have caused several southern members, as well as Secretary Jefferson, to reluctantly accept the assumption legislation.

Establishing the Bank and the Currency

In his second report to Congress, Hamilton proposed the creation of a national bank empowered to issue a uniform national currency. After a long and sometimes bitter debate, Congress passed the bill chartering the Bank of the United States in February 1791. It authorized the formation of the institution by issue of $10 million in capital stock, a fifth of which was to be purchased by the government, the remainder by the public. The Bank was authorized to issue notes; that is, paper money, backed in part by gold and silver but chiefly by government bonds. Hamilton modeled it on the Bank of England.

Washington hesitated to sign the bill, which Madison and Jefferson strongly opposed. They protested that the Bank would nurture a dangerous monied interest and argued that the Constitution contained no provision to authorize the act and, it was therefore unconstitutional. However, Hamilton's opinion, which relied on a loose rather than a strict construction, or interpretation, of the Constitution, convinced the president to sign the bill. Hamilton argued that by empowering Congress "To make all Laws which shall be necessary and proper for carrying into execution" (article I, section 8 of the document, which included the responsibility for coining money), the Constitution had implied the authority to establish the Bank. Thus was born the constitutional theory of implied powers.

The Protective Tariff

Hamilton's *Report on Manufactures* boldly urged the adoption of a high or protective tariff, well above the level required to raise revenues. Such a measure, he believed, would aid fledgling American industries (by hindering foreign competitors) and thereby stimulate the development of new domestic industries. His goal was the creation of a balanced economy that would strengthen the nation and in time free it from dependency on foreign suppliers for finished goods. The House, again led by Madison (who feared a concentration of power in the national government) rejected this third and most controversial of Hamilton's reports. The Revenue Act of 1792 raised the tariff rates slightly.

Through systematic refunding and payment of the national debt, Hamilton managed to reduce interest charges, thus effecting savings for the government. To secure the income needed to meet expenses, he outlined in detail proposals for

- Customs duties on imports
- Excise taxes on domestic goods, especially distilled liquor
- Procedures for the rapid sale of lands in the national domain

■ THE NEW NATION IN FOREIGN AFFAIRS

The first government under the Constitution faced formidable challenges, from Native Americans in the interior and from the British and Spanish, in asserting its authority over the great extent of its boundaries. Great Britain's hostility to its former colonies further emphasized the fragile condition of American independence. The French Revolution and the ensuing wars in Europe complicated the Washington administration's efforts to establish good relations with the European powers while maintaining American neutrality.

Securing the Nation's Boundaries

On the periphery of the original thirteen states, where settlers confronted attacks by Native Americans and the difficulties of getting their produce to market, loyalty to the union wavered. In Vermont, Kentucky, and Tennessee, there was open talk of separation. Spanish policy in the Mississippi valley encouraged this dissention. To anchor these areas to the union, Congress quickly admitted all three to statehood—Vermont (formed from parts of New York and New Hampshire) in 1791; Kentucky (from Virginia), in 1792; Tennessee (from North Carolina), in 1796.

Military Action on the Frontier

One of the most pressing problems for the Washington administration was to prevent attacks on settlers by Indian tribes. Although some tribes accepted the futility of further resistance, others continued to raid border settlements in their attempt to halt the westward advance of land-hungry white settlers. The president did not hesitate to deploy the U.S. army to frontier areas to make clear the government's intention to secure its boundaries.

The Northwest Territory

From their forts and fur-trading posts along the Great Lakes, the British occasionally incited the many native nations that still inhabited the Northwest Territory against the land-hungry American settlers.

U.S. army regulars and militia under General Arthur St. Clair attempted to establish control of the region south of Lake Erie in 1791, but suffered a humiliating defeat at the hands of Indians. Three years later, General Anthony Wayne, with some 4,000 troops, won a decisive victory in the Battle of Fallen Timbers. In 1795, Wayne persuaded the leading chiefs to sign the Treaty of Greenville, whereby the Indian nations surrendered their claims to most of the area that is now Ohio.

The Southwest Territories

Spanish agents in Florida and Louisiana subsidized attacks on border settlements by Creeks, Cherokees, Chickasaws, and Seminoles. By offering the Creeks favorable terms in the Treaty of New York (1790), President Washington had quieted their Chief Alexander McGillivray (son of a Scottish trader), but the agreement had only a limited effect. The militia of Tennessee managed to check native resistance in 1794, but the probability of new outbreaks of hostilities, encouraged by the Spanish, kept the region unstable. By its reading of the Peace of Paris, 1783, Spain claimed much of the lower Mississippi valley on the east bank to the south of Natchez, and this boundary dispute with the United States made more difficult the maintenance of peace on the southwestern frontier.

The Whiskey Rebellion

Fearing the effects of a new Shays' Rebellion, the president led some 15,000 troops to western Pennsylvania to suppress a farmers' revolt against the excise tax on whiskey. The show of force was criticized when the perpetrators hid and dispersed; it nevertheless signaled the government's intention to assert its authority on the frontier.

American Neutrality

The terms of the Treaty of Alliance (1778) with France provided that the United States would defend the French West Indies in the event of a British attack. However, the Washington administration ignored the provision when a general European war broke out in 1793, after King Louis XVI was executed by French revolutionaries.

Citizen Genét

On the advice of Secretaries Hamilton and Jefferson, the president issued a proclamation that extended official recognition to the new French government but stated that the United States would remain at peace. Ignoring the proclamation, Edmond Genét, newly appointed minister of the French republic, who had landed in Charleston early in April 1793, rashly and openly recruited support for his country. Calling upon the United States to fulfill the terms of its alliance with France, he began to fit out privateers, enlist seamen, and organize military plans before he had presented his credentials to the president. Although President Washington received Genét, the administration demanded his recall. Hamilton defended the administration's policy on the grounds that the alliance of 1778 had been made with the government of Louis XVI, not with the French republic, and that the treaty had not pledged the United States to support France in a war against European monarchies. The Genét Affair worsened political rivalries between Hamilton and Jefferson.

The Neutrality Act (1794)

The president's proclamation had warned United States citizens not to "take part in any hostilities on land or sea with any of the belligerent powers." The Neutrality Act made illegal the activities Genét had engaged in and prohibited Americans from joining the forces of foreign countries.

Jay's Diplomatic Mission

In an attempt to gain a settlement of American grievances against Great Britain and to avoid war, Washington sent John Jay to London. His special mission produced a treaty that achieved a modest degree of success. However, the agreement caused a tumult in American domestic politics and disruption in the new nation's foreign affairs.

British Provocations

Although Great Britain had recognized American independence in the Peace of Paris, its posture toward the United States remained hostile. The British government committed (or allowed to be directed) against Americans several provocative acts, including

- A refusal to evacuate British trading posts in the Northwest Territory, specified in the treaty of 1783
- The encouragement and support for Native American tribes that regularly warred on American settlers
- A failure to open up British ports in the West Indies to American commerce
- Beginning in early 1794, seizures of United States ships trading with the French West Indies
- The boarding of American ships and impressment of American seamen into British naval service

Jay was instructed to obtain British withdrawal from the trading posts and forts, compensation for ship confiscations, a trade agreement, and British acceptance of the United States' neutral rights.

Outcome of the Jay Negotiations

Jay's discussions resulted in a treaty in which the British agreed to surrender the fur posts by June 1796, opened their East Indian ports to the United States, and made some minor concessions in the West Indian trade. No mention, however, was made of the seizure of American ships or the impressment of seamen. The question of debts owed to British creditors by Americans and of American claims for damages to shipping was referred to arbitration commissions.

Reaction to the treaty was violent. Opponents calling themselves true republicans denounced it as a capitulation to the British. In the fight to defeat ratification in the Senate and the necessary appropriation measures (to implement the treaty) in the House of Representatives, their coalition was transformed into a political party (see "The Republican Opposition" section later in this chapter). The administration barely succeeded in getting the Federalist Senate to ratify the agreement and had to go to extraordinary lengths to secure appropriations.

The episode dramatically underscored the new nation's inexperience and uncertainty in foreign affairs. During Jay's negotiations, Secretary Hamilton provided confidential information about the American objectives to British officials; Secretary of State Edmund Randolph (who succeeded Jefferson) and James Monroe, U.S. minister to France, had similar exchanges with French officials in efforts to defeat the treaty.

Pinckney's Treaty

Jay's negotiations in London had a more positive effect on American relations with Spain. Convinced that the United States and Great Britain were drawing closer together, the Spanish government determined to settle differences. In October 1795, Thomas Pinckney negotiated the Treaty of San Lorenzo, whereby Spain recognized the 31st parallel as the boundary of Florida (the U.S. claim), promised that Spanish officials would restrain the Indians from making raids across the borders of the United States, and granted the United States free navigation of the Mississippi, with the right to deposit goods at New Orleans free of duty.

Hostilities with France

The news of the Jay treaty aroused intense indignation in Paris, where the American representative, James Monroe, had been trying to establish more friendly relations. In seeming retaliation for American overtures to Britain and Spain, French ships began seizing American vessels and sailors.

The XYZ Affair

When the ruling French Directory refused to acknowledge Charles C. Pinckney, Monroe's successor as U.S. minister to France, President John Adams, Washington's successor, sent John Marshall and Elbridge Gerry to join Pinckney as negotiators in Paris. This commission was waited upon by three agents of the French foreign minister, Prince Talleyrand, who demanded a bribe and a loan as preconditions for the commencement of negotiations. "Messieurs X, Y, and Z," as they were referred to in official documents, also made threats to organize revolutionary activities in America. News of the affront to the American commissioners caused popular sentiment, increasingly expressed in outbreaks of violence, to shift dramatically from an anti-British to an anti-French footing.

The Undeclared or Quasi War (1798–1799)

The country was soon gripped by war fever. President Adams convinced Congress to suspend trade and the treaties with France and to establish a Navy Department. Harbors were fortified, frigates built, and cooperative measures undertaken with the British navy. During 1798, more than eighty French armed vessels were seized by United States warships and privateers. Although he recalled George Washington to assume the chief command of U.S. forces, Adams successfully resisted pressures to activate the provisional army that was being championed by Hamilton and the High Federalists, the more extreme elements in the Federalist Party.

The Convention of 1800

Neither the French Directory nor President Adams wanted an outright war. Adams dispatched a new commission (William Vans Murray, Oliver Ellsworth, and William R. Davies), which reached France in 1800. Napoleon Bonaparte, now in power as first consul, signed a convention permitting the United States to abrogate the 1778 treaty of alliance and providing a new basis for commerce and maritime relations between the two nations.

■ THE DEVELOPMENT OF POLITICAL PARTIES

During the 1790s, the first American political parties took form. The development of party politics was not anticipated by the framers of the Constitution, who believed partisan activity invariably led to corruption of representative government. Rather, political parties grew almost by necessity to accommodate strong differences over domestic and foreign issues. At issue were fundamental disagreements about the future of the United States. The Federalists supported the views of Alexander Hamilton, while the Democratic-Republicans reflected the orientation of Jefferson and Madison.

The Federalists in Power 1787–1789

The Federalists in office expected the consensus they had reached to continue in the new government. Roughly half of the first Federal Congress had attended the Constitutional Convention. As appointments were made, legislation was introduced, and policies took hold, however, members of Congress representing interests that were hurt or hindered by new measures began to voice their opposition. They quite naturally began to join together to pursue common aims. Most Federalists, however, notably President Washington, considered factions to be dangerous to the republic and believed the administration's opponents, by forming a party, wished to undermine the legitimate government.

Emerging Political Factions

In the congressional battles over the assumption of state debts, the Bank of the United States, the excise taxes (on domestic goods, especially distilled liquor) of 1791, and the protective tariff, factions were formed to advance or oppose Secretary Hamilton's proposals. His program for economic development, and the strong and active central government that was necessary to bring it about, roused those agricultural, landed, and state-oriented interests that stood to lose from the creation of a new and distant pole of power. At first, these groups were loosely organized and not always composed of the same members.

The Election of 1796

President Washington had been inclined to retire from office in 1792 but had been persuaded by Hamilton, Jefferson, and Madison to stand for reelection, which he won without opposition. In the summer of 1796, however, he prepared his Farewell Address, in which he would warn of dangers to the union, the principal of which he identified as "entangling alliances" with foreign powers.

Vice-President Adams defeated Jefferson for the presidency by three electoral votes in 1796, but his victory was diminished by serious dissension among the Federalists. The followers of Hamilton, notably such key members of Adams's cabinet as Timothy Pickering (war), Oliver Wolcott (treasury), and James McHenry (navy), were hostile to the president and sought to minimize his influence. Jefferson was elected vice-president and became president of the Senate, while Madison retired from the House of Representatives and began to coordinate political strategy for the opposition.

The Republican Opposition

Following the leadership of Madison and Jefferson, elements of the original Federalists, joined by former anti-Federalists, coalesced in opposition during the administrations of Washington and Adams.

After Jefferson's resignation from Washington's cabinet in 1793, he became the principal spokesman for this coalition, which identified itself as Republican or Democratic-Republican.

The Republicans shared a common distrust of the growing centralized power and identified in Hamilton's measures a pattern reminiscent of British imperial regulation before the Revolution. Many were alarmed by his Report on Manufactures, concluding that he wished to model America after Europe, where the Industrial Revolution had begun to destroy the agrarian landscape and lifestyle in several countries. Jefferson and his party agreed that America should remain predominantly agricultural and that the seemingly limitless supply of land available for settlement promised a unique destiny. In economic matters, he would note in 1801, the proper role of government was the "encouragement of agriculture and of commerce its handmaid."

Protest and Resentment

Republicans believed that they kept alive the Spirit of '76 and that the Federalists in office, like the British before them, had been corrupted by power and had formed a political party to promote the interests of financiers and manufacturers. Hamilton and some of the more prominent Federalists, in fact, openly stated that government should be in the hands of substantial property holders. But there were many more modest Federalists who supported the politics of stability and law and order out of real fears of godlessness, social disorder, and the threat of foreign invasion. Many Americans believed that Jefferson was an atheist, the head of a "French party," and a dangerous demagogue.

Republicans objected strongly to the manner in which the Washington administration had suppressed the Whiskey Rebellion, the farmers' revolt in western Pennsylvania protesting Hamilton's excise tax on distilled liquors. They argued on two points: that the excise was an unnecessarily burdensome tax imposed on the farmers for the benefit of the capitalists, and that the government had put in doubt the western settlers' loyalty to the union.

The Republicans were also quick to denounce the Jay treaty, which they argued benefited Great Britain to the detriment of the United States. Most wished to fulfill the obligations of the Franco-American alliance. They had rejoiced in the establishment of the French republic and, despite the excesses of the guillotine, continued to believe that it confirmed a favorable, worldwide trend toward republicanism. At the least, they could agree with Jefferson that it was necessary to expand commercial relations with France if only to reduce Britain's domination of America's overseas trade, which had actually increased since the Revolution.

The Political Revolution of 1800

Issues raised by the undeclared war (also known as the Quasi War) with France further intensified differences between Federalists and Republicans. The Federalists regained control of the Congress as a result of popular reaction to the news of the XYZ Affair, although differences between Hamilton's High Federalists and Adams' Federalists continued to divide their councils.

Republicans directed their energies to the states and prepared for the election of 1800. Their hostility to the war effort and friendly posture toward France led the Federalist Congress to take actions to put the country on a war footing. Republicans feared, with some reason, that the Federalist pressures for an expansion of the army were made for the purposes of suppressing opposition rather than repelling an invasion.

The Alien and Sedition Acts (1798)

During the height of the war fever of 1798, the Federalists in Congress, not without some legitimate fears of French threats, passed a series of harsh measures directed against foreign nationals (principally the large number of French in the country) and the Administration's domestic critics. The legislation included

- The Alien Acts, consisting of the Alien Enemies Law, which authorized the president to detain or deport foreigners when the nation was at war, and the Alien Law, which gave the president power to expel any alien deemed dangerous to the country (both were never used)
- The Naturalization Act, which required all aliens to live fourteen years in the country before they could become citizens
- The Sedition Act, which introduced fines or imprisonment for persons convicted of conspiring to oppose the execution of the laws or of publishing false and malicious writings concerning the president or the government

This last piece of legislation was used against several Republican newspaper editors. This resulted in the conviction of ten persons under the Sedition Act, representing the first serious test of the scope of the First Amendment.

The Kentucky and Virginia Resolutions (1798–1799)

To counter what they regarded to be oppressive acts, Jefferson and Madison turned to the states for authority to declare the Alien and Sedition laws unconstitutional. They drafted the Virginia Resolutions (Madison) and the Kentucky Resolutions (Jefferson), which were endorsed and published by the legislatures of those states. Defining the Constitution as a compact entered into by the states, they argued that the states had the right to declare acts of the central government void when they went beyond the powers that had been specifically delegated. Jefferson's argument that nullification by the states was "the rightful remedy" in such instances was not pursued by Kentucky, while other states did not endorse the Virginia and Kentucky Resolutions in the campaign of 1800.

The Election of 1800

The presidential campaign was bitterly contested. Mudslinging and rumor mongering were commonplace; political passions extreme and often violent. Electioneering brought unprecedented numbers to the polls; Jefferson's supporters in particular went to extraordinary lengths to get out the vote. President Adams carried New England, New Jersey, Delaware, and parts of Maryland and North Carolina but lost the electoral vote (by 73–65) as well as the popular vote to Jefferson.

The Burr Intrigue

Because all the Republican electors had voted for both Jefferson and Aaron Burr, a New York party leader, there was a tie vote in the Electoral College. The election was thus thrown into the House of Representatives, where the Federalists held a majority. Some of their leaders connived with Burr in an attempt to prevent the election of Jefferson, but after thirty-six ballots, Jefferson was elected president, Burr vice-president. The Federalists who voted for Jefferson did so thinking him the lesser of the two evils. The Twelfth Amendment, ratified in 1804, changed the method of electing the president and thus prevented a recurrence of the tie vote of 1800.

Significance of Jefferson's Election

The election of Jefferson represented more than the substitution of a Republican administration for a Federalist one. Although there is some evidence that civil war might have broken out if Jefferson had been denied the presidency, there is no way to know whether such threats would have been acted upon. The most significant fact in the outcome of the election of 1800 was that the party in control of the central government had been defeated and removed by means of the ballot box, rather than bullets. The first contested transfer of power had been accomplished peacefully.

The creation of the United States Constitution, the world's oldest and most influential written organic law, was an extraordinary achievement, drawn from and shaped by the frustrations of the American experience in self-government. With the ratification of the document, accomplished by skillful and in some ways deceptive political means, the thirteen states gained a new central government that was far more "national" (a seldom-spoken word) in emphasis than the prevailing political consensus could sustain.

The efforts of Federalists in power to create a strong national interest by governing vigorously achieved some territorial and security objectives, but they overreached the new republic's tolerance for direction from a new source of central power, alienating popular sentiment. Secretary Hamilton's efforts to extend the financial powers of government effectively empowered a national commercial interest. At the same time, however, his program roused a new political coalition of local, state, and regional forces, formed of anti-Federalist democrats and disaffected agrarian interests. This coalition gradually took the form of a new Republican party and reasserted the majority consensus by reenacting the revolution of 1776.

Fragments of the national program advocated by the Federalists would reemerge in the political life of the nation but never again in the same way. The peaceful transfer of power to the Republican opposition in 1800 removed the fear that party activity would be destructive to the republic and effectively established the legitimacy of organized political opposition.

Selected Readings

Adair, Douglas. *Fame and the Founding Fathers* (1974).

Buel, Richard Jr. *Securing the Revolution: Ideology in American Politics, 1789–1815* (1972).

Collier, Christopher. *Decision in Philadelphia: The Constitutional Convention of 1787* (1987).

Combs, Jerald A. *The Jay Treaty* (1970).

Cooke, Jacob E., ed. *The Federalist* (1961).

Currie, David P. *The Constitution in Congress: The Federalist Period, 1789–1801* (1997).

DeConde, Alexander. *The Quasi-War: Politics and Diplomacy of the Undeclared War with France, 1797–1801* (1966).

Ellis, Joseph. *American Sphinx: The Character of Thomas Jefferson* (1997).

Ferling, John. *Adams v. Jefferson: The Tumultuous Election of 1800* (2004).

Hoffman, Ronald and Peter J. Albert, eds. *Launching the "Extended Republic": The Federalist Era* (1996).

Hofstadter, Richard. *The Idea of a Party System: The Rise of Legitimate Opposition in the United States, 1780–1840* (1969).

Kennedy, Roger G. *Burr, Hamilton, and Jefferson: A Study in Character* (1999).

Kohn, Richard H. *Eagle and Sword: The Federalists and the Creation of the Military Establishment in America, 1783–1802* (1975).

Levy. Leonard W. *Legacy of Suppression: Freedom of Speech and Press in Early American History* (1960). *Original Intent and the Framer's Constitution* (1988).

Main, Jackson Turner. *Political Parties before the Constitution* (1974).

McGuire, Robert A. *To Form a More Perfect Union: A New Economic Interpretation of the United States Constitution* (2003).

Randall, Willard Sterne. *Alexander Hamilton: A Life* (2003). *George Washington: A Life* (1997).

Rakove, Jack N. *Original Meanings: Politics and Ideas in the Making of the Constitution* (1996).

Rutland, Robert A., et al., eds. *The Papers of James Madison* , vols. 8–14 (1973–1983).

Ryerson, Richard Alan, ed. *John Adams and the Founding of the Republic* (2001).

Siemers, David J. *Ratifying the Republic: Antifederalists and Federalists in Constitutional Time* (2002).

Stourzh, Gerald A. *Alexander Hamilton and the Idea of Republican Government* (1970).

Tarr, G. Alan. *Understanding State Constitutions* (2000).

Wiencek, Henry. *An Imperfect God: George Washington, His Slaves, and the Creation of America* (2003).

Wood, Gordon S. *The Creation of the American Republic, 1776–1787* (1969).

Test Yourself

1) Which of the following political leaders of the 1780s did not attend the Constitutional Convention and did not support ratification of the new document?
 a) Benjamin Franklin
 b) Patrick Henry
 c) James Madison
 d) George Washington

2) The first attempt to declare a law of Congress to be void, and thus unconstitutional, occurred with the
 a) Whiskey Rebellion
 b) Kentucky and Virginia Resolutions
 c) Bank of the United States
 d) XYZ Affair

3) True or false: The Jay Treaty with Great Britain was a popular measure in Congress, especially with many political supporters of the Federalist party.

4) Which of the following persons is considered to be the principal architect of the Constitution?
 a) James Madison
 b) James Wilson
 c) Benjamin Franklin
 d) John Dickinson

5) Washington Administration demanded that France recall Edmond Genét as its Minister to the United States because
 a) Genét was a personal friend of Thomas Jefferson.
 b) The French Envoy did not support the Alliance of 1778.
 c) Genét outfitted privateers and enlisted seamen in the United States before presenting his diplomatic credentials to the President.
 d) The United States did not formally recognize France.

6) True or false: Spanish agents in Florida and Louisiana during the 1790s encouraged Native Americans to attack the western settlements of the United States and thus make the frontier unstable.

7) The Republicans, as they became the opposition political party during the Washington Administration, believed in all of the following policies, except that
 a) America should remain predominantly agricultural.
 b) Political power exercised by state governments was preferable to centralized, national power.
 c) Britain and the United States should become primary trading partners instead of France.
 d) The availability of western land represented the future area of most important development for the nation.

8) True or false: The House of Representatives almost elected Aaron Burr as President of the United States, although the election of 1796 was between Thomas Jefferson and John Adams.

9) As president, George Washington supported and worked to achieve all of the following, except for
 a) Hamilton's financial plans
 b) the use of the cabinet as his chief circle of advisors
 c) personal consultation with the Senate on foreign affairs
 d) the creation of a strong and independent Executive Branch

10) True or false: The constitution created a general framework and broad outline for the three branches of the national government, but contained no specific guidelines for how they would be implemented or might operate.

Test Yourself Answers

1) **b.** Patrick Henry did not attend of the Constitutional Convention, and at least initially, he did not support ratification of the Constitution. Eventually, however, he did favor the new document, once promises had been made to include a Bill of Rights. Madison, Franklin, and Washington all attended the Constitutional Convention.

2) **b.** The respective legislatures of these two states passed them in response to the Alien and Sedition Acts.

3) **True.** The Jay Treaty was popular. Many in Congress wanted to improve relations with Spain, secure a diplomatic relation of the United States from that nation, and establish a profitable commerce with it. This was especially true among the mercantile interests of New England and the major Atlantic port cities

4) **a.** James Madison is considered to be principal architect of the United States Constitution. He worked very hard at the convention to secure a series of compromises that produce the final document. In addition, he kept a detailed diary of the deliberations that have proven to be a valuable source used today in Constitutional interpretation.

5) **c.** Citizen Genét delayed in presenting his diplomatic credentials to President Washington in a timely fashion, as was the established custom in the formality of foreign relations. Moreover, Genét outfitted privateers in American ports soon after his arrival in the United States, even before he eventually did present his credentials to the president. Washington viewed Genét's activism in this regard as improper behavior for a diplomat. For that reason, he would not accredit Genét as an envoy from France.

6) **True.** Spain held title to Louisiana, the Gulf coast, and parts of the lower Mississippi Valley throughout the 1790s. Some of these agents were British traders who got special trade concessions in Florida from the Spanish government. British and Spanish influence of Native American populations against United States citizens in these regions would not be completely resolved until the War of 1812.

7) **c.** Jefferson and the Democratic Republican Party favored France over Great Britain, both in terms of foreign-policy and their political sentiments. They can therefore be called Francophiles. As noted in this question, they did believe that the United States should remain agricultural, believed in the concept of the case strong state governments, and believed that western land represented the best option for future national development.

8) **True.** There was no definitive winner in the Electoral College because some ballots from the states did not identify who were the presidential and vice presidential candidates. Thus, under the provisions of the Constitution, selection of the president fell to the House of Representatives. The outgoing Federalist Congress attempted to elect Jefferson's declared vice-presidential candidate, Aaron Burr, as president against his will in an effort to damage the Democratic Republican Party. This effort, however, failed. After a number of ballots in the House, Thomas Jefferson became president and Aaron Burr became vice president, as they had intended. The disputed election of 1796 resulted in an amendment to the Constitution that provides for separate balloting for president and vice president in the Electoral College.

9) **c.** Washington did not like to consult personally with the Senate by visiting its chambers. On his first such visit, when he personally appeared before the Senate in an effort to consult on foreign policy, he had such a bad experience that he never again went personally to the Congress for purposes of consultation. This established a precedent that the president of the United States would not go personally to the Congress in order to consult with it on routine matters. Such appearances are today formally restricted to the State of the Union Address. Washington worked to achieve all of the other matters noted in this question.

10) **True.** The Washington Administration set many of the precedents for how the government would operate in logistics and day-to-day practice. These included Washington's creation of the cabinet, many offices in the government bureaucracy, and the way his administration dealt with Congress.

Jeffersonian Republicanism

1801: Jefferson-Burr ticket wins but ties in the Electoral College; Jefferson chosen president by the House of Representatives (January 20); passage of Judiciary Act of 1801 (February 27); Adams makes midnight appointments until March 3 at 9 p.m.; Jefferson inaugurated president March 4. Tripoli declares war on the U.S. (May 14); Jefferson determined to respond with force

1802: Repeal of the Judiciary Act of 1801 (March); passage of Judiciary Act of 1802 (April)

1803: Decision in *Marbury v. Madison* handed down by Chief Justice Marshall (February); Louisiana Purchase transacted and U.S. takes occupation (December)

1804: Death of Hamilton in duel with Burr (July); Lewis and Clark Expedition sets out (August); Jefferson re-elected with Vice-President George Clinton (N.Y.)

1805: Judge John Pickering impeached by the House and convicted by the Senate (March); Supreme Court Justice Samuel Chase impeached but acquitted; Zebulon Pike begins first of two expeditions

1806: Return of Lewis and Clark expedition

1807: H.M.S. *Leopard* stops and attacks U.S.S. *Chesapeake* off Norfolk, Virginia (June); The Embargo Act becomes law (December 22)

1808: Presidential election won by the ticket of James Madison–George Clinton over Federalists C.C. Pinckney–Rufus King (December)

1809: Repeal of embargo; passage of Non-Intercourse Act (March 1); Madison inaugurated (March 4)

1810: Passage of Macon's Bill No. 2, reopening trade and revising terms of non-intercourse (May)

1811: General Harrison surprises Tecumseh's forces at Battle of Tippecanoe (November)

(continued on next page)

1812: War declared against Britain (June 19); British suspend orders in council (June 23); Madison re-elected over anti-war Republican DeWitt Clinton, supported by Federalists (128–89 electoral votes), who made large gains in Congress (December)

1813: Britain blockades U.S. coastline; Commodore Perry's victory in Battle of Lake Erie (September); American offensive against Canada repelled

1814: Andrew Jackson slaughters Creeks at Horseshoe Bend, Alabama, removing them from war (March); British burn Washington but fail to take Baltimore; their northern invasion stopped at Plattsburgh, New York (August–September); Hartford Convention convenes (December); Treaty of Ghent concluded (December)

1815: Jackson's victory at New Orleans (January); news of treaty reaches New York (February 11)

After the extreme partisanship of the campaign of 1800, it was expected, by supporters and foes alike, that the presidential administration of Thomas Jefferson would introduce substantial and even radical changes. The federal government was now firmly in the control of a man and a party that proposed to diminish its size and influence. But although he reversed the principal Federalist domestic and foreign policies, Jefferson generally pursued a moderate course as chief executive, observing in his inaugural address that "we are all Federalists, we are all Republicans." With "true" republicans occupying most of the seats of power, except in the Judiciary, he saw the apparatus of government less as a potential instrument of oppression than as the means to achieve republican aims.

■ PEACE, ECONOMY, AND LIMITED GOVERNMENT

Thomas Jefferson assumed the presidency believing that his election represented the triumph of the true republican principles of the American Revolution, the defeat of those who had reverted in varying degrees to policies derived from monarchism. His first acts were to reduce the size of government and to cut spending. The best government, he believed, was that which placed the lightest burden on its citizens.

The Philosopher President

Jefferson is a large and now almost mythical figure in American history. In the flesh, he was a man of great intellect and learning, of subtlety, and of contradictions. The person who had drafted the Declaration of Independence continued to keep accounts for more than a hundred slaves until his death. Although he admired their courage, he had little sympathy for the plight of Native Americans, largely because they stood in the way of the American farmer, whose prosperity he deemed essential to the survival of the republic. This conformed to his belief in the progress of civilization and his ambition to put in place "a government founded not on the fears and follies of man, but on his reason."

Although an intellectual and scholar, Jefferson was the first president who was also, unquestionably, the leader of a political party. He skillfully made use of party politics in making appointments to office and in pursuing his legislative aims, and he entertained members of Congress at the president's house as a means of keeping himself in touch and them in line. Occasionally, he used less-than-honorable means in the service of a worthy political end. The exponent of limited government and the initiator of the concept

of nullification, Jefferson, more than either Washington or John Adams, used the powers of the presidential office to achieve his goals.

Cabinet Members

James Madison, Jefferson's close friend and political colleague, the principal framer of the Constitution and first parliamentary leader of the Republicans in Congress, was named secretary of state. Albert Gallatin, a Swiss by birth who had rallied western Pennsylvania for Jefferson and was skilled in accounts, became secretary of the treasury. The four other cabinet posts went to loyal Republicans from Massachusetts, Connecticut, and Maryland.

Jefferson appointed no Federalists to high office and none of Burr's supporters. He removed some who had been appointed by Washington and John Adams, complaining that few died and none resigned, and when there was a vacancy to fill he invariably named a dependable Republican. However, he resisted the demands of the more radical members of his party for wholesale removals and rarely discarded the competent moderate Federalist, a type he largely succeeded in converting to the Republican cause. In four years, he was able to replace about half of the Federalist holdovers with Republican appointees.

Financial Retrenchment

Soon after taking office, Jefferson took steps to repeal Hamilton's financial program and to reduce and eliminate the national debt (by this time, some $83 million). He gained congressional repeal of internal or domestic taxes, including the detested excise tax. The federal government was to be funded solely from duties on imported goods and from the sale of western lands. To reduce government expenditures, Secretary Gallatin imposed sharp cuts in spending by means of

- Reductions in military and diplomatic expenditures
- Strict accounting in the expenditure of all appropriations
- A rapid reduction of the principal of the national debt

The number of diplomatic missions overseas was reduced from seven to three (London, Paris, and Madrid). The U.S. army, deprived of a general staff, was cut by about a third, to an authorized force of 3,312. Jefferson justified the reductions by citing the dangers posed by standing armies and touting the civilian militia in the states. The navy was also drastically reduced to a mere six active ships; after cutting nineteen captains, only nine remained in active service. A large navy, the president reckoned, would give undue weight to the demands of commerce and, by posing a threat to the European powers, increase the chances for war. In 1802, naval expenditures dropped by more than a half to a total outlay of $915,000. However, in response to international events, the budget for the navy increased thereafter.

Restraining the Judiciary

After Democratic-Republicans won majorities in both the House and the Senate, and the Federalist ticket was defeated for the presidency in 1800, the Federalists in Congress passed the Judiciary Act of 1801. Because appointments to the federal bench were for life, they expected to extend their control of that branch of government. The Judiciary Act of 1801 created ten new positions on the federal district courts and a new category of appellate court, the circuit courts of appeals, between the Supreme Court and

the district courts. The act also reduced the size of the high court by one justice. Prior to leaving office, President Adams had appointed as many Federalists to these new positions (derisively called the midnight appointments) as he could.

Faced with a decidedly hostile judicial branch, the Republicans quickly took steps to counter Federalist moves. In March 1802, Congress repealed the 1801 act, eliminating the new judgeships and designating one Supreme Court justice and one district court judge to sit on the traveling circuit courts. Republicans in Congress, with the encouragement of the president, then moved to impeach two federal justices who had openly attacked the administration from the bench. The first, John Pickering of New Hampshire, was mentally deranged. Presenting a constitutional dilemma, his incompetence fell short of the requirement for removal (high crimes and misdemeanors). He was nevertheless convicted by the Senate and removed in 1804. The following year House Republicans impeached Supreme Court Justice Samuel Chase, citing only his partisan excesses; this time the Senate failed to vote conviction. The Chase trial was a pivotal event, for if the Senate had voted to convict on merely partisan political charges, it is likely that impeachments of judges and justices would have continued and perhaps significantly influenced the development of the judiciary. Many Republicans were, in fact, pressing at this time for constitutional changes to make federal judges more accountable, notably by means of election.

One of Adams's midnight appointees, William Marbury, sued the new secretary of state to gain a commission as justice of the peace for the District of Columbia, which had not been delivered before the Republicans took office. Citing a provision of the Judiciary Act of 1789, he asked the Supreme Court to order Madison to deliver the commission. Chief Justice John Marshall, speaking for the Court, found the appointment to be technically valid, but at the same time observed that Madison had no authority to order delivery of the commission, ruling that the enforcement provision of the 1789 law was unconstitutional. By finding that the Supreme Court was powerless to act for Marbury, Marshall avoided a direct confrontation with the administration while asserting the Court's right to review acts of Congress and rule upon their constitutionality.

In Marshall, a distant cousin whom he despised, Jefferson had gained his most formidable political adversary. Like Lincoln and many other presidents, it should be noted, Jefferson did not consider himself obligated to enforce all rulings of the Supreme Court, interpreting the enforcement power of the executive branch to be a constitutional check on the judiciary.

Barbary Coast Wars

An advocate of military retaliation against the Barbary pirates of northern Africa since his service as secretary of state, President Jefferson chose in 1801 to respond with force to affronts against the American flag and consulate in Tripoli (today the capital of Libya) and the seizure of American hostages. To prevent attacks on American merchant shipping in the Mediterranean, the United States, like the European nations, had been paying tribute and ransom money to the Barbary states of North Africa: Morocco, Algiers, Tunis, and Tripoli. Having decided that Tripoli's declaration of war allowed him to proceed without a similar declaration from Congress, Jefferson ordered a squadron of four ships to sail for North Africa in 1802.

The continuing difficulties with the Barbary States and growing concern for defense of the American coast led the president to request funds from Congress for the construction of, ultimately, several hundred gunboats. These light vessels (derisively referred to as the mosquito fleet) gradually replaced the frigates

then in service. Nine gunboats had reached the Mediterranean by 1805, when the first of the Barbary wars ended in a standoff. In order to free American prisoners who were threatened with execution, Commodore James Barron signed an agreement that purported to end the requirement of tribute while exacting ransom for the freedom of the hostages.

The Louisiana Purchase

Soon after taking office, Jefferson learned that Spain had ceded the vast province of Louisiana back to France. This raised troubling questions about French intentions, particularly regarding navigation on the Mississippi River. Access to that highway to the American interior was considered vital by some 50,000 Americans who lived and traded in the valleys of the Ohio and the Tennessee rivers (which flow into the Mississippi).

Napoleon's Colonial Ambitions

France's reacquisition of Louisiana (with the port of New Orleans) in the secret Treaty of San Ildefonso (1800) was part of Napoleon's ambition to re-create the French colonial empire in America. The scheme was defeated in part by Toussaint L'Ouverture, revolutionary leader of the blacks of Santo Domingo (on Hispaniola in the West Indies), who had gained control of their island and established a republic; their new government had been officially recognized by the Adams administration. Aided by an outbreak of yellow fever among the French troops and delays in reinforcing them from Europe, L'Ouverture's forces successfully resisted Napoleon's efforts to retake his island.

On hearing that Louisiana had been ceded, Jefferson, who had gone so far as to suggest to the French that the United States might be willing to join them in overturning Toussaint, shifted course. New Orleans, he observed, was so connected to American interests that if the French gained control of that port, "we must marry ourselves to the British fleet and nation."

The Treaty (1803)

When news reached Washington that the Spanish had suspended the right of Americans to deposit goods in New Orleans, President Jefferson asked Congress to appropriate funds ($2 million) to purchase the port—he also requested funds to increase the army and to build riverboats suitable for a war in the west. The president's determination was given emphasis when he instructed the American negotiators in Paris, Minister Robert R. Livingston and special envoy James Monroe, to open discussions with the British government in the event the French refused to sell New Orleans.

Events were, characteristically, determined by Emperor Napoleon himself. Before the American negotiators could make their proposals, he had decided to get rid of Louisiana. His friend (and Jefferson's), the French traveler C. F. Volney, had given him a firsthand report on the degradation of French settlements in the territory. Calculating his losses in the West Indies, the possibility of renewal of war with Great Britain, and no doubt the geographical advantages enjoyed by the Americans, Napoleon was ready to sell the entire province for the right sum. Livingston had already suggested that the French might wish to part with the northern part of Louisiana; he and Monroe were surprised when offered the whole province. They were not authorized to negotiate for it, but, aware of the urgency of proceeding and of the enormity of the prize, they agreed to a purchase price of $15 million. A treaty was signed in May, the Senate ratified the document in October, and the territory was transferred to the United States in December 1803.

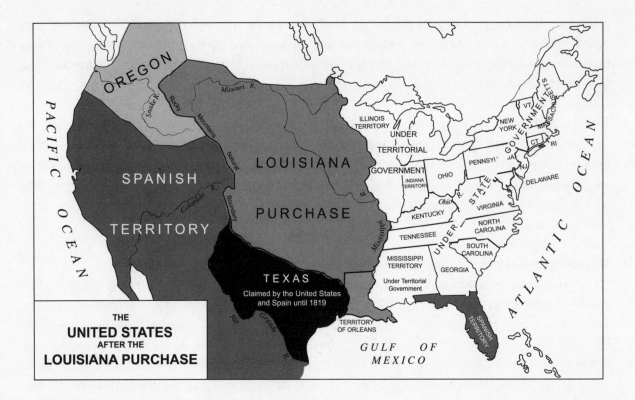

THE
UNITED STATES
AFTER THE
LOUISIANA PURCHASE

Although Jefferson doubted the constitutionality of the purchase and at first believed an amendment to the Constitution was required to legally acquire Louisiana, he put aside his scruples and accepted a loose construction of the executive's constitutional power to make treaties. The acquisition was immensely popular, except with New England Federalists, who reacted to the promise that several new states would be formed from the new territory, further diluting the political power of the northeast.

The Lewis and Clark Expedition (1804–1806)

Responding to a secret request from the president, Congress appropriated $2,500 to fund an expedition to the territory beyond the Mississippi to chart and gain information about the region. Jefferson designated Meriwether Lewis, his private secretary, to lead a carefully selected group up the Missouri, across the Great Divide, and into the valley of the Columbia River. An experienced back woodsman, Lewis and his associate William Clark (brother of George Rogers Clark) set out from St. Louis in May 1804 with a party of fifty, accompanied by the Shoshone woman Sacagawea. They reached the Pacific a year and a half later. The work of Lewis and Clark strengthened American claims to the Oregon country (derived from the Louisiana Purchase), which was also claimed by Britain and Spain.

Zebulon Pike's Expeditions (1805, 1806)

A second expedition into the new territory set out in late 1805 under Lieutenant Zebulon Pike to explore the upper Mississippi Valley and search for the source of the great river. The following year, Pike led another group up the Arkansas River to the easternmost Rocky Mountains of modern-day Colorado and New Mexico.

The Red River Expeditions

Jefferson also laid plans for an expedition into the southwestern regions of the Purchase territory. During the winter of 1804–1805, Natchez resident and scientist William Dunbar made a preliminary trip up the Ouachita River to trace a possible route for a larger expedition toward Santa Fe. In 1805, Congress appropriated $5,000 for this expedition, which was led by Thomas Freeman. This group (composed of scientists and naturalists, along with army troops to protect them) traveled up the Red River along the present-day boundary between Oklahoma and Texas for over 600 miles until it was met by a Spanish force dispatched from New Mexico to turn them back. Although the Freeman Expedition failed in its goal to scout the complete upper reaches of the Red River, it did provide valuable ethnographic information about Native Americans living on the southern Great Plains.

■ PARTISAN POLITICAL BATTLES

By the end of his first term, President Jefferson had doubled the size of the national domain, eliminated the foreign threat to the southwest, and checked the Barbary menace to American commerce in the Mediterranean, while eliminating internal taxes and reducing substantially the national debt. Not surprisingly, he trounced his Federalist opponent in the election of 1804, Charles Cotesworth Pinckney of South Carolina, by 126–14 electoral votes (losing only Connecticut and Delaware). His second term, however, was dominated by factional strife and political intrigue.

Republican Factions

Although the Federalist party made some inroads by fashioning popular appeals to the electorate, their gains were confined to a few states in the Northeast and posed no national threat to Jefferson's leadership. Without the discipline that the Federalist opposition had forced upon them in 1800, the Republican party became diverted by local quarrels between rival factions (especially in New York and Pennsylvania), while ideological differences among Republicans gave the administration serious trouble in Congress. The rise of factions exposed the weakness of the Republican consensus and enhanced Congress's powers at the expense of the executive.

The Quids

In his first term, Jefferson had wielded the powers of his office with an authority that Presidents Washington and Adams would not have been permitted. His political moderation and willingness to compromise had won over many of the moderate or Adams Federalists. At the same time, those Republicans who had rallied behind him in expectation of a radical departure from previous administrations grew increasingly frustrated. Led by the colorful and eccentric John Randolph of Roanoke, a group of Republicans in the House, who called themselves the Quids (or "something or other"), objected to what they identified as federalism in the administration's policies. Relying on the Virginia and Kentucky resolutions, they advocated a strict construction of the Constitution and states rights and became the most troublesome of the president's opponents.

The Yazoo Controversy

Randolph achieved his most notable success in opposing Jefferson's plan to resolve the Yazoo land claims. When Georgia ceded her western claims to the federal government, the United States had inherited numerous law suits lodged by those who had made purchases from the Yazoo land companies. The original land grants to these companies had been annulled by the Georgia legislature in 1796 on the grounds that they had been made fraudulently.

After several years of dispute, a special commission appointed by President Jefferson proposed a compromise solution that was acceptable to the state of Georgia and to the Yazoo claimants—an appropriation of five million acres of public land was to be made to compensate bona fide purchasers. This compromise solution gained the president's support, but Randolph and his supporters blocked the settlement for ten years, charging that the claims (many of which were held by members of Congress) were undeserving of compensation. The matter was ultimately resolved by the Supreme Court in the case of *Fletcher v. Peck* (1810). Chief Justice Marshall, for the Court, ruled that the original sale contracts were not invalidated because of fraud and took the opportunity to affirm the Supreme Court's authority to review state laws to determine their constitutionality.

Federalist Intrigues

The extreme elements of the New England Federalists, aware that the center of political power had shifted to the South and West and that New England's role in the union would be diminished, eventually came to believe that secession was better than accepting such a fate.

The Essex Junto

A small group of these high Federalists of New England, known as the Essex Junto, even deliberated upon the possibility of a union with Canada in order to escape from policies framed by southern planters and western farmers. They determined to work for a Northern Confederacy or Eastern Confederacy, defending their position with states' rights arguments that echoed those of the Virginia and Kentucky resolutions. Their plans were effectively thwarted, however, when Hamilton stated his opposition to "a dismemberment of our empire."

The Coalition with Aaron Burr

In the hope of joining New England with New York and New Jersey in a confederacy, the high Federalist faction supported Vice-President Aaron Burr in the election for governor of New York in 1804. Hamilton accused Burr of treasonous activity and impugned his character in such an open way that his comments were reported in the newspapers. After his defeat, Burr, blaming Hamilton, challenged his nemesis to a duel and killed him.

Burr's Conspiracy

Burr avoided possible prosecution in New York by leaving the state, but because dueling was considered a private (if not entirely just) affair among gentlemen at that time, he was not universally condemned as a murderer, particularly in the southern states, where the practice of dueling was less frowned upon. He presided over the Senate as vice–president until his term ended in March 1805, then made a curious trek that took him and a small group of armed men to the southwest, probably with the ultimate

goal of "liberating" Mexico from the Spanish. Burr's ambitions were thwarted when he was indicted on a charge of treason in late 1806.

The principal evidence against Burr was supplied by an admitted collaborator in the scheme, General James Wilkinson, governor of the Louisiana Territory, who had warned of Burr's intention to attack New Orleans. President Jefferson, convinced that Burr was an enemy of the republic, directed the government's prosecution of the trial, which was presided over by Chief Justice Marshall in Richmond. Marshall, strictly interpreting the language of the Constitution (which required two witnesses to the overt act of treason for conviction), refused to admit crucial evidence against Burr and thus all but determined his acquittal.

The Burr conspiracy was the most noteworthy incident of its kind in the early history of the United States. Although government presence in the United States and its territories was slight, the strong ambitions and conflicting interests that flourished in the politics of the young republic never combined to threaten the Constitution.

■ THE DIPLOMACY OF PEACEABLE COERCION

Europe's brief respite from war ended in 1803. Napoleon's drive to control and reshape Europe roused Great Britain and her allies to renew their struggle to destroy him. The American merchant fleet at first derived great benefits in its role as a neutral carrier, but as losses in the conflict mounted, the belligerent powers ignored the maritime rights of neutral nations in attempts to gain advantages and punish their enemies. Once again, "the exterminating havoc" in Europe disrupted the republican experiment and threatened American independence.

British Maritime Policies

After Admiral Lord Nelson smashed the French fleet at the Battle of Trafalgar in 1805, Britain ruled the seas. Pressed by British merchants, who had become alarmed at the rapid growth of American shipping, the British government invoked imperial regulations to control the exchange of goods with the continent.

Taking full advantage of its superior sea power, Great Britain issued several orders in council (the first in April 1806) to restrict the trade of neutral shippers. By November 1807, these measures, at least on paper, had put in place a blockade of European ports and forced neutrals to trade with the continent through Great Britain.

Impressment and the Chesapeake Incident

Conditions in the British navy and merchant marine were hard and often subhuman, leading British sailors, most of whom had been impressed into service by physical force, to jump ship when they could. Many joined the U.S. navy or took assignments on American merchant ships. The British considered these men deserters and maintained their right to apprehend them by stopping and searching American ships and removing suspects. Under this claim, they seized thousands of men—many, in fact, deserters, but also many naturalized Americans who had been born within the dominions of the British Empire, as well as native-born Americans.

The attack and seizure of the U.S. frigate *Chesapeake* just outside of Norfolk by the British warship *Leopard* in June 1807 gave dramatic emphasis to the issue of British impressments. Although the British

government agreed to return the sailors abducted from the *Chesapeake* and to pay damages, it persisted in claiming the right to board and search foreign vessels to apprehend deserters.

Napoleon Retaliates

In an effort to cripple Britain and in response to the orders in council, Napoleon put in place his Continental System. The Berlin Decree (November 1806) forbade all commerce with the British Isles and ordered the seizure of ships coming from Britain or her colonies to ports under French control. The Milan Decree (December 1807) declared that all ships that paid a tax to the British or obeyed the orders in council were "good prize." By subsequent decrees (1808–1810), Napoleon sequestered American vessels in French ports and confiscated their cargoes. His measures, combined with those of the British, severely hindered the neutral carrying trade and violated the traditional rights of neutral or nonbelligerent nations.

Jefferson's Alternative to War

Although the president recognized that the *Chesapeake* incident had roused Americans to "a state of exasperation" not seen since the Battle of Lexington, he knew that the success of his domestic program—limiting the size of government, reducing the national debt, and eliminating internal taxes—depended on the maintenance of peace. Having long believed that economic measures could be fashioned to serve as an effective alternative to war, he now determined to make the experiment.

The Embargo Act of 1807

Jefferson and Secretary of State Madison believed that the British and the French were dependent on American foodstuffs, the principal products carried by American ships. Believing that the nation was willing to make sacrifices to gain redress, they designed an economic boycott to force the belligerents to recognize American neutrality and to observe the neutral rights of American shippers. In late December 1807, Congress enacted the administration's embargo, which prohibited all foreign commerce.

The embargo resulted in a serious economic contraction, which severely disrupted the businesses of the merchants and ship owners of New England and other northern states. Those whose livelihood and work depended upon foreign commerce not surprisingly perceived in this policy, with some justice, an overt bias against the interests of merchants and for those of farmers. Opposition steadily grew. Owing to the nation's long coastline and extended border with Canada, the embargo proved difficult to enforce and relatively easy to evade. Congress passed several force acts, some reminiscent of onerous British imperial regulations, to empower customs officials to seize ships and cargoes on suspicion of intent to sail for Europe. The administration found itself closely monitoring the coastal trade, and the president even sent troops to upstate New York to prevent violations.

The Non-Intercourse Act of 1809

With no evidence to suggest that the boycott was having the desired effect in Britain or France, but clear indications that the Federalists were reaping political gains from it, the Republican Congress repealed the embargo legislation at the end of Jefferson's second term. Commerce with the world was again permitted, if only in theory. The Non-Intercourse Act of 1809, which replaced the embargo, prohibited all trade with the nation's principal trading partners, Great Britain and France, until they recognized the maritime rights of neutrals.

Madison's Diplomacy

James Madison, who succeeded Jefferson in the presidency in 1809, continued to guide American relations with Europe by the policy of peaceable coercion. During his administration, the challenges posed by the Napoleonic Wars became more frequent and menacing.

The Erskine Fiasco

David Erskine, British minister in Washington, persuaded Madison that Great Britain would rescind her orders in council if the United States would reopen trade. Accordingly, the president proclaimed resumption of commercial relations with Great Britain only to discover that Erskine had not stated all of the conditions demanded by his government, which refused to confirm the agreement. Many American ships that had set sail under the assumption that the dangers to commerce had been removed were in fact taken by the British navy.

Macon's Bill Number 2

In May 1810, Congress, with Madison's approval, passed a bill submitted by Congressman Nathaniel Macon of North Carolina that revised the Non-Intercourse Act. The new measure reopened trade with all nations, including France and Great Britain, but it empowered the president to take action against those belligerents under certain conditions. If either of them ceased "to violate the neutral commerce of the United States," and the other refused to do the same, the president could then declare an embargo or resume non-intercourse with the other power.

Napoleon, seeking an advantage against Britain, responded to Macon's bill by proclaiming, in the Cadore letter, his intention to observe the rights of neutral traders (the insincerity of which was revealed only in time). Relying on the French statement, Madison announced that non-intercourse with Great Britain would resume early in 1811 unless the British orders in council were revoked.

Republican Policy Toward Native Americans

Jefferson believed that the American farmer was the backbone of the republic, his prosperity crucial to its health and survival. "Those who labor in the earth are the chosen people of God, if He had a chosen people, whose breasts He has made His peculiar deposit for substantial and genuine virtue," he wrote in his *Notes on the State of Virginia* (1785, 1787). The Republican Indian policy he fashioned and implemented, which was continued under Madison, derived from this conviction about the use of the land. In practice it provided a basis for removing the Indians west of the Mississippi. Tribal claims to hunting grounds in the Northwest Territory were considered illegal and were not recognized. The Indians were offered the opportunity to either assimilate themselves into the "civilized" white agricultural communities or to resettle west of the Mississippi.

Settlement of the Northwest Territory by American farmers had dramatically increased during Jefferson's two terms, aided by the Harrison Land Bill of 1800, which had made it easier to acquire land in the region. To enforce this policy and encourage settlement, Jefferson appointed William Henry Harrison, author of the 1800 law, as governor of the Indian Territory, a position he held until 1812.

Tecumseh's Confederacy

In reaction to the encroachments of white men and Republican policy, the Shawnee chief Tecumseh and his brother Tenskwatawa (a shaman, called the Prophet) organized a confederacy of tribes in the

Mississippi Valley and attempted to revive their native cultures. The chief told Governor Harrison that the settlers had "driven us from the sea to the lakes—we can go no farther." Along the frontier, from the Great Lakes to the Gulf of Mexico, Native Americans rose up in opposition to white settlers, who largely blamed the British for their troubles. When Harrison's troops, after destroying the central Shawnee village at the Battle of Tippecanoe (November 1811), reported that the Indians had been armed with English guns and ammunition, the western regions and states pressed for war.

British Sentiment

Since 1783, the British presence in Canada and in the Great Lakes region claimed by the United States had been an irritant to American settlers, who detected British influence in the hostilities directed at them by Indian tribes. The British needed friendly relations with Native American tribes to maintain the fur trade and their control over the vast and thinly populated extent of Canada, but, in fact, the British did not organize native peoples for military purposes, as had the French. They provided supplies and on occasion directly aided their Native American allies in resisting the relentless sweep of American settlers. After the *Chesapeake* incident of 1807, however, the British in Canada took measures to strengthen these alliances in anticipation of an American invasion.

The War Hawks

The failure of Jefferson's and Madison's economic and diplomatic alternatives to war, along with the continuing insults of the European powers and the increasing hostilities on the western frontier, eventually eliminated the administration's options. Demand for war came not from New England shipping interests but from a rising generation of Republicans sent to Washington to represent the western and southern states. They feared the consequences of war less than those of national humiliation. This group of War Hawks dominated the new Congress that convened in December 1811. Prominent among them were Henry Clay of Kentucky, elected speaker of the House; John C. Calhoun of South Carolina, whom Clay appointed to the House Foreign Affairs Committee; Felix Grundy of Tennessee; and Peter B. Porter of western New York.

The War Hawks and their followers were not merely frustrated nationalists; they were also united by expansionist ambitions and eager to acquire new territory to resolve the nation's problems. Their principal objective, clearly identified by Calhoun, was to gain Canada and thereby remove the British influence from North America. In the South and Southwest, their objective was the eastern portion of Florida, still a possession of Spain, now an ally of Great Britain. It had been a base for Indian attacks against white settlements and a refuge for runaway slaves. In 1810, American settlers in western Florida (then consisting of portions of Louisiana, Mississippi, and Alabama) had gained control of that portion of Spanish Florida, which was annexed to the United States in 1812. With Madison's sanction, a similar but unsuccessful effort had been made to take eastern Florida in 1811.

The Declaration of War

Recognizing that pressures in Congress could no longer be resisted, Madison abandoned the policy of peaceable coercion and recommended war against Britain on June 1, 1812 (approved by Congress two weeks later). In his war message, the president cited Britain's refusal to observe the maritime rights of neutral nations, its impressment of American sailors and merchantmen, and its agitation of the western

Native Americans against American settlers. Assuming that Canada could easily be taken, the administration now entertained the idea that an invasion by American troops would force the British to accept the maritime rights of neutral nations, the Republican objective during three presidential administrations. Even after making the popular decision for war, Madison barely won re-election (by 128 to 89 electoral votes) over DeWitt Clinton, governor of New York, the candidate of Federalists and antiwar Republicans.

■ THE UNITED STATES AND THE WAR OF 1812: THE SECOND WAR WITH BRITAIN

After yielding to pressures for war, the administration learned soon after declaring it that the British government had moved (on June 16, 1812) to eliminate its restrictions on American merchant shippers. In an age in which sailing ships were the only vehicle of transatlantic communications and crossings usually took three to five weeks, depending on the season and weather, such ironies, or accidents of history, were always possible. Warfare with Britain, however, was not averted. After years of grievances, the dispute now encompassed questions about the nature of American independence and national destiny. The treaty that settled the conflict did not resolve many of the outstanding issues with Britain, but by the time fighting in America and the wars in Europe had concluded, less tangible national objectives had been achieved.

The Field of Battle

The war fever that had forced Madison to abandon the policy of peaceable coercion did not translate into congressional support for increases in expenditures required to outfit and support a credible army and navy. Congress rejected proposals for direct taxes to support the war effort and grudgingly voted basic appropriations. New England opposed the war and ignored strictures against trading with the British during the conflict.

Lack of Preparedness

The country was utterly unprepared to fight a war against a world power. The weakness of American forces quickly became apparent, although until Napoleon suffered a massive defeat in his attempt to conquer Russia, Great Britain concentrated its war effort on the European continent. Although Jefferson had effectively deployed the navy against the Barbary States and established the U.S. Military Academy at West Point (1802), he put in place a policy that relied almost exclusively on volunteer militia of citizens to defend the nation against invasion. The regular or "standing" U.S. army was kept purposely small so as to discourage its role in domestic affairs, and not surprisingly, it was poorly equipped. In early engagements, the volunteer militia proved largely unreliable; they were handicapped by incompetent leaders, who were often politicians confidently expecting opportunities for glory.

The Canadian Offensive (1812–1813)

Reflecting the rhetoric of the War Hawks, American military strategy first focused on Canada. A three-pronged attack in the summer of 1812, however, ended disastrously. General William Hull, appointed governor of the Michigan Territory, was forced to surrender Detroit and its fort; Generals Alexander Smyth and Stephen Van Rensselaer failed at Niagara; General Henry Dearborn never crossed

the border in his attack on Montreal. Fort Mackinac (at the juncture of Lakes Michigan and Huron) and Fort Dearborn (modern Chicago) fell to the British and their Indian allies.

Admiral Perry on the Great Lakes (1813)

In 1813, the U.S. navy managed to gain control of Lakes Ontario and Erie. Having gained command of the former, American troops again pushed northward, landing at York (modern Toronto), the capital of British Canada, in late April. The poorly organized action amounted to little more than a raid but resulted in the burning of public buildings as well as ships and materiel, destruction that would not be forgotten by British forces.

The hard-won victory of Admiral Oliver Hazard Perry (sailing under the banner "Don't Give Up the Ship") in the Battle of Lake Erie caused the British to abandon Detroit. This permitted the American army in the west, now assigned to General William Henry Harrison, to mount an overland invasion of the peninsula of upper Canada. Harrison defeated the British and Indian forces at the Battle of the Thames in September 1813. Although this clash contributed to no substantial American objective, it was a demoralizing blow to Native American forces. Tecumseh, now holding the rank of brigadier general in the British army, died in the fighting.

The Naval War at Sea

American naval victories at first compensated for disasters on land. In the first six months of the war, American frigates forced five British ships to strike their colors (lower their flags) in surrender; American privateers captured three hundred British merchantmen. The nation's spirits rose with the impressive victory of Captain Isaac Hull's U.S.S. *Constitution* over the larger British warship H.M.S. *Guerriere*. However, with the turn of the war in Europe, Britain directed its superior sea power against the United States and its commerce in 1813. By the spring of the following year, the Royal Navy had put in place an effective blockade of the chief American ports (except those of New England, which traded openly with the British).

The British Attack the United States (1814)

After the defeat of Napoleon in Europe, British forces orchestrated an elaborate three-part invasion of the United States in a concerted attempt to defeat and punish their American foes. The plan called for an invasion from Canada and attacks on the Chesapeake Bay and at the mouth of the Mississippi. Defeats on the crucial northern front—at Niagara and on Lake Champlain, where Captain Thomas Macdonough won an important naval victory (the Battle of Plattsburgh) in September 1814—undermined the strategy. The British gained a full measure of revenge, however. Admiral Sir George Cockburn's fleet easily penetrated American defenses surrounding the Chesapeake Bay, scattered the feeble force of American militia charged with defending the national capital, and, under General Robert Ross, torched the public buildings of the Federal City (justifying their action as retaliation for the burning of York). The gallant resistance Ross's men encountered at Fort McHenry prevented them from entering Baltimore. This event inspired Washington lawyer Francis Scott Key, who watched the battle from a British ship in Baltimore harbor, to compose the words to "The Star-Spangled Banner."

In the southwest, Sir Edward Pakenham's seasoned British regulars (who had been with the duke of Wellington in Spain) were unimpeded until they reached the outskirts of New Orleans in early January

1815. Between them and the city was a force of frontier militia, local residents (including "people of color"), and pirates, under the command of General Andrew Jackson. Jackson had won a complete victory over the hostile Creek tribe at the Battle of Horseshoe Bend (Alabama) in March, and then defeated the Spanish at Pensacola, Florida. From behind well-constructed earthen fortifications before New Orleans, his troops stopped a series of frontal assaults by British forces with their long frontier rifles. Although it was actually fought after the signing of a treaty of peace, Jackson's overwhelming victory at the Battle of New Orleans proved to be the most celebrated and memorable military engagement of the war. His small force suffered but eight deaths and thirteen wounded; Pakenham lost his own life, as well as those of 700 British troops (with 1,400 wounded; 500 captured).

The Hartford Convention

Opposition to the war was widespread in New England, which identified in it and the Madison administration's objectives a calculated hostility to northern and commercial interests. The state legislatures of the region refused to furnish militia for the Canadian campaigns; the banks and businesses boycotted the government's efforts to sell bonds to finance the war; New England farmers and merchants supplied British armies in Canada with meat and grain. Led in Congress by Daniel Webster, then a Federalist representative from Massachusetts, New Englanders attacked Madison's war as unnecessary; they thwarted the administration's efforts to increase revenues and raise additional troops.

Reflecting increasing dissatisfaction with the war and frustration with their minority position in the union, Massachusetts, Connecticut, Rhode Island, Vermont, and New Hampshire sent delegates to a convention in Hartford in October 1814 to consider their options. Secessionists failed, however, in their attempt to gain control of the meeting. Still, the Hartford Convention issued a report recommending seven constitutional amendments that delegates considered necessary to New England's interests. The report endorsed the doctrine of state nullification and proposed amendments do the following:

- Eliminate slaves from the population count in determining representation in the House of Representatives
- Require a two-thirds majority vote of Congress to admit new states, impose commercial restrictions, or declare war
- Limit the president to a single term and prohibit the election of two persons from the same state in succession

Had the war continued badly, as Federalists expected, the convention might have exerted influence on national events. However, the news of Jackson's victory at New Orleans and then of the signing of a peace treaty ending the war made the gathering appear to be a pointless and discordant (to some, a treasonous) episode. It was regarded then as now to be the last gasp of the dying Federalist party.

The Treaty of Ghent

The negotiations that produced the agreement that concluded the war with Britain began in Ghent, Belgium, in August 1814. John Quincy Adams, son of the former president and recently minister to Russia (1809–1814), was appointed by Congress to head the United States delegation (of five), the most notable of whom were Henry Clay and Albert Gallatin. The British government, primarily concerned with negotiations to settle the European war, sent a less distinguished delegation.

Conflicting Demands

The British negotiators were instructed in August 1814 to demand the following:
- Cession to Canada of land in Maine and northern New York
- British control of the Great Lakes
- Exclusion of American ships from the Newfoundland fisheries
- The creation of a northwestern buffer state for the Indians south of the Great Lakes

The British prolonged the negotiations as long as prospects for British troops in the field appeared favorable. American representatives initially attempted to gain all or part of Canada and British assistance in securing Florida from Spain. They resisted British demands and pressed for acceptance of the administration's position on neutral rights. Their position was weak at the outset, but news of American victories, especially the Battle of Lake Champlain (Plattsburgh), considerably strengthened their hand.

Terms of the Treaty

The agreement as finally signed provided merely for the cessation of hostilities and a return of both nations to the status quo ante bellum (conditions that existed before the war). Such questions as boundaries and fisheries were referred to commissions for future adjustment. No mention was made of maritime issues.

Postwar Nationalism

Although the peace treaty with Great Britain reflected an inconclusive result, Americans, for the most part, considered the outcome of the war favorable to the United States. The news of Jackson's remarkable victory became public before the signing of an agreement at Ghent was known, strengthening the impression that the Battle of New Orleans had been significant. The fact that the republic had survived its greatest peril and that the British military machine, which had finally conquered the great Napoleon, was unable to subdue much smaller contingents of determined Americans, appeared to confirm the nation's claim to a special destiny.

Jefferson's election put an end to the ideological struggle that had brought the new nation to the brink of civil war. In power, he fulfilled his promise to reduce government expenditures, taxes, and the national debt. He also broadened his consensus and moved it to the moderate center, gaining support from Adams Federalists and further isolating the high Federalists. Faced with challenges to his leadership and opportunities of national import, he demonstrated flexibility, making full use of the mechanisms of the central government to assert control and achieve what he regarded to be worthy republican ends.

Jefferson, and Madison after him, believed they could alter hostile British policies toward the United States by using American commerce and trade as a peaceable weapon, an alternative to war. The efforts they took to reduce America's dependency on and vulnerability to British commercial supremacy, which can be traced to the American Revolution, were ultimately defeated by events in Europe and the ironies of history. Their failed policy did have the positive, if not entirely intended, effects of allowing the new nation time to grow, of stimulating American manufacturing, and of generating a new spirit of nationalism.

Selected Reading

Ambrose, Stephen. *Undaunted Courage: Meriwether Lewis, Thomas Jefferson, and the Opening of the American West* (1997).

Banning, Lance. *The Sacred Fire of Liberty: James Madison and Founding of the Federal Republic* (1995).

Borneman, Walter R. *1812: The War that Forged a Nation* (2004).

Brown, Roger H. *The Republic in Peril: 1812* (1964).

DeConde, Alexander. *This Affair of Louisiana* (1976).

Clark, Thomas D. and John D. W. Guice. *The Old Southwest, 1795–1830* (1996).

Dunn, Susan. *Jefferson's Second Revolution: The Election Crisis of 1800 and the Triumph of Republicanism* (2004).

Ellis, Richard E. *The Jeffersonian Crisis: Courts and Politics in the Young Republic* (1971).

Fischer, David Hackett. *The Revolution of American Conservatism: The Federalist Party in the Era of Jeffersonian Democracy* (1965).

Kastor, Peter J. *The Nation's Crucible: The Louisiana Purchase and the Creation of America* (2004).

Kennedy, Roger G. *Mr. Jefferson's Lost Cause: Land, Farmers, Slavery, and the Louisiana Purchase* (2002).

Kulka, Jon. *A Wilderness So Immense: The Louisiana Purchase and the Destiny of America* (2003).

Hickey, Donald R. *The War of 1812: A Short History* (1995).

Hoffman, Paul, ed. *The Louisiana Purchase and Its Peoples* (2004).

DeVoto, Bernard, ed. *The Journals of Lewis and Clark* (1953).

Horsman, Reginald. *The Frontier in the Formative Years, 1783–1815* (1970).

Malone, Dumas. *Jefferson and His Time* (6 vols. 1948–1981).

Nelson, William E. *Marbury v. Madison: The Origins and Legacy of Judicial Review* (2000).

Newmyer, R. Kent. *John Marshall and the Heroic Age of the Supreme Court* (2002).

Perkins, Bradford. *Prologue to War: England and the United States, 1805–1812* (1961).

Peterson, Merrill D., ed. *The Portable Thomas Jefferson* (1975).

Remini, Robert V. *Andrew Jackson and the Battle of New Orleans* (1999).

Smith, Jean Edward. *John Marshall: Definer of a Nation* (1996).

Sheehan, Bernard W. *Seeds of Extinction: Jeffersonian Philanthropy and the American Indian* (1974).

Stagg, J.C.A. *Mr. Madison's War: Politics, Diplomacy, and Warfare in the Early American Republic, 1783–1830* (1983).

Zacks, Richard. *The Pirate Coast: Thomas Jefferson, the First Marines, and the Secret Mission of 1805* (2005).

Test Yourself

1) Thomas Jefferson's policy regarding Native Americans in the Northwest Territory centered on the assumption that
 a) They enjoyed a natural right to their land.
 b) They had to "civilize" themselves into white communities or move west of the Mississippi River.
 c) They had a right to "health and survival" in the region.
 d) none of the above

2) True or false: The Lewis and Clark expedition was the only expedition sponsored by the Jefferson Administration to explore the Louisiana Purchase territory.

3) The Supreme Court decided in the case of *Marbury v. Madison* (1803) that
 a) William Marbury did not deserve his commission as a judge.
 b) James Madison acted improperly in denying Marbury the commission.
 c) The Supreme Court has the power to rule on the constitutionality of congressional legislation.
 d) Only Congress can determine who should be appointed as a federal judge.

4) True or false: Thomas Jefferson doubted the constitutionality of the Louisiana Purchase and initially thought an amendment to the Constitution would be necessary to bring this territory into the nation.

5) Which of the following battles constituted a great military victory for the United States during the War of 1812?
 a) New Orleans
 b) Fort Mackinac
 c) Fort McHenry
 d) Fort Dearborn

6) True or false: Lack of American military preparedness at the start of the War of 1812 proved to be little of a problem as military victories came quickly for the United States.

7) Which of the following groups emerged as the chief supporters of the War of 1812?
 a) the Hartford Convention delegates
 b) the War Hawks
 c) the Federalist party
 d) New England merchants

8) Which of the following was a provision of the Treaty of Ghent?
 a) The British gained control of the Great Lakes.
 b) American fishing ships were excluded from the Grand Banks off Newfoundland.
 c) Both nations returned to *status quo ante bellum*.
 d) Canada ceded land along the northern border in what would become Maine.

9) Great Britain seized American merchant ships on the high seas during the Jefferson and Madison administrations because the British contended such trade by United States vessels violated
 a) the Berlin and Milan Decrees
 b) Macon's Bill No. 2
 c) the Orders in Council
 d) the Embargo Act

10) The major cause of the Barbary War was
 a) the desire of the United States to aid European nations in securing free trade
 b) a declaration of war against the United States by Tripoli
 c) Jefferson's desire to test his "mosquito fleet" in a naval battle
 d) his exasperation against the Barbary states stemming from his time as Secretary of State

Test Yourself Answers

1) **b.** Jefferson was a staunch supporter of the American farmer and frontiersman. In spite of his affinity for Native Americans, Jefferson believed that American frontier folk had a natural right to the land and did not recognize the tribes as having such. He thus believed that Native Americans either had to "civilize" to European cultural standards or move west.

2) **False.** The Jefferson Administration sponsored three different expeditions into the Louisiana Purchase territory. The one led by Lewis and Clark remains the best-known in United States history. In addition, however, the expeditions of Zebulon Pike and Thomas Freeman went into parts parts of the purchase territory south of the route traveled by Lewis and Clark. Freemen explored the Red River Valley, while Pike's expedition traveled through the central region into present-day Colorado, where a major mountain bears his name.

3) **d.** This famous decision upheld all other points noted in this question. The court held that Marbury did not deserve his commission because of a flaw in the Judiciary Act, that Madison acted properly in failing to deliver the commission, and that the Supreme Court has the right to rule on the constitutionality of federal legislation.

4) **True.** Jefferson initially believed that the Louisiana Purchase was unconstitutional. That was because Madison and Livingston had exceeded their presidential instructions in purchasing the entire territory. Jefferson was a strict constructionist and hence could not initially approve of their actions, but members of his own party convinced him to support the purchase, which he did before it was ratified.

5) **a.** The Battle of New Orleans was a significant American victory in the war. In the minds of many Americans, it legitimized the Treaty of Ghent by providing clear-cut evidence that the United States was indeed the military victor in the war. This battle also made Andrew Jackson into the major hero of the conflict. All of the other engagements noted in this question were American defeats.

6) **False.** The United States military was remarkably unprepared at the time the United States declared war against Great Britain in 1812. The army was undermanned, the Navy was poorly equipped, and the commanding general was aged and infirm. The unprepared state of the American army during 1812 and 1813 was a major problem and an impediment to military success. Eventually, General Winfield Scott took over command and, by 1814, had revamped the army. Admiral Oliver H. Perry did the same for the Navy.

7) **b.** The War Hawks were a group of political leaders, mostly from the frontier areas, who favored a war with the Great Britain. They saw such a war as a way to end British influence over Native Americans in the West, secure freedom of the seas, and—in the minds of some of them—secure Canada. They worked very hard in Congress during 1812 to have a declaration of war passed against Great Britain. Almost all of them were members of the Democratic Republican Party, hence enjoying the support of President Madison in this regard. The War Hawks were responsible for the fact that Congress declared war against Great Britain. All of the other groups mentioned in this question did not favor or support the declaration of war that brought the nation into the war of 1812.

8) **c.** The Treaty of Ghent returned all captured territory to its prewar owners, a diplomatic practice known as *status quo ante bellum*. No other provisions noted in this question were a part of the treaty.

9) **c.** The Orders in Council were the British trade decrees that prohibited foreign trade with France. Great Britain passed these in an effort to keep American merchant vessels from trading their flour with France. Napoleon countered by issuing the Berlin and Milan decrees that prohibited the same American ships from trading with Great Britain. This placed the United States and its merchant vessels in harm's way as they became the targets of both the European nations. The Embargo Act and Macon's Bill No.2 sought to deal with this situation, but both were unsuccessful.

10) **d.** The Barbary Coast nations had been demanding tribute from maritime nations whose vessels travel through the straits of Gibraltar. This had been occurring for many decades in the 18th century. Thomas Jefferson, as President Washington's Secretary of State, had been particularly concerned about this situation. When he ran for president in 1800, Jefferson promised strong action to stop United States tribute payments to the Barbary Coast nations. The other choices noted in this question were, therefore, not motivations for the Barbary War.

The Awakening of American Nationalism

1810:	Supreme Court rules in *Fletcher v. Peck*
1812–1821:	Six western states admitted to the union (Louisiana, Indiana, Mississippi, Illinois, Alabama, and Missouri)
1813:	Waltham manufacturing system introduced by the Boston Manufacturing Company
1815:	U.S. Navy defeats Algiers and Barbary States
1816:	First steamboat operates on the Mississippi; Congress charters the Second Bank of the United States and passes protective tariff legislation
1817:	Bonus Bill of 1817 vetoed by President Madison; James Monroe inaugurated president
1817–1825:	Construction of Erie Canal in New York State
1818:	Jackson's raids in Florida (ending the First Seminole War, 1817–1818); settlement of Anglo-American Convention of 1818
1819:	Adams-Onís Treaty results in acquisition of Florida; financial panic and depression begins; Supreme Court rules in *McCulloch v. Maryland* and *Dartmouth College v. Woodward*
1820:	Missouri Compromise legislated; Maine admitted as a free state; Missouri admitted as a slave state; Monroe, having won the popular vote in the election of 1820, receives all but one electoral vote
1820s–1830s:	Revisions to state constitutions introduced
1822:	United States recognizes Latin American republican governments
1823:	President Monroe proclaims the Monroe Doctrine in his annual presidential message (December)

(continued on next page)

1824: Supreme Court rules in *Gibbons v. Ogden;* Lafayette revisits the United States (1824–1825)

1825: Andrew Jackson wins plurality in the Electoral College; John Quincy Adams elected president by the House of Representatives (February)

1826: Death of John Adams and Thomas Jefferson (July 4, the fiftieth anniversary of the Declaration of Independence)

1828: Congress passes the Tariff of Abominations (May); Jackson wins presidential election

After the War of 1812, the new nation seemed to explode in movement and activity. The perception that the war had ended favorably, with the memory of the Hartford Convention, reduced the political opposition of the Federalist party to meaninglessness. The victory of James Monroe, last of the Virginia Dynasty of presidents, in the election of 1816, was followed by a period of relative political tranquility, causing many to herald an Era of Good Feelings. However, Congress' implementation of the American System, advocated by those eager to promote the emerging national market economy, soon revived what President John Quincy Adams called the "baneful weed of party strife." More ominously, owing to differences in the economic development of the country, the economic nationalists' legislative agenda also roused dormant sectional interests.

■ EXPANDING NATIONAL INTERESTS

In the aftermath of the War of 1812, Congress took action to improve the defenses of the nation. It defiantly determined to rebuild the public buildings in Washington rather than relocate the national capital. The national mood was buoyed by Jackson's victory at the Battle of New Orleans, his raids in Florida, and Decatur's dramatic exploits in the Mediterranean.

Postwar Military Establishment

Reflecting a new sense of military preparedness, Congress made provision for a standing army of 10,000 men in March 1816. President Madison, who had asked for a force twice that number, appointed Jacob Brown and Andrew Jackson to the rank of major general, to command, respectively, the northern and southern departments. Congress put the navy's gunboats up for sale and mothballed the warships used on the Great Lakes, but otherwise did not reduce the navy significantly. Coastal defenses were improved, the coast guard was enlarged, and new warships were built.

Decatur's Victories

After the treaty with Britain had been ratified in 1815, Congress declared war on Algiers, which had resumed its attacks on American shipping and declared war on the United States. Captain Stephen Decatur, commanding one of two squadrons sent to the coast of North Africa in 1815, won a series of engagements with the Barbary corsairs. He imposed a blockade on Algiers and dictated terms to its ruler, the Dey. By treaty, Algiers ended its demands for ransom and tribute and agreed to pay reparations to the United States. Decatur exacted similar agreements from the rulers of Tunis and Tripoli. The U.S. navy's actions in establishing American principles of freedom of the seas were widely celebrated as a great national victory and encouraged American merchants in their overseas ambitions.

The Advancing Frontier

A new pulse of westward migration began at war's end, bringing waves of settlers into the interior. This movement brought renewed pressure for expansion of the nation's borders and the opening of the frontiers for settlement. In Washington, President Monroe, who took office in March 1817, envisioned a continental destiny for the United States. He was encouraged in this by his Secretary of State, John Quincy Adams.

The Rise of the New West

The population of the United States grew dramatically in the first twenty years of the nineteenth century by more than 80 percent, from 5.3 million to 9.6 million. As of 1820, almost 2.5 million Americans, or 25 percent of the total population, lived in regions west of the Appalachians; that number more than doubled over the subsequent ten years. Six new western states joined the union between 1812 and 1821: Louisiana, Indiana, Mississippi, Illinois, Alabama, and Missouri. After reapportionment in 1822, the new west held 47 of 213 seats in the House of Representatives, 18 of 48 seats in the Senate. There were many reasons for the great westward migration across the mountains, all in some way related to the fact that there were rich and abundant lands in the interior. Knowledge of their availability at cheap prices became a factor in the older and more settled areas of the eastern seaboard, where the growth of towns and cities caused land to increase significantly in value (producing a profit for some; impossible prices for others). In many areas of the older plantation South, where farmland had been exhausted by staple crop agriculture, whole families (including slaves) migrated to the new states of the southwest territory, which is today the Deep South.

THE ROUTES OF WESTWARD MIGRATION
1815 - 1825

Native American Removal

Following General William Henry Harrison's victories over the Native Americans of the Northwest Territory during the War of 1812, several treaties were concluded to open lands in Michigan, Indiana, and Illinois for settlement. Native Americans were forced to migrate to lands west of the Mississippi River. In the southwest, action was taken in July 1816 against hostile Seminoles and runaway slaves, who were in possession of Fort Apalachicola in Spanish East Florida; this precipitated the First Seminole War (1817–1818).

Florida and the Trans-Continental Treaty of 1819

Command of American forces in the region was given to General Andrew Jackson in late 1817. He pursued the Seminoles into Florida, capturing Spanish forts in the process. During this campaign, he also court-martialed and executed two British traders for having aided the Seminoles. Jackson's raids were popular at home, but were the cause of outrage abroad. They enabled Secretary of State Adams, who defended American actions as self-defense, to convince the Spanish that they could no longer effectively hold their colony.

Pressured by Adams, Spain agreed to cede Florida on condition that the United States would assume the unpaid claims of American citizens against Spain up to the amount of $5 million. The terms of the Adams-Onís Treaty of 1819 also provided for Spain to abandon its claims to the region north of California and east of the Rocky Mountains to the United States. The United States abandoned the somewhat spurious claims to Texas made by some Americans, including Henry Clay, who contended that region had been included in the Louisiana Purchase.

Independence Movements in Latin America

The early 1820s witnessed various successful independence movements in Spanish-speaking America as liberation created almost one dozen republics that replaced Spanish colonialism in the new world. This process began with a revolt in Bolivia in 1809, although this colony did not become fully independent until 1825 after some sixteen years of struggle. Several other Central and South American Spanish colonies also threw off their bonds of colonialism as well: Argentina (1816); Bolivia (1825); Chile (1818); Colombia (1819); Guatemala (1821); Mexico (1821); Peru (1821); and Venezuela (1821). Henry Clay became an early advocate in 1818 of recognizing the independence of the Latin American republics. It was his hope that a flourishing trade and commerce could be established in the Western Hemisphere, with merchants in the United States providing the lead for this economic transformation. President Monroe and Secretary of State Adams had also adopted this policy by 1822, when the United States extended diplomatic recognition in that year to Argentina, Chile, Peru, Colombia, and Mexico.

The Anglo-American Convention of 1818

American interests in the Pacific Northwest were safeguarded in an agreement with the British government providing both that the northern boundary of the United States west of the Lake of the Woods was the 49th parallel to the Rockies and that the Oregon country was to be held in joint occupation for ten years and renewable thereafter. At this time, the region was principally of interest to companies engaged in the fur trade.

■ THE EMERGING NATIONAL ECONOMY

The economy of the United States before the War of 1812 was largely shaped by geography and its extensive river systems. Time and space worked against the creation and expansion of interregional markets, crucial to the prosperity of new inland settlements. In the years after the war, transportation projects and innovations, funded by private and public funds, refashioned nature and laid the foundations for a national market economy. To encourage this development, Congress passed legislation to regulate banking and encourage domestic manufacturing.

The Transportation Revolution

By cutting off the overseas and coastal trades, the embargo and the blockade put in place by the British in 1813 had demonstrated the inadequacies of the nation's roads and waterways for economic and military purposes. The economic premium placed on improvements in transportation stimulated private and public schemes for roads, canals, and related technological improvements.

Internal Improvements

The rapid growth of the nation's population, particularly in the new western and southwestern regions, increased pressure for direct government support of internal improvements. Most championed were turnpike and canal projects. Funds for such improvements had been budgeted during the Jefferson administration and used to construct the National or Cumberland Road, from Cumberland, Maryland, to Wheeling on the Ohio River (1811–1818).

The Bonus Bill of 1817. Despite sectional rivalries and states' rights prejudices, Congress passed a bill proposed by John C. Calhoun to set aside the bonus ($1.5 million) owed the government by the Bank of the United States to create a permanent fund for internal improvements. "Let us bind the republic together with a perfect system of roads and canals," he implored. "Let us conquer space." Madison (although supportive of internal improvements) vetoed the bill in the last days of his presidency. He believed, as Monroe would after him, that such measures required a constitutional amendment.

State-Supported Improvements. Most of the new roads and canals that were constructed were financed by state appropriations and private capital. New York started work on the Erie Canal in 1817. Upon its completion in 1825, the Great Lakes were linked to New York City and the flow of trade redirected. The project was a financial success well before work was finished.

More Canals and Turnpikes. The example of the Erie Canal stirred other states, mercantile interests, and entrepreneurs to frenzied action. They realized that they were in competition for the nation's trade and wealth, so only by improving roads and waterways could they hope to bring the produce of the interior to their depots. Pennsylvania aided turnpike companies and canal promoters, notably to extend the Lancaster Pike, connecting Pittsburgh to Philadelphia—but with less financial success than other similar projects elsewhere, largely because of geographical factors. New Jersey, Maryland, Virginia, Ohio, and Indiana supported similar projects.

Toll roads and canals made travel much easier and more comfortable, but freight still had to be transported by cart (or barges on canals) and animals. Inland freight transportation, particularly for heavy

finished goods, made little progress against river currents. The solution of this grudging problem in the ongoing assault on space was left to the railroad.

Steamboats. Because it was common knowledge that, for farmers and merchants alike, prosperity depended upon how fast producers could get their goods to market, it is not surprising that inventors and entrepreneurs made many efforts to improve travel by horse-drawn stage and sailboat. The financial rewards for increased speed were substantial.

Steam-powered carriages and vessels had lived in inventors' dreams for more than a century before the steamboat was first made practicable by John Fitch in Philadelphia in 1790. The invention was improved by the trials and errors of several others and commercially developed by Robert Fulton and his wealthy backer, Robert R. Livingston. The steamboat proved difficult to perfect owing to the different requirements of the several river systems and the ocean. No one before Fulton had the capital and entrepreneurial skills required to make it a financial success. Steamboats were most noticeably a factor in the quickening economic activity on the western waters of the Ohio and Mississippi valleys, where (after their introduction in 1816) some seventy boats were in operation by 1820.

Effects of the Transportation Revolution

Expansion and improvement of roads and waterways, aided by the development of new and faster vessels, made it possible for farmers and merchants to reach new and more distant markets. Greater and easier access to markets led in turn to regional specialization and interregional interdependency. Southern planters concentrated more and more on supplying cotton to British (and New England) textile producers. New England turned more and more to manufacturing. The Northwest sold foodstuffs to both regions. By modern standards, each region remained to a considerable extent self-sufficient.

National Finance

For the national economy to expand productively, it had to have an adequate supply of currency and credit. During this period, the Treasury Department did not issue paper money or certificates—financial sources for expansion had to be gained elsewhere. Commercial and business investment depended on paper bank notes issued by state banks (redeemable for hard currency on demand) and on the credit extended by mercantile firms for commercial and business transactions. To resolve these inadequacies, the nationalists, much like Hamilton before them, sought to establish a national system of finance.

The Banking System

After Congress failed to re-charter the Bank of the United States (1811), state-chartered banks increased rapidly, from 88 in 1811 to 246 in 1816. Only Massachusetts exercised control over the quantity of bank notes that such banks were permitted to issue. The demand for credit in the first years of peace was enormous. By 1816, the amount of currency in circulation was twice as large as it had been five years earlier.

Second Bank of the United States

To curb what were perceived to be loose banking practices by state banks and to check further inflation of the currency, Calhoun and Clay joined in securing a congressional charter for a second Bank of

the United States (1816). One fifth of its capital stock was subscribed by the federal government, while more than 31,000 citizens purchased the remaining four-fifths. Through the issue of its own notes, the national bank (the Bank of the United States, or B.U.S.) managed to compel state banks to limit their issues and to honor them at full face value.

The Panic of 1819

Alarmed by the high level of speculation in the purchase and sale of western land, which state banks fueled with easy credit, the B.U.S. took steps to contract the supply of paper bank notes in circulation. This action increased demand for redemption of bank notes in hard currency, which drained the under-capitalized resources of many state banks. The resulting deflation in prices set off a financial panic that produced a long and severe depression, with many losses, failures, and bankruptcies.

In the western and southern states, which were particularly hard hit, the B.U.S.'s action was bitterly resented. Anti-bank and debtor relief movements grew, transforming state and local politics. Congress provided some relief in 1820 and 1821. Prices for new land were reduced to encourage outright purchases. Distressed purchasers were credited with reductions in price and given extensions for installment payments.

The Growth of American Manufactures

Restrictions on international maritime trade under the embargo and the wartime blockade forced the United States to become more self-sufficient economically. Demand for domestically produced manufactured goods diverted capital investment from trade into industry and stimulated technological innovation. Without foreign competition, prices for such American goods had remained artificially high throughout the war. Manufacturing, particularly of textiles in New England, grew rapidly.

Demands for Protectionism

Following the Treaty of Ghent and the reopening of trade, the British merchant fleet returned to American ports. In an effort to take back the business they had lost, British merchants engaged in the practice of dumping their exports on the American market—they sold manufactured goods at prices below production costs so as to regain customers at the expense of American producers. Because British goods were also in many cases superior to their American counterparts, such predatory pricing threatened doom for fledgling American businesses.

Domestic manufacturers lobbied Congress for protection, demanding that a high tariff or duty be placed on certain foreign goods entering the home market. Manufacturers of textiles in New England and of iron and metal goods in the Middle Atlantic States were joined by growers of hemp in Kentucky and by sheep raisers in Ohio, New York, and Vermont to form a protectionist coalition. Farmers and those tied to commercial agriculture—who either exchanged their produce for, or purchased, finished goods, and consequently preferred the lowest prices possible—generally tended to oppose tariff protection.

The Tariff of 1816

Protectionism enjoyed wide support in Congress immediately after the war, even among southerners, notably John C. Calhoun. The development of the home market, it was believed, would make the United States economically independent of Europe, benefiting all regions of the country.

The tariff legislation that passed in 1816 set high duties on selected woolen and cotton goods. New England's cotton manufacturers were thus able to retain domination of the market for coarse cotton fabrics. Still, woolen and cotton goods remained the nation's principal imports (amounting to 29 percent of the total in 1821).

Beginnings of the Factory System

The stimulus given to manufacturing also had an effect on methods of production. The domestic system of assembling products, whereby different components or processes were put out to workers in their homes, gradually died out. Instead, various manufacturing functions were brought to a single site: the factory or mill.

The movement to a factory system of production was made possible by two innovations. Eli Whitney, of Connecticut, introduced the system of interchangeable parts (a concept of mass production) to manufacturing. By 1799, he was making pistols by assembling component parts, fabricated by machine tools. In 1813, three merchants, Francis Cabot Lowell, Patrick Tracy Jackson, and Nathan Appleton, who had formed the Boston Manufacturing Company, brought cloth production into one factory in the town of Waltham, Massachusetts. Here, the entire process of spinning and weaving was accomplished by machines, driven by water power.

The Lowell Experiment

Although some of the new manufacturing concerns recruited whole families as factory workers, the methods introduced by the Boston Manufacturing Company proved to be the most widely influential. The new mill they established at Lowell, Massachusetts, was operated by young unmarried women, who lived closely regulated lives, residing in well-managed boardinghouses. These factory girls worked long and tedious hours for relatively low wages, but, except for the nature of the grouping, the conditions they encountered at Lowell and similar sites were probably not much different (and in some ways better) than those they knew on the New England farms. The decline of farming in New England caused many farm boys to go to sea or look for work in towns. The choices for their unmarried sisters were few, usually domestic service of some kind.

At this stage in the development of the American factory system, when labor was scarce, manufacturers sought to attract workers and provide them with a better alternative. Work conditions in Britain and Europe were decidedly different. There, where labor was not scarce, workers were generally exploited and not infrequently brutalized.

■ THE MARSHALL COURT

During John Marshall's long tenure as chief justice of the Supreme Court, the judicial branch became coequal with the legislative and executive branches. The decisions reached by the Court during this period enhanced the power of the national government and expanded the realm of property rights. The Court's rulings reduced the authority of the state governments, eliciting resentment from those who subscribed to the states' rights philosophy of the Kentucky and Virginia resolutions.

The Chief Justice's Influence

Marshall, a Virginia Federalist and the disciple and biographer of George Washington, came to the high court at a time when the judiciary was weak and its constitutional role still in doubt. The Court's powers had barely been sketched in the final version of the Constitution (Article III); an attempt made during the Constitutional Convention to specify that its right of judicial review had been defeated. Like Hamilton, Chief Justice Marshall saw the Constitution as a framework for the construction of a nation, not as a sacred document that delimited the sphere of government. He also used the powers of the federal judiciary to prevent national economic development from being hindered by the several state legislatures and court systems.

Marshall was a dominating intellect and figure on the Supreme Court, serving from 1801 to 1835. Although Republicans held the presidency continuously during his tenure, and Jefferson and Madison made six appointments to the Supreme Court, the chief justice continued to win over his colleagues to his views. He wrote 519 of the 1,106 opinions the Court handed down during his time on the bench.

Asserting the Court's Jurisdiction

Marshall rejected states' rights theories, repeatedly holding that the Constitution was not a mere compact among sovereign states. His decisions effectively established the principle of judicial review and the Supreme Court's preeminent role as interpreter of the constitution and arbiter of disputes in the American court system.

Marbury v. Madison (1803)

In this signal decision, the Court struck down a provision of the Judiciary Act of 1789. In effect, it asserted its authority to review Congress's use of its constitutional power to define the functions and jurisdiction of the federal judiciary (Article I, Section 8).

Other Major Decisions

In *Fletcher v. Peck* (1810), the Court struck down an act of the Georgia legislature, finding that it conflicted with the Constitution's mandate that the states make no laws "impairing the obligation of contracts." Although the Court had previously stated its opinion concerning the constitutionality of state laws, this was the first time the Court had rendered such an act void. In *Martin v. Hunter's Lessee* (1816), the Court strongly maintained its appellate jurisdiction over the state courts when decisions were challenged on the basis of conflict with the federal Constitution. The principle was reasserted in *Dartmouth College v. Woodward* (1819) and, particularly forcibly, in *Cohen v. Virginia* (1821).

The Power of the Federal Government

In its review of state and federal legislation, the Marshall Court regularly applied the doctrine of implied powers first invoked by Hamilton. The Court used the doctrine with great consistency to sanction the national government's powers to act in matters not specified in the Constitution.

In *McCulloch v. Maryland* (1819), Marshall, speaking for the Court, upheld the constitutionality of the second Bank of the United States, finding that it fell within what was "necessary and proper" for

Congress to do in fulfilling its responsibility to coin and borrow money. He denied the right of the states to restrict the Bank's activity by taxing it, stating, in words borrowed from the argument of counsel Daniel Webster, that the power to tax contained the "power to destroy."

In *Gibbons v. Ogden* (1824), Marshall, for the Court, declared invalid a monopoly granted by New York State for the operation of steamboats. His far-reaching decision defined Congress's power to regulate so broadly that it embraced a large part of intrastate as well as interstate and foreign commerce. Commerce was not simply "traffic" but "every species of commercial intercourse." This decision was particularly significant for the growth of the nation's economy, permitting the development of regional and national markets and denying states the ability to direct the flow of business.

The Protection of Property

The Marshall Court carefully scrutinized legislation that seemed hostile to property interests, particularly the acts of the states. State legislatures, tracing their origins to the colonial assemblies, had continued to be active in economic matters. For example, they continued to make grants of monopolies, or exclusive rights, to inventors after Congress had passed federal patent legislation (1790, 1793).

Fletcher v. Peck (1810) had effectively established the principle of the "sanctity" of contracts, also holding that "a grant is a contract." In the Dartmouth College case, the Court held that the charter of Dartmouth College, granted by King George III, was a valid contract and therefore could not be altered by the state of New Hampshire against the will of the college. In *Craig v. Missouri* (1830), Marshall offered a strict interpretation of the constitutional provision prohibiting the states from issuing bills of credit, thereby protecting creditors from an inflationary scheme.

■ THE "ERA OF GOOD FEELINGS" AND ITS AFTERMATH

After the War of 1812 the Federalist party's opposition to Republican administrations completely collapsed, giving the appearance of an Era of Good Feelings. In 1820, President James Monroe was re-elected with only one dissenting vote in the Electoral College—that of William Plumer of New Hampshire, who believed the first Monroe administration had indulged in wasteful extravagance.

A strong nationalist, Monroe continued to be guided by precedents established in the Washington and Jefferson administrations, in which he had served. In fact, Monroe even continued to dress in eighteenth-century style. The president consciously worked to promote harmony, still believing, like his predecessors in office, that political partisanship was dangerous to the republic.

The Missouri Compromise

Sectional differences related to the institution of slavery had been a major obstacle in the Constitutional Convention and a source of friction in the first Federal Congresses. After a period of dormancy, they re-emerged in 1819 like "a fire bell in the night," as former President Jefferson put it.

The Tallmadge Amendment

When the territory of Missouri had applied for admission to statehood and a bill to that effect had been introduced, James Tallmadge of New York rose in the House of Representatives in February 1819

and proposed an amendment that threatened to disturb the numerical balance between slave and free states in the union. Slavery had been established in Missouri since its early settlement, and the proposed state constitution provided for the protection of property (implying property in slaves as well). Tallmadge proposed the gradual emancipation of slavery in Missouri by prohibiting the introduction of additional slaves and specifying that all children born to slave parents within the state would be free at the age of twenty-five. The House passed the amendment; the Senate rejected it. The Tallmadge amendment touched off a heated controversy, which the few remaining elected Federalists and some northern Republicans attempted to exploit at the expense of the Virginia Dynasty, meaning the succession of Presidents who had been natives of that state including Washington, Jefferson, Madison, and Monroe.

Sectional Compromise

The Missouri question was resolved in 1820 after Maine (then a part of Massachusetts) applied for statehood. Engineered by Henry Clay, the Missouri Compromise provided for the admission of Missouri to the union as a slave state and of Maine as a free state, thus keeping the number of slave and free states in balance. Congress also legislated the principle that slavery was excluded from all of the territory embraced by the Louisiana Purchase north of latitude 36°30´, except in Missouri itself. The nationalist mood of the country contributed to the desire for a resolution of the question by compromise.

The Monroe Doctrine

A renewal of European interest in the western hemisphere and a revival of European colonial ambitions caused the administration to adopt a vigilant nationalist foreign policy. In his presidential message of 1823, the president declared the position of the United States on European interference in the Americas, which, over time, became known as the Monroe Doctrine.

The Diplomatic Background

Following the end of the Napoleonic Wars in Europe, Spain's colonies in Central and South America took up arms in attempts to win their independence. The United States adopted a policy of neutrality, but with public sentiment in America supportive of the patriot cause, the U.S. took positions that had the effect of favoring the new republics. The federal government did not, for example, prevent the revolutionaries from purchasing armaments and material in the United States. Monroe and Secretary of State Adams attempted to enlist Great Britain's support for recognition of Latin American governments, but, failing in this, the administration in 1822 gave official recognition to Colombia, Argentina, Peru, Mexico, and other states.

At the Congress of Verona (1822), the representatives of the Quadruple Alliance (Russia, Austria, Prussia, and France) had considered a scheme that had as its goal the re-colonization of Spain's former colonies in America. They had previously united to re-establish monarchies in Europe. Great Britain, which enjoyed a lucrative trade with the former Spanish colonies, refused to participate in such a policy. George Canning, the British foreign minister, suggested in 1823 that the United States join Great Britain in opposition to the intervention in Latin America—a proposal that gained the support of former presidents Jefferson and Madison. Britain's refusal to extend official recognition to the new republics remained an obstacle to such collaboration. Canning began to back away from his proposal after the French government pledged not to intervene in Latin America.

John Quincy Adams's Recommendations

Throughout his long career in diplomacy, Secretary Adams had been a strong nationalist and ardent expansionist. He and Monroe subscribed to the policy declared by President Washington (and his successors) against entangling alliances and disliked the idea of putting the United States in the position of appearing a "cock-boat in the wake of the British man-of-war."

Adams took the threat of the Quadruple Alliance seriously. He particularly feared that its intervention in Latin America might provoke Britain to take Cuba, which he believed in the natural course of things would join the United States ("an apple severed by the tempest from its native tree cannot choose but fall to the ground"). He was also alarmed by the Russian Czar's Edict of 1821, in which the boundary of Russian Alaska was extended southward to the 51st parallel (within the Oregon country) and the western coast of North America was identified as a possible field for future Russian colonization. Adams believed the British proposal for collaboration presented the administration with an opportunity to make a bold statement concerning the differences between the new world and the old. Confident that the British government would support the United States in any event, Adams urged Monroe to independent action.

Monroe's Message to Congress and the Doctrine (1823)

Monroe heeded Adams's advice and chose to announce the Monroe Doctrine in his presidential message of December 1823. In this communication, he advised European powers of the following:

* That the North and South American continents were not to be considered fields for future colonization
* That the attempt by any European monarchy to extend its political system to the western hemisphere would be regarded as dangerous to the peace and safety of the United States
* That the United States had no intention of interfering "in the internal concerns" of the European powers.

Although the Monroe Doctrine was, in fact, merely a presidential proclamation of the national right of self-defense, it had important implications for American foreign policy. After years of indecision and vacillation in matters relating to the Latin American republics, the United States had found a clear and understandable basis for defining its national and hemispheric interests.

The ability of the United States to enforce the Monroe Doctrine in this period was limited; however, it did have an effect on the weaker European powers. In 1824, only months after the publication of Monroe's message, the Czar backed away from his earlier position and abandoned Russia's claim to the Oregon country.

Revival of Party Strife

Beneath the surface calm of the Era of Good Feelings, there were growing divisions. New political factions were forming, primarily in response to the depression caused by the Panic of 1819 but also in reaction to the centralizing and activist policies of the national government. A variety of interests began to coalesce under the banner of states' rights.

The Election of 1824

The congressional caucus system had generally determined the nominees in presidential elections prior to 1820 (when Monroe was virtually unchallenged). In 1824, however, the nominee of the Republican caucus,

Secretary of the Treasury William H. Crawford, of Georgia, who fell ill shortly after his nomination, was opposed by three other candidates put forward by their respective states: Andrew Jackson of Tennessee, Henry Clay of Kentucky, and John Quincy Adams of Massachusetts.

Crawford had the support of states' rights advocates. Jackson had served in both houses of Congress and was celebrated as a military hero, but he took no clear stand on political issues. Clay ran on his proposals to revive the nation's economy and build a domestic market. His American System called for spending on internal improvements, protection of domestic manufacturing by means of the tariff, and support for the Bank of the United States. Adams had an impressive record as a diplomat and statesman but no broad political appeal; like Clay he was strong on economic issues.

The House of Representatives Decides the Election of 1824

Jackson won a plurality of the popular vote, but he fell short of a majority in the Electoral College, receiving 99 votes (Adams won 84, Crawford 41, Clay 37). The election was thus thrown into the House of Representatives, where Clay gave his support to Adams. When Jackson learned that Clay had been named Secretary of State (by tradition the heir apparent to the presidency), he was persuaded that a political deal between Adams and Clay had robbed him of the office. His supporters denounced the arrangement as a "corrupt bargain" and determined to ensure his election in 1828. Jackson obliged them by beginning his campaign during Adams's first year in office. No evidence was presented to document the charge of corruption, but both Adams and Clay continued to be haunted by it.

Democrats and National Republicans

The Jacksonian leaders promoted a cult of personality for their hero, called Old Hickory. A coalition that gradually resembled a political party formed around his candidacy, and the great house of the Republican party began to fall apart. Calhoun, now vice-president, Crawford, and Martin Van Buren joined the anti-Adams forces after 1824, and, using the name Democrat, emphasized their return to fundamental Jeffersonian principles. Republicans who continued to support the administration called themselves National Republicans and embraced the nationalistic program of Clay and Adams.

John Quincy Adams as President (1825–1829)

John Quincy Adams was perhaps the most intelligent and learned man ever to serve as president of the United States. However, he lacked the attractive personal qualities that increasingly formed a requirement for popular support. His strongly nationalist agenda included proposals for spending on roads and canals and the construction of warships to strengthen national defense. He also revived Enlightenment ambitions in advocating measures to promote information, knowledge, and learning, and to improve and enrich the nation culturally by means of legislative and administrative initiatives directed from Washington.

Adams had an array of political enemies in Congress and within the executive branch before he took the oath of office. Nevertheless, he refused to remove government officeholders and clerks who owed their appointments to his political opponents if they were competent. His sincerity and seriousness of purpose sounded a high but discordant note in the new age of rough-and-tumble politics and increasingly bitter partisanship.

The Adams administration never enjoyed good relations with Congress. The Senate fell into extended bickering over his proposal to send two delegates to the Panama Congress of Latin American republics, which had been called by the patriot leader of Venezuela, Simon Bolivar, in 1826. Many southern representatives and senators did not want delegates from the United States to deal with black diplomats, from places such as Haiti, on a basis of equality. Nonetheless, the Congress narrowly approved the mission, although the American representatives failed to reach the Congress before it adjourned, due to delaying tactics employed by Jackson's supporters. The campaign to discredit the Adams administration played a large role in the political maneuvering that brought about the tariff of 1828 (also called the Tariff of Abominations; see Chapter 9). The rates in that tariff were set at extraordinarily high levels, in part to create a dilemma for the president. He nevertheless signed the bill.

Adams took a particularly unpopular stand in opposing the state of Georgia's effort to remove the last Creek Indians from lands within the state. He determined to uphold the good faith of the federal government, which had guaranteed the Indians' possession of their land under a 1791 treaty. Georgia had gained their approval to another agreement in 1825, but Adams believed it had been obtained by fraud. The confrontation, a unique episode in early Indian relations, ended in 1827 when the Creeks signed an enforceable agreement with the state.

Prior to the War of 1812, Americans perceived their republican experiment as an international event, a manifestation of the Enlightenment values and ambitions that shaped the culture of the late eighteenth century. Significantly, the principal front of the first United States capitol (designed 1793) had faced east, toward Europe. The expectation that America's experiment would inspire a new republican order in Europe was unfulfilled, however, first by Napoleon and, after his defeat, by the revival of the European monarchies.

Not surprisingly, after the happy conclusion of the War of 1812 and in the face of Europe's exhaustion, a new sense of American independence arose. The nation's attention shifted to the settlement and development of the interior; its thinking became more continental, its culture and speech more Americanized. The visit of the marquis de Lafayette in 1824 and the death of both Adams and Jefferson on July 4, 1826, confirmed Americans in their belief that the United States had a special destiny.

Selected Readings

Ammon, Harry. *James Monroe and the Quest for National Identity* (1990).

Bemis, Samuel Flagg. *John Quincy Adams and the Foundations of American Foreign Policy* (1949).

Bernstein, Peter L. *Wedding of the Waters: The Erie Canal and the Making of a Great Nation* (2005).

Billington, Ray Allen. *Westward Expansion* (1974).

Cunningham, Noble E. *The Presidency of James Monroe* (1996).

Dangerfield, George. *The Era of Good Feelings* (1963).

Dublin, Thomas. *Women at Work: The Transformation of Work and Community in Lowell, Massachusetts, 1826–1860* (1979).

Green, Constance McLaughlin. *Eli Whitney and the Birth of American Technology* (1956).

Horwitz, Morton. *The Transformation of American Law, 1780–1860* (1977).

Hunter, Louis T. *Steamboats on the Western Rivers* (1949).

Jeremy, David J. *Transatlantic Industrial Revolution: The Diffusion of Textile Technologies between Britain and America, 1790–1830* (1981).

Larson, John Laurtiz. *Internal Improvement: National Public Works and the Promise of Popular Government in the Early United States* (2001).

Linklater, Andro. *Measuring America: How an Untamed Wilderness Shaped the United States and Fulfilled the Promise of Democracy* (2002).

Mayo, Bernard. *Henry Clay: Spokesman of the New West* (1937).

McCoy, Drew. *The Last of the Fathers: James Madison and the Republican Legacy* (1991).

Murphy, Gretchen. *Hemispheric Imaginings: The Monroe Doctrine and Narratives of U.S. Empire* (2005).

Nagle, Paul. *John Quincy Adams: A Public Life, A Private Life* (1997).

Nevins, Alan, ed. *The Diary of John Quincy Adams, 1794–1845* (1951, 1969).

Remini, Robert V. *Henry Clay: Statesman for the Union* (1993).

Scheiber, Harry N. *Ohio Canal Era* (1969).

Schivelbusch, Wolfgang. *The Railway Journey: The Industrialization of Time and Space in the 19th Century* (1987).

Taylor, George Rogers. *The Transportation Revolution, 1815–1860* (1951).

Turner, Frederick Jackson. *The Rise of the New West* (1906).

Ware, Caroline F. *The Early New England Cotton Manufacture* (1931).

Way, Peter. *Common Labor: Workers and the Digging of North American Canals, 1780–1860* (1997).

Wiltse, Charles M. *John C. Calhoun: American Nationalist, 1782–1828* (1944).

Test Yourself

1) The Adams-Onís Treaty of 1819 provided that
 a) the Louisiana Purchase territory contained parts of Texas
 b) Spain would cede to the United States all claims to California
 c) American title to Florida would come to the United States without financial costs
 d) none of the above

2) True or false: As a southern Senator, John C. Calhoun of South Carolina supported the creation of the Second Bank of the United States and the protective Tariff of 1816.

3) The Missouri Compromise provided for all of the following provisions, except
 a) the admission of Missouri as a slave state
 b) the admission of Maine as a free state
 c) that all children born to slaves in Missouri would be free
 d) slavery would be prohibited north of a line drawn at 36°30´.

4) Which of the following candidates in the election of 1824 received the smallest number of electoral votes?
 a) Henry Clay
 b) Andrew Jackson
 c) John Quincy Adams
 d) William Crawford

5. Which of the following was not employed by the Jacksonian faction in the Congress as a source of political controversy for the purpose of discrediting President John Quincy Adams?
 a) the Panama Congress of 1826
 b) the Tariff of 1828
 c) opposing Georgia's efforts to remove the Creek nation from its state
 d) federal spending on roads and canals

6) Under Chief Justice John Marshall the Supreme Court expanded nationalism and created a positive atmosphere for business development, especially in the case *Fletcher v. Peck* (1810), which established that
 a) the right of interstate commerce belongs to the federal government
 b) states cannot issue bills of credit
 c) one level of government in the federal system cannot tax another level
 d) all legal contracts have sanctity at law and are inviolate agreements

7) True or false: The Panic of 1819 was a depression that hit the western and southern regions of the country particularly hard, thus resulting in a growing hatred in those areas of the Second Bank of the United States, which residents there saw as a cause of the hard times.

8) Eli Whitney had a significant impact on the development of the factory system in the United States because he invented
 a) the water mill loom
 b) the concept of interchangeable parts in manufacturing
 c) the machine process of spinning and weaving
 d) the concept of the factory town

9) Which of the following was not an influence on James Monroe and John Quincy Adams as they developed the Monroe Doctrine during 1823?
 a) the threat of the Quadruple Alliance
 b) the Russian Czar's Edict of 1821, extending the boundary of Alaska far to the south
 c) that Great Britain might move to possess Cuba
 d) the desire to support Simon Bolivar's independence movement in South America

10) Which of the following was a notable and successful example of state-level support, instead of that from the federal government, for internal improvements and transportation development?
 a) the Bonus Bill of 1817
 b) the Cumberland Road
 c) the Erie Canal
 d) the Wilderness Road

Test Yourself Answers

1) **d.** This treaty contained none of the responses noted in this question. Its major provision was the drawing of a boundary line between United States and Spanish territory in the West. The treaty also gave the United States title to Florida, for which the United States made payments to Spain.

2) **True.** In the year following the war of 1812, John C. Calhoun was an ardent supporter of nationalism. He favored the creation of a national bank and a high protective tariff. During the 1820s, however, Calhoun changed his political viewpoints regarding nationalism, as he became a staunch defender of slavery, state's rights, and the South as a unique region different from the rest of the United States.

3) **c.** The Missouri Compromise had no provision that children born to slaves in the territory would be free. Although such a proposal was discussed in congressional debates, it never became part of the compromise. The Missouri Compromise did provide for the admission of Missouri as a slave state, the admission of Maine as a free state to provide balance in the Senate, and the drawing of a line at 36°30′, with the slavery being legal only to the south of that demarcation.

4) **a.** Henry Clay came in fourth. For that reason, under the provisions of the Constitution, the names of the other three candidates went to the House of Representatives. John Quincy Adams, Andrew Jackson, and William Crawford had their names submitted to the House, which would elect one of them. Many historians believe that Henry Clay intervened with his colleagues in the Congress in order to secure support for John Quincy Adams, who was elected president. Adams then appointed Clay as Secretary of State, thereby earning the political hatred of Andrew Jackson and his followers.

5) **d.** The Jacksonians supported spending on roads and canals. These public works were known as internal improvements. In particular, Jacksonians used the question of the United States participation at the Panama Congress of 1826 and passage of the tariff of 1828 as political issues to discredit John Quincy Adams and his administration.

6) **d.** Chief Justice John Marshall never missed an opportunity in his rulings to increase nationalism or to strengthen the power of American business. The case *Fletcher v Peck* (1810) dealt with the sanctity of private business contracts which, according to this decision, could be altered only by due process of law. This sanctity of contractual rights thereafter became a fundamental legal premise of the American private business economy.

7) **True.** Many Westerners engaged in land speculation during the years after the war of 1812. They bought much of their land on the time-payment plan, borrowing its purchase price from the Bank of the United States. Over-speculation greatly increase the price of land beyond its true value. In some cases, land owners owed more money on their land holdings than such was actually worth. This house of cards came tumbling down in the panic of 1819. Many people in the West and the South lost their investments. This created much hatred of the Bank of the United States, especially in the West. This western hatred of the bank would later be manifested during the presidential administration of Andrew Jackson when he dismantled it in the mid-1830s.

8) **b.** Eli Whitney invented the concept of interchangeable mechanical parts, and thus prepared the way for methods of assembly-line manufacture. Although he is more popularly known as the inventor of the cotton gin, it was Whitney's contribution as the father of the concept of interchangeable parts that had a larger impact on the development of American industry. Selling the rights to his cotton gin to others, he built a laboratory at New Haven, Connecticut. There, he first manufactured rifles using the concept of interchangeable parts.

9) **d.** Monroe and Adams had no desire to support independence movements in Latin America. They were more interested in United States' diplomatic relations with Europe than with the United States supporting the newly independent Latin American governments. For that reason, the threat of the quadruple alliance in retaking Latin American republics for Spain, Russia's territorial expansions into Alaska, and possible British designs on Cuba served as motivations for the Monroe doctrine.

10) **c.** The Erie Canal was paid for without federal funds. Instead, the State of New York constructed it in order to link New York City with the Great Lakes, by way of the Hudson River to Albany, westward across the Mohawk River Valley, to Lake Erie. The completion of this Canal in 1824 shifted much of the nation's canal shipping from the Ohio and Mississippi River Valleys from its previous downriver transit to New Orleans, instead tying these interior regions to New York City across the Great Lakes and the Erie Canal. Completion of the Erie Canal marks the rise in rise of New York City as the nation's preeminent Atlantic seaport and helped make it the largest city in the United States by the time of the Civil War. The other public works noted in this question were all projects of the national government.

Jacksonian Democracy and Whig Opposition

1828: Tariff of Abominations passes (May); Calhoun writes South Carolina Exposition and Protest

1829: Jackson inaugurated president

1830: Hayne and Webster debate the nature union (January); Congress passes Maysville Road bill (vetoed by Jackson) and Indian Removal Act

1831: Anti-Masonic party holds first national party convention (September)

1832: Congress votes to recharter of the Bank of the United States (vetoed by Jackson); Democrats hold their first national convention and nominate Jackson for a second term; Congress passes Tariff of 1832, which South Carolina nullifies, along with the 1828 tariff (November); Black Hawk War results in defeat of Sauk and Fox Indians

1833: Congress passes Force Bill (January) and Compromise Tariff of 1833 (March); South Carolina rescinds tariff nullification (March)

1833–1834: Jackson orders removal of federal funds deposited in the Bank of the United States and its branch offices and transferring them instead to banks owned and operated by his political supporters

1835: Chief Justice Marshall dies; Jackson names Roger B. Taney to succeed him

1836: Jackson issues Specie Circular (July); Van Buren wins presidency

1837: Supreme Court rules in *Charles River Bridge v. Warren Bridge;* financial panic precedes a depression (1840–1843)

1840: Congress passes Independent Treasury Act (July, repealed August 1841); presidential election between Van Buren and Whig candidate General William Henry Harrison of Indiana

(continued on next page)

1841: Harrison inaugurated (March) and dies (April); Tyler succeeds to the presidency

1842: Webster-Ashburton Treaty negotiated; Treaty of Wanghia, opening China to American trade, is concluded

The politicians who managed Andrew Jackson's campaign for the presidency in 1828 were the first to recognize the implications in the shift to direct elections. In that year, only two states still chose presidential electors indirectly in their state legislatures. The rule of King Caucus, the selection of presidential candidates in closed congressional caucuses, had ended. Popular participation dictated a new political order. Jackson's men perceived that political theater had become an integral part of the election process.

The Republican consensus collapsed in the mid-1820s, giving rise to the second party system and intense party rivalries. However, competition between the Democrats and the Whigs, unlike that between the Federalists and the Republicans, served to strengthen the bonds of union. While it flourished, the second-party system effectively contained or masked the sectional differences that grew and intensified in response to regional patterns of economic development.

■ THE AGE OF THE COMMON AMERICAN

During the 1820s and 1830s, property requirements for voting and holding office were either eliminated or lowered. These and related changes encouraged a new era of participatory politics.

Political Reforms

The growth of the New West and consequent shifts in population soon had effects on state and national politics. By the late 1820s, most states had drafted or modified their constitutions and laws so as to permit more direct popular participation in the electoral process.

Geographical Pressures

The struggle between western and eastern interests in American politics, present from the colonial period, reemerged after the War of 1812. In Congress, politics increasingly reflected the rise of the New West and political issues relating to its growth and development. In 1820, eighteen of the forty-eight members of the Senate represented western states. In the next decade, the population of these states rose from 2.2 million to 3.7 million.

The inhabitants of the western counties and frontier regions of the established eastern and southern states generally shared the outlook of the New West. They pressed for direct popular sovereignty, reapportionment of electoral districts, and greater representation in the legislatures of their states.

Writing over one hundred years ago, Harvard historian Frederick Jackson Turner argued that this frontier expansion fueled by western land created the New West as an additional political section that eventually came to rival the North and the South as politicized regions of the nation. He noted that the West was marked by characteristics of optimism, egalitarianism, and individualism. Although several generations of historians have debated—and in some cases disagreed with—this Turner Thesis, scholars agree that the westward expansion into the New West profoundly affected the United States and its national character.

Changing State Constitutions

Most of the eight new western states that entered the union before 1820 drafted constitutions that provided for frequent elections, removal of religious and property qualifications for the suffrage, and effective popular control of the executive and the judiciary. Older states followed, gradually loosening or eliminating property qualifications for voting and holding office during the 1820s and 1830s.

Changing Role of the Political Party

Coincidental with the expansion of the electorate were increases in the number of elected offices and more frequent elections. By the end of the decade, a new attitude emphasizing the positive benefits of permanent political parties had emerged. The leading exponent and practitioner of the idea was Martin Van Buren, head of the popular Bucktail faction that wrested control of the Republican party in New York from entrenched Governor DeWitt Clinton. Van Buren organized the first modern political machine in America, the Albany Regency, which, after 1824, worked for the election of Jackson.

The Election of Andrew Jackson

The politicians who ran Jackson's campaign organized supporters and formed alliances on the state and local levels well in advance of the election of 1828. They were careful to subordinate specific issues to political image-making, in order to find the broadest basis for support in casting their appeal. The growing circulation of inexpensive newspapers enabled them to reach wide audiences.

Jackson's Campaign Style

In Jackson, the new party managers had an ideal candidate: a popular military hero, western Indian fighter, and outspoken nationalist with few ideas. He was effectively portrayed as "Old Hickory," the "farmer from Tennessee," the "second Washington," and the "friend of the common man." An elaborate ceremony celebrating the victory of the "Hero of New Orleans" was staged in that city in January 1828, where the candidate was present to deliver ghostwritten speeches.

Although effective, little of the image-making had much basis in fact. Jackson had been born in poverty in western North Carolina, to be sure, but those days were well behind him. He was a lawyer and successful land speculator, a rich cotton planter, and squire of the Hermitage plantation outside Nashville, Tennessee, which was worked by more than one hundred slaves. His political managers shamelessly directed a negative campaign against President Adams, portraying him as a corrupt aristocrat. Friends of Adams struck back with personal attacks of their own directed at Jackson, but their attempts backfired. Adams himself practiced the old politics, remaining above the political fray. Jackson won a big victory in the election of 1828, carrying all of the southern and western states, Pennsylvania, and most of the electoral votes of New York—his margin in the Electoral College was 178 to 83.

Removals and Appointments

Expressing contempt for the trained expert and a belief that government could be made "plain and simple," Jackson declared his intention to remove competent as well as incompetent government clerks and officeholders. Despite his endorsement of the spoils system and the pressures to reward his supporters, during two presidential terms, the new president removed only about one-tenth of the government employees who served under him.

Jackson appointed Van Buren to what was considered the top post in his administration, that of Secretary of State. His other cabinet appointments were made to satisfy the various factions of his party. The president never established close contact with Congress, and he surrounded himself with personal friends. This kitchen cabinet contained his principal political advisors and managers: William B. Lewis (who lived in the White House), Amos Kendall, Francis P. Blair, and Isaac Hill. Jackson sought advice on a regular basis from these individuals rather than from his formal, official cabinet, causing some dissention in the regular cabinet.

A feud quickly developed between the president and Vice-President John C. Calhoun, who had presidential ambitions and several friends in the cabinet. Calhoun's support of his wife, who, along with others, engaged in a social campaign to ostracize Peggy Eaton, wife of the Secretary of War (and a favorite of Jackson), angered the president. Calhoun's fall was complete after the president was told by his advisors that at the time of the First Seminole War (1818), Calhoun, as Secretary of War, had recommended that Jackson be court-martialed for his raids into Florida. Jackson removed Calhoun supporters from his cabinet in 1831.

Democracy and Opportunity

Eager for rapid growth and expansion, the Jacksonians portrayed established economic interests as the bastions of aristocracy. They called their new political party the Democracy, and it became known as the Democratic party. Although Jackson's managers and supporters made effective use of the rhetoric of egalitarianism, the new administration pursued policies that expanded economic opportunities for the common man rather than measures to promote social reforms (civil liberties were still confined to white male citizens) or to regulate economic activities for the public good.

Western Lands and Native American Removal

Jacksonian Democrats pushed to lower the sales price for government land in the western regions and to gain easy terms for purchasers. Southern planters, in particular, coveted Native American lands for expansion of cash-crop agriculture. Jacksonians in Congress attempted to legislate a progressive reduction in the price of public land unsold after a given period. The administration opposed Henry Clay's proposal to distribute the proceeds from the sale of public lands to the states.

The Removal of Native Americans

In his first annual message to Congress, Jackson urged a speedy and complete removal of Native American tribes to the region beyond the Mississippi. As a consequence of the Removal Act of 1830, more than ninety treaties were concluded during his eight years in office to compel the remaining 60,000 Native Americans to surrender some 25 million acres in the states east of the Mississippi. Jackson did not mask his personal hatred for native peoples; he refused to recognize native lands guaranteed by previous treaties with the federal government. He even went so far as to support actions against the Cherokees taken by the state of Georgia in defiance of federal authority. He also refused to enforce the Supreme Court's ruling against the state's unilateral action in *Worcester v. Georgia* (1830).

The Trail of Tears

Several tribes resisted, and Jackson forced their removal. The Sauk and Fox under Chief Black Hawk, who had returned to Illinois, were crushed by the Illinois militia in what became known as the

Black Hawk War (1832). The Cherokee nation, which had adopted a republican form of government and taken up agricultural ways, resisted the attempt to infringe on their treaty rights. Jackson dispatched troops to force them to move westward to lands considered deserts; most Cherokees followed the Trail of Tears (on which many died) to Oklahoma in 1838.

The Seminoles likewise refused to accept a treaty of removal, and their chieftain, Osceola, fought to keep their lands. The Second Seminole War, in which the Seminoles, joined by their black allies (who had run away from the plantations of the deep South), fought a guerrilla action that lasted from 1835 until 1843, when the government gave up the effort to defeat Osceola's surviving forces. Against this background, the Bureau of Indian Affairs was formed in 1836 to administer the western reservations (which the U.S. army was to oversee).

Jacksonians and the Supreme Court

When John Marshall died in 1835, Jackson appointed a loyal political lieutenant, Roger B. Taney, to replace him as chief justice. Although Taney was by no means a dominating figure, there was an increasingly Jacksonian direction, a bias in favor of expanding economic opportunity, in the Supreme Court's decisions while he was on the bench. This trend was made clear in the case of *Charles River Bridge v. Warren Bridge* (1837), which concerned the state charters of two companies operating toll bridges over the Charles River in Massachusetts. The Court found that the first-issued charter could not exclude the competition of a second company and bridge. In his opinion, Taney modified the Marshall Court's doctrine on the sanctity of contracts, finding that the states could amend or void contracts when the public good required it.

■ STATES' RIGHTS AND THE UNION

The personal quarrel between President Jackson and Vice-President Calhoun reflected a growing constitutional crisis over the question of states' rights and federal authority. Led by South Carolina, the states of the old South became increasingly outspoken in reaction to the high tariff duties on imported goods. Jackson shifted course in attempts to maintain his political strength in the South, but when Calhoun and South Carolina threatened to leave the union, he acted decisively.

Jackson and Internal Improvements

Although Jackson had favored federal support for internal improvements prior to taking office, he altered his position once in office to gain support from states' rights advocates of the South and inflict a blow on his rival, Henry Clay. In 1830, he vetoed a bill authorizing the federal government to subscribe to the stock of the Maysville and Lexington (Kentucky) Turnpike, intended as an extension of the National Road. Echoing the veto messages of Madison and Monroe on similar subjects, he called for a constitutional amendment to resolve questions about such legislation; he asserted that the Maysville Road (to be constructed within Kentucky) was more properly a state than a federal project. Despite this stricter standard for federal funding, total expenditures on federal internal improvements increased during his administration.

Calhoun and the Tariff

Calhoun had vigorously supported the protective tariff of 1816, expecting that South Carolina would benefit from it and share in the industrial expansion of the nation. The economy of the state, however,

grew more and more dependent on cotton growing, its lands steadily exhausted for lack of crop rotation or fertilization. With the opening up of the rich lands of Alabama and Mississippi, which many South Carolinians left to work, cotton production dramatically increased, causing prices to fall. South Carolina's population growth dropped to insignificant levels and, unable to compete with the better lands of the southwest, its agricultural production declined.

Ignoring these economic factors, planters of the old South blamed their plight on the protective tariff, which increased the cost of the imported goods they bought from abroad (principally Britain). While South Carolina's economic position declined, protectionist sentiment in New England and the middle states grew.

The Tariff of Abominations (1828)

The tariff legislation of 1828 had been the product of election-year politics. Jacksonians in Congress had attempted to persuade both protectionist and low-tariff men that the president was safe on the tariff question. Southern supporters of Jackson, led by Calhoun, permitted rates to be pushed to excessive levels in certain schedules in the hope that the Adams men in New England would find the bill unpalatable and vote it down. The tactic backfired, however, leading embarrassed southern politicians to blame northern interests for the outcome.

South Carolina Protests the Tariff

Fearful that his state's hostility to the tariff might result in secession, Calhoun turned to the Virginia and Kentucky resolutions of Madison and Jefferson (1798–1799) to devise a constitutional mechanism to check the rule of the majority. He adopted and expanded upon Jefferson's concept of nullification and put forward a systematic states' rights theory of the union. The *South Carolina Exposition and Protest* was published by the state legislature, without indicating Calhoun's authorship, in 1828.

Calhoun began his tract by asserting that the Constitution was a compact among the states (or "principals"). The union they had created was merely their "agent"; they had retained sovereignty. When the constitutionality of specific legislation was in question, therefore, the states had the recourse of interposing themselves and nullifying or voiding a measure they found to be unconstitutional. A specially called state convention, embodying the state's sovereignty, could apply the remedy of nullifying and preventing the enforcement of an act of Congress within the state. The objectionable legislation could then be enforced only by ratification of an amendment to the Federal constitution, which required the approval of three-fourths of the states. If an amendment were ratified, the objecting state had the choice of submitting or seceding from the union.

Following the procedure outlined by Calhoun, the South Carolina legislature passed a series of eight resolutions declaring the 1828 tariff unconstitutional. But Calhoun, then a candidate for re-election as vice-president on the ticket with Jackson, urged his state not to attempt nullification until it could be determined what course the new administration would take in tariff matters.

The Webster-Hayne Debate (1830)

A major controversy erupted in the Senate in January 1830, when Senator Samuel A. Foot of Connecticut proposed that Congress investigate the desirability of temporarily limiting public land sales. This provoked Thomas Hart Benton of Missouri to charge that eastern manufacturing interests wished to restrict the growth and prosperity of the new western states. Eager to form a sectional alliance to defeat

the tariff, Senator Robert Y. Hayne of South Carolina supported Benton, declaring that the South and the West were victims of New England's manufacturing interests.

Daniel Webster, senator from Massachusetts, took the floor to reply to Hayne's remarks, with the argument moving from the question of public lands to the constitutional basis of the union. Hayne presented Calhoun's views on state sovereignty and the doctrine of nullification. Webster, in his famous reply, rebutted them—maintaining that the states were sovereign only in their sphere. Webster asserted that the Constitution, "erected by the people," had granted the federal government superior authority in certain specified powers.

Webster asked who was to decide the constitutionality of federal laws. The answer? The Supreme Court, the judicial branch created by the Constitution. Webster then shifted the question from what the framers had intended, in effect admitting the historical basis for Calhoun's compact theory; he elaborated on the consequences of acceding to South Carolina's theory, which he suggested would be disunion and civil war. He concluded with the ringing words "liberty and union, now and forever, one and inseparable."

Webster's text was widely reprinted, acclaimed by former presidents Madison and Monroe as well as by the public. President Jackson, who had sent a message of congratulations to Hayne after his speech, took note. At a political dinner celebrating Jefferson's birthday a few months after the debate, at which Calhoun was also present, Jackson stunned states' rights advocates with the carefully calculated toast: "Our federal union: it must be preserved." Calhoun's reply: "The union—next to our liberty most dear."

South Carolinians closely followed the deliberations of Congress on tariff matters. In his presidential message of December 1830, Jackson recommended a decrease in tariff duties to conciliate the South but observed that the protective tariff of 1828 was constitutional.

The Tariff of 1832

On July 14, 1832, Jackson signed a new tariff act, which reduced duties to levels slightly below those set by the legislation of 1828. The reaffirmation of protectionism, however, strengthened the pro-nullification party in South Carolina, which won control of the state's legislature and quickly issued a call for a state convention to consider the momentous question of nullification.

The Nullification Controversy

South Carolina's state convention convened in November 1832. It passed an ordinance declaring the tariff acts of 1828 and 1832 null and void, thus prohibiting the collection of customs duties within the state and threatening secession if the federal government used force. The legislature made provisions for raising and arming troops and elected Calhoun, who then resigned from the vice-presidency, to the U.S. Senate. Its invitation to other state legislatures to meet in a general convention elicited only denunciations of its actions. One modern historian has called this controversy a "rehearsal for the Civil War."

Jackson and the Force Bill

In December 1832, President Jackson issued a proclamation to the people of South Carolina, declaring that federal laws could not be disobeyed, that secession was illegal, and that "disunion by armed force is treason." He stationed warships in Charleston harbor, transferred artillery to South Carolina's Fort Moultrie, and held troops in readiness. In January 1833, he asked Congress to endorse the use of military action to enforce federal laws.

The Compromise of 1833

Calhoun, aware of his state's isolated position, and Henry Clay, seeking to defuse the crisis, cooperated in pushing through a compromise. On March 2, 1833, Congress passed a new tariff law, providing for a gradual reduction of tariff rates over ten years until they reached twenty percent *ad valorem;* that is, of the value of an item. The Force Bill, authorizing the president to use the army and navy to collect duties, was enacted on the same day. Following the lead of Calhoun, South Carolina suspended, and then (in convention) rescinded, its ordinance of nullification. However, the convention reasserted the legitimacy of state action by nullifying the Force Bill.

■ THE BANK WAR AND PARTY POLITICS

During the same week that he signed the tariff of 1832, Jackson vetoed a bill that would have renewed the charter of the Bank of the United States. The fight over his presidential veto played into the skillful hands of Jackson's advisors, who successfully transformed the contest into a symbolic popular campaign against monopoly and special privilege.

Jackson and the Bank

Jackson had signaled hostility to the Bank of the United States in his first annual presidential message, citing questions about its constitutionality and effectiveness. A substantial portion of the Democratic party represented the interests of state banks, which coveted federal deposits in the Bank's branch offices and wished to be free of their supervisory interference. Others such as Jackson himself, particularly southerners and westerners, expressed provincial distrust of banks and corporations of all kinds, believing only hard money had real value. Van Buren, the mastermind of the Bank war, realized that the destruction of the Bank of the United States (B.U.S.) would benefit the financial interests of New York City and reduce those of Philadelphia.

Biddle and the Bank of the United States

Under the leadership of Nicholas Biddle, a member of a wealthy Philadelphia family who became its president in 1823, the B.U.S. had brought order to the nation's financial system, generally pursuing conservative banking policies in the national interest. The B.U.S., although a private institution, was closely connected to the U.S. government, which owned twenty percent of its stock. It was the only bank to hold deposits of federal monies. With headquarters in Philadelphia and twenty-nine other branch offices in other cities around the country, the B.U.S. exercised wide influence in the national economy. Because it regularly used its financial powers to limit the supply of bank notes issued by state banks and served to check easy credit, the B.U.S. was hated in expanding frontier regions and opposed by entrepreneurs and debtors.

The Bank had been chartered for twenty years in 1816 and did not require congressional reauthorization until 1836. It had generally remained neutral in politics, but Jackson's outspoken hostility toward the institution (and the prospect of his reelection) irritated Biddle and caused him to take a new and dangerous course. He began to lend money and extend favors to members of Congress to strengthen support for the Bank. On the advice of Daniel Webster and Henry Clay, Jackson's principal opponent for re-election, Biddle chose to push for re-charter legislation before the presidential election of 1832.

Jackson's Veto Message

The Bank bill passed both houses of Congress but was vetoed by the president in a strong message prepared by his advisors, calculated for use in the presidential campaign.

Jackson's message described an institution that had become too large, too independent, and too powerful to be given control of banking and finance in the states. He denounced the B.U.S. and its practices, accusing Biddle and the Bank's stockholders of being "a favored class," "opulent citizens" advancing their own interests at the expense of "humble members of society—the farmers, mechanics, and laborers." Even worse, Jackson observed, was the fact that "more than a fourth part" of the Bank's stock was held by foreign investors, a fact he whipped up into a threat to the nation's liberty and independence: "If we must have a bank with private stockholders, every consideration of sound policy and every impulse of American feeling admonishes that it should be purely American."

The Election of 1832

With the B.U.S. veto message, Jackson's advisors had again accurately measured popular sentiment, providing the president with a ringing, if demagogic, popular issue. By exaggerating the role of the common enemy, the Monster Bank, they also managed to keep their coalition of often conflicting component groups (such as those of hard money [meaning coinage] and state banking interests) together.

The National Party Convention

In September 1831, the Anti-Masonic party had held the first national nominating convention. Delegates met as representatives to nominate William Wirt of Maryland as their presidential candidate and drafted the first national party platform. In December, the National Republicans met in Baltimore to nominate Henry Clay for president and draft a platform. In May 1832, the Democratic party held its first national convention in the same city and re-nominated Jackson for a second term, without a platform. The adoption of the party nominating convention further increased the role of popular participation in national politics. But at the same time, it justified the role of party leaders and managers, increasingly professional politicians, and provided an enlarged arena for the political machine.

The Jackson-Clay Campaign

Henry Clay, the popular Spokesman of the West, overlooked the new power of public opinion in the presidential campaign of 1832. Misled by the passage of the re-charter legislation, the great parliamentarian confidently expected to defeat Jackson with the B.U.S. issue. Biddle directly aided Clay's campaign and used his patronage and influence to buy newspaper endorsements. Nevertheless, Jackson was re-elected by a wide margin, with Van Buren (whom the Senate had refused to confirm as minister to Great Britain) as vice-president.

The Bank and Federal Deposits

Jackson interpreted his re-election as a mandate to destroy the B.U.S., even though his stance on this issue might not have been the major reason for his re-election. Infuriated by Biddle's use of B.U.S. resources in support of Clay's candidacy, he determined to kill the institution by removing federal deposits from its control. He had to dismiss two treasury secretaries (who feared the financial consequences of the

action) before a third, the loyal Roger B. Taney, dutifully drew out the governmental surpluses. Federal funds were then deposited with selected state banks, called the administration's pet banks (on one of which Taney served as a director).

Biddle responded to the removal of federal funds by taking measures to reduce the B.U.S.'s lending and by raising its interest rates on new loans. He believed that the move was required by the reduction of B.U.S. capital, but extended and prolonged the tightening in the hope that the inevitable recession (which, indeed, came in 1833–1834) would be blamed on Jackson. Although opposition to Jackson's policies grew, Biddle's action served only to strengthen Jackson's claim that the B.U.S. and its president were too powerful and independent.

The Second-Party System

By the late 1830s, a new two-party political system structured American politics. This second-party system was profoundly different from the first in its emphasis on grass-roots organization and party loyalty. Democrats and Whigs, reflecting different concepts of growth and expansion, contested elective offices on the national, state, and local levels.

The Formation of the Whig Party

Hostility to the methods and policies of President Jackson eventually produced a coalition that formed a permanent opposition party. The Whigs declared their opposition to "King Andrew I," recalling the political tradition of the era of the American Revolution and opposition to King George III.

The party took form between 1834 and 1836. Its nucleus was one part of the old Republican party, the National Republicans of the Clay-Adams school. Other groups joining the Whig ranks included

- Fiscal conservatives who opposed Jackson's attacks on the B.U.S. and the financial system
- Native-born Americans hostile to the growing numbers of foreign immigrants (who more frequently became Democrats)
- States' rights advocates who had broken with Democrats because of Jackson's handling of the nullification controversy

Party Creeds and Loyalties

Democrats and the Whigs presented two quite different visions of the future to American voters during what became annual campaigns on the state and local levels. Still, the parties shared many ideas and beliefs, and both were continuously engaged in efforts to harmonize radical and conservative elements.

Whigs. Whigs advocated steady growth through careful nurturance. They wished to develop the national economy of the country as an integrated domestic market. They thus encouraged manufacturers and subscribed to Clay's American System. They embraced Clay's idea as well as the political issue of internal improvement. For this reason, they for some time opposed territorial expansion of the nation, believing it scattered the nation's wealth and resources and hampered economic growth. Those in the manufacturing sector, capitalists and workers, tended to support the Whig program. Whigs disputed the idea that there was an innate conflict between capital and labor (which their protectionist policies, by reducing foreign competition, tended to mute).

The Whigs believed in institutions, professed faith in church (they were overwhelmingly Protestant) and family, and decried the lack of order and stability in Jacksonian society. They were stronger in the settled communities of the nation and among the older British stock of inhabitants, but they were not in fundamental terms conservative. They generally embraced the idea of progress, accepted technological innovation, and were active in many social reforms.

Democrats. Democrats feared the consequences of consolidation of power and believed the Whig program, by increasing the value of land, would raise prices beyond the reach of the common man. Whig measures, they believed, would be detrimental to the worker and small landholder and only further enrich the monied class. Their hopes lay in a continuing process of westward expansion, a constant supply of cheap land and a safety valve for those who wished to retain their independence. In an age of boom and bust economic cycles (and no government safety nets), this remedy for hopes and disappointments had tremendous appeal.

The Democratic rhetoric of unlimited freedom attracted many groups within the rapidly expanding American population—such as those with entrepreneurial ambitions and most, but not all, non-British immigrants. To prevent the entrenchment of power and privilege, Democrats advocated a small and relatively passive national government and rotation in office. In practice, however, they pursued many of the measures advocated by Whigs, such as internal improvements, on the state level. Their rhetoric also masked their own injustices—the opportunities presented by cheap western lands, for example, were more often than not seized by land speculators and developers, who sold small portions to new settlers at marked-up prices. Democrats were not an anti-business party—they enjoyed the support of commercial, manufacturing, and farming interests that were opposed to protection and centralizing policies.

Party Factions. Both parties contained discordant elements. Democrats were divided on fiscal and currency matters. The majority supported an expansionist monetary policy and soft money (easy credit) through state banking systems. However, a significant number of Democrats (such as Jackson himself) distrusted all banks. The Workingman's party, or Locofocos, which emerged in 1834–1835 in New York and other northern cities, believed that banks fostered inflation (robbing the worker of the value of his labor) and insisted that workingmen's wages be paid only in hard currency. They also resisted technological change, fearing that new machines would eliminate jobs.

Whigs had equally contradictory elements within their coalition. Southern Whigs were advocates of states' rights and tended to be strict constructionists. The Whig party also absorbed the Anti-Masonic faction, which had formed with surprising strength in opposition to secret and privileged societies. (Their principal concern was with the secret Society of Freemasons, of which both Jackson and Van Buren were members.)

The Election of 1836

Jackson's influence was strong enough to gain the election of his hand-picked successor, Vice-President Martin Van Buren. The Whigs adopted a regional strategy, devised by Biddle, in an unsuccessful attempt to throw the election into the House of Representatives. They ran three candidates: Daniel Webster (Northeast), William Henry Harrison (West), and Hugh Lawson White (South). Still, Van Buren won by a small majority of the popular vote and received 170 votes in the Electoral College to 124 for the three Whigs.

The Panic of 1837

The last years of Jackson's presidency were marked by rapid economic expansion and flush times, fueled by the activity of the state banks (some eighty-nine of which had begun to receive government funds under the new deposit system). These developments contributed to the financial panic and economic depression that began in 1837.

Speculative Boom. The rapid growth and extension of the population of the United States, in a period of largely unregulated economic activity, made a boom and bust cycle of some proportion inevitable. The effects of Jacksonian policies, however, exaggerated the phenomenon.

The construction of turnpikes, canals, and railroads by private investors and state governments had stimulated new settlements and the formation of new markets. Prices of town lots as well as farm lands rose, reflecting the exuberant confidence in the future of the nation. The steady increase in government land sales reached boom proportions in 1835 and 1836; the government's receipts in 1836 ($24 million) were ten times those of 1834. Faced with huge surpluses in government revenues, the Congress and the president agreed in 1836 to distribute to the states large sums (based on congressional representation), which were quickly expended on transportation projects.

The expansion of credit more than accommodated the requirements of economic growth and new settlement. The issuance of bank notes and credit by state banks, the growth of foreign investment in state bonds and the stocks of railroad and canal companies, combined with the elimination of the B.U.S.'s restraining influence, contributed to a speculative mania in 1835–1837. Prices spiked to levels that overconfidently discounted (or anticipated) future successes.

The Specie Circular (1836). By July 1836, Jackson and his advisors had become alarmed by the extent to which payment for federal lands was being made with largely unsecured bank notes (resting upon inflated land values). In order to check inflation and protect government revenues, the president issued the Specie Circular, requiring federal land offices to receive only gold and silver in payment for government lands. This order curbed speculative land ventures but, together with the payment of the federal surplus (out of the pet deposit banks) to the states, set in motion a violent deflation.

Financial Crash

The market value of the state bank notes dropped sharply. Panicked European investors, already worried by economic troubles in their own countries, attempted to liquidate their American securities on the open market. Eastern banks, which were pressed to meet foreign obligations, called in the loans they had advanced to banks in the South and West.

The nation's credit system collapsed. Excessive demand for gold and silver caused banks across the country to suspend specie payments (or redemption of paper bank notes). Debtors defaulted on loans. Several states repudiated their state bonds. During the next few years, many banks and businesses closed their doors; factories and shops shut down. Crop failures, especially in 1837, further worsened conditions.

Van Buren's Remedies

Government revenues from customs and land sales fell off so rapidly that the Van Buren administration approved the issue of $10 million in Treasury notes as an emergency measure. Some 20 million acres

of public land had been sold in 1836; only 3.5 million sold in 1838. The distribution of the surplus funds to the states was suspended. After a long fight in Congress, the Independent Treasury Act (1840) was signed, whereby the government was divorced from the banking system and sub-treasuries were created in the important cities as depositories of government funds.

■ THE WHIGS AND THE ELECTION OF 1840

In 1840, with the country still in a depression, Whigs had little difficulty blaming the Panic of 1837 on Jackson's policies and Van Buren's failure to find solutions.

The Log Cabin and Hard Cider Campaign

The Whig party was grounded in deep differences over political and economic issues. But remembering how the Democrats had manipulated the B.U.S. issue, delegates to the Whig nominating convention passed over the party's leader, Henry Clay, and instead selected General William Henry Harrison as their candidate for president. The capture of the presidency was the sole objective of party professionals like the powerful Thurlow Weed of New York.

Whigs skillfully exploited the Jacksonian formula for electioneering success, winning a great popular majority with a military hero and Indian fighter (noted for his victory at the Battle of Tippecanoe), clever images and slogans, and a well-organized political machine. They presented Harrison as the log-cabin candidate (although he had been born in a mansion in tidewater Virginia) and the "man of the people." In a manner reminiscent of Jacksonian characterizations of John Quincy Adams, they succeeded in portraying Van Buren as an aristocratic, Europeanized dandy.

In a campaign remarkable for noise and the constant display of coonskin caps, cider barrels, and miniature log cabins, the Whigs out-shouted and out-voted the Democrats. Harrison took 53 percent of the popular vote and won the Electoral College by 234 to 60. Clay, still the Whig leader, confided that he lamented "the necessity, real or imaginary, which had been supposed to exist, of appealing to the feelings and passions of our countrymen, rather than to their reasons and their judgments."

Tyler Too

To strengthen their party in the South, the Whigs had nominated for vice-president John Tyler, a states' rights Virginian who had once been a Democrat, who hated Andrew Jackson, but who was no friend either of the policies championed by Clay and Webster. This had given them a campaign slogan—"Tippecanoe and Tyler too"—but it soon became a taunt. Harrison died of pneumonia five weeks after his inauguration. Tyler became the first vice-president to succeed to the presidency due to the death of his predecessor.

The Whig Legislative Agenda

With majorities in both houses of Congress, Whigs called a special session in 1841 to enact their party's national legislative program. Their agenda included the following:

- Repeal of the Independent Treasury Act and the charter of a new Bank of the United States
- Enactment of a protective tariff

- Passage of the log cabin bill (the Preemption Act of 1841), originally put forward by the Democrats, which provided easier terms for obtaining western lands
- Endorsement of a measure to distribute the proceeds from the sale of public lands to the states

This agenda was, in essence, an updated version of Clay's American System.

The Independent Treasury Act was quickly repealed, but the Whigs in Congress could not convince President Tyler to approve legislation (he vetoed two bills) to form a new national bank. After much wrangling, Tyler did sign the moderately protective tariff act of 1842, but he refused to permit the tariff to go into effect unless Clay abandoned his plan to distribute the land sales to the states.

Tyler's Cabinet

Tyler's refusal to accept Clay's program brought about open war between Whig leaders in Congress and the president (whom they dubbed His Accidency). Clay's followers in the cabinet resigned. Following the recapture of the House of Representatives by Democrats in the 1842 elections, Clay left the Senate. Tyler's new cabinet and policies reflected an unmistakable states' rights and pro-South bias, which cut across established party lines. The change in direction was punctuated by his appointment in 1844 of Calhoun, now again a Democrat, as Secretary of State.

Whig Diplomacy

Daniel Webster, when Secretary of State, did not resign from the cabinet with other Harrison appointees, choosing to proceed with negotiations he had begun with Great Britain on several difficult issues, which had, in fact, brought the two nations close to war.

Anglo-American Controversies

The chief questions were the dispute concerning the boundary between Maine and New Brunswick and the unsatisfactory joint occupation of the Oregon country. Minor but irritating grievances included the following:

- The *Caroline* incident, in which British authorities in Canada had destroyed an American ship hired to supply Canadian rebels during the country's 1837 rebellion
- The Creole case, involving American slaves who mutinied and sailed to the Bahamas, where they were freed by British authorities
- British interference with American merchant ships suspected of engaging in the slave trade
- Complaints against several states that had repudiated their debts to British investors

The Webster-Ashburton Treaty

When Robert Peel replaced Lord Melbourne as prime minister of Great Britain in 1841, his new government sent the friendly Lord Ashburton to Washington to negotiate differences. The treaty he and Secretary Webster signed in August 1842 did the following:

- Settled the Maine–New Brunswick boundary by defining a compromise line, which gave the United States 7,000 of the 12,000 square miles in dispute
- Provided for American ships to join British patrols off the coast of west Africa to police slave traders flying the American flag

The Creole case and the Oregon question were not resolved, but Ashburton conveyed "regret" for the attack on the *Caroline*. The treaty averted war and improved relations between the two countries.

The China Trade

American, principally New England, merchants had been trading with China, through Canton, since 1785. The typical voyage to the Orient included a stop in the Pacific Northwest to obtain furs to exchange with the Chinese. Following Great Britain's success in forcing the Chinese to expand trade with foreigners in 1842, the United States, through its commissioner Caleb Cushing (backed by four U.S. navy warships), negotiated a commercial treaty that gave American merchants privileges identical, and in some particulars superior, to those gained by the British. The Treaty of Wanghia marked the beginning of a period of expanding trade with China and renewed interest, especially on the part of northern Whigs, in the strategic importance of the Oregon country and the Pacific Coast.

In the 1820s and 1830s, constitutional checks on the direct popular vote, originally believed necessary to prevent the tyranny of the majority, were gradually eliminated. The founding fathers' views on political power—and their fears of its abuse—seemed out of date in the new democratic age. The people chose a popular military hero as national leader. From the White House, he embarked on a "dismantling operation" of the federal government to check concentrations of power and privilege and expand opportunities for the common man. The apparatus that his lieutenants employed to capture the presidency, the political party and machine, introduced a new, if extra-constitutional mechanism, of national cohesion.

Jackson's policy of weakening the power of the national government, and of interests that coalesced around it, however, had its dangers. His victory in the Bank war led to instability in the financial system, which led to a panic that erased the gains his supporters had realized from their expanded opportunities. Faced with an extreme expression of states' rights, the nullification movement, he was forced to define the limits of his dismantling principles. He acted decisively once he perceived a threat to the corporate union. The states' rights theory that underlay his politics on the national level would not be permitted to obstruct the principle of majority rule. And yet Old Hickory could not arrest the deepening divisions created by economic and social forces.

Selected Readings

Atkinson, James R. *Splendid Land, Splendid People: The Chickasaw Indians to Removal* (2003).

Bodenhorn, Howard. *A History of Banking in Antebellum America: Financial Markets and Economic Development in the Era of Nation Building* (2000).

Brands, H. W. *Andrew Jackson: His Life and Times* (2005).

Cole, Donald B. *Martin Van Buren and the American Political System* (1984).

Debo, Angie. *And Still the Waters Run: The Betrayal of the Five Civilized Tribes* (1973).

Ellis, Richard E. *The Union at Risk: Jacksonian Democracy, States' Rights, and Nullification Crisis* (1990).

Feller, Daniel. *The Jacksonian Promise: America, 1815 to 1840* (1995).

Freehling, William V. *Prelude to Civil War: The Nullification Controversy in South Carolina* (1966).

Hammond, Bray. *Banks and Politics in America from the Revolution to the Civil War* (1957).

Holt, Michael. *The Rise and Fall of the American Whig Party* (2003).

Howe, Daniel Walker. *The Political Culture of American Whigs* (1979).

Kohl, Lawrence Frederick. *The Politics of Individualism: Parties and the American Character in the Jacksonian Era* (1991).

Meyers, Marvin. *The Jacksonian Persuasion: Politics and Belief* (1960).

Pessen, Edward. *Jacksonian America: Society, Personality, and Politics* (rev. ed., 1979).

Prucha, Francis Paul. *American Indian Policy in the Formative Years* (1962).

Remini, Robert V. *The Presidency of Andrew Jackson* (1996).

 Andrew Jackson: The Course of American Empire, 1767–1821 (1998).

 Andrew Jackson: The Course of American Freedom, 1822–1832 (1998).

 Andrew Jackson: The Course of American Democracy, 1833–1845 (1998).

 Daniel Webster: The Man and His Time (1997).

Rohrbough Malcolm J. *The Land Office Business: 1789–1837* (1968).

Sibley, Joel H. *Martin Van Buren and the Emergence of American Popular Politics* (2002).

Tocqueville, Alexis de. *Democracy in America* (1st ed., 1835; trans. George Lawrence and ed. J.P. Mayer and Max Lerner 1966).

Watson, Harry L. *Liberty and Power: The Politics of Jacksonian America* (1990).

Ward, John W. *Andrew Jackson: Symbol for an Age* (1955).

Wilson, Major L. *Space, Time, and Freedom: The Quest for Nationality and the Irrepressible Conflict, 1815–1861* (1974).

Test Yourself

1) During the Nullification Controversy, South Carolina and its political leaders showed their displeasure with President Jackson by doing all of the following, except
 a) declaring the Tariffs of 1828 and 1832 null and void
 b) prohibiting the collection of federal tariff duties in the port of Charleston
 c) South Carolinian John C. Calhoun resigning as vice-president of the United States
 d) dispatching state militia troops to South Carolina's borders to keep out officials of the federal government

2) Andrew Jackson interpreted his successful 1832 re-election as president by a wide margin over Henry Clay as the voters
 a) approving his Native American removal policy
 b) supporting his position in the Nullification Controversy
 c) giving him a special mandate to destroy the Second Bank of the United States
 d) rejecting the Anti-Masonic party

3) True or false: During the 1830s, the Whig party believed in the vitality of the manufacturing sector as the major source of national strength and prosperity, while the Democratic party looked to westward expansion and frontier growth as more essential to the nation's future development.

4) Which of the following was not a cause of the Panic of 1837?
 a) payment for federal lands with unsecured bank notes
 b) inflation caused by overvalued land prices
 c) crop failures in the western areas
 d) failure of European investors to buy American securities in the 1830s

5) Which of the following was not a source of tension between the United States and Canada that helped to bring about the Webster-Ashburton Treaty?
 a) Native American depredations on the Maine frontier motivated from Canada
 b) the *Caroline* incident
 c) disputed fishing rights on the St. Lawrence River
 d) the Oregon boundary question

6) As president, Andrew Jackson regularly sought much of his political advice from
 a) Martin Van Buren
 b) John C. Calhoun
 c) the Kitchen Cabinet
 d) the Albany Regency

7) Which of the following was not a result of Andrew Jackson's Native American policy as embodied in the Removal Act of 1830?
 a) the Black Hawk War
 b) the Trail of Tears
 c) *Worcester v. Georgia* (1830)
 d) the Quaker Peace Policy

8) True or false: John Tyler supported the Whig political program, as embodied by his membership in that party when he became president upon the death of William Henry Harrison.

9) In his famous 1830 debate with Senator Robert Y. Hayne of South Carolina, Daniel Webster advanced the point that
 a) states had sovereignty in constitutional disputes and could support nullification
 b) the federal government had superior authority over the states in certain specified powers
 c) the constitution was a compact of co-equal states
 d) none of the above

10) Andrew Jackson relied on the following person as his loyal Secretary of the Treasury in 1832 and 1833 who would kill the Second Bank of the United States by withdrawing federal deposits
 a) Nicholas Biddle
 b) Levi Woodbury
 c) Roger B. Taney
 d) William Wirt

Test Yourself Answers

1) **d.** South Carolina never mobilized its state militia to fight against the military troops that President Jackson was willing to send to the state in order to stop the nullifiers. Leaders in South Carolina, however, did declare the tariffs of 1828 and 1832 to be unconstitutional, in so doing prohibiting their collection in the state. South Carolinian John C. Calhoun resigned as vice president of the United States, immediately receiving an appointment to the United States Senate from his home state's legislature as he continued in the Congress to wage his campaign in support of nullification against the Jackson administration.

2) **c.** Jackson and his supporters hated the Bank of the United States. It was due for re-charter in 1836. Jackson made rechartering the bank an issue in his campaign for reelection. Jackson ran his campaign vigorously on this issue, although his stance on the bank might not have been the major reason why he was re-elected.

3) **True.** The Whig Party, which grew up in the early 1830s in opposition to Andrew Jackson, drew most of its support from the major cities, the mercantile classes, and wealthy landowners. For that reason, the Whigs believed in the vitality of industry, commerce, trade, and manufacturing. On the other hand, the Democratic Party under Jackson represented the interests of factory workers, small farmers, and the common folk. The Democrats looked to westward expansion and frontier growth as desirable national policies. These distinct beliefs were some of the primary differences between the two parties.

4) **d.** The failure of Europeans to buy American securities was not a cause of the panic of 1837. Many Europeans invested in the economic development of the United States during that era. Causes of the panic included over valued land prices, crop failures in western areas, and payment for Western lands with unsecured bank notes. In addition, some historians feel that the policies of the Jackson administration, especially those that encouraged westward migration, also served as a cause of this violent economic downturn.

5) **c.** The United States never had any fishing rights on the St. Lawrence River, nor did it claim any in the negotiations that Secretary of State Daniel Webster had with Lord Ashburton. Instead, the Webster Ashburton Treaty had several causes related to relations between the United States and Canada including settlement of the northwestern boundary of the Oregon region, American activities in the recently failed Canadian independence movement including the *Caroline* incident, and problems with Native Americans along the border between Maine and Canada.

6) **c.** As President, Jackson routinely relied on the advice of a group of personal advisors known as of the Kitchen Cabinet, which included friends such as John Henry Eaton, Francis P. Blair, and Amos Kendall. The Kitchen Cabinet, named for the room in the White House where it sometimes met informally, was thus composed of a group of individuals who were close personal advisors to President Jackson. The president often relied on the advice of this group over

that of Martin Van Buren, his Secretary of State, and John C. Calhoun, who served as his vice president during the first years of the administration.

7) **d.** The Quaker Peace Policy had nothing to do with Andrew Jackson's Native American policy; instead, the term refers to policies from a later era of American history. The Removal Act of 1830, passed by the Jackson administration, caused the forced removal of Native Americans from the southeastern part of the United States to what is today modern Oklahoma. The Trail of Tears refers to the route and hardships these Indians experienced along the way during their westward journey. In the Supreme Court case *Worcester v. Georgia* (1832), the Supreme Court declared Jackson's removal policy to be unconstitutional. Jackson refused to comply with this ruling. He said: "John Marshall has made his law, let him enforce it." Jackson's Native American policy also caused The Black Hawk War along the Fox River Valley in Illinois.

8) **False.** As president, John Tyler did not support the policies of his own party, the Whigs. Tyler had been a Jacksonian Democrat during much of his career, converting to the Whig Party only in the late 1830s. In the election of 1840, William Henry Harrison ran as the Whig presidential candidate, with Tyler as the vice presidential candidate on the same ticket. Harrison's untimely death brought Tyler into the White House. Because of his Democratic Party sympathies, however, Tyler quickly found himself at odds with Whig party leaders, especially Henry Clay and Daniel Webster, regarding the policies and programs of the administration. This eventually resulted in Tyler's leaving the Whig party and becoming a political independent.

9) **b.** Daniel Webster became the eloquent voice for the Union in this great debate. In it, he said that the federal government was preeminent over the states in the constitutional system. The states did not have their own sovereignty. This meant, to Webster, that the Constitution was not a compact of coequal states and that the doctrine of state nullification was invalid. Most certainly, Webster did not advocate the rights of the states over that of the national government.

10) **c.** Roger B. Taney assisted Jackson during the president's War on the Bank. Jackson decided to kill the bank of the United States, headed by Nicholas Biddle, by withdrawing all public monies from its accounts, an action in violation of banking laws. Jackson's secretary of the treasury, Levi Woodbury, refused to support Jackson in these efforts. Jackson fired Woodberry and appointed Taney in his place. Once the bank had been effectively destroyed, Jackson rewarded Taney for this support by naming him Chief Justice of the Supreme Court upon the death of John Marshall. William Wirt was a prominent attorney who was not involved in Jackson's war on the bank.

American Society at Mid-Century

1793: Cotton gin invented by Eli Whitney of Connecticut

1800: Gabriel Prosser, a slave, attempts to lead an insurrection of some 1,000 slaves near Richmond, Virginia; he and thirty-five others are executed

1801: Revival meeting at Cane Ridge, Kentucky, marks beginning of Second Great Awakening

1817: Formation of the American Colonization Society

1822: Plans of Denmark Vesey, a free black, for a slave insurrection in Charleston, South Carolina, are discovered

1823: Publication of James Fenimore Cooper's first Leatherstocking Tales novel, *The Pioneers*

1824: New Harmony experiment begun by Robert Owen

1826: The American Temperance Society is founded

1829: David Walker, a free black of Boston, publishes his Appeal to the Colored Citizens, urging slaves to "kill, or be killed!"

1831: Insurrection of slaves in Virginia led by Nat Turner results in death of some sixty whites; William Lloyd Garrison begins to publish *The Liberator,* calling for "immediate and complete emancipation"

1832: Key vote in the Virginia legislature defeats hopes for gradual emancipation

1833: Founding of the American Antislavery Society

1834: Patent issued to Cyrus H. McCormick for his reaper

1837: Mob attack kills abolitionist editor Elijah Lovejoy in Alton, Illinois; Ralph Waldo Emerson delivers his "The American Scholar" address at Harvard University

1839: Patent issued to John Deere for his steel plow

(continued on next page)

1844: Telegraph successfully demonstrated by painter and inventor Samuel F. B. Morse; organization of Brook Farm community near Roxbury, Massachusetts; Millerites assemble to witness the end of the world

1845: Frederick Douglass publishes his autobiography; Edgar Allan Poe publishes *The Raven and Other Poems*

1846: Richard M. Hoe invents the rotary printing press

1847–1848: Migration of Mormon community to Utah

1848: Women's Rights Convention held at Seneca Falls, New York (July); John Humphrey Noyes establishes Perfectionist community at Oneida, New York

1851: Nathaniel Hawthorne publishes *The House of the Seven Gables;* Herman Melville publishes *Moby Dick*

1851–1852: First serial publication of Harriet Beecher Stowe's *Uncle Tom's Cabin* (book issued in 1852)

1854: Publication of Henry David Thoreau's *Walden* and George Fitzhugh's *Sociology for the South*

1857: Publication of Hinton Rowan Helper's attack on slavery, *The Impending Crisis in the South;* panic and depression of 1857 begins; cotton continues to boom, with prices for the commodity peaking in 1860

1859: John Brown raids Harper's Ferry arsenal, an action celebrated by Emerson, Thoreau, and others

Mid-century America was predominantly rural—five times as many Americans lived on farms as in towns and cities. The landscape, however, was changing. The population of the North and Old Northwest was swelling as unprecedented numbers migrated from Europe to escape famine, war, and poverty. Rails and telegraph wire were crisscrossing the natural features of the North American continent, especially in the northern latitudes.

The evidence of progress and prosperity in the North and Old Northwest raised expectations and stirred anxieties, contributing to a broad and powerful impulse for reform. Technological and social changes, as well as a deepening sensitivity to the slavery question among white southerners, tended to isolate the South. In the North, the movement against slavery increasingly took on the qualities of a moral crusade. American culture responded to the nation's growth and expansion but reflected the deepening sectional divisions as well as the increasing literacy and patronage of the prosperous middle class.

■ THE URBAN AND INDUSTRIAL NORTH

In the decades before the Civil War, the northeast and the Old Northwest Territory were transformed by rapid growth and technological change. Advances in manufacturing, transportation, and communications—the component forces of what is identified as the Industrial Revolution—created a dynamic, rapidly industrialized economy. As the controversy over slavery grew, the Northeast and Old Northwest were increasingly thought of as a single section, the North.

Population Trends

The census of 1860 revealed the remarkable growth of the nation's population and its sectional distribution. The nucleus of 3,929,000 in 1790 had grown to a total population of 12,866,000 in 1830; 23,191,000 in 1850; and over 31,000,000 in 1860.

Immigration

Early population growth in the United States was due chiefly to the rapid reproduction of native-born stock, not to immigration: Between 1820 (when statistics were first accurately kept) and 1830, fewer than 500,000 foreigners came to American shores. But five times as many immigrants came in the next two decades—over 4 million in all—most from Great Britain, Ireland, and Germany. By 1850, 12 percent of the population was foreign-born. The United States became an asylum for those who fled from unsatisfactory labor conditions in Great Britain, famine in Ireland, and political revolutions and economic depression on the continent. Few immigrants—only half a million by 1860—settled in the South.

Over 1.5 million native Irish-born were living in the United States in 1860, most in the cities of the Northeast. Some one million native-born Germans were entered in the census of that year, most of them on farms or in the new cities of the Old Northwest.

Urban Growth

At the close of the American Revolution, only five cities in the country had more than 8,000 inhabitants. In 1850, there were 141 such cities, representing every section of the nation. They contained 16 percent of the total population. Already they were struggling with such problems as sanitation, transportation, public health, fire protection, and public safety. Most of the cities of the Northeast more than doubled in population between 1840 and 1860. This rapid urban growth reflected the decline of the farming population in many areas of the Northeast as well as sharp increases in foreign immigrants.

Urban Unrest. The rapid growth of northern cities, coupled with the growing tide of immigration, gave rise to the specter of urban unrest starting in the 1830s. In some cities, riots became almost regular occurrences as craftsmen, factory workers, the urban poor, and newcomers competed for jobs, living spaces, and political power. In 1828, native workers at Philadelphia attacked Irish weavers while, in the mid 1830s, the docks of that city saw several riots fought between white and black longshoremen. These incidents paled in comparison to the Philadelphia Riot of 1844 in which Protestant laborers in the city attacked their Roman Catholic counterparts. Other cities experienced similar unrest, to the point that Boston established a uniformed police force in 1837 to deal with these problems, as did New York City in the following decade. In addition, city governments began to pass local ordinances designed to maintain public order, such as vagrancy laws, regulation of public parades, and rules against disturbing the peace.

Nativism. There was thus a pronounced reaction among native-born Americans to the enormous increase in foreign immigration. Although many business owners welcomed the new influx of willing workers (labor costs had been high), others viewed the human wave as a threat to their lives and work. Native-born Americans, overwhelmingly Protestant in religion, blamed the new, largely Catholic, immigrants for perceptible increases in political corruption and social disorder. More fundamentally, they feared that the

rising tide of immigration would bring with it economic competition, radical politics, and a role in American life for the pope, the head of the Roman Catholic Church.

Significantly, efforts to organize and manipulate nativist fears for political purposes proved short-lived and largely ineffective. Several organizations joined in 1850 to form the secret Order of the Star-Spangled Banner, which advocated citizenship tests and restrictions as well as new, tighter immigration laws. The American party (or Know Nothing party) scored some striking victories in state and local elections between 1854 and 1856 but quickly faded into oblivion.

Industrial Expansion

In 1840, the nation's mills and factories had produced goods valued at less than $500 million. By 1850, their annual output had reached more than $1 billion, surpassing the value of agricultural products. In the following decade, manufacturing output almost doubled. Southern New England, southern New York, New Jersey, eastern Pennsylvania, and eastern Maryland comprised the first industrial area.

After 1840, industrialization spread to western New York, western Pennsylvania, Ohio (along the Ohio River and on the south shore of Lake Erie), Indiana, and Illinois. By 1860, only half of the nation's mills and factories were located in the Northeast; however two-thirds of the nation's manufactured goods were still produced there. Except in Maryland and sections of Virginia, manufacturing made little progress in the South prior to 1860.

The Factory System

After its introduction in the New England textile industry, the factory system proved adaptable to the production of other goods, notably woolens, iron goods, shoes, clocks, guns, and sewing machines. Mass production of goods lowered their prices, making them affordable to larger numbers of consumers. It did not necessarily improve the quality of goods, however. New England textiles, for example, remained predominantly coarse goods; in spite of the growth of that industry, foreign-made cottons and woolens were the principal imports to the United States, amounting to some 20 percent of the total (as opposed to 29 percent in 1820).

The financing for new factories and mills was increasingly provided by merchant capitalists, redeploying profits from overseas mercantile ventures. With few exceptions, the early factories and mills were small establishments owned by individual proprietors, partners, or joint-stock companies. By mid-century, however, the corporate form of organization (under which a few or many holders of shares or stockholders owned an enterprise) was used more widely, particularly in the textile industry in New England.

The Rise of Consumerism

The textile industry and the factory system created new consumer demands in the national marketplace. For example, the 1820s and 1830s saw the increased popularity of ready-made clothes, items that had traditionally been made at home by women sewing for the family. By the 1830s, there were dozens of clothing manufactures in cities such as Boston, where over thirteen hundred women assembled clothing in factories for the salary of $2 per day. The New York City firm of Lewis and Hanford reported that its factory cut more than 100,000 garments during 1848 and 1849. Cincinnati had a large ready-made clothing industry that made it one of the largest in the nation, employing almost 10,000 women in its apparel factories. All of this activity gave rise to specialized merchants, who attempted to meet demand

by retailing certain types of goods. In 1827, one Boston retailer advertised that his store kept on hand over 10,000 garments for the perusal of his customers. New Orleans merchant Paul Tulane opened a large clothing store in his city and operated a supply factory in New York City to meet his needs, in the process gaining a large fortune with which he endowed the modern university that bears his name.

Women and Family Life

The family had been the primary economic unit for many Americans, especially in the North, prior to the mid-nineteenth century. The factory system caused family members to leave the household in order to earn a living, thus creating increased specialization of gender roles, because it was often the man who sought outside employment. Women took on greater roles in maintaining the domestic sphere, while unmarried children of adolescent age (both boys and girls) often joined their fathers in seeking factory jobs. Many young women worked in factories and retail establishments until such time as they married, whereupon they took up the unpaid labor of homemaking.

Freed from the necessity of producing goods at home for the family's economic survival, however, domestic activities at home fell in prestige. Among the urban poor, women often devised ingenious and creative ways to survive economically. Many worked as domestic servants, cooks, and dressmakers. They sold food on the streets or managed small shops. A few even engaged in illegal and immoral activities of a seamier sort, sometimes turning to the types of criminal activities that centered around bars or taverns. For the most part, however, women brought civilizing contributions to the growing cities, especially in the areas of educational reform, religion, music, and the arts.

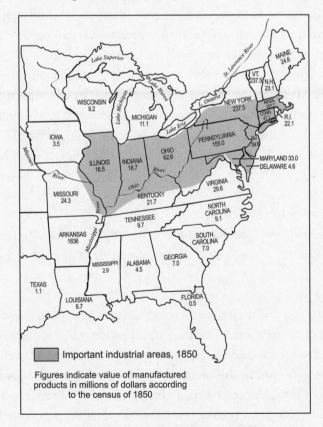

Fig. 10.1 Industrial United States in 1850

Industrial Innovation

Beginning in the late eighteenth century, early industrialization had relied on imported technologies, such as the spinning and carding machinery used in England. By the mid-nineteenth century, however, as a consequence of growing manufacturing expertise and technological advances, Americans had already achieved superiority in key areas. The excellence of American machine tool making—exemplified in the turret lathe and the vernier caliper—was widely acknowledged. New industries were created by several inventions: Charles Goodyear's process for vulcanizing rubber (1839); Elias G. Howe's sewing machine (1846); Elisha G. Otis's invention of the first passenger elevator (1851); Gail Borden's method for processing food, permitting products such as condensed milk (1856).

New Forms of Power. Oliver Evans converted the low-pressure steam engine of James Watt into a more effective high-pressure engine (1803). But steam replaced water power slowly as the motive force in American factories. In 1830, more than one third of the plants in Pennsylvania used steam, but in New England less than 10 percent had abandoned water power.

Wood remained the principal fuel until the Civil War. However, after 1820, the use of coal increased rapidly (production rose from 50,000 tons in that year to over 14 million tons in 1860).

Changing Working Conditions. Several factors contributed to a deterioration of working conditions in American factories and the failure of idealistic enterprises such as the Lowell experiment, in which owners built a model factory in that Massachusetts town. Huge increases in the pool of unskilled laborers made it unnecessary for manufacturers to attract workers—high levels of foreign immigration in the 1840s and 1850s kept pace with the industrial capitalists' needs to expand output.

Additionally, reductions in the protective tariff allowed foreign exporters to sell goods at lower prices in the United States, forcing domestic manufacturers to either reduce production costs or face the prospect of declining profits, losses, and bankruptcy. Many employers reacted by extending the workday and saving money in ways that adversely affected labor conditions. In response to changing work and market conditions, some unions were formed in the 1850s (such as National Typographical Union, Hat Finishers, United Cigarmakers, Iron Molders). However, the constant influx of laborers from Europe made organization difficult.

Transportation and Communication

The development of the steam-powered locomotive in the 1830s and the rapid extension of railways in the 1840s and 1850s dramatically altered patterns of economic development in the North.

The Rise of the Railroad

Innovations in transportation, permitting space to be traversed more rapidly, were crucial to the industrial expansion of the North. The great spaces that separated producers from consumers in the United States placed a high premium on speed, especially in the movement of perishable freight. At the height of the canal craze, the railroad became practicable and held out the promise of even faster transport.

The first railroad venture was sponsored by Baltimore merchants and bankers who incorporated the Baltimore and Ohio Railroad in 1827. In 1830, there were 32 miles of rails in the country; in 1840 there were

2,818 miles; by 1850, more than 9,000. The rapid extension of rail mileage enabled railroad companies to significantly reduce their costs for shipping freight and carrying passengers, thus allowing them to price their services more cheaply and competitively. The extension of trunk lines, into which short or local lines fed, further tightened the east-west flow of commerce and bound together the Northeast and the Old Northwest with bands of steel. The railroad companies received generous grants of land and stock subscriptions from various states as well as from the federal government (both directly and indirectly). By 1860, some 30 million acres of federal land had been assigned to the states for such purposes.

Other Modes of Transport

River and canal transport continued to be significant in moving goods to market, especially for bulky freight not susceptible to spoilage. The widespread use of steamboats, especially on inland waters, persisted—in 1860, there were more than 1,000 plying the waters of the Mississippi and its tributaries. Canals, notably the great Erie Canal, continued to bring freight from the interior to eastern cities, and by 1850, more than 3,200 miles of canals had been dug in the United States. Nevertheless, the railroad, which could more easily surmount geographical barriers and had the advantage of speed, gradually replaced these established modes of commercial transport.

On the high seas, the sleek and swift clipper ships, introduced in the mid-1840s, enabled American merchants to expand their position in, and briefly dominate, international commerce. They allowed American captains to sail around Cape Horn and reach California in three rather than the usual five weeks' time; however, the completion of a railroad across Panama in 1855 and competition from British ironclad ships caused their rule of the seas to be a brief one.

The Telegraph

The invention of the electric telegraph gave birth to the first communications industry. Although Samuel F. B. Morse succeeded in making the invention practicable in 1837, the first telegraph line of consequence was not constructed until 1843. By 1860, more than 50,000 miles of lines united the country east of the Rocky Mountains; the next year, San Francisco was brought into the network. The national telegraph network strengthened the ties between Northeast and Old Northwest and also, by providing an efficient means to monitor schedules and routes, contributed to the rapid expansion of the railways.

A National News Media

The extension of the telegraph, combined with the invention of the steam-driven rotary printing press by Richard M. Hoe in 1846, revolutionized the world of journalism. The business of gathering and distributing news, previously dependent on the mails and hand-operated presses, was greatly accelerated. The formation of the Associated Press, a central wire service founded in 1846, heralded the advent of a new era of journalism and further expanded the amount of information that an individual newspaper could supply.

Agriculture

Growth and technological change also transformed American agriculture. The establishment of a rail link between Chicago and New York in 1853 accelerated the flow of commodities from the Old Northwest to the Northeast, diverting the north-south pattern of river transport through the Mississippi River Valley.

Shifting Patterns of Agriculture

The grain-producing and livestock-raising regions shifted to the Old Northwest. The South came to rely upon the West for its grain and livestock. New England and other parts of the East, in order to meet the competition of western farms, turned to stockraising, dairying, and truck farming. Demand for farm products (and farm prices) increased steadily from the rapidly growing cities of the Northeast and from Europe, creating a period of prosperity. The nation's production of staple commodities such as corn, wheat, cotton, tobacco, and wool, as well as other crops, more than doubled between 1830 and 1860.

New Methods of Farming

Although the abundance of cheap and fertile land was responsible for careless and wasteful methods among American farmers, significant improvements in land fertilization, crop rotation, and scientific stockbreeding were introduced throughout the nineteenth century. Many societies for the promotion of agriculture sprang up in the years following the establishment of the first such American organization at Philadelphia in 1785. Institutions dedicated to the advancement of agricultural education and opportunities for competitions, such as the country fair, increased.

Agricultural Machinery

From the earliest colonial settlements, American agriculture had suffered from labor shortages (a circumstance that had contributed to the spread of slavery). Not surprisingly, labor-saving devices were a subject of keen interest to American farmers; they formed a significant portion of the patents issued before 1860. Mechanization became increasingly vital to the farms in the North during the 1840s as a consequence of migration from the farms to the northern cities and the great exodus of settlers to the West. Among the many important labor-saving inventions of this period were John Deere's steel plow (1839) and Cyrus H. McCormick's reaper (1834). These machines, together with horse rakes, mowing machines, seed planters, cultivators, and mechanical threshers and separators, lightened the farmer's labor and helped increase farm production.

■ THE SOUTH AND SLAVERY

Economic and social development in the South had been shaped from the earliest settlements by large-scale plantation agriculture. The decline of staple-crop production in the more settled areas of the upper South after the American Revolution led many to question the desirability of retaining a slave economy. However, after the opening of the southwestern frontier, the institution was perceived differently. The flush times in the Cotton Belt, as well as fears of slave rebellions and the growing abolition movement in the North, closed the mind of the South on matters of race and slavery. The region remained overwhelmingly agricultural, dominated by large holders and barely affected by industrial and technological changes.

Slavery and the Plantation Economy

The South's principal enterprise, the large-scale production of staple or cash crops, had become during the course of the eighteenth century almost totally dependent upon the forced labor of slaves. At the time of the Revolution, the principal cash crops were tobacco in the upper South and rice, sugar, and long-staple cotton in the coastal plains of the deep South.

Declining Fortunes of the Upper South

Shortly after the War of 1812, a long decline began in tobacco farming. The large profits that tobacco planters had reaped during good growing years in the eighteenth century were rarely seen in the nineteenth. Fluctuations in world supply made market prices unpredictable, while the uninterrupted cultivation of the plant in the tidewater regions of Maryland, Virginia, and North Carolina led to severe soil exhaustion. Tobacco cultivation spread into inland regions, notably to Kentucky, but was increasingly replaced by wheat-growing and other less intensive (and less labor-dependent) agriculture in the upper South.

Southern Criticism of Slavery

This shift, at least initially, led many to question the desirability of retaining the institution of slavery. The inhabitants of western districts of the upper South had long opposed it. Planters such as Washington, Jefferson, and George Mason of Virginia had openly questioned the economic value of the institution and feared its divisive influence in national affairs, as well as the social evils it bred. Such views led Virginia to call a constitutional convention to discuss the abolition of slavery in 1829. The news of a bloody insurrection led by the slave Nat Turner in that state during 1831 initially strengthened support for emancipation in the Virginia legislature, but after a key vote was lost the following year, discussion of the question ceased. Although changing economics caused many to consider some form of emancipation, the South, it should be emphasized, never envisioned a social alternative to slavery nor any civil rights for the large number of blacks in the region.

The Rise of the Cotton Kingdom

Slavery would likely have continued to decline in the South were it not for the rapid expansion of the cotton culture after the War of 1812. Expectations of huge profits from raising cotton gave new life to the slave-based plantation economy.

The Whitney Gin

Cotton had been cultivated along the coasts of South Carolina and Georgia since colonial times. It was in great demand in Great Britain; there, the textile industry had been industrialized since the mid-eighteenth century and was manufacturing ever-increasing supplies of finished cotton goods. The long-staple or sea-island variety grown in the Atlantic coastal plain could not be raised successfully further inland, however. The hardier but coarser short-staple cotton plant grew well in soils from the mid-South to the Gulf of Mexico, although it was difficult to extract seeds from the bolls of the plant without damaging the fibers.

Eli Whitney's invention of the cotton gin (1793), a machine that removed the seeds from raw cotton without injuring the fiber, thus transformed the nature of cotton culture. Cotton plantations spread inland, transforming the landscape of the frontier South. By the 1820s, the upland regions of South Carolina and Georgia had been given over to cotton production. The success of the short-staple variety increased land values in the interior. This also led to increased pressures for the removal of the Creek and Cherokee Indians from their tribal lands.

Expansion of the Slave Economy

The opening up of rich new lands in the southwest territory and the Louisiana Purchase lured thousands from the established states. The promise of quick profits from cotton production and the abundance

of uncultivated land on which the plant could be grown also brought a sharp rise in the demand for black slaves. Gang labor was required to clear the newly formed cotton plantations of what became the states of Alabama, Mississippi, Texas, and Arkansas and the new sugar plantations of Louisiana. The slave population of the new region grew more than tenfold between 1820 and 1860: in Mississippi, it grew from 32,000 in 1820 to 436,000 in 1860; in Alabama, from 41,000 in 1820 to 435,000 in 1860.

This expansion occurred for both political and agricultural motivations. Southern planters naturally desired expansion of the cotton culture for the logical reason of increasing their political influence. At the same time, however, those growing cotton in the South faced a very real problem because the planting of this crop leached vital minerals from the soil. Many planters, especially small producers and yeoman farmers, found the practices of fertilizing and crop rotation too expensive, or otherwise impractical. For them, the westward movement of cotton planting into the fertile, unleached soils of the Mississippi valley seemed the most economically prudent course of action given the inescapable exhaustion of southern soils, especially with the agricultural practices of the time. It can be noted that the westward expansion of the cotton planting South from the Atlantic coast to Texas, starting in the 1810s and ending in the 1850s, followed progressively the amount of nutrient exhaustion in the land under cultivation, decade by decade.

The Domestic Slave Trade

Many settlers from the upper South migrated with their entire families and their slaves. Those slaveholders who remained behind in the older states often took advantage of the rising market for slave labor and sold some of their slaves. Slave traders, though a despised group, operated freely in the upper South. They purchased and transported slaves to new masters in the deep South or sold them at auction in public markets. About 400,000 slaves were conveyed there from the upper South, by one means or another, in the two decades before the Civil War.

Cotton Is King

The enormous growth of the cotton culture in the South, which gave rise to much boasting in the 1850s, is easily measured. In 1792, the South produced some 13,000 bales; in 1820, 500,000; in 1840, 1.35 million bales; in 1850, 3 million; in 1860, 4.8 million. By mid-century, southern planters were producing 75 percent of the world's annual harvest of raw cotton, generating more than 50 percent of the nation's total income from exports. The price of the commodity rose steadily, even defying the Panic of 1857. Significantly, cotton culture, with enterprises related to the production and marketing of the crop, formed the nation's leading business sector prior to the Civil War.

Southern manufacturing, however, did not grow significantly. Despite the efforts of proponents of a diversified (and thus more independent) economy, such as J. D. B. DeBow of *DeBow's Review,* the South remained in many ways a colonial economy. Some industrial concerns enjoyed considerable success, however, notably the Tredegar Iron Works in Richmond, Virginia. Urban growth in the South increased only slightly before the Civil War—the population of southern cities showed growth at the rate of only 6 percent in the census of 1840, 10 percent in that of 1860.

The Rule of the Planter

The compilations of the 1860 census indicate that the households of planters (agriculturists owning twenty or more slaves) composed roughly four percent of the white population of the South. The most

affluent planters, those owning fifty or more slaves, were a mere one percent of the region's white population. This small group, however, dominated the politics, wrote the laws, and defined the social standards of the old South. With few exceptions, they preferred to see themselves and their society in romantic terms, distinct from the commercial hustle and bustle, the get-and-gain life they identified in the industrializing North.

The Planter's World View

Southern planters subscribed to a code of chivalry that placed certain notions of honor and duty above self-interest and indeed life itself (for example, dueling not infrequently resolved disputes). By this process of romanticization, the plantation lady was elevated to a lofty but isolated position, not unlike that of a statue on a pedestal. She was nevertheless required to confront the unpleasant facts of farm life every day, often serving as the only dispenser of medical care on the plantation. Although the aristocratic, cavalier ideals to which the planter society aspired were in many ways at odds with the harsh realities of life in the old South, these ideals nevertheless remained powerful social forces.

Most of the large and prosperous plantations were established by those who rose from humble origins. The great planters were intensely ambitious men, often like William Faulkner's Thomas Sutpen of his novel *Absalom! Absalom!* (1936). Fine manners and the accoutrements of great house living were usually acquired after, not before, a fortune was made. Having made their killing, such men indulged their pride, seeking acceptance in the ranks of the older order, the descendants of the great figures of the eighteenth century. Wealth and standing in the planter's society were measured in terms of political and social influence, family connections, and, always, the amount of land and number of slaves one owned.

Plantation agriculture was, if successful, a capitalist enterprise, even if it operated, ultimately, by the threat of physical violence. The production of the cash crop was all important, and therefore the planting, nurture, and harvest of the crop required wise planning. Although they conceived of themselves as landed gentlemen, the great planters also had to be tough businessmen. The world market for commodities fluctuated sharply. Over-production in a bad year or, conversely, underproduction in a good year could mean the difference between prosperity and bankruptcy. The more substantial planters hired overseers to handle work gangs and enforce discipline but kept a close eye on their accounts. Small planters directed the work of their own slaves.

The Plantation Mistress

Women, both slave and free, played important roles in the plantation system of the South, even though both groups experienced subjugation in the traditional world of the planter. The plantation mistress, usually the wife of the planter, provided a wide variety of domestic managerial skills to daily life in the region. The entire system was based on patriarchy, meaning that men dominated the system. This assumption served as the basic organizational underpinning of the plantation system. Nonetheless, the management of the planter's home, the supervision of foodstuff production, the care and beneficence extended to the slave population, and the social life of the region were in the hands of the plantation women. They worked hard, often under difficult conditions, while at the same time, the male-oriented values of their society tended to glorify them as chaste individuals on a pedestal, above the fray of everyday life in the region.

Plain Folk of the Old South

According to the 1860 census, fully 75 percent of white families in the old South held no slaves at all. Of those who did own slaves, most (some 88 percent) owned fewer than twenty. Despite their numerical superiority, these whites—mostly small farmers who raised grains and livestock—exercised slight influence in southern society. They differed with the large planters on some political issues, notably political representation, but they did not oppose the institution of slavery and the measures that protected it. The planters maintained authority over the white majority by skillfully manipulating their racial and economic fears and by promoting the planter ideal, to which many small holders and farmers aspired. Enough self-made men achieved great wealth to make the promise of upward mobility believable.

The Proslavery Argument

Open debate about the feasibility of slavery came to an end in the aftermath of Nat Turner's rebellion in Virginia (1831). The aggressive rhetorical attacks of abolitionists eliminated what flexibility remained in the South. Southern publicists and statesmen were soon defending slavery as a sound and humane basis of social organization. Their arguments, derived from the writings of intellectuals such as Thomas Roderick Dew, president of the College of William and Mary, stressed the following:

- The historical and scriptural justification of slavery
- The economic advantages of the institution
- The social benefits that it conferred upon the dominant white population

The most clever defender of the institution, George Fitzhugh, author of *Sociology for the South,* or the *Failure of Free Society* (1854), and other works, went so far as to argue that slaves enjoyed better living conditions than the wage slaves of northern factories. Although there continued to be opponents of slavery—none as outspoken or courageous as Henry Clay's cousin Cassius Marcellus Clay of Kentucky, who for a time even printed an abolitionist newspaper in Lexington—the South became increasingly intolerant of criticism on the subject. The defensive view that slavery was a necessary evil was replaced by the affirmation that it was, as John C. Calhoun expressed it in 1837, "a positive good."

The Gag Rule

Reacting to the literature circulated by northern abolitionists, southern congressmen demanded that abolitionist material be barred from the mails. In 1836, they succeeded in persuading the House of Representatives to refuse to hear or consider antislavery petitions that were regularly sent to Congress. This gag rule was finally rescinded in 1844, largely as a result of the persistence of a small group of northern congressmen led by John Quincy Adams and Joshua Giddings, who defended the civil rights of the abolitionists. The former president served as a member of the Massachusetts delegation in the House of Representatives from 1831 to 1848, when he died shortly after suffering a stroke on the floor of the House.

Human Property

The predicament of slaves in the old South is summed up by the contradictory phrase human property. Transported against their wills from Africa (and later the West Indies), black slaves were powerless before their white owners under the laws of the slaveholding states. They had no standing as persons under the United States Constitution. By law, and under the slave codes that governed their behavior and

movements, the slave was chattel, the category of property to which the law assigned horses and cows. Most states had laws that made the murder of a slave by a brutal master a capital crime, but instances of attempts to enforce these laws were few and convictions rarer still.

There is abundant anecdotal evidence of the physical abuse of slaves in the old South, some exaggerated by incensed abolitionists who felt compelled to rouse the men and women of the free states to action. However, because human beings are always capable of it, there were also many examples of kindness and humanity in the strange world of masters and slaves. The gentlemanly code and paternalistic values subscribed to by the leading planters held the scoundrel and abuser of inferiors in the highest contempt. And while the pressure to produce a successful crop led many to drive their field hands to the breaking point, this tendency was counterbalanced by the fact that the financial capital of the planter was almost totally invested in his slaves (the average cost of a field hand was $800)—an economic incentive, among those who heeded reason, to care for their human property.

Nevertheless, as Harriet Beecher Stowe so powerfully reminded the readers of *Uncle Tom's Cabin* (1852), the horror of slavery was not ultimately measured by assessments of the number or degree of severity of abuses; rather, the evil was that the potential for physical abuse always existed under the slave system.

Slave Life and Labor

Many slaves lived on sizeable plantations and were forced to work long hours, performing bone-tiring crop labor under close supervision. Those who went to the fields in gangs were put to the hardest toil; the fortunate ones assigned to task work could look forward to some free time after a job was done. A few were permitted to learn skills and were hired out to earn cash for their masters.

Most slaves could rely on their masters for basic welfare. They were provided coarse work clothing, sufficient food to keep them at work, and shelter. On many plantations, slaves grew their own gardens, enjoyed a few holidays, and received small rewards. On the large plantations, only the privileged few, the house servants, had any significant contact with the master's family. The small number of slaves who were owned by town residents lived more varied and interesting lives.

Subjugation and Resistance

Slaveholders took great pains to tightly circumscribe the world of the slaves. They had to carry passes with them when off the plantation and were forbidden to be out at night. Only those who were very light-skinned could evade this constant surveillance. Slave patrols were vigilant in finding offenders, and punishments were severe and swift. As a means of preventing communications, slave codes made it illegal to teach slaves to read and write. However, there were masters and mistresses willing to overlook this stricture, and it is estimated that roughly ten percent of the slaves risked punishment to achieve literacy. The ability to read and write was understood to be the key to freedom, and thus cherished.

The degree to which slaves accepted or resisted their subjugation has been discussed at great length by twentieth-century writers, often reflecting their own political convictions about protest and rebellion. Considered from the perspective of the black slave (especially that of the field worker), however, it is remarkable that a few substantial rebellions did, in fact, occur. After Nat Turner's rebellion in 1831, no slaveholder needed to be reminded of the possibility of a slave insurrection.

In addition to the discipline enforced by the slave system, the physical geography and sheer extent of the slaveholding states reduced the odds for successful escape. Still, despite the regimen of their lives—

the predictable, if minimal, comforts as well as the constant threat of punishment—there were always runaways or fugitives willing to take the chance of reaching the world of limited freedom blacks enjoyed in the northern states. The South's insistence on a tough new fugitive slave law in the agreements that formed the Compromise of 1850 bears this out. Small acts of resistance, in the form of sabotage of plantation property, abuse of farm animals, and feigned sickness were everyday occurrences. Slaves did, on occasion, murder their masters or members of his family.

African-American Culture

Although the area of their personal freedom was circumscribed, black slaves expressed their humanity in other ways. Even though slaves' marriages were not recognized by law, they maintained a strong sense of familial community and consciousness. Continuity with African culture and earlier forms of worship was retained in their practice of Christianity. The source of their endurance, and of much of their sense of identity as a community and people, was their religion. It gave them an emotional release from their hard lives and dim prospects and provided moments of rapturous joy that no one could take away. Spirituals, the rich song legacy of their religion, lifted worshipers and provided opportunities for commentary about everyday life. During the antebellum period, several slave spirituals and songs were adapted by composer Stephen C. Foster, beginning a new and important influence on American popular culture.

Recent historical research has confirmed that slaves created for themselves a vital and vibrant culture. This was especially the case in the lower Mississippi valley, where a variety of African folkways blended together in order to form an identifiable Creole culture that was a complex mixture of African and European traditions. Music, dance, religion, cuisine, styles of dress, and language all crossed racial boundaries between Africans and Europeans to create a very distinctive regionalism among the common people of both races. Indeed, all across the South beyond Louisiana, African tastes and norms informed Anglo-American culture. The historical vestiges of this exchange can be in numerous ways even today, especially in food, music, religion, and regional dialects.

Free Blacks

There were some 250,000 free blacks in the South. Many of them (or their parents) had been freed by their masters for acts of nobility or faithful service. They existed independently, held property (some owned slaves), but were denied civil rights. Like the slaves, their lives were increasingly regulated by the slave codes in the years before the Civil War, and they were constantly in danger of being kidnapped, falsely identified as runaways, and forcibly returned to slavery.

■ REFORMING THE NATION AND ITS INSTITUTIONS

American society during the first half of the nineteenth century was permeated by an optimistic faith in the perfectibility of man. The effort to improve the world as it was went forward in two modes: the impulse to liberate the human spirit, and the call to reform or remake society, which not infrequently were present at the same time.

Social and Religious Experiments

Many radical and experimental proposals for social reform emerged in the 1840s and 1850s. Some emphasized self-realization and the fulfillment of the individual, while others strove for new or stronger forms of community and denial of self. Both varieties reflected tensions and strains within northern society.

Religious Backgrounds

In the first quarter of the nineteenth century, a Second Great Awakening of religious fervor swept first the southwestern and western frontiers and then the East. Evangelical Protestant preachers—principally Methodists, Presbyterians, and Baptists—staged revivals, often in camp meetings outdoors, to win personal conversions to Christ. In sharp contrast to the Calvinist concept of predestination, the foremost Evangelical preacher, Charles G. Finney, who drew large audiences in the 1820s and 1830s, preached that the individual could be purged of sin and achieve salvation by an act of free will. Significantly, Finney also urged his followers to enlist in the cause of moral reform.

While the Evangelicals sought regeneration of the individual through emotional appeals, the rational religious tradition, embodied in Unitarianism (which denied the divinity of Christ), also contributed to the reform impulse. The influential William Ellery Channing and other Unitarian clergymen taught that all human beings contained the capacity for good, advising the faithful to trust their own consciences in ordering their lives rather than church dogma. The cause of humanitarian reforms thus gained strong moral grounding.

The Second Great Awakening, in producing a wide-spread evangelical movement, resulted in hundreds of itinerant preachers holding thousands of revivals each year in most parts of the country, especially in the South and Southwest. Daniel Baker, a Presbyterian minister, was prominent among these traveling ministers. Baker, a Georgia native, graduated from Princeton University before becoming the pastor of a large and influential church in Washington D.C. that included both Andrew Jackson and John Quincy Adams as members. In the mid-1820s, forsaking the pulpit of his large church, Baker began traveling all over the nation in order to hold revival meetings as he became one of the best-known of such preachers. He lived variously in Kentucky, Alabama, and Mississippi before he moved to the new Republic of Texas in the 1840s, where he helped to found Austin College (named for Stephen F. Austin) and served as its president.

Transcendentalism

In the 1830s, many nonconformist Unitarians were led to Transcendentalism. It was a spiritualist movement, closely linked to European Romanticism (and thereby influenced by the religions of the East); it appealed mainly to intellectuals. Transcendentalists conceived of God as the "Over-Soul" and believed that human beings contained elements of the divine. Human perfectibility was therefore assumed—they could identify no evil in mankind or nature.

Social and Economic Utopias

In response, or reaction, to changes introduced by the Industrial Revolution and to population trends, some Americans sought to create, or participate in, a new social order. Several idealistic communities were formed, advocating revolutionary economic and social principles.

New Harmony. Robert Owen, an English industrialist and philanthropist, founded a utopian socialist cooperative community at New Harmony, Indiana, in 1824. His fame led to the establishment of a dozen similar ventures. After a formative period, he announced a Declaration of Mental Independence on July 4, 1826—private property, organized religion, and the state of marriage were condemned. Although his ideas were controversial, Owen's socialist experiment failed for more practical reasons the next year. His son Robert Dale Owen later observed that New Harmony had failed because of economic factors: Land was too cheap and labor too highly paid in America to sustain cooperative action.

The Fourierist Phalanxes. In the 1840s, Albert Brisbane and Horace Greeley collaborated in popularizing and promoting the principles of the French philosopher Charles Fourier. Fourierism proposed the organization of society on the basis of phalanxes or cooperative groups, not to exceed 1,800 persons, cooperating in industry, science, and art. More than thirty such phalanxes were established in the northern and mid-western states but only one, the North American Phalanx, in Red Bank, New Jersey, had any real success. It numbered ninety members at its peak and lasted but twelve years. Members of the North American Phalanx were allowed to choose what work they wished to do, the highest wages going to "necessary but repulsive" labor, the lowest to the most pleasant.

Brook Farm. Organized by George Ripley, a Boston Unitarian minister and Transcendentalist, Brook Farm, the most famous of communes, was organized as a joint-stock company near Roxbury, Massachusetts, in 1841. Its initial mission was to demonstrate the possibilities for self-realization by a communal sharing of labor and leisure "to combine the thinker and the worker, as far as possible in the same individual."

Toward the end of its six-year existence, it became a Fourierist phalanx. To several members, Brook Farm was an intellectual's paradise, although one of the most notable, Nathaniel Hawthorne, later wrote critically of the experiment and of the dangers of the egotism he found there in *The Blithedale Romance* (1852).

Religious Communitarism and Radicalism

Several Christian sects separated themselves from established Protestant denominations and from conventional society in the early nineteenth century to form new religious communities. These groups built upon a religious tradition that had begun with the first colonial settlements.

The Shakers. Originally a French sect, the Shaker Society (derived from their description as Shaking Quakers) proved to be the most successful communitarian Christian sect in America. The first Shaker community in America was established at Watervliet, New York, in 1776, and guided by Mother Ann Lee (1736–1784), the principal prophet of the church, a refugee from religious oppression in England. By 1825, members had founded more than twenty new communities, most in the northeastern states (there were four in Ohio, two in Kentucky). By the second quarter of the nineteenth century, they numbered 6,000.

Following Mother Ann's teachings, the Shakers believed in the dual nature of God, Mother Ann herself representing the feminine side of the divine personality. The sect was fundamentalist in its belief in Holy Scripture, and ritualistic dances and, later, hymns united the communities in worship and fellowship. The Shakers believed in the equality (and separation) of the sexes, practiced celibacy, and strove for

simplicity and industry in their lives and work. Membership was purely voluntary, but the social and religious order was authoritarian and completely denied democratic instincts. Shakers surrendered individual will for the good of the community; decisions were made by a central ministry, the Head of Influence.

The Oneida Community. The religious society organized by John Humphrey Noyes at Putney, Vermont, established a famous and financially successful socialist community at Oneida, New York, in 1848. The Perfectionists subscribed to complete equality between the sexes. They also subscribed to the idea of complex marriage, a form of communal living in dormitories, which horrified the outside world and caused them to be branded as advocates of free love. In fact, they were deeply religious and believed in a responsible concept of mutual marriage—sexual relations were closely monitored. Traditional marriage and family ("special love" unions) were, however, judged to be dangerous to the community. On Noyes's recommendation, the Oneida community bowed to the outside world and abandoned complex marriage in 1879. The following year, it abandoned socialism and was reorganized as a joint-stock company.

The Millerites. The religious revivalism of the early nineteenth century had been millennialist, preaching the necessity of conversion and re-conversion in anticipation of the second coming of Jesus Christ. In 1832, William Miller, a Calvinistic Baptist minister, predicted that the second coming was imminent. His summons to a new way of life stirred multitudes in all parts of the country, many of whom disposed of their possessions in expectation that the world would come to an end in 1844.

The Mormons. The Church of Jesus Christ of Latter Day Saints took form as a consequence of the religious experience of Joseph Smith in upstate New York in 1820. He believed he was inspired by divine revelation to restore an earlier (but lost) Christian civilization in America, described in *The Book of Mormon,* which he published in 1830.

Smith persisted in the effort to found a New Jerusalem in America. The sect's secrecy, unorthodox religious views, and especially its advocacy of polygamy (one husband could marry several wives) caused others to fear and persecute them. In 1844, a mob in Carthage, Illinois, stormed the jail in which Joseph Smith was confined and killed him. In 1846, led by his successor, Brigham Young, some 12,000 Mormons left a flourishing settlement in Nauvoo, Illinois, to begin a trek into the far west. They established their permanent community, the State of Deseret, on the edge of the Great Salt Lake in 1847. Taking as their symbol the beehive, the Mormons prospered and multiplied, laying the foundation for what became the state of Utah.

Mormonism taught that God had once been a human being and that all men and women had the capacity to attain the ultimate perfectibility of divinity, as had Joseph Smith. The Mormon Church imposed a strict authoritarian order on its community, rejecting the prevailing American faith in democracy and allegiance to personal freedoms.

Institutional and Moral Reforms

Although conservative in its social implications, the impulse to reform society was no less fervent than that to liberate the individual. Some of these efforts expressed concerns for the social order, others the growing reach of humanitarianism. Women assumed key leadership roles in these reforms.

Educational Reforms

The push to establish universal public education was the most significant of the social reforms that looked to institutions to implement change and supplement the role of the family. The foundations of the American public school system were laid in the generation before the Civil War.

Secondary Schools. Although the idea of public education was endorsed in the early days of the republic, widespread acceptance by the various states of free, compulsory, tax-supported elementary schools did not begin until the second quarter of the nineteenth century. Public support for such measures reflected increasing concern for the conditions that were shaping the lives of children, particularly those of new immigrants.

Massachusetts, under the leadership of Horace Mann from 1837 to 1848, took the lead in organizing a system of secondary schools. Mann, a firm believer in the shaping power of education, won support for broadening the curriculum and creating professional standards for teachers.

Many educational reforms of the era were based on new theories of education. Prior to the 1820s, most schools had been organized around a style of teaching known as the Lancastrian Monitorial method, in which students memorized classical assignments and repeated them from rote memory. They did so in large classrooms that contained students of all ages with learning levels mixed together under the guidance of one teacher who sat at a desk located at the front of the room. Mann, along with other reformers of the era, introduced the ideas of an Italian educational reformer named Johann Pestalozzi to the United States. The Pestalozzian Method stressed an individual learner's mastery of critical thinking rather than memorization, the development of useful skills, and the study of practical subjects needed for success in life. These new subjects were taught in smaller classes where students were grouped by age and level of learning.

By 1850, there were 80,000 elementary schools with 3,300,000 pupils and 6,000 high schools and academies with 250,000 students in the United States. The quality of the education they provided varied considerably. In 1860, roughly 70 percent of school-age children in the North attended schools; in the South, perhaps 33 percent of white children. School terms and attendance varied; parents who worked on farms and in factories frequently complained that they needed their children to work. Some Roman Catholic immigrants charged that the public schools indoctrinated their children with Protestant values.

Special Education. In the belief that all impediments to human progress could be overcome, reformers also focused on the problems of people with disabilities. In 1816, Thomas H. Gallaudet opened the first school for pupils with hearing impairments at Hartford, Connecticut. The first serious effort to educate those with visual disorders was undertaken by the Perkins Institute for the Education of the Blind, of Boston, founded in 1829.

The Asylum and Prison Reform

The rapid growth of the population, especially in American cities, made previously tolerable conditions for the common custodianship of criminals, debtors, the mentally ill, and the senile appear harsh and inadequate. Although understanding of social deviance remained rudimentary, the creation of asylums to deal with particular problems represented a step forward. At least at the outset, the movement to improve conditions also embraced the goal of rehabilitation of the individual.

From the 1820s, new penitentiaries or criminal asylums began to be constructed, the first at Auburn, New York, in 1821. Imprisonment solely for debt was abolished; penal codes were modified to curtail inhuman punishments. Prison management was organized about the idea that rigid structure and discipline in everyday life (including solitary confinement for wrongdoing) would contribute to moral regeneration of the criminal. Similar principles of organization were introduced to asylums for the mentally ill—the first was established at Worcester, Massachusetts, in 1833. Progress in the treatment and care of the mentally ill and handicapped owed much to the crusading efforts of Dorothea Dix to inform the American public about inhumane conditions in public facilities.

Temperance

The crusade against excessive drinking of alcoholic beverages, which had its origins in the eighteenth century, grew noticeably after the creation of the American Temperance Society in Boston in 1826. Local auxiliaries and state societies, supported by the churches, convinced thousands to sign the temperance pledge (close to a million had done so by 1840). In that year, the Washingtonian Society was formed and, employing the emotional methods of the religious revival, rapidly spread across the country.

At first, these reformers relied upon persuasion to affect their purposes. But in the decade of the 1840s, many began to urge restrictive and prohibitory legislation against the liquor traffic as the best way to promote temperance. Some of this activity reflected fears of the growing population of new immigrants and the disorder attributed to them. The Maine law of 1851 was the first state enactment forbidding the manufacture, importation, and sale of intoxicating beverages. Women played prominent roles in the temperance movement, documenting the evils that alcoholism visited on the American family.

The Campaign for Women's Rights

The participation of women in the reform and evangelical movements led to the first sustained campaign to eliminate political and economic discrimination against them. The demand for civil rights, stressed by Sarah and Angelina Grimke, Frances Wright, Lucretia Mott, and Elizabeth Cady Stanton, brought changes in the laws of several states concerning a woman's control of her property after marriage. The Woman's Rights Convention, held at Seneca Falls, New York, in 1848, was the first of several national conventions to demand the vote for women, equal opportunity with men in education and employment, and an end to legal discrimination against women.

Sojourner Truth

The remarkable life of an African-American woman named Sojourner Truth tied together for this era the abolitionist movement and the popularity of utopianism with the campaign for women's rights. Born a slave with the name Isabella Baunfree, she lived in bondage until age 28. Isabella took the name Sojourner Truth after she gained her freedom in adult life and moved to New York City. There, she worked as a domestic servant before she became an itinerant preacher and traveled throughout southern New England. Sojourner Truth finally settled in Northampton, Massachusetts, where she joined a Utopian community and became associated with abolitionist leaders including William Lloyd Garrison and Frederick Douglass. Sojourner Truth published her memoirs in 1850 and, the following year, served as a major speaker at a women's rights convention in Akron, Ohio. At this meeting, she gave an emotional and memorable speech entitled "Ain't I a Woman?" In so doing, she became one of the best-known women of her era.

Women in the Domestic Sphere

As the industrial and commercial economy grew, it caused a corresponding expansion of the middle class, especially in urban communities. More and more women, freed from the burdens of household work (taken up by servants), had time to devote to reading and education, outside activities, and their homes. This economic and domestic change had broad and important implications for social life and popular culture in the antebellum period.

Although denied an active role in politics and most business activity, middle-class women effectively used their enhanced authority over the family to exert a stabilizing influence in society. Many were active in educational, humanitarian, and institutional reforms. Others, following the lead of Sara Josepha Hale, editor of *Godey's Lady's Book,* were prominent in the union movement, seeking to avert civil war. The Mount Vernon Ladies' Association of the Union, formed in 1853, worked throughout the decade to raise funds to purchase George Washington's home to serve as a symbol of the Union. Their success also laid the foundations for the historic preservation movement.

The importance of the domestic sphere in antebellum society is documented by Harriet Beecher Stowe's novel *Uncle Tom's Cabin* (1852) and its extraordinary impact. Her success had much to do with the fact that she relied on middle-class domestic values, rather than mere abolitionist rhetoric, to demonstrate the evils of the slave system.

The Antislavery Crusade

There were many southern sympathizers in the free states, especially among those who had business interests with the South; but hostility to slavery in the North steadily grew. Organized antislavery activity in the South came to an end in the 1830s.

Early Antislavery Societies

Prior to 1830, antislavery societies carried on their work in such a moderate spirit that they enjoyed much success in forming units in slave states. In 1827, in fact, there were more antislavery societies in the South (principally organized by Quakers) than in the North.

The American Colonization Society, founded in 1817, enjoyed wide support in both sections and even received a $100,000 appropriation from Congress. It encouraged a conservative solution to the problem of slavery: gradual emancipation with compensation to masters and public financing of transportation of freed blacks to colonies abroad. The only colony the society managed to establish, however, was Liberia, on the west coast of Africa, founded in 1822. By 1831, just 1,400 free blacks had crossed the Atlantic to join the settlement.

The American Anti-Slavery Society

There was a sharp change in the temper of the antislavery movement when William Lloyd Garrison began to publish *The Liberator* in Boston in 1831. The radical Garrisonians, who formed the American Anti-Slavery Society in 1833, scorned the American Colonization Society's gradualism, arguing that the problem of slavery should be approached from the viewpoint of the slave rather than from that of the master. They demanded the immediate abolition of slavery without compensation to the owners of slaves. The uncompromising nature of their stand gained them support—after five years, over 1,300 constituent societies were in existence, with a combined membership above 250,000. One of the society's most noted lecturing

agents was the black abolitionist and newspaper editor Frederick Douglass, who also advocated temperance, women's rights, and industrial education for blacks.

Abolitionist Tactics

Despite the growth of the American Antislavery Society, a majority of northerners considered the Garrisonian abolitionists to be single-issue fanatics. Fears that they posed a threat to the stability of society, fueled by race prejudice among whites, were widespread and, on occasion, led to hostile mob action. The most notorious anti-abolitionist mob violence resulted in the murder of Elijah Lovejoy, an abolitionist newspaper editor in Alton, Illinois, in 1837.

Garrison's increasingly extreme views, most notably his attack on the Constitution as "a covenant with death and an agreement with hell," coincided with a split in the American Antislavery Society in 1840. More moderate abolitionists moved away from the tactics and rhetoric of confrontation, advocating "immediate abolition gradually achieved." Some chose to work within the political system or their churches—many more joined in petitions to the federal government to abolish slavery in the District of Columbia and other areas under its jurisdiction and in the fight to reverse the gag rule in Congress. Still others were active in the Underground Railroad, which sheltered and assisted fugitive slaves.

■ AMERICAN CULTURE

In the period after the War of 1812 and before the Civil War, the first distinctively American culture took form. American writers began to look within themselves and across their enlarged continental homeland for their subjects and themes. While the nation's primal energies were taken up with territorial expansion, political controversy, business activity, and social and economic reforms, new traditions in literature and the arts emerged to give meaning to the American experience.

Literature

The rise of an American tradition in literature paralleled the expansion of the nation. The great American writers and poets of the period were drawn to universal themes. Local and regional writing also flowered.

The American Novel

While Washington Irving, the nation's first prominent writer, among others, had called for a distinctively American literature, he himself continued to work in the English literary traditions, New York's Dutch past serving as his principal subject. James Fenimore Cooper, of Cooperstown, New York, dealt with larger American themes. In his Leatherstocking novels, or romances, notably *The Pioneers* (1823) and *The Deerslayer* (1841), his frontiersman hero Natty Bumppo (and the Mohican guide Chingachgook) confronted the environment of the American frontier, chronicling the advance of civilization and questioning the implications of its impact on the natural world.

The romance proved a useful form for dealing with the large moral subjects and the peculiar circumstances of the American setting. The theme of the individual confronting the expanse of nature was further developed and exploited by Herman Melville and Nathaniel Hawthorne. Melville probed the underside of the natural world, the dangers of democracy's heroic reach, producing the classic *Moby Dick* (1851). In *The Scarlet Letter* (1850) and *The House of the Seven Gables* (1851), Hawthorne dealt with

equally difficult questions of inner limits and the individual's responsibilities to society. Hawthorne also chronicled New England's Puritan past and, in the *Marble Faun* (1860), considered the predicament of the American abroad, confronting the moral ambiguity of the old world.

Emerson, Thoreau, and Whitman

The foremost essayist of the period was Ralph Waldo Emerson, of Concord, Massachusetts, the leading spirit of Transcendentalism. His intellect and learning were grounded in New England Calvinism. But in his effort to transcend that tradition, to chart the life of self-fulfillment and man's place in nature, he became a national spokesman, the poet of human perfectibility. His friend and fellow Transcendentalist Henry David Thoreau gave classic expression to these ambitions in his inner voyage *Walden* (1854).

Walt Whitman, generally regarded as America's finest poet of the period, developed his expansive style while working as a Democratic party newspaper writer and editor. The bombast of the Young America movement can be identified in his writings. However, his best and most original poetry, of democracy and self-liberation, collected in *Leaves of Grass* (1855), transcended the superficial and jingoistic.

New England's Literary Flowering

Boston became an important intellectual center in the years after the War of 1812, largely due to the influence of its writers and publishing houses that formed to meet demands of the nation's highly literate reading public (estimated at 94 percent in the North; 83 percent in the white South).

New England's sense of being out of step with democracy and the course of American history gave its literature a distinctive regional tone but also the redeeming qualities of perspective and form. Its stronger sense of English literary background led to the establishment of a New England tradition of poetry and letters, best exemplified in the works of the Brahmin poets and essayists James Russell Lowell, John Greenleaf Whittier, Henry Wadsworth Longfellow, and Oliver Wendell Holmes. New England's distinction in narrative history was set by William Hickling Prescott and John Lothrop Motley, who dealt with the moral drama in the western progress of civilization prior to the founding of America. Francis Parkman drew on this tradition in beginning his classic histories of North America, the first of which, *The California and Oregon Trail* (1849) and *History of the Conspiracy of Pontiac* (1851), appeared before the Civil War.

Foundations of a Southern Literary Tradition

The South's literary imagination was deflected by the dilemma of slavery. The plantation novels of Nathaniel Beverly Tucker and John Pendleton Kennedy exhibited literary skill but provoked no deeper sentiment than amiability. South Carolina's William Gilmore Simms chronicled the southern frontier with a clear eye in his early career; he later lost focus in defending his section. Much energy was expended in fashioning polemics to justify slaveholding: the works of George Fitzhugh, in particular, displayed much learning, if warped brilliance. More enduring was the sharp and raucous humoristic tradition developed by Augustus Baldwin Longstreet and Joseph G. Baldwin, who prepared the way for Mark Twain.

The South's greatest writer of the antebellum period was Edgar Allan Poe. His poetry was highly original, if flavored with the Gothic in the prevailing romantic tradition of the period. His tales of detection and terror (establishing the genre) were placed in old world settings. However, the psychological episodes that formed them, such as the horrible walling up of the victim of the "Cask of Amontillado," drew on familiar

emotions in the South. Southern orators frequently described their fear that an awful circumwallation (walling up) of the South by free-soil settlement in the west would eventually lead to racial warfare.

American Popular Culture

Rapid increases in birth rate and immigration, a high level of literacy, and technological advances in publishing contributed to an ever-expanding readership. Book and periodical publishing, as well as newspapers, boomed. Much of what was printed was targeted for mass appeal: sentimental novelists flourished, while writers like Melville remained largely unknown. Harriet Beecher Stowe's enormous influence derived from her ability to reach the reading public through the tradition of the sentimental novel. In the theater, melodrama prevailed over serious art, although the classics, such as the works of Shakespeare, were regularly and professionally staged in the principal cities.

New Cultural Institutions

A hunger for knowledge and self-improvement among the adult public was perceptible throughout the country. Educational organizations, notably the lyceum and mechanics' institutes, penetrated deep into the interior, providing each sizeable town with a forum where traveling lecturers discoursed on mostly serious subjects. Emerson, Greeley, Simms, as well as visiting literary notables such as the English writer Charles Dickens, traveled the circuit, along with hundreds of other lecturers on various subjects. Debating societies also flourished. These existed even on the frontier, in towns like New Salem, Illinois, which contained about 25 families in the early 1830s: One of the New Salem Debating Society's members at that time was Abraham Lincoln.

The Arts of Design

The works of American painters, sculptors, and architects were less self-consciously American, because they depended on European techniques and methods to achieve competence. Most of the best American artists studied in Britain or on the European continent. The painters of the Hudson River School, notably Asher B. Durand and Thomas Cole, gave moral drama to the representation of the American landscape. George Catlin chronicled the nobility of the American Indian; John James Audubon, the natural life of North America. The homespun scenes captured by George Caleb Bingham reflected democratic self-confidence and western exuberance. From the 1830s, painting was substantially influenced by the new techniques of lithography and later of engraving, which expanded the artist's audience; the popularity of photography in the 1850s had profound effects on the whole world of representational art.

Architecture and sculpture depended to a considerable extent on government patronage; thus classical forms predominated, with decreasing vitality. American sculptors, most of whom secured their training in Italy, were encouraged as a matter of national pride as long as their classicism was literary and abstract, such as Hiram Powers's celebrated Greek Slave (1843). Horatio Greenough's ambitious statue portrait of the seated Washington, bare-chested in Roman dress (1832–1836), however, was refused a place in the Capitol—indicative, among other things, of the growing importance of middle-class Victorian standards. (It is now on display in the Smithsonian Institution in Washington.)

The Greek Revival style, vaguely reflecting democratic antecedents, predominated in the public buildings of the antebellum period. Its use in the construction of residences, large and small, reflected

the growing influence of popular culture on American architecture. With technological innovations in publishing and photography, visual images were more accurately and widely reproduced. The design arts as a consequence were increasingly influenced by broad public taste in its movement and multiplicity, mid-nineteenth-century American society accurately reflected the enormous, rapid physical growth of the United States. The vast amount of territory and the sheer physical size of the United States, especially when compared to Europe, continued to distinguish the American experience from that of the European—even when technological innovations such as the railroad and telegraph served to bring the young nation closer together, the later expansion of the country's western boundaries to the Pacific Ocean insured that the great geographical extent of the United States would be a significant factor in American history.

In the decades before the Civil War, the pace of industrialization and urbanization in the North steadily accelerated, with significant consequences for agriculture and consumer industries. In the main, northern society incorporated or adjusted to the powerful changes that were at work in the world. Those individuals who could not do so either headed west or south to recreate or experiment with the forms of community, following an established American tradition.

The South, however, stood aside from all this. It clung to a much older social structure—of ruler and ruled, of the few over the many—that had not changed since colonial times. That and its dependence on large-scale agriculture and the labor of black slaves set it apart from the rest of the nation and, indeed, from most of the world. By mid-century, the stark contrasts between the South and the rest of the nation could no longer be ignored or viewed as merely cultural variations.

Selected Readings

Eaton, Clement. *The Freedom-of-Thought Struggle in the Old South* (1964).

Camp, Stephanie M. H. *Closer to Freedom: Enslaved Women and Everyday Resistance in the Plantation South* (2004).

Douglass, Frederick. *Life and Times of Frederick Douglass* (1845, 1881).

Delano, Sterling F. *Brook Farm: The Dark Side of Utopia* (2004).

Fox-Genovese, Elizabeth. *Within the Plantation Household: Black and White Women of the Old South* (1988).

Gates, Paul W. *The Farmer's Age: Agriculture, 1815–1860* (1960).

Genovese, Eugene D. *Roll Jordan Roll: The World the Slaves Made* (1974).

Hansen, Marcus L. *The Atlantic Migration, 1607–1860* (1976).

Hirrel, Leo P. *Children of Wrath: New School Calvinism and Antebellum Reform* (1998).

Gizberg, Lori D. *Women in Antebellum Reform* (2000).

Johnson, Walter. *Soul by Soul: Life Inside the Antebellum Slave Market* (2000).

Klaw, Spencer. *Without Sin: The Life and Death of the Oneida Community* (1994).

Kraditor, Aileen, ed. *Up from the Pedestal: Selected Writings in the History of American Feminism* (1968).

Lehuu, Isabelle. *Carnival on the Page: Popular Print Media in Antebellum America* (2000).

McLoughlin, William G. *Revivals, Awakenings, and Reform* (1978).

McFarland, Philip. *Hawthorne in Concord* (2004).

Miller, Perry. *The Raven and the Whale: The War of Words and Wits in the Era of Poe and Melville* (1956).

Morrison, Michael A. ed. *The Human Tradition in Antebellum America* (2000).

Myers, Robert Manson, ed. *The Children of Pride: A True Story of Georgia and the Civil War* (1972).

Newman, Richard S. *Transformation of American Abolitionism: Fighting Slavery in the Early Republic* (2002).

Painter, Nell Irvin. *Sojourner Truth: A Life, a Symbol* (1997).

Pitzer, Donald E. *America's Communal Utopias* (1997).

Rose, Willie Lee, ed. *A Documentary History of Slavery in North America* (1976).

Rothman, David. *The Discovery of the Asylum: Social Order and Disorder in the New Republic* (1971).

Schafer, Judith Kelleher. *Becoming Free, Remaining Free* (2003).

Schwartz, Marie Jenkins. *Born in Bondage: Growing Up Enslaved in the Antebellum South* (2000).

Smith, Mark M. *Debating Slavery: Economy and Slavery in Antebellum America* (1998).

Taylor, Joshua C. *The Fine Arts in America* (1979).

Taylor, William R. *Cavalier and Yankee: The Old South and American National Character* (1961).

Tyler, Alice Felt. *Freedom's Ferment: Phases of American Social History from the Colonial Period to the Outbreak of the Civil War* (1944).

Walters, Ronald G. *American Reformers, 1815–1860* (1978).

Warren, James Perrin. *Culture of Eloquence: Oratory and Reform in Antebellum America* (1999).

Wells, Jonathan Daniel. *The Origins of the Southern Middle Class, 1800–1861* (2004).

Whalen, Terence. *Edgar Allan Poe and the Masses: The Political Economy of Literature in Antebellum America* (1999).

Wyatt-Brown, Bertram. *Southern Honor: Ethics and Behavior in the Old South* (1983). *The Shaping of Southern Culture: Honor, Grace, and War, 1760s–1880s* (2001).

Test Yourself

1) Which of the following Americans did not make an important invention in the 1830s or 1840s that resulted in creating a new industry for the United States?
 a) Gail Borden
 b) Charles Goodyear
 c) Elias G. Howe
 d) Thomas H. Gallaudet

2) Which of the following was not a religious group that separated itself from mainline Protestant dominations in order to live apart in a communitarian lifestyle during the nineteenth century?
 a) the Shakers
 b) the Mormons
 c) the Oneida Perfectionists
 d) the Transcendentalists

3) As the author of the 1852 book *Uncle Tom's Cabin,* this woman gave an enduring legitimacy to the pre–Civil War anti-slave movement that significantly convinced many Americans that southern slavery was an evil institution.
 a) Lucretia Mott
 b) Harriet Beecher Stowe
 c) Elizabeth Cady Stanton
 d) Dorothea Dix

4) Educational reform became an important motivation for the establishment of universal public education, especially in Massachusetts, where the following person served as superintendent of education from 1837 to 1848 as a leader in this effort.
 a) William Gilmore Simms
 b) Horace Mann
 c) Ralph Waldo Emerson
 d) James Russell Lowell

5) The South's greatest writer of the antebellum period, who mainly wrote poetry and short stories with Gothic or Old World themes, was
 a) Hinton Rowan Helper
 b) Edgar Allen Poe
 c) J. D. B DeBow
 d) George Fitzhugh

6) True or false: During the mid-nineteenth century, American painters, sculptors, and architects rejected European influences on their activities and fashioned a distinctive style of expression that completely divorced their work from the artistic conventions of Europe and the Old World.

7) Which of the following was not a reason for the rapid growth in the number of slaves in the southern United States during the antebellum era?
 a) Eli Whitney's invention of the Cotton Gin in 1793
 b) the opening of new cotton producing lands in the southwest
 c) an increase in the number of slaves imported from Africa
 d) the introduction of a prolific variety of short-staple cotton

8) Which of the following countries was not a major source of immigration to the United States in the decades before the Civil War?
 a) Ireland
 b) Germany
 c) Great Britain
 d) Italy

9) True or false: Most southerners did not own large number of slaves because, according to the 1860 census, those planters who owned more than fifty slaves composed less than one percent of the South's population, while seventy-five percent of the region's white residents owned no slaves at all.

10) The first national convention for achieving women's rights and political equality with men was held in 1848 at
 a) Red Bank, New Jersey
 b) New Harmony, Indiana
 c) Seneca Falls, New York
 d) Brook Farm, Massachusetts

Test Yourself Answers

1) **d.** Thomas H. Gallaudet was a reformer who pioneered in educating the hearing-impaired. A major university in the District of Columbia, which specializes in education for the hearing-impaired, today bears his name. Gail Borden developed a process for making condensed milk, Charles Goodyear refined the process for making durable rubber products, and Elias G. Howe invented the mechanical sewing machine.

2) **d.** The Transcendentalists were not a religious group. Instead, they were more literary than religious in their orientation. Prominent writers, including Ralph Waldo Emerson and Henry Thoreau, were counted among the Transcendentalists. They had progressive beliefs that made them distinctive in their era. The Shakers, the Mormons, and Oneida Perfectionists were all religious groups that lived communitarian lifestyles by which they sought to set themselves apart from the temptations of worldly influence.

3) **b.** Harriet Beecher Stowe was the author of *Uncle Tom's Cabin.* She was the daughter of a prominent New England clergyman and was very much against slavery. She saw her book as a powerful condemnation of that institution in the South. Lucretia Mott, Elizabeth Cady Stanton, and Dorothea Dix—who all lived during the same general historical era as Mrs. Stowe—were primarily involved in the women's rights movement

4) **b.** Horace Mann served as superintendent of public education in Massachusetts during the late 1830s and early 1840s. Mann implemented many reforms that supported universal public education. William Gilmore Simms, Ralph Waldo Emerson, and James Russell Lowell were all prominent writers of the period. Emerson and Lowell were identified with the Transcendentalist movement. Simms was a native of South Carolina whose work manifested southern themes.

5) **b.** Edgar Allan Poe remains the best known author from the American South during the mid-19th-century. In part, that is because Poe's work did not revolve around Southern themes. He wrote poetry, essays, and short stories that had universal appeal to an international readership. Thus, unlike the southern authors noted in this question, Poe's popularity transcended the South and he was widely read in all sections. Hinton R. Helper, George Fitzhugh, and J. D. B. DeBow all wrote about southern themes, including slavery, which gave their work limited appeal to readers outside the region and which today, unlike Edgar Allan Poe's work, can make their writings dated.

6) **False.** Europe had a tremendous influence on American art, literature, and architecture. American artists and writers embraced Old World styles, especially neo-classicism and gothic forms of expression.

7) **c.** The international slave trade did not cause a growth in the number of slaves during the era of the antebellum South. Such a trade was illegal. The Constitution contained a prohibition of the foreign slave trade that was enacted into an 1808 law of Congress. Instead, increased production due to the Whitney gin, the introduction of fast-growing short staple cotton, and the opening of new cotton lands in the southwest accounted for the rapid growth of the slave population during the antebellum era.

8) **d.** Italy provided a relatively small number of immigrants to the United States prior to the Civil War. Immigration from Italy did not become a large demographic movement until the late nineteenth and early twentieth centuries. There was, nonetheless, a large immigration to the United States during the late colonial period down to the time of the Civil War. During this time, large numbers of immigrants came to the United States from Ireland, Germany, and Great Britain.

9) **True.** Most southerners did not own large numbers of slaves, since according to the 1860 census, those planters who owned more than 50 slaves composed less than 1 percent of the South's population, while 75 percent of the region's white residents owned no slaves at all. Although most southerners did not own many slaves, if any at all, the large slave owners did control the politics and economy of the region.

10) **c.** Seneca Falls, New York is considered to be the birthplace of the women's rights movement. The other locations noted in this question were all places where communitarian religious groups established the farms and communities in which their members lived.

Territorial Expansion and Sectional Conflict

1844: Polk and the Democrats, calling for the "re-annexation" of Texas and "reoccupation" of Oregon, win the presidential election over Clay and the Whigs; gag rule (1836–1844) rescinded, principally due to efforts of former president Representative John Quincy Adams (December)

1845: Texas annexed (as a state) by joint resolution of Congress (March)

1846: Treaty with Great Britain settling Oregon boundary is ratified (June); war declared with Mexico (May); David Wilmot introduces his amendment to the military appropriations bill (Wilmot Proviso, August)

1847: U.S. forces capture of Mexico City (September)

1848: Senate ratifies the Treaty of Guadalupe-Hidalgo, ending war with Mexico and providing for Mexican cession (March)

1849: General Zachary Taylor, victorious Whig candidate, takes office as president; gold rush swells population of California, which requests admission to the union as a free state

1850: Death of Calhoun (March); death of President Taylor, succeeded by Vice-President Millard Fillmore (July); Compromise of 1850 legislated to resolve sectional crisis

1852: First book publication of Harriet Beecher Stowe's *Uncle Tom's Cabin*; death of Clay and Webster

1853: Democrat Franklin Pierce becomes president (March); Gadsden Purchase treaty signed (December)

1854: Kansas–Nebraska Act repeals Missouri Compromise of 1820, enacts popular sovereignty (May); formation of the Republican party

1854–1858: Civil strife in Kansas between proslavery and antislavery proponents

(continued on next page)

1856: John C. Fremont, first Republican presidential candidate, loses to Democrat James Buchanan; Charles Sumner of Massachusetts attacked while speaking in the Senate (May)

1857: Supreme Court rules in Dred Scott case (March); publication of Hinton Rowan Helper's *Impending Crisis of the South* and George Fitzhugh's *Cannibals All!*

1858: Lincoln and Douglas debates in Illinois Senate race

1859: John Brown attempts to capture Harper's Ferry armory; is tried and hanged in Virginia

1860: Presidential election contested by four candidates; Republican Abraham Lincoln elected

The lure of virgin land along the western frontier and the drive for territorial expansion can be traced back to the American colonial experience. The struggle to achieve independence from Great Britain, and to retain that independence against the background of the Napoleonic Wars in Europe, pre-occupied the new nation during the Jeffersonian period. At the conclusion of the War of 1812, however, there were, for a time, no external threats to distract attention from internal development. Increases in wealth and population gave the United States the means to deal decisively to secure its borders, the ambition of all sovereign states.

The immensity of the American frontier, unsettled by whites but first occupied by a myriad of Native Americans, as well as the requirements of American politics, caused the United States to identify and achieve its continental ambitions in stages. Territorial expansion was soon perceived as a remedy for the nation's ills: a safety valve for the unfortunate and defeated and a unifying formula for political victory. The process of expansion became a shaping event in the formation of the American nation, as important as the political experiment embodied in the Constitution. But it also provided the means for the nation's social disorder—the institution of slavery—to revive and flourish.

■ MANIFEST DESTINY

Even before North America had been extensively explored and mapped, some Americans had already embraced the belief that the boundaries of the United States should extend to the extremities of the continent. The French traveler de Tocqueville observed in 1831–1832 that a continental vision was "always flitting" before the American mind. The debate over the proposed annexation of Texas and Oregon brought American expansionist ambitions into sharp focus. Although many dissented, the major-ity embraced the ideas expressed by Democratic journalist John L. O'Sullivan when he coined the phrase Manifest Destiny, writing that it was America's "manifest destiny to overspread the continent allotted by Providence for the free development of our yearly multiplying millions." As the originator of this significant term, O'Sullivan further noted in an 1839 article written for the *North American Democratic Review* that "the far-reaching, the boundless future will be the era of American greatness" because of westward expansion.

The Annexation of Texas

Although the Adams-Onís treaty of 1819 with Spain provided for the United States to surrender any claim to Texas, American interest in the territory persisted. By the early 1820s, Anglo-Americans from the deep South and the former Louisiana Purchase territory had begun to develop plans for Texas.

The Republic of Texas

The Mexican province of Texas, which had been largely colonized by emigrants invited from the United States, declared its independence on March 2, 1836. By that time, there were already thousands of Anglo-Americans living legally in the province as Mexican citizens.

Anglo-American Migration to Texas. After achieving its independence from Spain in 1821, Mexico permitted migration from the United States into its sparsely populated province of Texas. It granted approval to Moses Austin and his son, Stephen F. Austin, to promote colonization by making large grants of land to prospective settlers from the north. Soon, other colonizers received generous land grants. By 1830, nearly 20,000 (by 1835, almost 35,000) Americans, chiefly from Tennessee, Mississippi, and Louisiana, had settled in Texas. Many immigrants came to establish plantations and brought black slaves with them; this trend continued even after Mexico eliminated slavery in 1829.

Texian Independence. Mexico soon became alarmed at the rapid increase of Anglo-Americans and in 1830, prohibited further immigration from the United States. The grievances of Anglo-American settlers against the Mexican authorities mounted.

- They wanted local self-government in Texas.
- They resented Mexican laws suspending land contracts, imposing duties on imported goods, and forbidding foreigners to enter the province.
- They feared that the Mexican government would enforce its religious requirement (that all immigrants subscribe to Roman Catholicism).
- They feared that Mexico would free their slaves.

Mexico did lift the law prohibiting foreign immigration, but a crisis came in 1835 when General Antonio Lopez de Santa Anna refused to grant further concessions to the Anglo-American residents.

The movement for provincial autonomy in Texas quickly developed into a war for independence. At the Battle of San Jacinto, Texians, under General Sam Houston, routed Santa Anna's forces and compelled him to acknowledge the independence of the province. The Mexican government, however, refused to honor the agreement made at gunpoint and would not recognize Texan independence. Nonetheless, Texas declared itself an independent republic in March, 1836.

Texas and the United States

The new republic formally applied for admission to the union. The overwhelming majority of Texans desired annexation, but there was anything but unanimity on the issue in the United States in 1836. Opposition was loudest in the northern states, particularly among antislavery groups, which charged that southern slaveholders were conspiring to create several slave states out of Texas in order to strengthen southern control of the federal government. The controversy, they argued, would end in war with Mexico. On the other hand, support for the admission of Texas came from:

- Manifest Destiny expansionists
- Those who feared the potential of an independent Texas and the designs of Great Britain

- Those eager for new lands, intending to expand the cash crop agricultural model of the South (there was also interest among free-soil settlers)
- A small group of speculators in Texas land and depreciated Texas bonds

Calhoun's Treaty (1844)

Jackson recognized the independence of Texas just before he left office, but he left the question of annexation to his successor. Van Buren displayed little interest, primarily because it was too hot an issue and threatened to divide the Democratic party. President Tyler seized on the Texas question after his break with the Whigs, expecting to gain a southern following by promoting it and thereby win the election of 1844. The annexation of Texas became a chief policy goal of the Tyler administration; it carefully conducted a propaganda campaign to "prepare the public mind" for the event, even manufacturing British and abolitionist designs on an independent Texas. Secretary of State Calhoun made no effort at subterfuge, however, and negotiated a treaty of annexation as a measure required for the protection of slavery in the South; it was defeated by a decisive vote in the Senate in June of 1844.

Presidential Campaign of 1844

Before the election of 1844, Henry Clay, the Whig nominee, and Martin Van Buren, the favorite for the Democratic nomination, both opponents of annexation, had agreed to refrain from discussion of the Texas issue in the upcoming presidential campaign. Pro-Texas Democrats, however, upset their plans. They engineered the nomination of a dark-horse candidate, James K. Polk of Tennessee, formerly speaker of the House of Representatives, at the Democratic convention. An ardent expansionist, "Young Hickory" Polk ran on a platform that called for the "re-annexation of Texas and the reoccupation of Oregon."

Many antislavery Whigs, irritated by Clay's attempt to straddle the Texas issue, cast their votes for James G. Birney, the candidate of the antislavery Liberty party. Polk was elected, polling only 49.6 percent of the total vote, to Clay's 48.1 percent. A shift of a few thousand votes in New York State, which Polk won narrowly, would have given Clay the margin of victory in the Electoral College.

Annexation of Texas by Joint Resolution

President Tyler interpreted Polk's election as an endorsement of his own policy. He sponsored a joint resolution for the annexation of Texas (which, unlike a treaty, required only a majority vote of both houses). Despite the constitutional objections of the Whigs, the resolution passed the Congress just three days before the end of Tyler's term. Texas accepted the terms of annexation and by December 1845 had drafted a constitution under which it was admitted to the union as a new slave state.

Acquisition of Oregon

In the campaign of 1844, the Democrats attempted to make the annexation of Texas more palatable to northern voters by linking it with the "reoccupation" of Oregon. Expansionists played on residual anti-British sentiment with campaign slogans such as, "Fifty-four, forty or Fight" (referring to the northern boundary of the Oregon country).

Basis for American Claims

In the late eighteenth century, Spain, Russia, France, and Great Britain all set forth vague claims to the Oregon country. Early in the nineteenth century, the United States claimed the region on the basis of

- The explorations of Captain Robert Gray, who in 1792 discovered and named the Columbia River
- The Lewis and Clark expedition of 1805–1806
- The establishment of John Jacob Astor's trading post, Astoria (1811)

Anglo-American Agreement

British claims to the territory were equally well founded. When attempts to divide the region failed, the United States and Great Britain agreed in 1818 to a ten-year period of joint occupation. The arrangement in effect gave the representatives of the Hudson's Bay Company temporary control of the region. Nevertheless, the joint occupation was renewed in 1827 for an indefinite period, with the provision that either nation might terminate the agreement by giving a year's notice.

Migration to Oregon

Prior to 1830, the contact of the United States with Oregon was limited to the visits of trappers and traders. During the next two decades, and particularly after 1840, migration into the Oregon country was stimulated by the following:

- Propagandists like Hall J. Kelley, who organized a society for the settlement of the territory
- The activities of businessmen like Nathaniel Wyeth, who demonstrated by his overland trips (1832, 1836) the practicability of a wagon route to the Oregon country
- The missionary activity among the Native Americans of the Pacific northwest by the Methodists, Presbyterians, and Roman Catholics.

By 1845, some 5,000 Americans resided in the Oregon country (the present states of Oregon, Washington, and Idaho, with parts of Wyoming, Montana, and British Columbia).

The Oregon Treaty of 1846

The steady stream of migrants, which expanded significantly beginning in 1843, encouraged Manifest Destiny expansionists in their ambitions to gain the entire Oregon country. In his first annual message, in December 1845, Polk asked Congress for authorization to suspend the joint occupation. After much bluster and talk of war, however, he agreed to a treaty that divided Oregon. The northern boundary of the United States (between the Rocky Mountains and the Pacific) was fixed at the 49th parallel of latitude. A diplomatic compromise had become necessary as a consequence of incidents on the Texas border. However, northerners interpreted Polk's willingness to abandon American claims to "All Oregon" as an indication that the president favored southern, slaveholding interests.

■ THE WAR WITH MEXICO

President Polk, a firm believer in Manifest Destiny, saw an immense opportunity for the United States in a conflict with Mexico. Aware of the strategic value of California and of Great Britain's growing interest, he increased diplomatic and military pressure on Mexico for territorial concessions in confident expectation

that the outbreak of hostilities would produce rapid results. Although American victories came, the war was not concluded quickly enough; opposition to it was strong from the outset.

Polk's Aggressive Strategy

Determined to exploit every advantage to advance American territorial interests in the southwest, President Polk sent troops to defend Texas's claim to the area between the Nueces and Rio Grande rivers in the summer of 1845. He was well aware of the implications of this action. Mexico had cut off diplomatic relations after the United States had annexed Texas and, still refusing to accept the loss of its former province, insisted that the contested region south of the Nueces was Mexican territory.

Polk also positioned a naval squadron off the coast of California and sent a sizeable expeditionary force under Captain John C. Frémont into that Mexican province, ostensibly to make topographical and scientific observations. These forces, and the American consul in the provincial capital of Monterey, were instructed to support a pro-American rebellion in California in the event that Mexico declared war.

The Slidell Mission

In the autumn of 1845, Polk sent John Slidell as a special envoy to Mexico with the following instructions:

- Offer to assume claims of United States citizens against Mexico if the Mexican government would recognize the Rio Grande rather than the Nueces as the southern boundary of Texas
- Offer $5 million for the cession of New Mexico
- Offer up to $25 million for California and New Mexico

Slidell was to conduct his negotiations in such manner as to promote cordial relations with Mexico.

Politics in Mexico

Political disturbances in Mexico made Slidell's task doubly difficult. The temper of the country was so hostile to the United States that two Mexican presidents refused to receive Polk's envoy. To patriotic Mexicans, it seemed as if the United States, having stolen Texas, was plotting the destruction of their nation. They willingly followed their irate leaders in demanding war against the northern enemy.

The United States Invades Mexico

Discouraging reports from Slidell caused Polk to order General Zachary Taylor, "Old Rough and Ready," in command of U.S. army forces in Texas, to advance across the Nueces to the Rio Grande. When the president learned that Mexican forces had crossed the Rio Grande, he informed Congress that a state of war existed as a consequence of Mexico's action (May 11, 1846).

War and Dissent

Congress, accepting Polk's statement that Mexico had assumed the role of aggressor, authorized the president to raise an army of 50,000 men and voted $10 million in war appropriations. The western and southern states responded enthusiastically, but the Northeast was apathetic. New England abolitionists were particularly severe in their criticism of the administration's policy, warning of the biblical parallels to the tale of King Ahab's coveting of Naboth's vineyard.

The Capture of California and New Mexico

California and New Mexico, where Mexican control was weak, were easily captured. In June 1846, Colonel Stephen W. Kearney set out from Fort Leavenworth, Kansas, took Santa Fe without opposition, and proceeded to San Diego. Meanwhile, Commodore John Sloat and his successor, Commodore Robert F. Stockton, had captured the ports of San Francisco, Monterey, and Los Angeles. The Pacific squadron and Captain Frémont's force provided support to a group of American settlers, who had declared California an independent nation under the bear flag. Kearney assumed the leadership of these insurgents and other American forces, completing the conquest of California in the fall of 1846.

American Campaigns in Mexico

General Taylor's victories in northern Mexico enabled him to enter the port city of Matamoros in May 1846. Although President Polk thought the pace of his campaign slow, by the end of the year, Taylor had captured Monterrey, Saltillo, and Victoria and held a front two hundred miles long. Anxious for a speedy conclusion to the conflict, Polk, in November 1846, ordered a force under General Winfield Scott to move on Mexico City by way of Vera Cruz (on the Gulf of Mexico). Scott's small army (some 14,000 men) encountered resistance but advanced decisively, winning key battles at Cerro Gordo and Chapultepec. It entered the Mexican capital in September 1847.

The Treaty of Guadalupe-Hidalgo (1848)

Despite crushing defeats and loss of territory, the Mexican government resisted American terms for surrender. The frustrated President Polk ordered his diplomatic agent, Nicholas P. Trist, to return to Washington. But, with Polk's aims in sight, Trist continued negotiations with Mexican commissioners and concluded a treaty in February 1848. Under this agreement Mexico agreed to the following:

- Recognize the Rio Grande as the southern boundary of Texas
- Cede New Mexico and California to the United States in return for $15 million and the assumption by the United States government of American citizens' claims against Mexico (up to $3.25 million)

The Senate ratified the treaty by a vote of 38 to 14 on March 10, 1848.

■ EXPANSION AND COMMERCE

The sweeping military successes and enormous territorial expanse gained by the United States from Mexico extended the nation's boundaries to the Pacific and altered forever the American mind. The rising nationalistic spirit was expressed in the Young America movement in politics, the arts, and literature. Not long after the war's end, however, the fruits of conquest turned bitter. Disputes arose over whether slavery should be prohibited or permitted in the new territories, reviving the forces of sectionalism and confirming the abolitionists' prophecy.

The Far West

When the Treaty of Guadalupe-Hidalgo was signed, the value of the lands that had been obtained from Mexico by the United States (some 338.6 million acres) was uncertain. Explorers had described vast areas of the New Southwest as desert, unfit for settlement.

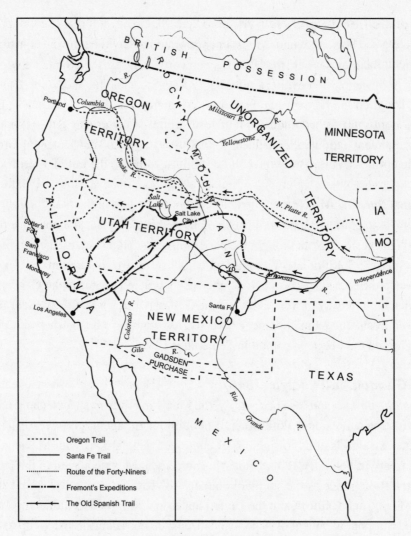

Fig. 11.1 Trails to the Pacific

California and the Forty-Niners

By the late 1820s, the Hispanic population of Mexican California numbered only 4,000 (although several times that number of Native Americans inhabited the region). In the 1830s, groups of merchants from New England and Great Britain began to enjoy growing business in the coastal ports and the provincial capital of Monterey. Although their glowing reports of the country sparked some interest in the East, California remained sparsely populated, broken up into large estates and ranches that bred enormous numbers of cattle and horses. Soon after the transfer of the Mexican cession, however, the news that gold had been discovered in the Sacramento Valley electrified the American public.

The gold rush that began in 1849 brought an extraordinary migration to the Pacific Coast. Fortune-hunters who sought a new El Dorado had a choice of three routes:

- The overland road across the plains and through the passes of the Rocky Mountains
- The Isthmus of Panama route
- The long voyage around Cape Horn

Within two years of the discovery of gold, more than 90,000 adventurers from all parts of the world and every social class had been drawn to California. The territory, having drafted a constitution, requested admission into the union.

The Utah Territory

The gold rush materially aided the Church of Jesus Christ of Latter Day Saints, popularly called the Mormon Church. Its members, led by Brigham Young, had settled in the vicinity of Great Salt Lake in 1847 when the region still belonged to Mexico. Initially, these settlers called their settlements bordering the great lake the State of Deseret, although that designation had no official standing. With the transfer of this region to the United States, this settlement quickly became an important halfway station on the overland route to California. In 1850, it became the Territory of Utah, with Young appointed as its first governor.

Canal Projects and the Isthmus of Panama

The Forty-Niners (those who trekked to California in pursuit of gold) emphasized the importance of a canal or railroad across the Isthmus of Panama. In 1846, the United States had negotiated a treaty with New Granada (Colombia) for an exclusive right of way across the isthmus. Two years later, American capitalists began the construction of a railroad.

Both British and American promoters pursued the idea of constructing a canal across Nicaragua. In 1850, the United States and Great Britain signed the Clayton-Bulwer Treaty, whereby each agreed not to obtain exclusive control over a Central American canal, erect fortifications commanding it, nor to colonize any part of Central America. The neutrality of any canal constructed by private capital was jointly guaranteed.

The Revival of Sectional Debate

From the outset of the Mexican War, it had been clear that the United States would acquire vast new territories when the fighting had been concluded. Disappointed by Polk's decision to compromise on the Oregon question, northern Democrats in the House of Representatives asserted their free-soil principles and pushed for the exclusion of slavery from such lands, thereby breaking the gentlemen's agreement to refrain from debate on the slavery issue.

The Wilmot Proviso

In August 1846, with the war going well and some expressing desires to annex "All Mexico," Congressman David Wilmot, a Pennsylvania Democrat, rose in the House of Representatives with an amendment to the military appropriations bill. He proposed to exclude slavery (or other involuntary servitude) from any territory acquired from Mexico as a result of war or purchase. The resolution reflected the growing resentment of northern Democrats for what they perceived to be Polk's pro-southern policies. The president's willingness to compromise claims to "All Oregon," his support for lower tariff duties, and his veto of internal improvements legislation strengthened this impression.

Wilmot's amendment precipitated a bitter struggle in Congress—it was carried in the House, on largely sectional rather than party lines, but defeated in the Senate. The administration was then able to secure the votes of enough northern Democrats to pass the appropriations bill without it. The principle of the Wilmot Proviso, however, would soon refashion the nation's politics.

Presidential Election of 1848

The presidential campaign of 1848 reflected the inability of the established two-party system to accommodate the burning issue of slavery in the territories. The two national political parties could maintain unity only by ignoring the question. The Whigs, despite their opposition to the Mexican War, sought to retake the presidency with the popular General Zachary Taylor. Their platform merely expressed confidence in their candidate. With Polk having declined to run again, the Democrats nominated Senator Lewis Cass, of Michigan. The party adopted the uncertain concept of popular sovereignty or squatter sovereignty, which left the decision of whether or not to adopt slavery in the territories to the settlers themselves.

In the North, there were defections from both political parties over the slavery issue, but more Democrats fell out of line. The old Liberty party and antislavery Whigs joined dissident Democrats under the banner of the new Free Soil party and nominated former president Martin Van Buren for the presidency. Although Van Buren failed to carry a single state, the Free Soil party won some 10 percent of the popular vote and finished second in the popular vote (ahead of the regular Democrats) in Massachusetts and New York. Taylor defeated Cass in the Electoral College, 163 to 127.

The Formula of Compromise

Since the days of the Confederation, the place of slavery in the constitutional order and its role in the future of the new nation had menaced national politics. At the Constitutional Convention in 1787, the framers had been forced to accept a sectional compromise (see Chapter 6) when disputes over congressional representation could not be resolved. That agreement was reached in large part because the framers believed that slavery was dying out. When the rich lands of the Deep South opened up immediately after the War of 1812, the future of the plantation-based slave economy became more promising.

The Missouri Compromise and Sectional Balance

During the first three decades after the adoption of the Constitution, a rough equivalency of slaveholding and non-slaveholding states was maintained. This occurred more by chance than by design. By the time Missouri applied for statehood in 1819, however, the sectional balance was considered a significant component of union. The controversy that ensued over the Tallmadge Amendment, which proposed gradual emancipation in Missouri, was resolved only after Maine requested admission to the union as a free state, which provided the means to maintain the representational balance between slave and free states.

Congress recognized the idea of sectional balance when it adopted the Missouri Compromise line, which prohibited slavery above 36°30′ latitude in the territory that comprised the Louisiana Purchase. The degree to which this idea had become enshrined in American politics was made evident in the strategy employed by pro-Texas Democrats in 1843–1844. They supported the occupation of "All Oregon" to create a coalition for expansion, expecting northerners to go along with the annexation of slaveholding Texas to achieve their own ends.

California and the Crisis of 1850

The introduction of the Wilmot Proviso, which in effect proposed to erase the Missouri Compromise line, turned the floor of Congress into a stage for extended debate over the status of slavery in the territories. How should the new territory won from Mexico be organized? The question dominated the congressional agenda for almost four years. Floor debate became increasingly acrimonious and by 1850 had

taken on the appearance of a rhetorical civil war. Sectional loyalties overrode all else. Although they had no illusions that slavery could take hold in Oregon, southern members, for example, held up the territory's admission to the union until 1848, determined to make clear the importance they attached to the sectional balance.

California and the Territorial Question. The congressional dispute over slavery might have continued for years were it not for the discovery of gold in the Sacramento Valley of California in January 1848. By the end of 1849, the territory's population had swelled to 100,000, giving a sense of urgency to the need for local government. Because of Congress's inaction, the Mexican cession was still under military control. In 1849, Californians drafted and ratified a constitution and applied for admission into the union as a free state. It was clear to most Americans that the nation had reached a pivotal moment in its history.

The extension of the nation's boundaries to the Pacific Ocean had brought vast new territories, capable of being organized into many states. The legislative mechanisms devised for their settlement would give shape to the economic and social development of the new region, and thereby profoundly influence the nation's political future. Both northerners and southerners recognized that slave economies could not take hold in the new western regions unless slaveholding was protected by law in the early stages of territorial settlement.

The Compromise of 1850

After President Taylor recommended that California be admitted as a free state, southern threats of disunion began to be made with regularity. Moderate members put forward various suggestions in an effort to resolve (or defuse) the crisis. The most prominent of these called for the following:

- The Missouri Compromise line to be extended to the Pacific
- Congress to defer the question of slavery in the territories to the federal courts
- The decisions on slaveholding to be made by the inhabitants of the territories when they began the procedure to apply for statehood

Most southerners continued to argue that, because slaves were legal property, Congress had the responsibility to provide protection for the slaveholder if he chose to migrate to new territories with his slaves.

In January 1850, as possible disunion loomed, Henry Clay, then seventy-two years old, returned to the Senate and attempted to conciliate the sectional conflict and save the union. He introduced a series of resolutions, five of which finally became the basis of the settlement known as the Compromise of 1850. Their introduction marked the beginning of the Great Debate, in which the great triumvirate—Clay, Calhoun, and Webster—would speak on the Senate floor for the last time. In response to a strong unionist movement that gained popular support in all sections of the country, members gradually moved toward compromise. The Southern Convention, which convened in Nashville in June 1850 to consider whether the South should secede, adjourned without taking any action. The death in the following month of President Taylor, who had insisted that California be admitted before compromise measures were considered, eliminated one obstacle to a broad agreement. Taylor's successor, Vice-President Millard Fillmore, actively contributed to its achievement.

Clay's omnibus bill (one with many provisions) offered something for all. Its most important provisions were that:

- California be admitted as a free state
- The slave trade, but not slavery, be abolished in the District of Columbia
- Congress enact a more effective fugitive slave law
- Territorial governments be established in New Mexico and Utah, with the stipulation that they might be admitted to the union with or without slavery, as they might determine (thus legislating the principle of popular sovereignty)

As a single package, the omnibus bill went down in defeat in the Senate in July 1850. Exhausted and in poor health, Clay departed for Kentucky. Others, led by Senator Stephen A. Douglas of Illinois, completed the compromise by pushing through its principal provisions in separate pieces of legislation.

The Finality of the Compromise

The compromise measures were opposed by the South's great spokesman and theorist Calhoun, as well as by antislavery men like William Henry Seward of New York. (Seward had spoken of the need to consult a "higher law" on the question of slavery.) In the North, Senator Webster was vilified by abolitionists for having agreed to the new and stricter Fugitive Slave Law of 1850, the one measure southerners had insisted upon in acceding to Clay's compromise package. However, the unionist movement was effective in strengthening the sentimental bonds of union in both North and South. Politicians in both sections endorsed the compromise as the permanent solution of the slavery question.

The Election of 1852

Both national parties pledged to observe the finality of the Compromise of 1850 and to refrain from discussing the slavery question. The Free Soil party denounced the congressional agreement. Democrats nominated Franklin Pierce of New Hampshire, who won a resounding victory over the Whig candidate, General Winfield Scott. Pierce strongly endorsed the compromise, which won him the support of many conservative Whigs, notably Daniel Webster. Suspicions that Scott took guidance from Seward and the antislavery element of the Whig party hurt his candidacy, especially in the South; he received only 42 out of 296 electoral votes.

■ HOUSE DIVIDED AGAINST ITSELF

The Compromise of 1850, it soon became clear, was a truce rather than a settlement. Still, because most believed that the nation's limits had been reached, the formula for determining the status of slavery in the western territories seemed to be fixed by either the compromise measures or the Missouri Compromise line. The sectional agreement was broken in 1854, however, when Senator Stephen A. Douglas of Illinois introduced legislation to organize the region west of Iowa and Missouri.

The Limits of Compromise

The flaw in the unionist appeal to the finality of the compromise was that it proposed a static remedy in a dynamic era of growth and expansion. The pledge to refrain from discussion of the slavery issue

depended upon restraint. American history had already demonstrated that the settlement of the continent did not conform to this formula.

The Underground Railroad

The Compromise of 1850 accelerated the activities of a semi-secret organization known as the Underground Railroad, a group composed of both black and white volunteers that had been in existence since the early 1830s. This organization coordinated a vast network of individuals, mostly abolitionists and free-soilers in the free areas of the Ohio valley, who worked very hard, sometimes risking their lives, to assist slaves who were escaping the South find refuge and safe haven, most often in Canada. By the 1840s and 1850s, some of these Underground Railroad workers routinely traveled to the South, where they would clandestinely assist slaves in their escape efforts. Once a fugitive, the escaping slave would be secretly escorted through a series of safe houses and other secure locations until they reached safety. Some historians estimate that over 100,000 slaves escaped the South between 1810 and 1850. Notable conductors on the Underground Railroad included the Quaker, Levi Coffin, who helped over 3,000 slaves gain their freedom, and Harriet Tubman (a former slave herself) who made 19 trips into slave territory in order to assist with the escapes.

Young America and the Expansion of Slavery

In response to a wave of popular revolutions that swept Europe in 1848 and to the United States' new status as a continental power, the eagle of Manifest Destiny again took to rhetorical flight. A Young America movement, reflecting similar movements in Europe, was championed by expansionist Democrats to promote new cultural as well as political nationalism.

Diplomatic initiatives were undertaken during both the Fillmore and Pierce administrations to expand American interests and territory. Although the Whigs were in power, the United States broke with tradition and gave official support to Hungary's movement to gain independence from Austria. In 1854, the efforts of Commodore Matthew C. Perry, at the head of a U.S. navy expedition in the Pacific Ocean, secured a treaty opening Japanese ports to the United States for the first time.

Expansionist activity, however, was no longer a salve for the ills of the nation. In fact, it now became a cause of divisiveness. Any initiative directed toward southern climes was suspected in the North as a ruse by southerners to secure additional territory for its slave economy. Antislavery groups pointed to the following:

- The private military expeditions of General Narciso Lopez in Cuba (1850–1851), which were supported by influential southerners
- The Ostend Manifesto, signed in 1854 by Pierre Soule, James Buchanan, and John Y. Mason (U.S. ministers to Spain, Britain, and France, respectively), which proposed the idea that the United States would be justified "by every law human and divine" in seizing Cuba
- The military activities, or filibustering, of William Walker in Nicaragua, which seemed to have the support of southern extremists

Southerners, on the other hand, fearing the implications for the sectional balance, opposed renewed efforts to annex Canada. They also blocked a treaty that would have provided for the admission of Hawaii into the union (without slavery).

Expansion, Railroads, and Popular Sovereignty

In the early 1850s, western settlement had reached the Missouri River and Native American lands. At the same time, pressures were increasing in Washington for the federal government to support the construction of a transcontinental railroad to link the Atlantic and Pacific coasts. A coalition of economic interests secured the opening of Kansas and Nebraska, at the cost of reigniting the sectional conflict.

Southern and northern interests competed intensively to secure the location of the transcontinental railroad. Aware of the great economic benefits it would confer, the powerful Senator Stephen A. Douglas of Illinois, chairman of the Committee on Territories, sought approval of Chicago or another northwestern city as the railroad's proposed eastern terminus. He believed the settlement of the Nebraska region would stimulate the population growth that would justify a northern route across the Great Plains, and he mustered his legislative skills to gain the means to ensure it.

Repeal of the Missouri Compromise

The Nebraska region was above the Missouri Compromise line, the 36°30′ line of latitude, where slavery had been prohibited since 1820. Knowing that he had to avoid a protracted dispute over the sectional balance of free and slave states to secure the organization of the area, Douglas worked out a deal with southern members to achieve his ends. He agreed to back a repeal of the Missouri Compromise so that the area west of Missouri would be open to settlement without any restriction against slavery. He also agreed to a division of the region into the Nebraska Territory and the Kansas Territory; it was presumed the latter would be settled by slaveholders.

The Kansas-Nebraska Act (1854)

This act thus repealed the Missouri Compromise, which, since 1820, had been regarded as the final settlement of the slavery question in the territory of the Louisiana Purchase. Douglas argued that the most democratic way to solve the issue was to allow the people of any new territory to decide whether or not they wished to legalize slavery within their boundaries. He was successful in gaining President Pierce's support for the bill on this basis. His legislation thus had the effect of elevating the principle of popular sovereignty, which had been incorporated into the Compromise of 1850, to the level of national policy. The measure ended the sectional truce on the slavery issue and bitterly divided the Congress— southern Whigs and Democrats supported it; northern Whigs opposed it; northern Democrats were evenly divided on the question.

Renewed Opposition to the Fugitive Slave Law

Antislavery groups in the North were incensed over the provisions of the Fugitive Slave Law passed in 1850. They denounced it because it failed to provide for a jury trial in the case of suspects, because it applied to slaves who had fled from their masters years before, and because it permitted federal officials to compel any citizen to aid in the apprehension and return of fugitives. Still, in the aftermath of the Compromise of 1850, public sentiment in the North supported enforcement of the new Fugitive Slave Law as the necessary price for preserving the bonds of union.

The Kansas-Nebraska Act changed all that. Mass meetings were held in northern cities to organize disobedience to the law. Between 1855 and 1859 several state legislatures passed "personal liberty laws"

to prohibit the use of local jails for the confinement of fugitives. On occasion, mobs formed in northern cities to prevent the apprehension of fugitive slaves. Such actions had the effect of undermining the position of moderates in the South; southerners indignantly accused the North of deliberate intent to violate the compromise.

The Gadsden Purchase

Meanwhile, proponents of a southern route for the projected transcontinental railroad were active. The rapid growth of California helped their cause. However, early surveys indicated rails would have to be laid through a part of Mexico. At the suggestion of Secretary of War Jefferson Davis of Mississippi, President Pierce sent James Gadsden, a South Carolinian and president of a railroad, to Mexico, where he secured the Gadsden Purchase (the southern portions of modern Arizona and New Mexico) for $10 million.

Formation of the Republican Party

The consequences of the Kansas-Nebraska Act were far-reaching. Anti-Nebraska Democrats and Whigs drifted into a new coalition, the Republican party, organized upon the principle of opposition to the expansion of slavery. The Democratic party was increasingly dominated by the South. The Whigs ceased to be a national political party.

The Slave Power Conspiracy

The public meetings that were held all over the North to protest the Kansas-Nebraska Act contributed to a reordering of national politics. To the free states, repeal of the Missouri Compromise represented a step backward, a violation of a sacred agreement that had the moral force of a constitutional provision. It seemed to confirm the accusations of abolitionists that the South was engaged in a slave power conspiracy of some kind, to make slavery legal in all of the territories or even throughout the settled states. The matter of the territories was enough to cause concern. It was certain that they would have much influence in shaping the nation's future. It was also clear that northern settlers as well as European immigrants would avoid settling in areas that permitted slaveholding. It even seemed possible that slavery might prove adaptable to mining enterprises in the far southwest.

The Republican Coalition

Many northern Democrats abandoned their party in protest against the Kansas-Nebraska Act, further strengthening the moderate and pro-South elements that remained in that party. These anti-Nebraska Democrats, together with groups of northern Conscience Whigs and remnants of the Free Soil party, quickly joined in opposition as Republicans. The strongest support for the new party was in the Old Northwest. In the fall elections of 1854, these Republicans joined with the American party (Know-Nothings) to capture a majority of the seats in the House of Representatives. Significantly, the new Republican party made no attempt to win support from the slaveholding South—its organizing principle was opposition to the extension of slavery anywhere within the territories of the United States. It gradually adopted significant portions of the old Whig agenda: the high tariff, support for government, assisted internal improvements, and homestead legislation (also championed by Democrats).

Bleeding Kansas

The principle of popular sovereignty, which Douglas had written into the Kansas-Nebraska Act, was quickly put to the test. The Kansas Territory became a battleground, the normal process of settlement transformed into a contest of opposing ideologies. Antislavery as well as proslavery forces recruited, subsidized, and even armed settlers and less permanent residents in efforts to gain control of the territorial government.

In 1855, the proslavery men, supported by residents of Missouri who rode across the border (Border Ruffians) to influence the outcome, elected a majority of the territorial legislature and established a government at Shawnee Mission, Kansas. Over 6,000 ballots were cast, although perhaps no more than 1,500 men were eligible to vote. The newly elected territorial legislators passed measures to legalize slavery in the Kansas Territory. In response, free-soil advocates held a convention at Topeka and framed a constitution barring slavery. President Pierce determined to support the Shawnee government.

Tension within the territory led to bloodshed in 1856. To arrest free-state leaders, a pro-slavery posse (accompanying a federal marshal) attacked the town of Lawrence, resulting in several deaths. In retaliation for this sacking of Lawrence, the fanatical John Brown led a small band against a settlement near Pottawatomie Creek, where five proslavery men were murdered. Guerrilla warfare continued despite the presence of U.S. troops in the territory.

The violence in Kansas, grossly exaggerated in many newspaper accounts, had its effect in Washington. On the floor of the U.S. Senate, Charles Sumner of Massachusetts was caned into unconsciousness after making a long speech that included a personal attack on Senator Andrew P. Butler of South Carolina. His assailant, Butler's nephew Preston Brooks, a member of the House of Representatives, became an instant hero in the South.

The Lecompton Constitution (1857)

Encouraged by Democratic administrations in Washington, proslavery forces in Kansas determined to press for admission to the Union as a slave state. Decidedly a minority, they drew the lines of voting districts to offset the free-state majority, who then boycotted the election for convention delegates. The constitution that was written at Lecompton, Kansas, protected slave property within the territory. In a series of tests of that document, it became clear, even to two territorial governors (presidential appointees), that free-state supporters were in an overwhelming majority and that proslavery advocates were manipulating the statehood process for their own purposes. Even Senator Douglas denounced the events in Kansas as a denial of popular sovereignty.

Nevertheless, President Buchanan persisted in support for the Lecompton constitution and recommended that Kansas be admitted as a slave state. This was approved in the U.S. Senate but defeated in the House of Representatives. Meanwhile, the free-state majority gained control of the territorial legislature. The Lecompton constitution was defeated in a direct referendum held in January 1858. Kansas entered the union in 1861 as a free state, after several southern states had already seceded.

The Election of 1856

The strife in Kansas was at its height in 1856 when the presidential contest began. Democrats nominated James Buchanan of Pennsylvania, formerly a member of the U.S. Senate, who had served as minister to Great Britain during the Pierce administration. He benefited by having had nothing to do with

Kansas. Nevertheless, the party endorsed the Kansas-Nebraska Act and the principle of popular sovereignty. The fact that Buchanan's signature was on the ill-fated Ostend Manifesto did not hurt him; the party platform renewed the call for the acquisition of Cuba.

The platform of the Republican party vigorously opposed the expansion of slavery into the territories; it denounced the Kansas-Nebraska Act and Democratic policy in Kansas. It also made recommendations for internal improvements legislation. General John C. Frémont of Missouri was nominated for president. The party's rallying cry in its first national election: "Free Soil, Free Speech, Free Men, and Frémont."

Although split by the free-soil issue, the American party once again fielded a candidate, former president Millard Fillmore, who drew support only from pro-compromise Whigs. The vote it polled may have influenced the election. Buchanan received 1.83 million votes in the popular balloting to Frémont's 1.34 million and Fillmore's 870,000. The margin of victory for the Democrats was slight in Pennsylvania and Illinois. Republican victories in those states would have won Frémont the presidency, without a single victory in the South. This fact was not lost on southerners.

The Panic of 1857

Reduced demand for American foodstuffs in Europe after the settlement of the Crimean War (1854–1856) led to an economic decline and contraction. Republican politicians effectively used the ensuing business depression, which became evident soon after Buchanan was inaugurated, to discredit Democratic policies. Manufacturers argued that the low-tariff policy of the Democrats (further reductions were made in 1857) had failed to protect them against British competition. The Republican alternative was quickly tested. In the congressional election of 1858 in Pennsylvania, Buchanan's home state, every incumbent Democratic congressman was turned out of office.

■ THE DRED SCOTT DECISION (1857)

In an attempt to settle the slavery controversy by judicial decision, the Supreme Court ruled in the case of *Dred Scott v. Sandford* on March 6, 1857, two days after Buchanan's inaugural. The Court's decision, one of the most controversial in its history, only increased the hostile feeling between the two sections. Dred Scott, a slave residing in Missouri, had been taken by his master into the free state of Illinois and later into the northern part of the Louisiana Purchase, where slavery had been forbidden by the Missouri Compromise. Scott sued for his freedom. In time, the case reached the Supreme Court. The principal majority opinion, written by Chief Justice Taney, held that no black slave or descendant of a slave could be a citizen of the United States; therefore, Scott had no standing to bring a suit in the federal courts.

More important was Taney's additional ruling on Scott's claim that his residence in the Wisconsin Territory had made him free: The slave was the property of his master, and Congress had no right to confiscate that property in the territories without due process of law. In effect, Taney ruled that the Missouri Compromise had been null and void from the day of its enactment.

The decision was denounced in the North. It delighted the South, which now saw slavery protected by constitutional guarantees in every part of the federal territories. The Republican party, however, ultimately gained the most from the outcome. The fact that five of the nine justices were residents of slave states, as well as the decision itself, seemed to confirm the Republicans' charge that slave power had gained control over the federal government.

The Emergence of Abraham Lincoln

Senator Douglas's effort to win re-election to the Senate from Illinois in 1858 was closely contested by Republican candidate Abraham Lincoln. Having broken with Buchanan, Douglas faced challenges from pro-administration Democrats as well as from Republicans. He had little choice but to accept Lincoln's invitation to a series of seven public debates. Against a background of "Bleeding Kansas" and the Supreme Court's Dred Scott decision, the Lincoln-Douglas debates were widely reported in the nation's press.

Lincoln, a native of Kentucky (he, in fact, had been born in a log cabin), was a skilled frontier lawyer. He had served several terms in the Illinois legislature but only one in the U.S. House of Representatives (as an antiwar Whig, 1846–1848). In accepting the Republican nomination to run against Douglas for the Senate, he made use of a biblical passage to explain the intensifying controversy over slavery: "A house divided against itself cannot stand. I believe this government cannot endure permanently half slave and half free. I do not expect the union to be dissolved; I do not expect the house to fall; but I do expect it will cease to be divided. It will become all one thing, or all the other."

Lincoln's prospects for victory were slight. Senator Douglas, the leading figure in the Democratic party, was a skilled debater and parliamentarian. Douglas's quarrel with the Buchanan administration over its policy in Kansas had actually won him sympathy in Illinois, causing even some Republicans to endorse his re-election to the Senate.

The Lincoln-Douglas Debates (1858)

Lincoln was anxious to demonstrate that Douglas and his doctrine of popular sovereignty worked to the advantage of southern extremists; he attacked his opponent's evasiveness on the morality of slaveholding. Sensitive to the moderate political instincts and race prejudice of his region, Douglas retaliated by trying to associate Lincoln and the Republicans with radical abolitionist positions, including racial equality (then perceived as an extreme view). Lincoln responded by distancing himself from the abolitionists. He did not endorse interference with the institution of slavery within the South, where it was specifically protected by the Constitution. Rather, like the founding fathers, he opposed the extension of slavery into the territories.

Douglas won the Illinois election and was returned to the Senate. More important, however, the debates transformed Lincoln into a national figure, one of the leading spokesmen of the growing Republican party. His friends began to organize the campaign that was to bring him the presidential nomination in 1860.

The Freeport Doctrine

The most significant of the debates between Lincoln and Douglas was held at Freeport, Illinois, on August 27, 1858. There, Lincoln compelled Douglas to explain how, in light of the Dred Scott decision (which the Democrat supported), the settlers of a new territory might exclude slavery. Douglas's reply, which became known as the Freeport Doctrine, was fateful for his political career. He pointed out that although slavery might be constitutionally legal in the territories, it could not "exist a day or an hour anywhere, unless it is supported by local police regulations." This explanation, calculated to reassure Illinois voters, further alienated southern Democrats, reducing what chances Douglas still had to win the presidency.

The Impending Crisis

As the presidential election of 1860 loomed, the drift of events seemed to confirm the fears of each section. From the northern perspective, there was additional evidence of the slave power's ambition to control the federal government. The South calculated the possible effects of a Republican victory in the presidential election of 1860.

The War of Words

By the late 1850s, the slavery controversy had extended its reach into almost every kind of printed matter. The war of words had been ignited by Harriet Beecher Stowe's novel *Uncle Tom's Cabin* (1852), which sold over 300,000 copies the first year of its publication. There was a flurry of proslavery responses in fiction, all ineffective but telling evidence of the extent to which Stowe had affected the debate.

The Pro-Slavery Argument (1852), a compilation of writings, provided the southern audience with reassuring defenses. In his *Sociology for the South,* or the *Failure of Free Society* (1854), and *Cannibals All!* (1857), the Virginia lawyer George Fitzhugh went on the attack. He condemned the factory system of the North for reducing workers "to separate, independent but conflicting monads, or human atoms." Southern slavery was presented as a benign social welfare state. Fitzhugh confirmed the free-soil movement's worst fears when he predicted that "slavery will everywhere be abolished or everywhere be reinstated."

More troubling to southern planters than Stowe's book was the North Carolinian Hinton Rowan Helper's *The Impending Crisis in the South, How to Meet It* (1857), which was widely circulated by abolitionists. Helper argued that slavery worked against the interests of small farmers and workers. His call for abolition suggested the likelihood that the Republican party would exploit class conflict and pursue an alliance with non-slaveholding southern whites upon taking office. The war of words also continued in Congress. In 1859, southerners blocked the candidacy of Republican John Sherman of Ohio for speaker of the House because he had endorsed Helper's book.

John Brown's Raid (1859)

On October 16, 1859, John Brown, the abolitionist fanatic, and eighteen followers attacked the U.S. arsenal at Harper's Ferry on the upper Potomac River (then in Virginia). His goal was to gain enough rifles and ammunition to launch a slave insurrection in the upper South. He was captured, tried for treason against the state of Virginia, and hanged (with six of his group) in December 1859.

Brown's raid seemed a signal event to many southerners rather than an isolated episode of fanaticism. The South was too sensitive to slave uprisings to see such bloodletting objectively. Furthermore, testimony at Brown's trial revealed that his activities had been funded in part by donations from abolitionists. In death, moreover, Brown was transformed into a hero and martyr in the cause of freedom by northern abolitionists and intellectuals, even by writers such as Emerson and Thoreau. Although Lincoln, William H. Seward, and other Republican leaders denounced Brown's act as criminal, southern extremists portrayed it as the logical result of the principles the Republican party was advocating.

The Election of 1860

The strength of the two-party system had been the capacity of the national parties to contain disparate regional elements and to unify them in the common cause of winning elections. In 1860, the one

surviving national political party could no longer contain sectional conflict in this way, an ominous sign for the Union.

Democrats, North and South. At the first of two gatherings of the Democratic national convention, held in Charleston, South Carolina, in early May, southerners demanded a proslavery plank in the party platform. They were able to stop Stephen A. Douglas from gaining the presidential nomination; however, they could not prevent the convention from endorsing popular sovereignty and deference to the Supreme Court as remedies to the slavery question. This caused some southern Democrats to bolt the party.

Many more walked out of a second gathering in Baltimore in mid-June when Douglas's supporters won key tests, thereby giving him the regular party's nomination. Southern Democrats formed their own convention and nominated John C. Breckinridge of Kentucky for president. Their platform called for the protection of slavery in the territories and the annexation of Cuba.

Republicans. At their national convention, held in Chicago in mid-May 1860, the Republicans passed over their most senior leader, Seward, thought by many to be too radical (and unacceptable to the Know-Nothing element of the party). Instead, they nominated Lincoln for president. They drafted a platform that reaffirmed opposition to slavery in the territories but went well beyond that previously all-defining issue. Broad appeals were made to business and agricultural interests—notably, endorsement of federal support for a railroad to the Pacific and support for a liberal immigration policy. The party also called for a free homestead act, a high protective tariff, and congressional appropriations for internal improvements.

Constitutional-Unionists. Just prior to the Republican convention, remnants of the old Whig party and of the American, or Know-Nothing, party had united, somewhat in protest, as the Constitutional Union party. Expressing support for a compromise on the slavery question to save the union, their convention chose John C. Bell of Tennessee for president. Their support was concentrated in the border states of the upper South.

Lincoln's Victory

The contest in the free states was between Lincoln and Douglas; in the slave states, between Breckinridge and Bell. Although Lincoln received only 40 percent of the popular vote, he won 18 free states, giving him 180 votes and a majority in the Electoral College. Breckinridge won 11 slave states, with 72 electoral votes. Bell took 3 border states, with 39 votes; Douglas took only Missouri, and 3 of New Jersey's electoral votes, for a total of 12. Southerners did not overlook the mathematics of the election. In spite of his failure to win a majority of the popular vote and to carry a single southern state, Lincoln would even have defeated a fusion ticket of all three opponents.

The election of 1860 gave the Republican party control of the presidency and the House of Representatives. Democrats still had a majority in the Senate, and the Supreme Court retained its proslavery bias. There was no immediate threat to slavery in the South. The decision for secession and war was by no means a foregone conclusion or inevitable.

The South, however, could not fail to see the fact that the handwriting was on the wall. It was increasingly isolated from the rest of the nation by economic developments and cultural differences. The sectional

balance had tilted in favor of the North on the admission of California as a free state. It was only a matter of time before the federal government would be completely controlled by free-soil majorities. By 1860, southern leaders could not avoid concluding that their way of life was in jeopardy.

Selected Readings

Anbinder, Tyler. *Nativism and Slavery: The Northern Know Nothings and the Politics of Slavery* (1992).

Barney, William L. *The Road to Secession: A New Perspective on the Old South* (1972).

Bauer, K. Jack. *The Mexican War, 1846–1848* (1974).

Brands, H. W. *The Age of Gold: The California Gold Rush and the New American Dream* (2002).

Buenger, Walter. *Secession and the Union in Texas* (1984).

Campbell, Randolph B. *An Empire for Slavery: The Peculiar Institution in Texas, 1821–1865* (1991).

Campbell, Stanley W. *The Slave Catchers: Enforcement of the Fugitive Slave Law, 1850–1860* (1972).

Cantrell, Gregg. *Stephen F. Austin: Empresario of Texas* (1999).

Fehrenbacher, Don E. *The Dred Scott Case: Its Significance in American Law and Politics* (1978).

Finkelman, Paul, ed. *His Soul Goes Marching On: Responses to John Brown and the Harper's Ferry Raid* (1995).

Foner, Eric. *Free Soil, Free Labor, Free Men: The Ideology of the Republican Party before the Civil War* (1970).

Foos, Paul. *A Short, Offhand, Killing Affair: Soldiers and Social Conflict during the Mexican-American War* (2002).

Francaviglia, Richard V. and Douglas W. Richmond, eds. *Dueling Eagles: Reinterpreting the U.S.-Mexican War, 1846–1848* (2000).

Frazier, Donald S., ed. *The United States and the Mexican War: Nineteenth Century Expansion and Conflict* (1998).

Goetzmann, William H. *Exploration and Empire* (1966).

Haynes, Sam and Christopher Morris, eds. *Manifest Destiny and Empire: American Antebellum Expansionism* (1997).

Hedrick, Joan D. *Harriett Beecher Stowe: A Life* (1994).

Holt, Michael. *The Political Crisis of the 1850s* (1983).

Johanssen, Robert W., ed. *The Lincoln-Douglas Debates of 1858* (1965).

 To the Halls of the Montezumas: The Mexican War in the American Imagination (1985).

Klein, Maury. *Days of Defiance: Sumter, Secession, and the Coming of the Civil War* (1997).

Merk, Frederick. *Manifest Destiny and Mission in American History* (1963).

 Slavery and the Annexation of Texas (1972).

Nevins, Allan. *The Emergence of Lincoln* (2 vols., 1950).

 The Ordeal of the Union (2 vols., 1947).

Potter, David M. *The Impending Crisis, 1848–1861* (1976).

Stan, Kevin. *Americans and the California Dream, 1850–1915* (1973).

Stegmaier, Mark J. *Texas, New Mexico, and the Compromise of 1850* (1996).

Thomas, Benjamin P. *Abraham Lincoln: A Biography* (1952).

Unruh, John D., Jr. *The Plains Across: The Overland Immigrants and the Trans-Mississippi West, 1840–1860* (1979).

Test Yourself

1) The journalist who coined the term Manifest Destiny to describe the westward movement was
 a) Horace Greeley
 b) John L. O'Sullivan
 c) George Wilkins Kendall
 d) Joseph Pulitzer

2) Which of the following political leaders was not a political party candidate for the presidency in the election of 1860?
 a) John C. Bell of Tennessee
 b) John C. Breckinridge of Kentucky
 c) Abraham Lincoln of Illinois
 d) William Seward of New York

3) Which of the following was a well-known abolitionist who led vigilante raids against towns in Kansas and Virginia, thereby helping to cause the Civil War by increasing paranoia in the South?
 a) Charles Sumner
 b) William Lloyd Garrison
 c) John Brown
 d) Theodore Weld

4) True or false: In 1845, President Polk sent a military force commanded by Zachary Taylor into the disputed territory along the Mexican border with Texas, with the full knowledge that so doing might explicitly provoke a war between the United States and Mexico.

5) The Republic of Texas was annexed to the United States in 1845 by means of
 a) a treaty of annexation between the two nations
 b) a special joint resolution of the United States Congress
 c) the territorial provisions of the Northwest Ordinance
 d) none of the above

6) The War with Mexico came to an end with the negotiation of the following peace accord
 a) the Clayton-Bulwer Treaty
 b) the Treaty of Guadalupe-Hidalgo
 c) the Treaty of Velasco
 d) the Wilmot Proviso

7) The Compromise of 1850 had all of the following as provisions, except
 a) the passage of a federal fugitive slave law
 b) the cancellation of the Missouri Comprise Line of 1820
 c) the organization of Utah and New Mexico into two new territories without reference to slavery
 d) the creation of the Mormon State of Deseret

8) The controversial Supreme Court decision in the case *Dred Scott v. Sandford* (1856) upheld all of the following points, except that
 a) Dred Scott was not a citizen of the United States and could not bring suit in federal court.
 b) The Missouri Compromise was effectively null and void from the day of its passage in 1820.
 c) Dred Scott was not a free man and remained a slave even though he had moved to a free state with his master.
 d) Congress had the right to confiscate slaves as contraband property when they moved to free soil areas of the nation with their masters.

9) Which of the following military leaders was not a major commander of American troops in the War with Mexico?
 a) Winfield Scott
 b) Stephen W. Kearney
 c) John C. Frémont
 d) Sam Houston

10) Which of the following was not a reason why the United States claimed the Oregon territory as part of the nation?
 a) the visit of the Lewis and Clark Expedition to the area in 1805–1806
 b) the 1792 explorations of United States army Captain Robert Gray, who named the Columbia River
 c) the 1811 establishment of a fur trading post at Astoria by John Jacob Astor
 d) the popularity of Oregon as a destination for immigrants

Test Yourself Answers

1) **b.** Journalist John L. O'Sullivan coined the term Manifest Destiny, although he is little remembered today. Instead, Horace Greeley—the publisher of the New York *Tribune*—eventually became the best known journalistic advocate of Manifest Destiny. Greeley is remembered for his comment: "Go West, young man, Go West!" George Wilkins Kendall and Joseph Pulitzer, also a journalist in the mid-19th century, were not explicitly involved in the Manifest Destiny movement.

2) **d.** William Seward of New York wanted to be the Republican presidential candidate in 1860. He lost the nomination to Abraham Lincoln. Although Seward had presidential aspirations, he was not the nominee of any party in 1860. Instead, he served as Lincoln's Secretary of State. John C. Breckenridge of Kentucky ran as a Democratic candidate in that election, while John C. Bell of Tennessee was the standard bearer of the Constitutional Union Party.

3) **c.** All of the people noted in this question were active abolitionists. It was, however, John Brown who became the active abolitionist who led raids both at Pottowamanee, Kansas, and Harper's Ferry, Virginia. In so doing, he helped cause the Civil War. Charles Sumner was United States senator from Massachusetts. William Lloyd Garrison published in abolitionist newspaper in Boston. Theodore Weld was an educator who aggressively supported the abolitionist movement.

4) **True.** Mexico considered the territory between the Rio Grande River and Nueces River in Texas to be part of her homeland territory, an area known popularly as the Nueces Strip. The United States, instead, felt that the southern boundary of its national territory was the Rio Grande and believed the whole Nueces strip was located inside the United States. President Polk sent Zachary Taylor and his army into this disputed zone, thereby initiating hostilities between the two nations. Some Mexican historians have subsequently blamed Polk purposefully, saying he caused the war by this action.

5) **b.** A joint resolution of Congress brought Texas into the Union during the closing days of the Tyler administration. Senate passage of an annexation treaty with Texas had failed several weeks earlier. The Republic of Texas was therefore never annexed by treaty, because Congress failed to pass it. Instead, the provisions of the treaty were recast as a joint resolution, which did pass.

6) **b.** The Treaty of Guadalupe-Hidalgo, negotiated in Mexico City during 1848 by the American diplomat Nicholas P. Trist, ended the war with Mexico. The Wilmot Proviso, the Clayton-Bulwer Treaty, and the Treaty of Velasco were all political or diplomatic occurrences associated with foreign-policy, but none had to do with ending the United States war with Mexico.

7) **d.** The State of Deseret never had any federal sanction. It was, instead, the popular name by which the Mormon settlers around the Great Salt Lake called their settlement. The compromise of 1850 provided for a fugitive slave Law, canceled the Missouri compromise line of 1820, and called for the organization of Utah and New Mexico territories without reference to slavery.

8) **d.** The 1857 decision in the Dred Scott case failed to legitimize the confiscation of slaves as contraband. So doing was never a part of national policy until during the Civil War, when Union commanders did so with territory taken militarily from the Confederacy. The decision did claim that Dred Scott was not a citizen, that his removal to a free state had not given him a freedom, and that the Missouri Compromise of 1820 was effectively null and void.

9) **d.** Sam Houston was not a military commander in the war with Mexico. He, instead, represented Texas in the United States Senate during the War with Mexico. Winfield Scott commanded the American forces that captured Mexico City. Stephen W. Kearney and John C. Frémont led military expeditions in the west.

10) **d.** Oregon was not a popular destination for immigrants until after the war with Mexico. All of the other events noted in this question were employed by American diplomats as United States diplomatic claims to the Oregon territory. They used these as reasons for an American claim to Oregon in drafting with Great Britain the Treaty of 1846, which provided for joint occupation by citizens of both nations.

The Civil War

1860: Secession crisis in South Carolina (November–December)

1861: Secession of Mississippi, Florida, Alabama, Georgia, Louisiana, Texas (January–February); formation of the Confederacy (February); Lincoln inaugurated president (March 4); Confederate attack on Fort Sumter (April); Lincoln proclaims naval blockade of southern coastline (April 19); secession of Virginia, Arkansas, Tennessee, North Carolina (April–May); first Battle of Bull Run won by Confederates (July 21); the Trent affair (November–December)

1862: Confederates surrender Forts Donelson and Henry and the city of New Orleans; McClellan's Peninsular Campaign fails (March–July); Congress passes Homestead Act, Morrill Land Act, Pacific Railway Act, and Second Confiscation Act; Lee's advance into Maryland turned back at Antietam Creek (September); preliminary emancipation proclamation (September)

1863: Emancipation Proclamation (January 1); West Virginia, formed from fifty western counties of Virginia, admitted to the Union; French armies occupy Mexico; Confederate invasion stopped at Gettysburg (July); U.S. forces take Vicksburg (July 4); first conscription act and draft riots in New York City (July)

1864: Grant invades Virginia; Congress passes second Pacific Railway Act; Sherman takes Atlanta and marches to the sea (September–December); Lincoln re-elected president over the Democratic nominee McClellan

1865: Confederate forces surrender at Appomattox (April 9) and in North Carolina and Louisiana (April–May); Lincoln's second inaugural (March 4) and assassination (April 14); Thirteenth Amendment, abolishing slavery, ratified

The Civil War that threatened to destroy the United States between 1861 and 1865 profoundly transformed the political, social, and economic life of the nation. It began as a constitutional struggle, became a test of federal authority and of opposing political wills, but soon took on much broader dimensions. The initial belief that it would be short in duration proved tragically mistaken.

The seceding states fought to achieve independence and yet closely modeled the government of their Confederacy on the U.S. Constitution. The Lincoln administration responded with a crusade to preserve the Union but, as casualties increased and political pressure mounted, expanded its war aims to include the destruction of slavery and the liberation of black slaves. Thus, as the U.S. army extended its occupation deeper into the South, it took on social and economic as well as military responsibilities. In the end, after four years of armed conflict, the Union had been preserved. Questions left unresolved since the founding of the republic had been answered at the high cost of 618,000 lives, still the largest number of American fatalities in any war in the history of the United States. Some 2.5 million men served in Union and Confederate forces.

■ SECESSION

South Carolina reacted to the election of Abraham Lincoln by seceding—or withdrawing—from the Union. A special convention, convened to consider the subject, unanimously passed an ordinance of secession on December 20, 1860. In less than six weeks, the other six states of the lower South (Mississippi, Florida, Alabama, Georgia, Louisiana, and Texas) had also seceded. Secessionists justified the act on the grounds that the individual states had not surrendered their sovereignty in forming the Union and subscribing to the Constitution (which, however, made no provision for secession). According to this compact theory of union, each state retained the legal authority to withdraw.

Southern Nationalism

During the 1850s, the idea that the South had its own destiny and the capacity to exist as a separate nation gained increasing acceptance. Southern nationalists argued that their section would prosper more outside the Union once free of the taxes and tariffs that increased the cost of their goods to foreign purchasers. They also argued that necessity would compel economic diversification in an independent South. Southern nationalism grew as political events diminished the section's influence within the Union.

Southern Fears

The extension of free soil not only closed possible avenues for southern expansion but raised general fears in the South about the future. Stirred by the intemperate rhetoric of sectional politicians, the South believed that its loss of voting power in Congress, and consequent reduction in influence in the federal government, placed its institutions and social ways at risk. By 1860, an atmosphere had been created in which conspiracy theories thrived.

Southerners perceived in the growing strength of abolitionism a direct threat to their way of life. The victories of the Republican party, which had elected Lincoln without carrying a single southern state in 1860, seemed to herald their fate. Although Republican politicians maintained that their party would not interfere with slavery in the southern states, such promises were not a guarantee against the possible control of the party machinery by the abolitionists. Furthermore, the Republican party's pledge to exclude

slavery from the territories would, if carried out, make the working majority of free states in Congress permanent. In the election of 1860, the Republicans had also championed a protective tariff, a homestead act, and a railroad to connect the Pacific Coast with the old northwest—measures the South had consistently opposed and viewed as hostile to its economic interests and plantation agriculture.

The Confederacy

In February 1861, in Montgomery, Alabama, representatives of the seven states that had seceded from the Union organized a new national entity, the Confederate States of America. They selected as their provisional president Jefferson Davis, a Mississippi cotton planter who had served in the U.S. Senate and as Franklin Pierce's secretary of war. He later won a general election for a six-year term. The seceding states quickly seized facilities and property belonging to the U.S. government, leaving but two forts (Fort Sumter, in Charleston, South Carolina, and Fort Pickens, in Pensacola, Florida) under federal control.

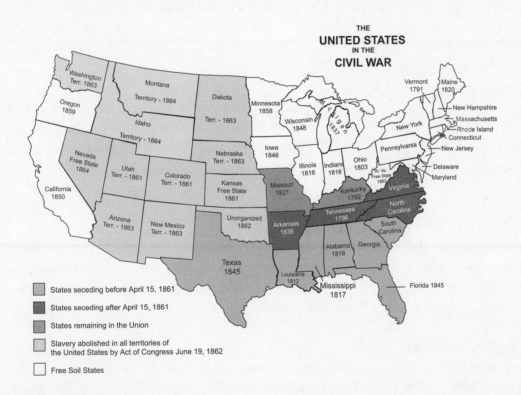

THE
UNITED STATES
IN THE
CIVIL WAR

- States seceding before April 15, 1861
- States seceding after April 15, 1861
- States remaining in the Union
- Slavery abolished in all territories of the United States by Act of Congress June 19, 1862
- Free Soil States

Efforts at Compromise

Confusion characterized the general reaction to the secession of the southern states. The abolitionists were pleased to be rid of the "nefarious institution," slavery. There was strong opposition among business interests to the idea of coercion in order to preserve the Union. Sentiment for the Union in both North and South remained strong, however, and numerous schemes for reconciliation were proposed during the fateful winter of 1860–1861.

President Buchanan Vacillates

President Buchanan, surrounded by a cabinet in which southern influence was dominant, maintained that there was no constitutional right of secession—but he found no power vested in the federal government

to compel the states to obey federal laws. He took no steps to collect customs and enforce federal laws in the seceded states. In January 1861, he sent reinforcements to Fort Sumter on board the merchant vessel *Star of the West,* but, after receiving fire from Confederate guns in Charleston harbor, the ship returned to port.

The Crittenden Compromise

The compromise solution advocated by Senator John J. Crittenden of Kentucky consisted of five proposed permanent amendments to the Constitution. The most important of these would have done the following:

- Restored the Missouri Compromise line (36°30´) in the existing (and future) territories of the Union, permitting slaveholding south of that line and prohibiting it above
- Protected slavery in the states where it was then legal

Southern members who sat on the committee that was to draft the legislation generally approved of these provisions. The Republicans, however, at Lincoln's insistence, refused to endorse a compromise that permitted the extension of slavery into any federal territory.

The Peace Convention of 1861

At the call of the Virginia legislature, representatives from twenty-one of the thirty-four states gathered in Washington in February to attempt a reconciliation. The convention produced proposals that differed little from those that formed the Crittenden Compromise. These were submitted to the Senate but attracted no meaningful support.

■ ABRAHAM LINCOLN AND THE UNION

Lincoln's policy reflected his determination to preserve the Union, his need to unite the sentiment of the North behind his administration, and his belief that some of the slave states would remain loyal to the federal government. He was guided by the belief that the principle of majority rule, which he considered essential to the functioning and survival of democracy, was under attack around the world.

Lincoln the Politician

Lincoln lacked experience in public office but was a keen judge of character and a supreme political manager. These qualities enabled him to assert the leadership and command required by the crisis. The selection of his cabinet exemplified his political skills. He brought together a varied group of talented and influential individuals, possessed of strong opinions and personal ambitions, and enlisted their best efforts in the cause of managing the Union. William H. Seward of New York (Secretary of State) represented the old antislavery Whigs; Salmon P. Chase of Ohio (Secretary of Treasury) and Gideon Welles of Connecticut (Secretary of the Navy) had been anti-Nebraska, free-soil Democrats; Simon Cameron of Pennsylvania (Secretary of War) and Caleb Smith of Indiana (Secretary of the Interior) were leaders of important political machines; Edward Bates of Missouri (Attorney General) and Montgomery Blair of Maryland (Postmaster General) represented the border slave states. Similarly, Lincoln skillfully used his power to make appointments to lesser offices to strengthen the bonds of Union.

Fort Sumter

President Lincoln considered secession to be illegal and was determined not to surrender Forts Sumter and Pickens, though he indicated he would not attempt to retake the federal installations that had already been seized. He did not wish to alienate the border slave states by making a direct attack on the Confederacy. His decision to send provisions to Major Robert Anderson at Fort Sumter, communicated to Confederate authorities in advance, placed them in the position of having to either acknowledge federal authority or become the aggressor in resisting it. The Confederacy's decision to bombard Fort Sumter (April 12–13), after Major Anderson had refused to surrender without a fight, thus became the precipitating event that marked the outbreak of the Civil War.

On April 15, the day after Sumter fell, President Lincoln proclaimed that an "insurrection" existed in the South. Because U.S. army regulars numbered only 16,000 at the time, he called on the loyal states to raise 75,000 militiamen to serve for three months, soon adding to this a call for 42,000 state troops for a period of three years. Once Congress had been assembled, it authorized the president to enlist 500,000 volunteers for three years' service.

The Border Slave States

The call to arms rallied support for the Lincoln administration in the North but tested the loyalty of the border slave states. Arkansas, Tennessee, North Carolina, and Virginia seceded, considerably strengthening the Confederacy. The capital was moved from Montgomery to Richmond, a clear indication that the upper South (with its more diversified economy) was crucial to the survival of the Confederacy.

In four other slave states—Delaware, Maryland, Kentucky, and Missouri—Unionist sentiment proved strong enough to defeat secessionist efforts. In Kentucky, Lincoln's conciliatory gestures overcame the influence of the secessionist governor. In Maryland, Lincoln's use of martial law was decisive. In Missouri, where civil war broke out between the forces aligned with another secessionist governor and friends of the Union, the president's decision to station regular troops in the state affected the outcome. Had one or more of these states joined the Confederacy, the Union cause would have been greatly complicated.

The Belligerents

The superiority of the Union in human and physical resources was great. The total population of the eleven states that composed the Confederacy was 9,100,000 (of whom 3,500,000 were slaves), while those states loyal to the Union had a population of approximately 20,700,000. The roads and railways, factories and businesses, banking capital and investments, and food supply in the loyal states were vastly superior.

To offset these disparities, the South expected to rely upon its export crops, particularly cotton. Many believed that demand for cotton by European textile manufacturers would cause those governments to support the Confederate cause. The nature of the struggle also gave the Confederacy an early advantage—the Union had to wage war in the South to enforce its authority, while the Confederates, fighting on their own soil, would prove victorious simply by thwarting it. In its defensive strategy, the South could rely on a disproportionately large number of trained military leaders, many of whom had attended West Point.

■ THE RESORT TO ARMS

In their goal of suppressing rebellion and preserving the Union, President Lincoln and his military advisors settled on three principal objectives:

- The capture of Richmond
- The blockade of the ports of the Confederacy
- Control of the Mississippi River

The president's leadership was decisive if at times arbitrary—his objective in the struggle was to inflict defeat on the Confederate armies and to destroy their capacity to wage war.

Early battles were fought according to traditional military tactics and rules and proved indecisive. As the war progressed and casualties rose, military leaders on both sides turned to more daring and unconventional methods in the effort to bring the military struggle to a conclusion.

On to Richmond

The proximity of Richmond to Washington (sixty miles by land) encouraged quick strikes by Union forces directed at the Confederate capital. Southern commanders—Robert E. Lee, Joseph E. Johnston, and Thomas J. "Stonewall" Jackson—withstood every attempt of the U.S. army to take Richmond during the early years of the war.

First Battle of Bull Run (July 1861)

U.S. forces under General Irvin McDowell, eager to seize Richmond, were checked by the Confederates at Bull Run, near Manassas, Virginia. This test of the two uncertain armies resulted in the unexpected rout of U.S. troops.

The Peninsular Campaign (March–July 1862)

After the first Battle of Bull Run, George B. McClellan, fresh from a successful campaign in western Virginia, was given command of the Army of the Potomac, which he reorganized, drilled, and equipped for the advance on Richmond. Ordered by the president to set his army in motion, he finally decided to approach the Confederate capital by way of Fortress Monroe and the peninsula between the York and James rivers. With much caution, he proceeded from Yorktown to within twenty miles of Richmond, where he waited in vain for reinforcements. Faced with stiffening resistance from Confederate troops, now commanded by General Lee, McClellan determined that his position was untenable and abandoned the campaign. Exasperated, Lincoln removed him from his command.

Antietam (September 17, 1862)

After General John Pope suffered a disastrous defeat at the hands of Stonewall Jackson in the Second Battle of Bull Run, McClellan resumed command of the Army of the Potomac and attempted to stop Lee's move northward. As a consequence of the bloodiest single-day battle of the war at Antietam, Maryland (in which some 4,500 were killed and 18,500 wounded), McClellan forced Lee to retreat. He failed, however, to follow up his victory with a quick pursuit. Lincoln (who said McClellan had "the slows") removed him again, giving the command to General Ambrose E. Burnside.

Confederate Victories

Lee, with smaller forces, inflicted a disastrous defeat on Burnside at Fredericksburg (December 1862) and at Chancellorsville (May 1863) humiliated Burnside's successor, Joseph "Fighting Joe" Hooker.

Lee Invades the North

During the early summer of 1863, Lee planned another invasion of Union territory, hoping this would serve to relieve pressure on Confederate positions in the western theater of the war and convince the European powers to recognize and give assistance to the Confederacy.

Gettysburg (July 1–3, 1863)

General George G. Meade, now in command of the Army of the Potomac, managed to engage Lee's forces in the town of Gettysburg, in southern Pennsylvania. This was the greatest battle of the war and a significant turning point for the Confederacy. A daring charge led by General George Pickett almost broke through the center of the Union lines, but reserves finally held the key positions and Lee's bold strategy failed. On July 4, 1863, he gave up his invasion and began a retreat to Virginia. Meade hesitated to take the offensive and lost a chance to destroy the Army of Northern Virginia.

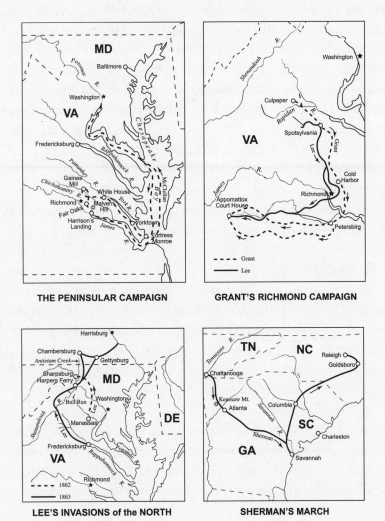

THE PENINSULAR CAMPAIGN

GRANT'S RICHMOND CAMPAIGN

LEE'S INVASIONS of the NORTH

SHERMAN'S MARCH

The Blockade

In April 1861, President Lincoln declared a blockade in force around the Atlantic coastline of the Confederacy, from South Carolina to Florida. This naval action was taken to restrict the Confederacy's capacity to wage war and it was calculated to cause shortages in the South's supply of food, medicine, parts, and supplies. The U.S. navy's effective implementation of the blockade had an important cumulative effect on the conduct of the war.

Federal Naval Supremacy

At the outbreak of hostilities, the South had no navy and virtually no merchant marine from which a navy could be formed. The U.S. navy, on the other hand, continuously expanded its squadrons. It played an important role in controlling the coasts and in supporting the U.S. army in the field. By the close of 1862, the navy controlled all of the important ports in the South except Charleston, Mobile, and Wilmington. Blockade-runners, who enjoyed some success at the outbreak of war, found it increasingly difficult to carry on their trade through ports in the West Indies.

Ironclads and Submarines

The Confederates made a bold attempt to break the blockade when they reconstructed the U.S. frigate *Merrimac* as the ironclad *Virginia* and sent it into the harbor at Hampton Roads, Virginia (March 8, 1862), to demolish the wooden ships of the U.S. navy. It might have accomplished its mission had it not been for the appearance of another ironclad gunship, the U.S.S. *Monitor.* The duel between the two ships was indecisive, but the attempt to break the blockade was thwarted. The battle was significant from a technological standpoint, heralding a new era of naval design and construction. Desperation later led the Confederates to experiment with torpedoes and submarines. One submarine, the *H.L. Hunley,* blew up the U.S.S. *Housatonic* (as well as itself) in Charleston harbor in 1864.

Opening the Mississippi

Although initial offensives in the upper South had failed, U.S. forces were successful in their efforts to gain control of the Mississippi Valley and to penetrate the lower South.

Grant's Western Campaigns

Early in 1862, General Ulysses S. Grant secured permission to advance against the Confederate defenses on the Tennessee and Cumberland rivers. With the aid of river gunboats and mortar boats commanded by Navy Flag Officer Andrew Hull Foote, Grant's troops captured Fort Henry on the Tennessee River and a few weeks later Fort Donelson on the Cumberland. They then advanced up the Tennessee and withstood a vigorous Confederate attack on the bloody field of Shiloh (April 6–7, 1862).

Federal Capture of New Orleans

In the same month, Flag Officer David G. Farragut, commanding a squadron of seventeen wooden and ironclad ships, ran past the shore batteries protecting New Orleans and secured control of the city. New Orleans, the South's largest city and financial depot, surrendered on April 25. The Confederates were still in possession of the Mississippi River between Vicksburg, Mississippi, and Port Hudson, Louisiana.

The Fall of Confederate Vicksburg

Late in the autumn of 1862, Grant began his long campaign against the heavily fortified river port of Vicksburg. Supported by Admiral David Porter's gunboats, he managed to get his troops in position to besiege the city from the east. For six weeks, the Confederates held out, capitulating on July 4, 1863. The capture of Vicksburg gave U.S. forces complete control of the Mississippi River and severed Arkansas, Louisiana, and Texas from the other states of the Confederacy.

The Closing Campaigns

After Vicksburg and Gettysburg, Confederate armies fought on, but against increasing odds and with declining morale. The Union's superior numbers, resources, and material were beginning to have a direct impact on the course of war to its advantage.

The War in the West

Generals Grant, William Tecumseh Sherman, Philip Sheridan, and George "Pap" Thomas cooperated in the autumn of 1863 to rescue the rash General William Rosecrans, who was besieged at Chattanooga, and to win the battles of Lookout Mountain and Missionary Ridge. In the spring of 1864, Sherman began his invasion of Georgia and by September 2 had captured the important railroad terminus of Atlanta. The Confederacy had suffered another major setback the previous month in Alabama when Admiral Farragut was able to penetrate the defenses of Mobile harbor and take the city.

Sherman's March to the Sea

While Thomas held the Confederates out of Tennessee, Sherman cut loose from his base of supplies and marched across Georgia, devastating all before him (across a line eight miles wide), until he reached Savannah on the Atlantic coast in late December. By waging total war and inflicting its horrors on the civilian population, Sherman expected to break the South's will to resist and thereby bring about a quick end to the conflict.

Grant Invades Virginia

With the Army of the Potomac under his direct supervision Grant, now general-in-chief, advanced relentlessly toward Richmond in the Wilderness Campaign of 1864. His punishing, if costly, frontal attacks against Confederate lines brought him close to victory in the spring of the following year. He was able to achieve it only after a prolonged siege of Petersburg, Virginia, a key rail center. On April 2, 1865, Lee abandoned Petersburg and Richmond and moved toward Lynchburg, Virginia.

Appomattox

By the spring of 1865, the cumulative effects of the Confederate reverses on land and sea made the outcome of the war inevitable and its prolongation senseless. Lee surrendered his army to Grant at Appomattox Court House, Virginia, on April 9, 1865. General Joseph E. Johnston's surrender to Sherman on April 27 at Durham Station, North Carolina, a few weeks later finally ended the last armed resistance of major Confederate forces.

■ FREEING THE SLAVES

Although the Lincoln administration insisted that the war was being waged to preserve the Union, the abolition of slavery eventually became an important war aim.

Compensated Emancipation

Lincoln proposed to end slavery by a gradual emancipation, with compensation to masters. Fearing the possibility of racial violence, he initially believed that colonization of free blacks in sites outside the United States was necessary. He tried to persuade representatives of the loyal slave states to accept emancipation with compensation on condition that the federal government bear part of the financial burden—but the effort failed. In 1862, Congress liberated the slaves in the District of Columbia and in the western territories, providing financial reimbursement to their owners.

Provisions for Confiscation

General Benjamin F. Butler treated slaves who entered the Union lines as contraband of war and, since they were technically "property" used in war service, "confiscated" them. The principle was applied by Congress in the first Confiscation Act, passed in August 1861. A second Confiscation Act (July 1862) liberated all slaves of rebel masters who came within Union lines and authorized the president to enlist free blacks and freed slaves in military and related war service.

The Emancipation Proclamation (1863)

As radical pressure for abolition grew, Lincoln concluded that freeing of slaves would be useful in the military effort to defeat the Confederacy. Immediately after the Battle of Antietam (September 22, 1862), he issued a preliminary proclamation, giving the Confederate states 100 days to surrender without having to forfeit their slaves. On January 1, 1863, he declared "forever free" the slaves in all the states still in arms against the authority of the federal government on that date. Although it did not apply to slaves in the states that remained loyal to the Union or were under military occupation, the Emancipation Proclamation strengthened support for the Union cause at home and abroad and contributed to the collapse of the Confederacy, which to a considerable extent depended on the labor of slaves to continue the fight. Many slaves responded to this additional encouragement and fled from plantations to the Union lines—possibly as many as 500,000 during the course of the war.

African-American Federal Troops

The Bureau of Colored Troops was established within the War Department in 1863 and given responsibility for the recruitment, organization, and service of black soldiers. African-American regiments performed well in combat, which served to strengthen support for emancipation. The 54th Massachusetts Regiment was the first to take the field. Some 180,000 emancipated slaves served in the armed forces of the United States or worked as laborers to support the war effort during the conflict.

The Thirteenth Amendment

A resolution proposing an amendment to the Constitution to prohibit slavery within the United States or any place subject to U.S. jurisdiction was introduced in the House of Representatives in December 1863. The necessary two-thirds majorities in Congress were not obtained until January 1865. The amendment

was then referred to the state legislatures, three-fourths of which ratified it by December 1865. Thus the abolition of slavery, only partially accomplished by the Emancipation Proclamation, was completed.

■ THE CIVIL WAR OVERSEAS

The policies of the European powers had an important bearing on the conduct and the outcome of the Civil War. The Confederacy's strategy depended upon gaining the recognition and assistance of its major overseas trading partners, Great Britain and France. The United States exerted all of its diplomatic influence to prevent such intervention.

British Policy

The Confederacy entered the war anticipating that Great Britain's (and France's) need for cotton would bring about a speedy recognition of southern independence. Lincoln, through U.S. minister Charles Francis Adams, son of John Quincy Adams and grandson of John Adams, pressed the British government to observe a strict neutrality. Lincoln's claim that the conflict was a domestic insurrection rather than a war was compromised to an extent by the U.S. navy's blockade of the seceding states. (The imposition of a naval blockade is an act of war.)

Europe's Failure to Recognize the Confederacy

Although it accorded the Confederate government the legal rights of belligerent status soon after the hostilities commenced, Great Britain never formally recognized the independence of the Confederate States of America. There were several factors behind this:

- The hostility of the British working classes and of British antislavery sentiment to the cause of the South
- The failure of the South to win a decisive victory
- The failure of King Cotton diplomacy, owing to several factors affecting supply and demand
- The successful diplomacy of the Lincoln administration

The other European powers followed Britain's lead—none formally recognized the Confederacy's independence.

The Trent Affair

The United States and Great Britain were brought close to war in 1861 by the action of Captain Charles Wilkes, commander of the frigate U.S.S. *San Jacinto*. Without authorization, he stopped the British steamship *Trent* off the Cuban coast and removed James M. Mason and John Y. Slidell, who had been appointed Confederate commissioners or envoys to Great Britain and France, respectively. The British government demanded the release of the commissioners and a disavowal of the act. Lincoln tactfully waited to release Mason and Slidell until resentment in the United States over the British attitude had subsided.

British-Made Confederate Warships

The Confederacy contracted with owners of British shipyards for the construction of six ships (including the *Florida, Alabama,* and *Shenandoah*) designated for service as commerce-raiders. In 1862,

they were delivered to the Confederate government by intermediaries and began destructive attacks upon U.S. merchant shipping. These transactions were vigorously protested by U.S. Minister Adams. Confederate efforts to secure two ironclads (the Laird rams, built by the Laird Shipyards in Liverpool) in 1863 prompted the U.S. government to warn Britain that such transactions might lead to a declaration of war. The British government intervened to detain the ironclads and thereafter was more scrupulous in observing neutrality. The activity of the commerce-destroyers later became the basis for the postwar *Alabama* claims against the British government.

France and Napoleon III

In private, Emperor Napoleon III attempted to persuade Great Britain and Russia to join him in forcing the United States to agree to an armistice. Failing in that, he observed his agreements with Britain and withheld formal recognition from the Confederacy. However, he permitted commerce-raiders to be constructed in French ports and assisted the Confederate commissioners in borrowing funds. He had his own purposes in aiding the South. Taking advantage of the conflict in America, he ignored the Monroe Doctrine and made his cousin Prince Maximilian of Austria the puppet emperor of a Mexican empire created by French troops. He refused to withdraw from Mexico until the United States sent General Philip Sheridan to the Mexican border at the close of the Civil War.

Powers Friendly to the Union

Russia, Prussia, and the Scandinavian countries were favorably disposed toward the United States during the war. Russia made its policy conspicuous by sending its fleets to visit New York and San Francisco.

■ THE COSTS OF THE CIVIL WAR

The war imposed a wide range of problems upon traditional government structures, the solution of which had far-reaching consequences.

Raising Forces

Both the United States and the Confederacy at first relied on volunteer troops induced to join the army by bounties. As it became apparent that the war would be long and hard-fought, both enacted conscription or draft laws. The Confederacy passed the first draft law in April 1862; the United States passed a similar Enrollment Act in July 1863. Both laws permitted draftees to obtain exemption by hiring a substitute, a provision resented by many of the poor. Opposition to these measures was extensive in both sections. In July 1863, the first draft selections (made in a public drawing of names) in New York City provoked riots that resulted in the deaths of several hundred (mostly black) residents. Troops had to be called from the armies in the field to suppress the disorder.

About 1.5 million men served in the U.S. army and navy during the war, some 900,000 in the Confederate forces. The Confederate ranks dwindled after Gettysburg when the course of the war turned against the South starting in late 1863. At their peak in late 1862, Confederate armies numbered no more than 500,000; in 1864 and 1865, more than 100,000 deserted. At the close of the war, the Confederate Congress was attempting to impress 300,000 slaves into military service.

Financing the War

Revenues were raised chiefly by means of increases in taxes and customs duties, public borrowings by the U.S. Treasury in the form of short-term notes and long-term bonds, and the issuance of paper money. The Lincoln administration obtained more than three times as much revenue from loans as from all other sources, some $2.6 billion. Congress passed the Internal Revenue Act in 1862, levying for the first time a tax on incomes. The reluctance of politicians to impose more burdensome taxes led the U.S. Treasury to issue paper currency or greenbacks, which were made legal tender for all debts, public and private. Some $450 million of these notes, backed by the government but not redeemable in gold or silver, were issued; they depreciated in value as their amount increased, contributing to inflation.

Prosperity in the North

After a financial panic and business uncertainty in the first months of the war, the economy of the North responded to the stimulus of war production. The general trend of economic activity was reflected in the statistics showing the following:

- Increased production of raw materials by farm and mine
- Increased mechanization of production in factory and on the farm
- Unprecedented output of manufactured goods
- Expansion of transportation facilities
- Expansion of trade and commerce.

While speculators and war contractors, as always, made fortunes by responding quickly to war-time demands, salaries and wages generally lagged behind prices, resulting in hardship and suffering for many.

Economic Legislation

As a consequence of secession, Republicans enjoyed large majorities in both houses of Congress, permitting them to pass landmark economic legislation that assigned new roles and powers to the federal government. The Homestead and Morrill Land Grant acts provided public lands for settlement (up to 160 acres for each citizen) and public education. Congress steadily raised the protective tariff (to the highest levels in American history). It passed legislation that chartered the Union Pacific and Central Pacific Railroad companies and provided support for their extension of the nation's rail system to the Pacific Ocean. To ease labor shortages caused by the war, Congress (in 1864) relaxed immigration laws to permit employers to transport foreign laborers into the country.

The National Bank Act (1863; amended 1864) promoted the sale of government bonds, but its primary purpose was to establish a uniform, federally regulated banking system throughout the country. It provided for the creation of national banks, each of which was required to purchase federal bonds to the extent of one-third of its capital stock and to deposit them with the Treasury. Against this security, the bank might issue bank notes up to 90 percent of the value of the bonds. These national bank notes gradually replaced the many issues of the state banks, which were discouraged by means of a ten percent tax in 1866.

Southern Finances

Because the blockade largely prevented the collection of customs revenues, the Confederate government resorted to levies on its member states. Most states met their quotas by issuing state bonds or notes.

In 1863, the central government passed measures imposing comprehensive excise and heavy income taxes on individuals. A ten percent tax was also levied in kind on agricultural produce. Bond issues, except the first in 1861, failed to produce much hard currency. The most important foreign loan was placed in Paris in 1863 and based upon cotton. The Confederacy financed its war principally by issuing large sums of paper currency (more than twice the amount issued by the U.S. Treasury). Confederate paper money, which was not legal tender for private debts, depreciated in value at staggering rates, contributing to rapid and damaging price inflation (prices rose almost 7,000 percent during the four war years).

Privation in the South

The South's small manufacturing sector found ways to produce ordnance and equipment in the first years of the war. Its plantations and farms, however, were unable to produce an adequate supply of food and provisions. Because the war was conducted almost entirely on southern soil, the devastation of battle had great impact. The blockade further crippled the economy, denying the South necessary replacement parts and material and contributing to disruption in the supply of food and supplies. Shortages of most necessities led to hoarding, black market activity, and food riots.

The Domestic Front

In the North as well as the South, the powers of the central governments were stretched to meet the demands of war. Restraint of civil liberty was deemed necessary in order to quiet criticism of government policies. Spying of various kinds was widespread.

Lincoln's War Powers

The president believed that the survival of the Union and, to his thinking, the survival of representative government rested on the suppression of the rebellion. The severity of the threat seemed to him to justify extraordinary measures. He frequently made use of martial law and military justice to quash disloyal activities, suspending civil liberties and *habeas corpus,* the right to be set free on bond pending trial when he felt that the war effort required it. Decisions of the Supreme Court had held that the writ of *habeas corpus* (preventing unlawful restraint) could be suspended only by an act of Congress.

Even after Congress passed a law (March 1863) providing that suspects could not be kept in prison more than twenty days without indictment by a grand jury, Lincoln continued to authorize political arrests and to uphold sentences by military tribunals. He ignored a ruling of the Supreme Court (in *ex parte Merryman)* that ordered the release of a proponent of secession jailed in Maryland. In 1866, the Court held (in *ex parte Milligan*) that the Lincoln administration had violated the constitutional rights of a civilian by trying him by military justice in a place where the civil courts were open.

Confederate Policies

The administration of Jefferson Davis proceeded more cautiously in its exercise of war powers. The writ of *habeas corpus* was suspended by authorization of the Confederate Congress (February 1862). So strong was the opposition in many of the states, where the state courts continued to issue the writ, that the Congress in August 1864 withdrew the president's authority. States' rights, which had been the basis of secession, made it difficult for the central government of the Confederacy to enforce its decisions.

Because the Confederate constitution forbade political parties, the Davis administration lacked a suitable process by which it could enlist support for, and rebut criticism of, its policies and decisions.

Political Dissent in the North

Opposition to the war, particularly among western Democrats and in the border states, posed problems for the Lincoln administration throughout the war. The president's vigorous use of his war powers and his willingness to overlook legal impediments to executive action prevented dissent from interfering with the war effort.

Republicans

In some regions, a sharp division developed within the Republican party between radicals, who demanded the immediate abolition of slavery, and conservatives, who believed that abolition was subordinate to the preservation of the Union. Lincoln's conduct of the war was the subject of frequent attacks by the radicals, who nearly succeeded in denying him renomination for a second term.

Democrats

Many Democrats, generally known as War Democrats, loyally supported the Lincoln government. Regular party organizations conducted political contests against Lincoln's supporters. A minority of Democrats, called Copperheads, demanded peace without victory and bitterly attacked the president for his despotism. This faction, strong in the states of the Old Northwest, carried on its propaganda through secret orders such as the Knights of the Golden Circle, the Sons of Liberty, and the American Knights. Lincoln dealt harshly with disloyal elements—most notably by exiling a leading Copperhead, Representative Clement L. Valandingham of Ohio, to the Confederacy.

Administration Supporters

The Lincoln administration was, in fact, supported by a coalition of Republicans and War Democrats. This was underscored in 1864 when Lincoln insisted that Andrew Johnson of Tennessee, a War Democrat, be nominated for the vice-presidency on the Union Republican ticket. The Democrats made substantial gains in the congressional elections of 1862 as a result of the dissatisfaction with the administration's attitude toward slavery, political arrests, and the conduct of the war. Many political observers believed that Lincoln could not be re-elected in 1864 in a campaign against General George B. McClellan, who had been nominated by the regular Democrats and their Copperhead allies. Timely military victories helped the president secure 212 electoral votes to his opponent's 21, although he won the popular vote by only 2.2 million to 1.8 million votes.

Social and Economic Effects

The experience of the Civil War became the central event in the lives of those who survived it. Veterans (whether physically disabled or not), widows, orphans, grieving relations, displaced planters, farmers, and freedmen all suffered losses and endured sacrifices that left deep psychological scars, well documented in the history and literature of the Civil War.

Dislocations to the family during the war, and the consequent need for women to take on new roles and responsibilities, had significant implications for the new modern era. Women, who composed perhaps

one-fourth of the nation's factory workers in 1860, were conspicuous in the war effort on both sides, particularly in nursing and related work. They took the jobs and places of men who went off to war, in factories and offices and on the farm. These experiences opened the way for some to pursue new careers and educational opportunities in the postwar years.

The conduct of the war, the manner in which it was waged and supported on the battlefield and on the home front, had a decided impact on the postwar economy. The need to deal quickly with large tactical questions set in motion a broad movement to reorganize work and accomplish tasks efficiently. New government agencies and offices, formed in response to pressing wartime needs, often had significant and enduring influence beyond their original purposes. The U.S. Sanitary Commission, for example, formed in 1861 as an auxiliary of the Army Medical Corps, set in motion the public health movement in the United States. The premium placed on rapid response also led to and encouraged consolidation of smaller businesses into larger units in the private sector. Many large American corporations took form during the war years and immediately after. Similarly, shortages of labor and mechanical parts urged the invention of new labor-saving equipment and devices for factory, farm, and home.

The Civil War resolved two important questions that had not been effectively addressed by the framers of the Constitution, by the founding fathers, or by the second generation of national leaders: the question of sovereignty and the place of the states in the federal union and questions that derived from the conflict between fundamental liberty and the constitutional protections given to slavery. After enormous loss of life, in which must be counted that of President Lincoln, a victim of assassination at the close of the war, the Union had been determined to be "one nation, indivisible." The contradiction of human property was expunged from the Constitution.

There was little to celebrate in military victory and occupation. With the collapse of the Confederacy in the spring of 1865, the federal government confronted difficult issues relating to the readmission of the seceding states and the citizenship of former slaves. The sectional conflict entered a new phase. President Lincoln's objective of "a just and lasting peace" with "malice toward none; with charity for all" was within reach. But to achieve it required the exceptional political leadership that only he had proved capable of providing.

There are many excellent narratives of the military and social history of the Civil War as well as biographies of political and military leaders. The war was the first to be documented extensively by the new medium of photography, and thus there are many pictures to chronicle the war effort (if not actual battles) at and behind the lines, which have been reproduced in several publications and formats. In addition, the following works are useful in identifying and documenting special subjects.

Selected Readings

Ayers, Edward L. and Anne S. Rubin, *Valley of the Shadow: Two Communities in the American Civil War* (2000).

Belz, Herman. *The Republican Party and Freedmen's Rights, 1861–1866* (1976).

Blanton, DeAnne and Lauren M. Cook. *They Fought like Demons: Women Soldiers in the American Civil War* (2002).

Boatner, Mark M., III. *The Civil War Dictionary* (1959).

Cashin, Joan E. ed., *The War Was You and Me: Civilians in the American Civil War* (2002).

Catton, Bruce. *Bruce Catton's Civil War* (1984).

Cornish, Dudley T. *The Sable Arm: Negro Troops in the Union Army, 1861–1865* (1956).

Crook, David P. *Diplomacy during the American Civil War* (1975).

Curran, Thomas F. *Soldiers of Peace: Civil War Pacifism and the Postwar Radical Peace Movement* (2003).

Cooper, William J. *Jefferson Davis: American* (2000).

Donald, David. *Abraham Lincoln* (1995).

Edwards, Laura F. *Scarlett Doesn't Live Here Anymore: Southern Women in the Civil War Era* (2000).

Eicher, David J. *The Longest Night: a Military History of the Civil War* (2001).

Esposito, Vincent J., ed. *The West Point Atlas of American Wars* (2 vols. 1959).

Harper, Judith E. *Women during the Civil War: An Encyclopedia* (2003).

Huston, James L. *Calculating the Value of the Union: Slavery, Property Rights, and the Economic Origins of the Civil War* (2004).

Jones, Terry L. *Historical Dictionary of the Civil War* (2002).

Jones, Virgil C. *The Civil War at Sea* (3 vols., 1960–1962).

Gallagher, Gary W. & Alan T. Nolan, eds. *The Myth of the Lost Cause and Civil War History* (2000).

Mahin, Dean B. *The Blessed Place of Freedom: Europeans in Civil War America* (2002).

McCardell, John M., Jr. *The Idea of a Southern Nation* (1979).

McPherson, James M. *Battle Cry of Freedom: The Civil War Era* (1988).

and William J. Cooper, Jr., eds. *Writing the Civil War: The Quest to Understand* (1998).

Moore, John Hammond. *Southern Homefront, 1861–1865* (1998).

Reid, Brian Holden. *The Origins of the American Civil War* (1996).

Rubin, Anne Sarah. *A Shattered Nation: The Rise and Fall of the Confederacy, 1861–1868* (2005).

Smith, Jean Edward. *Grant* (2001).

Thomas, Emory. *Robert E. Lee: A Biography* (1995).

Quarles, Benjamin. *The Negro in the Civil War* (1953).

U.S. Department of War. *War of the Rebellion: Official Records of the Union and Confederate Armies* (70 vols., 1880–1901).

Wagner, Margaret E., Gary W. Gallagher, and Paul Finkelman, eds. *The Library of Congress Civil War Desk Reference* (2002).

Ward, Geoffrey C. *The Civil War: An Illustrated History* (1990).

Weigley, Russell Frank. *A Great Civil War: A Military and Political History, 1861–1865* (2000).

Wesley, Charles H. *The Collapse of the Confederacy* (2001).

Wiley, Bell I. *The Life of Billy Yank* (1952).

The Life of Johnny Reb (1943).

Woodward, C. Vann, ed. *Mary Chesnut's Civil War* (1981).

Test Yourself

1) Great Britain never recognized the Confederate States of America for all of the following reasons, except
 a) the British working classes were hostile to slavery as a form of free labor
 b) the South could never win a decisive military victory that would convince the British to support the Confederacy
 c) Union diplomats in England proved to be very successful in influencing the British government to remain neutral
 d) the Trent Affair determined the British to adopt a cautious wait-and-see attitude in its relations with the Lincoln administration over the capture of Mason and Slidell as confederate envoys.

2) True or false: Robert E. Lee was offered command of all the Union armies in the spring of 1861, an offer he refused in favor of joining the Army of the Confederacy, in which he became the commander of the Army of Northern Virginia.

3) The first major battle of the Civil War occurred at this location in July of 1861.
 a) Fredericksburg
 b) Bull Run
 c) Chancellorsville
 d) Antietam

4) The decisive military turning point of the Civil War in favor of the Union came at this battle in 1863, when Lee's army had to retreat after the failure of a disastrous and unsuccessful charge against Union lines led by Confederate General George Pickett.
 a) Vicksburg
 b) New Orleans
 c) Gettysburg
 d) Shiloh

5) The Union general who helped to develop the concept of total war involving destruction of all resources available to the civilian population, as evidenced by his 1864 march to the sea through Georgia, was
 a) George Thomas
 b) Ulysses S. Grant
 c) William T. Sherman
 d) Irwin McDowell

6) The Lincoln Administration financed much of the cost of the Civil War by employing which of the following strategies?
 a) issuing paper money currency known as greenbacks
 b) confiscating Confederate private property behind Union lines
 c) selling captured slaves
 d) paying government debts in script and promissory notes

7) True or false: The Emancipation Proclamation freed only those slaves who were resident in the Confederacy, and did not provide freedom for those held in bondage in areas under the control of the Union or in states that remained loyal to the United States.

8) The armed resistance of the Civil War came to a final end as the last major armies laid down their arms when
 a) General Lee evacuated Petersburg on April 2, 1865
 b) General Lee surrendered to General Grant at Appomattox Courthouse on April 9, 1865
 c) General Joe Johnston surrendered to Union General William T. Sherman in North Carolina several weeks after Appomattox on April 27, 1865
 d) John Wilkes Booth assassinated Abraham Lincoln at Ford's Theatre in Washington, D.C.

9) True or false: In the 1866 case *ex parte Milligan,* the Supreme Court found President Lincoln posthumously guilty in that he he had violated the civil rights of a Maryland citizen during the war by trying him in a military rather than a civilian court, which Lincoln had done as part of his expansion of war powers.

10) Which of the following Union generals so disliked Abraham Lincoln that he left the army to run against him in the campaign of 1864 as the Democratic presidential candidate?
 a) John C. Frémont
 b) Ulysses S. Grant
 c) George B. McClellan
 d) George Meade

Test Yourself Answers

1) **d.** Great Britain supported the Confederacy in the Trent Affair. All of the other reasons noted in this question, however, were important reasons why the British never extended recognition to the Confederate States of America. In that regard, Union Ambassador to England, Charles Francis Adams, proved particularly effective in courting the support of British working classes hostile to slavery and securing the support of influential figures in the British government.

2) **True.** Union General-in-Chief Winfield Scott believed, during the weeks after the events at Fort Sumter, that Colonel Robert E. Lee of Virginia had the best qualities of any soldier in the Army to command Union forces on the battlefield, should there be a civil war. Scott invited Lee to his office in Washington, D.C., where, with Lincoln's approval, he offered such a command to Lee. Colonel Lee refused and instead decided to support his native Virginia. He returned to Virginia, where Jefferson Davis gave him the rank of general, placing Lee in command of the Army of Northern Virginia. Lee held this command until the end of the Civil War in April of 1865.

3) **b.** The location of Bull Run between Washington, D. C., and Richmond, the respective two capital cities of either side, was so important strategically that there were two major battles fought there, one in 1861 and the other in 1862. Both the Union and the Confederacy made the capture of each other's capital city an important strategic goal of their military planning. Bull Run lay on a main railroad line that linked the two cities. The other locations mentioned in this question were also sites of important Civil War battles, but never the site for two such encounters. In the end, this basic strategy did effectively end the war when Union forces finally captured Richmond in April, 1865.

4) **c.** Gettysburg represented the farthest north geographically that the major body of Lee's army ever advanced into Union territory. For that reason, the battlefield is sometimes referred to as the "high water mark of the Confederacy." Vicksburg, Shiloh, and the battles fought at New Orleans were all significant encounters as well. But because Gettysburg marks the northernmost march of the Confederate Army and General Lee's most devastating defeat, historians often consider it the most decisive turning point of the Civil War.

5) **c.** William Tecumseh Sherman is acknowledged as the Civil War general who invented the concept of "total war." He viewed war as a contest between nations, which included every aspect of their military strength, industrial capacity, agricultural capability, and civilian populations. For that reason, he sought to destroy the Confederacy's will to fight in any manner he could. His army's March through Georgia in 1864 was the most destructive campaign of the war in terms of consciously inflicted damage to civilian property by a Union army.

6) **a.** The Lincoln Administration financed much of the Union war effort by issuing paper money. The Civil War marked the first major appearance of paper money in the nation's consumer economy. Although initially controversial, the use of paper money soon became the norm not only in the United States but also throughout much of the rest of the world.

7) **True.** The Emancipation Proclamation of 1863 legally and technically freed only those slaves who were then residents of the Confederate States of America. For the remainder of the war, Union generals who occupied Confederate territory promulgated the Emancipation Proclamation in order to implement it in those newly conquered districts. Slaves living in territory under the control of the Union were presumed to be free.

8) **c.** The surrender of Confederate General Joe Johnston to Union General William T. Sherman in North Carolina on April 27, 1865, marked the final end to the war between major armies of the Confederacy and the Union. However, the surrender of Robert E. Lee to Ulysses S. Grant at Appomattox Courthouse on April 9, 1865, is much better known in American history, because it marked the end of fighting between the two largest armies on either side. Lee's surrender at Appomattox to Grant, however, applied only to his Army of Northern Virginia. The last surrender of a major southern army occurred when Johnston surrendered to Sherman.

9) **True.** The Supreme Court, after the Civil War in 1866, declared some of Lincoln's war powers in dealing with the civil population in Maryland to have been unconstitutional. This case, *ex parte Milligan*, is seen as a landmark case in the ensuring personal liberties of United States' citizens. Nonetheless, Lincoln's expansion of presidential power during the war contributed to a Union victory, even though some of his civil actions were later found to be unconstitutional.

10) **c.** George B. McClellan ran as the Democratic Party candidate for president of the United States in the election of 1864. McClellan served as commander of the Union Army of the Potomac during 1862, during which time he fought against General Lee in the battles around Richmond, Virginia. Lincoln did not approve of McClellan's slow tactics in engaging the enemy and believed the general was too cautious in committing his troops to battle. Lincoln removed McClelland from command, and this resulted in the general becoming a determined political enemy of the president.

Reconstruction and Reunion

1863: Emancipation Proclamation (January); Lincoln announces his plan for reconstruction (December)

1864: Congress passes Wade-Davis bill (July), Lincoln refuses to sign it; Arkansas and Louisiana comply with the President's plan; Congress refuses to seat its elected representatives

1865: Assassination of Abraham Lincoln (April 14); Vice-President Johnson assumes office; President Johnson implements his plan for "restoration," Congress rejects it; ratification of the Thirteenth Amendment

1866: Congress passes the Civil Rights Act, Fourteenth Amendment, Freedmen's Bureau bill; Joint Committee on Reconstruction recommends against seating the representatives of the former Confederate states and asserts Congress's authority over reconstruction; Tennessee readmitted to the union after ratifying the Fourteenth Amendment

1867: Congress passes the Military Reconstruction Act, Tenure of Office Act, and Command of the Army Act over Johnson's vetoes; Alaska purchase ratified

1868: President Johnson impeached and tried before the Senate; Grant elected president over Democrat Horatio Seymour; Arkansas, Alabama, Florida, Louisiana, North Carolina, and South Carolina satisfy congressional requirements and regain seats in Congress; ratification of the Fourteenth Amendment

1870: Virginia, Georgia, Mississippi, and Texas readmitted; passage and ratification of the Fifteenth Amendment

1870–1871: Congress passes the Enforcement (or Ku Klux Klan) Acts to enforce the Fourteenth and Fifteenth amendments

(continued on next page)

1872: Grant re-elected president, defeating Horace Greeley, the Liberal Republican and Democratic candidate; Congress passes the Amnesty Act

1873: Financial panic sets off an economic recession

1874: Democrats win a majority of seats in House of Representatives

1875: Congress passes the Specie Resumption Act and a civil rights act (based on a bill submitted by Senator Sumner in 1872)

1876: Presidential election between Tilden and Hayes inconclusive

1877: Electoral commission certifies Hayes's victory; Compromise of 1877 brings about withdrawal of remaining troops from South; President Hayes visits the South

As the nation recovered from its losses and the North and West enjoyed increasing prosperity, the federal government had to deal with the consequences of the Confederacy's defeat. The South and the southern economy were in ruins. Slaves had been liberated but needed protection and assistance if they were to benefit from their freedom and gain a livelihood. Many areas depended on the U.S. army to enforce law and order.

The sectional animosities that had led to the armed conflict, and intensified in battle, persisted in the postwar era. For a decade after Appomattox, the nation bitterly debated the procedures by which the defeated Confederate states should be permitted to regain their former standing in the union. At issue was the meaning of the Civil War and the depth of the nation's commitment to the political and civil rights of its new black citizens.

■ PRESIDENTIAL RECONSTRUCTION

The term "presidential reconstruction" refers to the period in 1865 when Andrew Johnson set policy regarding the return of the Confederates States to the Union without consulting Congress, which was not in session. Johnson made many decisions that later infuriated Congress when it resumed meeting in early 1866. Many Congressmen felt that the conditions President Johnson imposed on the southern states for their return to the Union were far too generous and did not include sufficient punishment for their attempt to leave the nation.

The South in Defeat

At the conclusion of the war, the South was in a state of economic and social collapse. Many areas saw a complete breakdown of the economy. From Virginia to Texas, travelers in the first years of peace found evidence of physical destruction, poverty, and hunger. The land between Washington and Richmond was described as a "desert." Atlanta, Columbia (South Carolina), Mobile, Richmond, and many smaller towns had been gutted by fires. Even in areas that had escaped the devastation of battle, the landscape bore evidence of war and privation—in ruined mills, bridges, dams, and railroad tracks and in fields overgrown with weeds.

The war had destroyed the basis of southern society and dislocated much of the population, both white and black. Confederate bonds and money were worthless. Transportation and industry were at a standstill. Having lost their ownership of slaves, southern planters, once affluent and powerful, found that $2 billion in investment had disappeared. Former slaves were now free from bondage but lacked a means of support.

Some U.S. army troops remained in the South to maintain order, and Congress created the Bureau of Freedmen, Refugees, and Abandoned Lands to provide assistance of various kinds to freed slaves (and poor whites) displaced by the war.

Political reconstruction was imperative for the South, where most governmental processes, except for the U.S. military control, had ceased with the demise of the Confederacy. But readmission of the seceding states had important implications for national politics. After the secession of the seven states and the withdrawal of their Democratic delegations, Republicans had become dominant in Congress and used their majorities to pass Whiggish economic legislation. The return of what would likely be seven solidly Democratic delegations to the House and Senate held out the prospect of a revival of the old political alliance between the South and the agricultural Northwest—and of new Democratic majorities in Congress.

The question of what role freed blacks would play in postwar southern society became the central issue in all political formulations. With the abolition of slavery, representation of the former slave states would no longer be calculated by means of the three-fifths clause of the Constitution. The number of seats allocated to the southern states in the House of Representatives was certain to increase, because it would be based simply on population figures for both blacks and whites.

Framing a Reconstruction Policy

Members of Congress, even before Lee's surrender, had turned their attention to political procedures for bringing the "states of the secession back into the union." However, they, as well as their constituents, were divided over how to deal with them. Some thought an early reconciliation preferable or necessary for the well being of the union; most expected the rebels to pay a heavy price for the consequences of their rebellion. Others demanded that the entire South be treated as a conquered province, arguing that Congress had the constitutional power to govern with military force, if necessary.

Lincoln's Plan

President Lincoln wished to restore the union as soon as possible. Because there was no constitutional right to secede, he argued, the states of the Confederacy had merely been "out of their proper practical relation" to the union. In December 1863, the president issued a Proclamation of Amnesty and Reconstruction by which he did the following:

- Offered to pardon all (with the exception of Confederate leaders) who would swear allegiance to the government of the United States and accept "all acts of Congress passed during the existing rebellion with reference to slaves"
- Authorized the establishment of a new government for any state if one-tenth of its qualified voters of 1860 would take the required loyalty oath

Following his formula, three states under the control of the U.S. army—Louisiana, Arkansas, and Tennessee—established new state governments.

Congressional Reaction

Lincoln's conciliatory proposals were supported by moderate and conservative Republicans but opposed by congressional leaders of his party's radical wing. The so-called Radicals (given the name by

journalists of the day) were unwilling to pass so quickly over the acts of secession. In July 1864, they put through the Wade-Davis bill. This reconstruction legislation took the following actions:

- Authorized the president to appoint a provisional governor and charged him with taking a census of adult males
- Permitted the governor to call elections to a state constitutional convention when a majority of white male citizens had taken a loyalty oath
- Excluded from the electorate former Confederate officeholders and soldiers, requiring of voters an "ironclad oath" that they had not taken up arms against the United States
- Mandated that the new state constitutions contain language that abolished slavery, denied the vote to former Confederate civil and military officials, and repudiated the debts of Confederate state governments

Lincoln refused to sign the Wade-Davis bill, giving it a pocket veto. This led some to accuse him of "dictatorial usurpation" of Congress's powers to legislate. Neither Lincoln's plan nor the Wade-Davis bill dealt with the issue of black voting rights.

Johnson's Plan for Restoration

The course of history changed dramatically when Abraham Lincoln was assassinated on April 14, 1865. That evening, the President and his wife attended a performance at Ford's Theater in the national capital. Shortly after 10 o'clock, the actor John Wilkes Booth slipped into the Presidential Box, fired a single shot into the President's head, and jumped to the stage, from where he made his escape. Lincoln died the following morning in the bedroom of a house located across the street from the theater. Eleven days later, a detachment of Federal troops cornered the assassin in a barn located in the Virginia country-side. Booth died when these soldiers set fire to the barn, which burnt down around him. Lincoln's unfinished work fell to his successor, Vice-President Andrew Johnson, the Tennessee Unionist and former Democrat. Like Lincoln, he approached the issues of reconstruction by denying that secession had been legal. In his formula for restoration of the states, he proposed granting amnesty to all former Confederates when they took an oath to "support, protect and defend the Constitution." (He exempted certain officers, political leaders, and substantial property holders, requiring them to apply individually for a presidential pardon.) Johnson appointed provisional governors in seven former Confederate states and authorized them to supervise the election of delegates to a state constitutional convention. To complete their restoration to the Union, these states had to repeal the ordinances of secession, repudiate the Confederate state debts, and ratify the Thirteenth Amendment. By the end of 1865, all but one of the states that had seceded (Texas) had met the terms of Lincoln's or Johnson's plans, established state governments, and elected representatives to Congress.

■ CONGRESSIONAL RECONSTRUCTION

Congress refused to seat the senators and representatives elected by the provisional state governments authorized by President Johnson. The members of these proposed delegations contained former leaders of the Confederacy, notably Alexander H. Stephens of Georgia, who had been its vice-president.

Also there was evidence that several of the southern states had not fully accepted emancipation. It was clear that the president's formula could not ensure that change would take place in the South.

Support for the Radicals

Opposition to the president's plan steadily grew among voters in the North. Responding to it, the Radicals, led by Thaddeus Stevens of Pennsylvania in the House and Benjamin Wade of Ohio in the Senate, created a Joint Committee on Reconstruction in the Congress. This committee, consisting of fifteen members, was empowered to examine conditions in the South and propose new reconstruction measures to be implemented by Congress rather than the executive.

Motives of the Radicals

High moral purpose and partisan self-interest merged in the plans and strategy of the Radical Republican leaders. Their sincere desire to safeguard the interests of blacks in the South existed side by side with their determination to create a Republican party in the South and prevent their Democratic opponents from regaining majorities and undoing their legislation. Their opposition to what they believed was executive encroachment on the authority of Congress grew with their dislike for President Johnson, who, unlike Lincoln, was inflexible and tactless in dealing with his political opponents.

Reconstruction Legislation

As details of new black codes passed by the southern states became known in the North, Congress, prodded by Radical leaders, took steps to place emancipated blacks under the protection of the federal government. The black codes were similar to the codes that had been established for slaves and free blacks in the old South. They empowered local officials with the means to govern the work and movements of freedmen.

Freedman's Bureau Bill (1866)

Early in 1866 President Johnson vetoed a bill extending the life of the Freedmen's Bureau, declaring it unconstitutional. In July 1866, a reauthorization bill was passed over the president's veto, extending the powers of the bureau to protect and assist the emancipated slaves, particularly in contending with the black codes. (The bureau's greatest accomplishment would be its role in establishing schools and providing educational opportunities for the freedmen.)

Civil Rights Act (1866). In April 1866, President Johnson vetoed a civil rights act, conferring citizenship on black Americans and assuring them equality with white citizens under the law. With support from moderate Republicans, the Radicals repassed the bill over a presidential veto.

The Fourteenth Amendment. Also in April 1866, the Joint Committee on Reconstruction proposed the Fourteenth Amendment to the Constitution, which Congress promptly passed and referred to the states for ratification. By its provisions, the amendment did the following:

- Conferred citizenship on every person born or naturalized in the United States and prohibited state laws from abridging rights of citizens without "equal protection" and "due process of law"
- Provided for reductions in the congressional representation of states that denied blacks the right to vote

- Barred ex-Confederates from holding national and state offices if they had filled similar posts before the war and violated their oaths to support the Constitution of the United States (this could be removed by a two-thirds vote in each house of Congress)
- Required repudiation of the Confederate debt and affirmation of the validity of that of the United States

Tennessee quickly ratified the amendment and was readmitted to the union (1866). While approval of the amendment would likely have secured readmission of the other seceding states, all of them, with Delaware and Kentucky, voted against it. President Johnson encouraged the southern states in their opposition. For the moment, the amendment failed to gain the required support of three-fourths of the states. In the North, rejection of the amendment, as well as acts of violence directed against blacks in the South, strengthened support for the Radicals in Congress.

The Radicals in Control

Radical Republicans increased their majorities in the congressional elections of 1866, thereby securing complete control of both houses of Congress and the margins needed to override presidential vetoes. President Johnson's active support for conservative Republican candidates during the campaign served only to further alienate the Radicals.

Congress moved quickly to ratify the Fourteenth Amendment. Over President Johnson's veto, it passed the Military Reconstruction Act, which was supplemented later in the year by acts outlining administrative and legal procedures. This legislation provided for the following formula:

- The ten unreconstructed states were divided into five military districts, with a major general in command of each.
- Military commanders were to supervise voter registrations, enfranchising adult black males and loyal white males, who would then elect state constitutional conventions.
- The conventions were to frame state constitutions, which had to provide for the suffrage of black men and be acceptable to Congress.
- State legislatures, elected by qualified voters, were expected to ratify the Fourteenth Amendment.

Upon ratification of the Fourteenth Amendment, the unreconstructed states could then apply for representation in Congress.

By 1869, most southern states had ratified the Fourteenth Amendment and had been permitted to rejoin the union. The amendment received the necessary majority of three-fourths of the states and became part of the Constitution. Virginia, Georgia, Mississippi, and Texas were not able to satisfy Congress until 1870, when they were readmitted on condition that their legislatures ratify the Fifteenth Amendment, which forbade any state to deny the right to vote to any person on the ground of "race, color, or previous condition of servitude."

Curbing Presidential Power

Fueled by resentment and distrust that had grown during the war years and in the debate over reconstruction, the struggles between the executive and legislative branches produced perhaps the most serious

constitutional crisis in the nation's history. Defeated and intemperate, President Johnson attacked Congress for usurping constitutional powers of the executive branch. In an effort to prevent their legislation from being obstructed by him, the Radicals took unusual steps to limit his authority. They also indicated their willingness to pass measures to limit the authority of the Supreme Court in the event the Court attempted to interfere with congressional reconstruction (which it did not). In conceiving the legislative as the dominant branch of government, congressional Radicals, in the opinion of growing numbers, threatened the constitutional principle of separation of powers.

The Tenure of Office Act (1867)

This act required the Senate's consent for the removal of any official, including cabinet members, whose appointment by the president had required Senate approval. At the same time, the Command of the Army Act virtually stripped the president of his functions as commander-in-chief, requiring him to issue military orders through the commanding general of the U.S. army (at the time, Grant).

Impeachment of President Johnson

When Johnson removed a favorite of the Radicals, Secretary of War Edwin M. Stanton, the House of Representatives impeached the president for high crimes and misdemeanors specified in nine charges based on the Tenure of Office Act and two others (accusing him of failing to properly execute the reconstruction acts and of giving speeches that encouraged disrespect for the Congress). Andrew Johnson was the first president to have been formally impeached and tried by the Senate.

Trial and Verdict (March 5–May 26, 1868)

The trial resulted in the acquittal of Johnson by one vote. In the proceedings, legal and constitutional issues were largely subordinated to questions of politics and ideology. On the key charges, the vote was 35 to 19 for impeachment, with seven Republican senators resisting Radical pressures and joining the Democrats in voting for acquittal. Having failed to obtain the necessary two-thirds majority to convict, the Radicals made no further efforts to remove Johnson.

Foreign Affairs During the Johnson Presidency

Despite the confusion and bad feeling caused by the constitutional struggles, Secretary of State William H. Seward was able to convince both Congress and the president to support measures that significantly extended the nation's boundaries. Alaska (called Seward's Folly at the time) was purchased from Russia for $7.2 million in 1867; the Midway Islands, one thousand miles west of Hawaii, were annexed the same year.

THE GRANT ERA

After the turmoil of the Johnson years, the union's best military commander, Ulysses S. Grant, was perceived (initially by both parties) to be a political savior. However, he provided little stability during his two terms in the presidency, during which the element of national purpose in reconstruction politics was dissipated by corruption and scandal.

The Grant Administration

Grant believed that the nation supported the political and economic policies of the congressional Radicals and cast his lot with the Republican party in 1868. His victory over the Democratic nominee, Horatio Seymour, wartime governor of New York, was won with three southern states still under military occupation. Although his popular margin was small, he carried all but eight states.

The Cabinet

Grant was unable to translate his abilities as a military commander into effective presidential leadership. He lacked vision and wisdom, and his years in the White House were characterized by political incompetence. He generally relied on the advice of machine politicians, but he did appoint three particularly able cabinet members: Hamilton Fish (Secretary of State), Jacob D. Cox (Secretary of the Interior), and E. R. Hoar (Attorney General).

Secretary Fish skillfully concluded the matter of the *Alabama* claims against Great Britain, the award for which an international tribunal set at $15.5 million. Hoar was forced to resign when he opposed Grant's plan to annex Santo Domingo, defeated largely through the efforts of Senator Charles Sumner of Massachusetts.

Corruption and Scandal

Grant ignored and sometimes contributed to abuses of the spoils system by Republican politicians, permitting unscrupulous and dishonest men to use him and his high office for their own purposes. His failure to enforce a standard of public behavior indirectly contributed to a series of scandals and unsavory episodes, which included the following:

- Black Friday (1869), when James Fisk and Jay Gould, using Grant's prestige, tried to corner the nation's gold supply
- The Credit Mobilier (1872), involving Vice-President Schuyler Colfax, which profited illegally through fraudulent contracts for the construction of the Union Pacific Railroad
- The Whiskey Ring (1875), among whom was Grant's private secretary, which conspired to cheat the government of internal revenue taxes on distilled liquor
- The Belknap fraud (1876), in which the family of Grant's Secretary of War gained large kickbacks from the assignment of trading posts in the Indian Territory

The Reformers

By 1872, some leaders in the Republican party were in revolt against the low level of public ethics tolerated by the Grant administration, often referred to as Grantism. A few had been charter members of the party in the years of its organization; others had been close to the Lincoln administration and were eager to persuade their fellow Republicans to return to the principles of the prewar years. They were joined by three larger groups:

- Those who felt that Grant had followed too harsh a line in the South
- Those who wanted a reform of the civil service
- Those who felt that Grant should lead Congress toward a systematic reduction of tariff schedules

At a convention of reformers in Cincinnati in May 1872, Horace Greeley, editor of the New York *Tribune,* was nominated as the liberal Republican candidate for president. The Democrats also nominated Greeley in the hope that fusion with liberal Republicans might enable them to defeat Grant. The president nevertheless went on to an overwhelming re-election victory in the fall.

Postwar Economic Expansion

As the South struggled with its tragic heritage, the rest of the nation underwent a rapid economic expansion. The boom was characterized by the penetration of the western regions beyond the Mississippi River, discovery and exploitation of natural resources, and the emergence of a national market economy.

The Republican Party and the Economy

During the war years, the Republican party passed legislation and pursued policies that made the federal government a promoter and facilitator of economic growth, expansion, and consolidation. It passed a series of measures to stimulate settlement of the West, encourage expansion of the nation's infrastructure, and protect American industry (principally by means of tariffs) from foreign competition.

Extending Rail and Wire

Eastern business interests, western mining companies, and the growing communities of the Pacific Coast bound the nation together with miles of steel rails. On May 10, 1869, the Union Pacific and Central Pacific railroads met near Ogden, Utah, with two engines "facing on a Single track, half a world behind each back." This first transcontinental line was one of five built before 1877. Numerous feeder lines contributed to formation of a national railroad system. This system brought manufacturers closer to the raw materials they needed and to the markets in which they sold their goods, gave the city dweller easier access to the resources of farm and forest, and greatly improved travel.

By 1866, as a result of merger and expansion, the Western Union Telegraph Company had created the first national communications system. The first transcontinental telegraph line was completed in 1861, the first successful trans-Atlantic cable in 1866. A more advanced communications technology was demonstrated in 1876 at the Centennial Exhibition in Philadelphia, when Alexander Graham Bell displayed his electric telephone machine.

Panic of 1873 and the Currency Issue

The boom after the war led investors and speculators to excesses, and, not surprisingly, an economic contraction soon marked the temporary limits of the expansion. It began with a panic caused by failed railroad investments and the Treasury's removal of some $100 million of greenback money from circulation. In the economic downturn that followed, a fierce debate was waged across party lines over whether government bonds should be redeemed in greenbacks or in gold. Debtors generally favored payment in greenbacks, which would have put more paper money in circulation and pumped up the money supply, contributing to a reinflation of the economy. Creditors and banks fought to maintain the gold standard, fearing that an increase in the circulation of greenbacks would result in depreciation of the dollar. Sectional and class antagonisms were heightened as the issue raged. Western, agrarian, labor, and growth-oriented business interests, hard hit by the fall of the economy, tended to be greenbackers. The capital-rich

East and hard-money advocates resisted their demands. The issue was only temporarily settled by the Specie Resumption Act of 1875, which introduced a new specie-backed paper currency to replace the greenbacks.

■ THE SOUTH UNDER RECONSTRUCTION

The control exerted by Congress over governments in the states of the former Confederacy redirected southern politics in the postwar years. Continuing federal intervention in state affairs was viewed as tyranny by most southern whites. Despite this intervention, blacks remained largely in a state of economic subjugation; and because of it they were frequently victimized by white terror groups.

In spite of the problems of Reconstruction in the South, the congressionally reconstructed governments did bring positive change to the region. This was most notable in the area of railroad construction, an activity that had been problematic in the antebellum South. In addition, many of the state governments created by Congress revamped the tax systems of their respective states to function in a more equitable manner while they brought order to the furnishing of public services. Importantly, they greatly expanded opportunities for public education.

Economic Adjustments

The postwar southern economy revived slowly and remained depressed in most regions due to a lack of capital for investment, widespread poverty, and poor agricultural practices.

New Patterns in Agriculture

The revolutionary changes effected by the war compelled many landholders of the South to either sell or reduce the size of their plantations. Some sold off surplus acres, but the majority preferred to try a plan of cultivation on shares, striking deals with tenants who were too cash poor to lease land by making regular payments. Owner and tenant entered into a partnership known as sharecropping, whereby one furnished land, the other labor—the proceeds from the sale of the crop were split on the basis of the share arrangement.

The cash necessary to finance these arrangements was generally supplied by merchants or store owners, who took mortgages or liens on the crops as security for credit (on heavily marked-up provisions and supplies) and loans. Planters, sharecroppers, and small farmers often became dependent on these merchants and moneylenders; planters who ran their own stores prospered. Interest rates were high, which almost dictated that farmers pursue the risky course of growing only staple or cash crops like cotton and tobacco. The system was not productive or just, and it resulted in increased debt and many failures.

Forty Acres and a Mule

Freedmen had initially hoped that a Radical idea advanced by Congressman Thaddeus Stevens would be adopted. He had called for the government to confiscate the land of former Confederates and redistribute it (also providing a work animal) to former slaves. At the end of the war, some 10,000 black farmers occupied small parcels of land that had been assigned to them by either military commanders or the Freedmen's Bureau. Their expectations of gaining title to these holdings were dashed, however, when Congress failed to legislate the necessary grants of land. Many blacks managed to farm as sharecroppers (and enjoy some control over their lives and work); most had to work under the contract labor system. A

small but significant number of blacks managed to purchase their own lands, and black entrepreneurship, evident in several southern cities before the war, responded to new, if limited, opportunities.

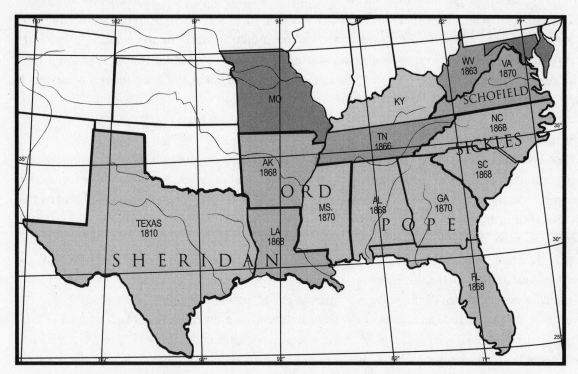

Emancipation and Restoration of Southern States

	Slaves freed by Lincoln's Proclamation Jan. 1, 1868		States in which reconstruction was begun by Lincoln
Slaves freed by action of states 1863-1865		Heavy border indicates the Military Districts of the Reconstruction Act of 1867	
	Slaves freed by Thirteenth Amendment 1865		

Political Transition

The Reconstruction Acts of 1867 denied to the planter aristocracy the political power it had enjoyed before the Civil War. Registration lists in the former Confederate states showed that there were 703,000 black and only 627,000 white voters in 1868. As new governments were formed in conformity with congressional measures, however, most whites regained the vote. The Amnesty Act (1872) permitted all except the most prominent ex-Confederates (perhaps numbering 500) to regain full citizenship. In the states of the upper South (notably, Virginia and North Carolina), where the majority of the population was white, the Democratic party quickly gained control of state government.

Reconstructed State Governments

The new Republican political majorities in the Deep South were formed by free blacks and freedmen; whites from outside the South who had come to pursue opportunities (called carpetbaggers); and

white Southerners, small farmers, enterprising manufacturers, and former Whigs—who hoped to advance themselves by cooperating with the congressional program (called scalawags).

Blacks made up the greater part of the Republican party in the South, but they held few offices during the reconstruction period—twenty blacks were elected to the U.S. House of Representatives, only two were sent to the U.S. Senate (most of these men had been born in freedom and educated outside the South). Blacks formed a majority in only one house of one state legislature (South Carolina); three African Americans were elected lieutenant governor and none governor. Only one gained appointment to a state supreme court during the period.

Corruption and Reform

The legislatures elected in the southern states in 1868 and 1869 passed many quick fix measures, notably generous subsidies to builders of railroads, hoping to revive the South's prostrate economy. The increases in public spending, largely funded by new taxes and the issuance of state debt, were in general too rapid and too poorly thought out, encouraging waste, extravagant expenditures, and fraud. In North Carolina, for example, the public debt more than doubled in two years, while the tax rate in Louisiana during 1870 was three times the rate in the more populous state of Pennsylvania. Many in official positions abused the public trust and engaged in outright fraud and graft. However, such practices also occurred in a number of northern legislatures and, of course, within the federal government itself, especially during the Grant years.

In spite of the excesses and abuses of the reconstruction governments, some black and white leaders sincerely tried to make life better for the average southerner. During the years 1870 to 1875, they persuaded Republican legislatures to enact laws to provide for more and better courts, new hospitals and asylums, and public school systems.

Organized Terrorism

By a variety of means, all relying on grass roots methods of harassment or intimidation, conservative southern whites managed to regain the control of state governments and reverse the congressional reconstruction program. Southern whites turned to nonpolitical methods in their efforts to defeat the Republicans. Secret societies—the Ku Klux Klan, the Knights of the White Camellia, the Boys of '76— were used as the instruments of a policy of terrorism designed to strike fear into blacks and compel them not to exercise their new political rights. The Klan, the most notorious of these vigilante organizations, was dominated in many districts by terrorists who made use of all forms of violence, including murder, to bring down the Republican state governments. In some areas, notably in the Deep South, such clubs and groups organized and acted openly with impunity.

Peaceful Coercion

Southerners who disdained the violent tactics of the Klan and other secret societies turned to more subtle forms of coercion. Freedmen were denied employment and credit, kept from the polls, and intimidated by other means short of force to prevent them from voting for Republican candidates.

The Enforcement Acts

As resistance and acts of violence against Republican state governments grew, they had an effect at the polls. (By 1870, new Democratic majorities had taken control of the legislatures of Georgia, North

Carolina, and Tennessee.) In response to these campaigns of intimidation, President Grant asked and received from Congress tough enforcement measures:

- An act passed in May 1870 imposed heavy penalties for violations of the Fourteenth and Fifteenth Amendments
- An act of February 1871 placed congressional elections under the control of the federal authorities
- The Ku Klux Klan Act of the same year gave the president military powers to suppress violence in the southern states. (In 1871 President Grant used these powers to subdue the Klan in South Carolina.)

These measures had the effect of restraining (but not eliminating) terrorism, and in the elections of 1872, blacks voted in large numbers. In the presidential election, Democrats managed to win only three states in the South: Georgia, Tennessee, and Texas.

Republican Retreat

In the aftermath of the 1872 election, Democrats and conservative opponents of the Republican governments in the South stepped up their efforts to regain power. They abandoned efforts to compete on a variety of issues and focused on winning over white voters with simple racist appeals. This strategy, with continuing intimidation, proved successful and formed a pattern that would maintain white supremacy in the South for another century.

These developments led Charles Sumner to draft and introduce in the Senate in 1872 a wide-ranging bill to secure the political and civil rights of freedmen. The Massachusetts senator also included provisions to outlaw the system of racial segregation that was spreading in the South. In 1875, Congress approved a civil rights act that only faintly resembled Sumner's first bill, clearly signaling a change in its mood—no provisions were made in the act for its enforcement.

In the congressional elections of 1874 the Democrats won control of the U.S. House of Representatives, thus breaking Republican control of Congress. The following year, President Grant acknowledged a shift in national public opinion when he refused to send troops to Mississippi at the request of that state's Republican governor. Still, he did intervene two years later, dispatching soldiers to South Carolina to quell racial violence that had erupted at a Fourth of July centennial celebration.

The End of Reconstruction

By 1876, only three state governments in the South remained in the hands of the Republicans: South Carolina, Louisiana, and Florida, the first two of which were still propped up by military authority. Most of the South had been reclaimed by southern Democrats, and the nation had grown perceptibly weary of conflict in the region.

The Disputed Election of 1876

After the failure of the liberal Republican movement, Horatio Seymour, defeated by Grant in 1868, had remarked, "Our people want men in office who will not steal, but who will not interfere with those who do." By 1876, however, the leaders of both political parties believed that the time for housecleaning had arrived. The Republicans were anxious to put the scandals of the Grant administration behind them and stop defections from their ranks over questions related to public ethics; their prospects in the fall elections were further dimmed by the severity of the economic decline that had followed the Panic of 1873.

Tilden versus Hayes

Reformers in the Democratic party engineered the nomination of Samuel J. Tilden, who as governor of New York had broken the power of William Marcy Tweed, the corrupt boss of New York City's Tammany Hall. Alarmed by the advantage the Democrats appeared to have with the issue of public morality, the Republicans ignored Grant's wish for a third term and turned to the governor of Ohio, Rutherford B. Hayes, whose career had been untouched by any hint of scandal.

The Inconclusive Balloting

Governor Tilden won the popular vote by a comfortable margin (over 55 percent of the vote), but although he carried New York and several other northern states in addition to the South, he was sure of only 184 electoral votes, one short of the necessary majority. Hayes had 165. Twenty electoral votes were in doubt: one of Oregon's three votes and those of South Carolina, Florida, and Louisiana, where both Republicans and Democrats claimed victories. It fell to Congress to determine the official results, although the Constitution provided no explicit procedure for resolving such a dilemma.

The Electoral Commission

Congress created a special electoral commission to settle the controversy. Three Republicans and two Democrats from the Senate, three Democrats and two Republicans from the House, and five justices of the Supreme Court voted eight to seven (along party lines) in favor of Hayes on every disputed point—he was awarded all twenty of the contested electoral votes and declared elected (by 185 to 184 electoral votes). The commission's report was presented to Congress on March 2, 1877, two days before the new president was to take office.

The Compromise of 1877

The decision of the electoral commission would not have been accepted were it not for the fact that Hayes and other Republican politicians had worked out a private political agreement with some practical-minded southern Democrats. Often called the Compromise of 1877, this series of informal understandings assured these southern leaders that Hayes would withdraw U.S. troops from the South and appoint at least one southerner to his new cabinet. In return for their cooperation, they also gained other concessions, including support for federal subsidies for railroads and other public works in the South.

Hayes (who gained the derisive nickname Rutherfraud) lived up to most of the terms of the agreement. While he expressed support for black political rights and vetoed a bill that would have repealed the Enforcement Acts, he withdrew the troops from South Carolina and Louisiana and clearly indicated that he had no intention of sending them back on similar missions. On a tour of southern cities following his inauguration, he told freedmen that they would be better off if southern whites were "let alone" by the federal government. This remark became a slogan throughout the South and seemed to sum up the Republican party's retreat from radical reconstruction.

The Redeemers

The withdrawal of U.S. troops from the South placed the states of the former Confederacy under the firm political control of their white citizens. Although Hayes and other Republicans thought they would

be able to bring former southern Whigs into their party, most southerners continued to see them as the party of blacks and corrupt outsiders who wished to exploit the region.

The New Ruling Coalition

The new state governments were supported by white majorities, of Democrats and conservatives, principally united by a commitment to sound government, by which they meant very limited government and white supremacy. Remnants of the old planter class and new leaders in fields of business and finance joined forces to form the coalition. They skillfully manipulated racial and sectional hatreds to retain support among white farmers and laborers of the South. In reaction to the high level of spending of the Republican state governments, the new majorities cut state budgets, reducing taxes and services, including those for education. Redeemed governments, however, were by no means free of fraud and corruption.

The bitter political battles of reconstruction eventually wore down the nation's will to persist in the effort to restructure southern society and lift former slaves to full citizenship. The measures that were required to enforce federal standards, particularly the stationing of troops, seemed to many Americans at odds with the traditions of local self-government. Similarly, the quite practical idea of providing parcels of land in the South to former slaves depended on confiscations, which, however justified by rebellion, appeared to conflict with constitutional rights of property. In retrospect, it would seem that the nation's commitment to the social ideals of reconstruction was brief, limited, and never clearly distinct from popular desires to punish the South and its secessionist politicians.

The promise of unlimited economic prosperity in a new modern era, combined with the pain of Civil War memories, contributed to a national desire for sectional reconciliation and reunion. The prevailing view among white Americans, that nonwhites were inferior to them, served to provide a rationale for an orderly retreat from Radical objectives.

The price of reunion was high. It introduced new inequalities and incongruities to American politics and social life based on race, in direct contradiction to constitutional amendments, legislative provisions, and the actual aims of the Civil War and Reconstruction. And it required the United States to abandon black freedmen in their day of greatest hope, consigning them to second-class citizenship, with tragic consequences for all Americans.

Selected Readings

Ash, Stephen V. *When the Yankees Came: Conflict and Chaos in the Occupied South, 1861–1865* (1995).

Baggett, James Alex. *The Scalawags: Southern Dissenters in the Civil War and Reconstruction* (2003).

Benedict, Michael Les. *A Compromise of Principle: Congressional Republicans and Reconstruction, 1863–1869* (1974).

Blight, David W. *Race and Reunion: The Civil War in American Memory* (2001).

Brock, W. R. *An American Crisis: Congress and Reconstruction, 1865–1867* (1963).

Foner, Eric. *Reconstruction: America's Unfinished Revolution, 1863–1877* 2nd ed. (2002).
 and Joshua Brown *Forever Free: The Story of Emancipation and Reconstruction* (2005).

Harris, William. *With Charity for All: Lincoln and the Restoration of the Union* (1997).

Hyman, Harold. *A More Perfect Union: The Impact of the Civil War and Reconstruction on the Constitution* (1973).

Leonard, Elizabeth. *Lincoln's Avengers: Justice, Revenge, and Reunion after the Civil War* (2005).

McFeely, William S. *Grant: A Biography* (1981).
 Yankee Stepfather: General O. O. Howard and the Freedmen (1968).

McKitrick, Eric L. *Andrew Johnson and Reconstruction* (1960).

Moneyhan, Carl H. *Texas after the Civil War: The Struggle of Reconstruction* (2004).

Perman, Michael. *Reunion Without Compromise: The South and Reconstruction, 1865–1868* (1973).
 The Road to Redemption: Southern Politics, 1869–1879 (1984).

Richardson, Heather Cox. *The Death of Reconstruction: Race, Labor, and Politics in the Post-Civil War North, 1865–1901* (2001).

Rose, Willie Lee. *Rehearsal for Reconstruction: The Port Royal Experiment* (1964).

Sefton, James. *The United States Army and Reconstruction* (1967).

Simpson, Brooks. *The Reconstruction Presidents* (1998).

Smith, John David. *Black Voices from Reconstruction, 1865–1877* (1997).

Sproat, John G. *"The Best Men": Liberal Reformers in the Gilded Age* (1968).

Trefousse, Hans. *Thaddeus Stevens: Nineteenth-Century Egalitarian* (1997).

Trelease, Allen. *White Terror* (1967).

Test Yourself

1) The Republican party political majorities that dominated in the Deep South during Reconstruction included individuals from all of the following groups, except
 a) freedmen
 b) carpetbaggers
 c) scalawags
 d) ex-Confederate Loyalists

2) True or false: Rutherford B. Hayes, the Republican presidential candidate in 1876, became president even though his opponent, Democrat Samuel J. Tilden, received fifty-five percent of the popular votes and got 184 electoral votes to the 165 secured by Hayes.

3) Which of the following was not a scandal in the Grant Administration?
 a) Black Friday
 b) the Crédit Mobilier
 c) the Wade-Davis Bill
 d) the Whiskey Ring

4) True or false: Abraham Lincoln advocated a quick and easy process for Reconstruction when he issued his plan to bring the region back into the national government, since he contended that the South had never legally succeeded from the Union.

5) Which of the following was not a program or policy advocated by the Republican party during Reconstruction?
 a) the Freedmen's Bureau
 b) completion of the Transcontinental Railroad
 c) acquisition of Alaska
 d) federal assumption of state indebtedness

6) Which of the following measures were passed by Congress during 1870 and 1871 in response to vigilante acts and terrorism in the South directed by white citizens against Freedmen?
 a) the Freedmen's Bureau Bills
 b) the Enforcement Acts
 c) the Reconstruction Acts
 d) the Tenure of Office Act

7) True or false: The impeachment of President Andrew Johnson in the Congress was motivated more by legal and constitutional issues related to the president's performance than by questions of politics and differences in his ideology from that of the Radicals.

8) Which of the following was a liberal reformer in a Republican party dominated in the 1860s and 1870s by Radicals and who did not wish to punish the South for having caused the Civil War?
 a) Horace Greeley
 b) Thaddeus Stevens
 c) Edwin M. Stanton
 d) Benjamin Wade

9) The Reconstruction Act of 1867 did all of the following, except
 a) divide the former Confederacy into five military districts
 b) assign military commanders to supervise voter registrations in the South
 c) require that southern states ratify the Fourteenth Amendment before they could rejoin the Union
 d) require that former Confederate office holders apply for amnesty and get a pardon before voting

10) True or false: The bitter and harsh controversies between North and South during Reconstruction had, by the mid-1870s, greatly weakened the efforts made by many to restructure southern society and give Freedmen in the region full rights of citizenship, thereby preparing the way eventually for an era of racial segregation in the former Confederacy.

Test Yourself Answers

1) **d.** Ex-Confederate Loyalists never supported the Republican Party in the South during Reconstruction. This was especially true after 1867, when ex-Confederate white voters who were loyal to the South were excluded from political participation. It was during this time that the former slaves—known as Freedmen—were given the right to vote. Former Confederates had names by which they belittled whites who supported the Republican Party and its Reconstruction policy: To them, Carpetbaggers were northern people who came south to aid in Reconstruction, while Scalawags were white southerners who supported Republican Reconstruction.

2) **True.** Rutherford B. Hayes became President of the United States in a disputed election caused by a malfunction of the Electoral College. The Republican Party disputed the electoral votes cast in three southern states, where the Democrat Samuel J. Tilden had apparently won, thus giving Tilden the presidency. An electoral commission dominated by Republicans eventually reassigned the votes from Samuel J. Tilden to Rutherford B. Hayes, thus putting the Republican in the White House. In return for this, prominent Republicans agreed to end the process of Reconstruction in the South. This informal agreement is known as the Compromise of 1877.

3) **c.** The Crédit Mobilier, the Whiskey Ring, and securities manipulation resulting in Black Friday were all public scandals in the Grant administration. In spite of his outstanding and successful career as a general, Ulysses S. Grant proved to be a poor politician and a weak administrator. Although Grant was personally honest, his administration was plagued by a series of scandals caused by the corruption of some of his supporters and appointees. The Wade-Davis Bill, however, was not a scandal of the Grant administration. Instead, it was a Reconstruction measure passed in 1864 by the Congress that provided for the appointment of provisional governors in areas that formally belonged to the Confederacy.

4) **True.** Abraham Lincoln supported a quick program of Reconstruction to bring the South back into the Union. He saw Reconstruction as a limited program to restore the South to participation in the national government, a view adopted by President Johnson and rejected by the Radical Republicans after Lincoln's death. The Reconstruction policies adopted by President Andrew Johnson were largely those which had first been crafted by Abraham Lincoln.

5) **d.** The federal government never assumed state debts, especially those of the Confederacy. The creation of the Freedmen's Bureau, the construction of the transcontinental railroad, and the territorial acquisition of Alaska all became actions supported by the Republican Party.

6) **b.** The Enforcement Acts were passed by Congress in 1870 in 1871 in an effort to end Ku Klux Klan activity in the South. All of the other acts pertained to other aspects of Reconstruction, dealing with other issues and concerns. The Freedman Bureau bills sought to help the ex-slaves of the region by setting up a social service agency. The Reconstruction Acts gave Congress tremendous power in directing events in the South after the Civil War. The Tenure of Office Act figured in the impeachment of Andrew Johnson, during which radical Republicans claimed the president had violated this law by removing an officeholder without congressional approval.

7) **False.** Radical Republicans grasped at any reason by which they could justify the impeachment of Andrew Johnson. They did not like President Johnson for a variety of reasons. He was a Southerner from Tennessee and had been a Democrat before the Civil War. They also disapproved of his leadership abilities, which they found lacking. The Radical Republicans badly wanted to remove Johnson from the presidency for reasons of political differences regarding Reconstruction, and they grasped at any logical legal or constitutional issues that could even tenuously support their efforts in that regard.

8) **a.** Horace Greeley was a progressive Republican who had a relatively conciliatory view of the South after the Civil War. All of the others noted in this question were Radical Republicans who wanted to employ harsh measures against the South during the Reconstruction process. Thaddeus Stevens, a congressman from Pennsylvania, was a leader among the radicals. Benjamin Wade, one of the sponsors of the Wade Davis Bill, was also anxious to punish the South during Reconstruction. Edwin M. Stanton, Lincoln's Secretary of War, continued in this office during the Andrew Johnson administration. Stanton often argued with Johnson (the two men did not get along), especially regarding Stanton's punitive views regarding southern Reconstruction.

9) **d.** Congressional Reconstruction had no provision for former Confederate officers to apply for amnesty or get a pardon before voting. That was because they were completely disenfranchised. There was no legal mechanism for them to secure the vote under the provisions of the Reconstruction Act of 1867. This Act did divide the former Confederacy in the five military districts, directed military commanders in those areas to supervise voter registration, and required states to ratify the Fourteenth Amendment before they could rejoin the Union.

10) **True.** The disputed Election of 1876 and the Compromise of 1877 served as historical evidence that many in the North had tired of Reconstruction, turning their attention instead to other concerns such as industrialization and continued westward expansion while, thereafter, former Confederates leaders returned to political power in the South.

Appendix A

■ THE DECLARATION OF INDEPENDENCE OF THE THIRTEEN COLONIES

In CONGRESS, July 4, 1776

The unanimous Declaration of the thirteen united States of America,

When in the Course of human events, it becomes necessary for one people to dissolve the political bands which have connected them with another, and to assume among the powers of the earth, the separate and equal station to which the Laws of Nature and of Nature's God entitle them, a decent respect to the opinions of mankind requires that they should declare the causes which impel them to the separation.

We hold these truths to be self-evident, that all men are created equal, that they are endowed by their Creator with certain unalienable Rights, that among these are Life, Liberty and the pursuit of Happiness. — That to secure these rights, Governments are instituted among Men, deriving their just powers from the consent of the governed, —That whenever any Form of Government becomes destructive of these ends, it is the Right of the People to alter or to abolish it, and to institute new Government, laying its foundation on such principles and organizing its powers in such form, as to them shall seem most likely to effect their Safety and Happiness. Prudence, indeed, will dictate that Governments long established should not be changed for light and transient causes; and accordingly all experience hath shewn, that mankind are more disposed to suffer, while evils are sufferable, than to right themselves by abolishing the forms to which they are accustomed. But when a long train of abuses and usurpations, pursuing invariably the same Object evinces a design to reduce them under absolute Despotism, it is their right, it is their duty, to throw off such Government, and to provide new Guards for their future security. —Such has been the patient sufferance of these Colonies; and such is now the necessity which constrains them to alter their former Systems of Government. The history of the present King of Great Britain [George III] is a history of repeated injuries and usurpations, all having in direct object the establishment of an absolute Tyranny over these States. To prove this, let Facts be submitted to a candid world.

He has refused his Assent to Laws, the most wholesome and necessary for the public good.

He has forbidden his Governors to pass Laws of immediate and pressing importance, unless suspended in their operation till his Assent should be obtained; and when so suspended, he has utterly neglected to attend to them.

He has refused to pass other Laws for the accommodation of large districts of people, unless those people would relinquish the right of Representation in the Legislature, a right inestimable to them and formidable to tyrants only.

He has called together legislative bodies at places unusual, uncomfortable, and distant from the depository of their public Records, for the sole purpose of fatiguing them into compliance with his measures.

He has dissolved Representative Houses repeatedly, for opposing with manly firmness his invasions on the rights of the people.

He has refused for a long time, after such dissolutions, to cause others to be elected; whereby the Legislative powers, incapable of Annihilation, have returned to the People at large for their exercise; the State remaining in the mean time exposed to all the dangers of invasion from without, and convulsions within.

He has endeavoured to prevent the population of these States; for that purpose obstructing the Laws for Naturalization of Foreigners; refusing to pass others to encourage their migrations hither, and raising the conditions of new Appropriations of Lands.

He has obstructed the Administration of Justice, by refusing his Assent to Laws for establishing Judiciary powers.

He has made Judges dependent on his Will alone, for the tenure of their offices, and the amount and payment of their salaries.

He has erected a multitude of New Offices, and sent hither swarms of Officers to harass our people, and eat out their substance.

He has kept among us, in times of peace, Standing Armies without the consent of our legislatures.

He has affected to render the Military independent of and superior to the Civil power.

He has combined with others to subject us to a jurisdiction foreign to our constitution and unacknowledged by our laws; giving his Assent to their Acts of pretended Legislation:

For Quartering large bodies of armed troops among us:

For protecting them, by a mock Trial, from punishment for any Murders which they should commit on the Inhabitants of these States:

For cutting off our Trade with all parts of the world:

For imposing Taxes on us without our Consent:

For depriving us, in many cases, of the benefits of Trial by Jury:

For transporting us beyond Seas to be tried for pretended offences:

For abolishing the free System of English Laws in a neighbouring Province, establishing therein an Arbitrary government, and enlarging its Boundaries so as to render it at once an example and fit instrument for introducing the same absolute rule into these Colonies:

For taking away our Charters, abolishing our most valuable Laws, and altering fundamentally the Forms of our Governments:

For suspending our own Legislatures, and declaring themselves invested with power to legislate for us in all cases whatsoever.

He has abdicated Government here, by declaring us out of his Protection and waging War against us.

He has plundered our seas, ravaged our Coasts, burnt our towns, and destroyed the lives of our people.

He is at this time transporting large Armies of foreign Mercenaries to compleat the works of death, desolation and tyranny, already begun with circumstances of Cruelty and perfidy scarcely paralleled in the most barbarous ages, and totally unworthy the Head of a civilized nation.

He has constrained our fellow Citizens taken Captive on the high Seas to bear Arms against their Country, to become the executioners of their friends and Brethren, or to fall themselves by their Hands.

He has excited domestic insurrections amongst us, and has endeavoured to bring on the inhabitants of our frontiers, the merciless Indian Savages, whose known rule of warfare, is an undistinguished destruction of all ages, sexes and conditions.

In every stage of these Oppressions We have Petitioned for Redress in the most humble terms: Our repeated Petitions have been answered only by repeated injury. A Prince whose character is thus marked by every act which may define a Tyrant, is unfit to be the ruler of a free people.

Nor have We been wanting in attentions to our British brethren. We have warned them from time to time of attempts by their legislature to extend an unwarrantable jurisdiction over us. We have reminded

them of the circumstances of our emigration and settlement here. We have appealed to their native justice and magnanimity, and we have conjured them by the ties of our common kindred to disavow these usurpations, which, would inevitably interrupt our connections and correspondence. They too have been deaf to the voice of justice and of consanguinity. We must, therefore, acquiesce in the necessity, which denounces our Separation, and hold them, as we hold the rest of mankind, Enemies in War, in Peace Friends.

We, therefore, the Representatives of the united States of America, in General Congress, Assembled, appealing to the Supreme Judge of the world for the rectitude of our intentions, do, in the Name, and by the Authority of the good People of these Colonies, solemnly publish and declare, That these United Colonies are, and of Right ought to be Free and Independent States; that they are Absolved from all Allegiance to the British Crown, and that all political connection between them and the State of Great Britain, is and ought to be totally dissolved; and that as Free and Independent States, they have full Power to levy War, conclude Peace, contract Alliances, establish Commerce, and to do all other Acts and Things which Independent States may of right do. And for the support of this Declaration, with a firm reliance on the protection of divine Providence, we mutually pledge to each other our Lives, our Fortunes and our sacred Honor.

The signers of the Declaration represented the new states as follows:
New Hampshire
Josiah Bartlett, William Whipple, Matthew Thornton
Massachusetts
John Hancock, Samuel Adams, John Adams, Robert Treat Paine, Elbridge Gerry
Rhode Island
Stephen Hopkins, William Ellery
Connecticut
Roger Sherman, Samuel Huntington, William Williams, Oliver Wolcott
New York
William Floyd, Philip Livingston, Francis Lewis, Lewis Morris
New Jersey
Richard Stockton, John Witherspoon, Francis Hopkinson, John Hart, Abraham Clark
Pennsylvania
Robert Morris, Benjamin Rush, Benjamin Franklin, John Morton, George Clymer, James Smith, George Taylor, James Wilson, George Ross
Delaware
Caesar Rodney, George Read, Thomas McKean
Maryland
Samuel Chase, William Paca, Thomas Stone, Charles Carroll of Carrollton
Virginia
George Wythe, Richard Henry Lee, Thomas Jefferson, Benjamin Harrison, Thomas Nelson, Jr., Francis Lightfoot Lee, Carter Braxton
North Carolina
William Hooper, Joseph Hewes, John Penn
South Carolina
Edward Rutledge, Thomas Heyward, Jr., Thomas Lynch, Jr., Arthur Middleton
Georgia
Button Gwinnett, Lyman Hall, George Walton

Appendix B

■ ARTICLES OF CONFEDERATION

Adopted by Congress November 15, 1777 (ratified and effective March 1, 1781)

To all to whom these Presents shall come, we the undersigned Delegates of the States affixed to our Names send greeting.

Whereas the Delegates of the United States of America, in Congress assembled, did, on the fifteenth day of November in the Year of our Lord One Thousand Seven Hundred and Seventy seven, and in the Second Year of the Independence of America, agree to certain articles of Confederation and perpetual Union between the States of Newhampshire, Massachusetts-bay, Rhode Island and Providence Plantations, Connecticut, New York, New Jersey, Pennsylvania, Delaware, Maryland, Virginia, North-Carolina, South-Carolina, and Georgia in the words following, viz. "Articles of Confederation and perpetual Union between the states of Newhampshire, Massachusetts-bay, Rhode Island and Providence Plantations, Connecticut, New-York, New-Jersey, Pennsylvania, Delaware, Maryland, Virginia, North-Carolina, South-Carolina and Georgia."

Article I

The Stile of this Confederacy shall be "The United States of America."

Article II

Each state retains its sovereignty, freedom, and independence, and every Power, Jurisdiction and right, which is not by this confederation expressly delegated to the United States, in Congress assembled.

Article III

The said states hereby severally enter into a firm league of friendship with each other, for their common defence, the security of their Liberties, and their mutual and general welfare, binding themselves to assist each other, against all force offered to, or attacks made upon them, or any of them, on account of religion, sovereignty, trade, or any other pretence whatever.

Article IV

The better to secure and perpetuate mutual friendship and intercourse among the people of the different states in this union, the free inhabitants of each of these states, paupers, vagabonds and fugitives from Justice excepted, shall be entitled to all privileges and immunities of free citizens in the several states; and the people of each state shall have free ingress and regress to and from any other state, and shall enjoy therein all the privileges of trade and commerce, subject to the same duties, impositions and restrictions as the inhabitants thereof respectively, provided that such restriction shall not extend so far as to prevent the removal of property imported into any state, to any other state of which the Owner is an inhabitant; provided also that no imposition, duties or restrictions shall be laid by any state, on the property of the united states, or either of them.

If any Person guilty of, or charged with treason, felony, or other high misdemeanor in any state, shall flee from Justice, and be found in any of the united states, he shall, upon demand of the Governor or executive power, of the state from which he fled, be delivered up and removed to the state having jurisdiction of his offence.

Full faith and credit shall be given in each of these states to the records, acts and judicial proceedings of the courts and magistrates of every other state.

Article V

For the more convenient management of the general interests of the united states, delegates shall be annually appointed in such manner as the legislature of each state shall direct, to meet in Congress on the first Monday in November, in every year, with a power reserved to each state, to recall its delegates, or any of them, at any time within the year, and to send others in their stead, for the remainder of the Year.

No state shall be represented in Congress by less than two, nor by more than seven Members; and no person shall be capable of being a delegate for more than three years in any term of six years; nor shall any person, being a delegate, be capable of holding any office under the united states, for which he, or another for his benefit receives any salary, fees or emolument of any kind.

Each state shall maintain its own delegates in a meeting of the states, and while they act as members of the committee of the states.

In determining questions in the united states in Congress assembled, each state shall have one vote.

Freedom of speech and debate in Congress shall not be impeached or questioned in any Court, or place out of Congress, and the members of congress shall be protected in their persons from arrests and imprisonments, during the time of their going to and from, and attendance on Congress, except for treason, felony, or breach of the peace.

Article VI

No state without the Consent of the united states in congress assembled, shall send any embassy to, or receive any embassy from, or enter into any conference, agreement, alliance or treaty with any King, prince or state; nor shall any person holding any office of profit or trust under the united states, or any of them, accept of any present, emolument, office or title of any kind whatever from any king, prince or foreign state; nor shall the united states in congress assembled, or any of them, grant any title of nobility.

No two or more states shall enter into any treaty, confederation or alliance whatever between them, without the consent of the united states in congress assembled, specifying accurately the purposes for which the same is to be entered into, and how long it shall continue.

No state shall lay any imposts or duties, which may interfere with any stipulations in treaties, entered into by the united states in congress assembled, with any king, prince or state, in pursuance of any treaties already proposed by congress, to the courts of France and Spain.

No vessels of war shall be kept up in time of peace by any state, except such number only, as shall be deemed necessary by the united states in congress assembled, for the defence of such state, or its trade; nor shall any body of forces be kept up by any state, in time of peace, except such number only, as in the judgment of the united states, in congress assembled, shall be deemed requisite to garrison the forts necessary for the defence of such state; but every state shall always keep up a well regulated and disciplined

militia, sufficiently armed and accoutred, and shall provide and constantly have ready for use, in public stores, a due number of field pieces and tents, and a proper quantity of arms, ammunition and camp equipage.

No state shall engage in any war without the consent of the united states in congress assembled, unless such state be actually invaded by enemies, or shall have received certain advice of a resolution being formed by some nation of Indians to invade such state, and the danger is so imminent as not to admit of a delay, till the united states in congress assembled can be consulted: nor shall any state grant commissions to any ships or vessels of war, nor letters of marque or reprisal, except it be after a declaration of war by the united states in congress assembled, and then only against the kingdom or state and the subjects thereof, against which war has been so declared, and under such regulations as shall be established by the united states in congress assembled, unless such state be infested by pirates, in which case vessels of war may be fitted out for that occasion, and kept so long as the danger shall continue, or until the united states in congress assembled shall determine otherwise.

Article VII

When land-forces are raised by any state for the common defence, all officers of or under the rank of colonel, shall be appointed by the legislature of each state respectively, by whom such forces shall be raised, or in such manner as such state shall direct, and all vacancies shall be filled up by the state which first made the appointment.

Article VIII

All charges of war, and all other expences that shall be incurred for the common defence or general welfare, and allowed by the united states in congress assembled, shall be defrayed out of a common treasury, which shall be supplied by the several states, in proportion to the value of all land within each state, granted to or surveyed for any Person, as such land and the buildings and improvements thereon shall be estimated according to such mode as the united states in congress assembled, shall from time to time direct and appoint.

The taxes for paying that proportion shall be laid and levied by the authority and direction of the legislatures of the several states within the time agreed upon by the united states in congress assembled.

Article IX

The united states in congress assembled, shall have the sole and exclusive right and power of determining on peace and war, except in the cases mentioned in the sixth article—of sending and receiving ambassadors—entering into treaties and alliances, provided that no treaty of commerce shall be made whereby the legislative power of the respective states shall be restrained from imposing such imposts and duties on foreigners as their own people are subjected to, or from prohibiting the exploration or importation of any species of goods or commodities, whatsoever—of establishing rules for deciding in all cases, what captures on land or water shall be legal, and in what manner prizes taken by land or naval forces in the service of the united states shall be divided or appropriated—of granting letters of marque and reprisal in times of peace—appointing courts for the trial of piracies and felonies committed on the high seas and establishing courts for receiving and determining finally appeals in all cases of captures, provided that no member of congress shall be appointed a judge of any of the said courts.

The united states in congress assembled shall also be the last resort on appeal in all disputes and differences now subsisting or that hereafter may arise between two or more states concerning boundary, jurisdiction or any other cause whatever; which authority shall always be exercised in the manner following. Whenever the legislative or executive authority or lawful agent of any state in controversy with another shall present a petition to congress stating the matter in question and praying for a hearing, notice thereof shall be given by order of congress to the legislative or executive authority of the other state in controversy, and a day assigned for the appearance of the parties by their lawful agents, who shall then be directed to appoint, by joint consent, commissioners or judges to constitute a court for hearing and determining the matter in question: but if they cannot agree, congress shall name three persons out of each of the united states, and from the list of such persons each party shall alternately strike out one, the petitioners beginning, until the number shall be reduced to thirteen; and from that number not less than seven, nor more than nine names as congress shall direct, shall in the presence of congress be drawn out by lot, and the persons whose names shall be so drawn or any five of them, shall be commissioners or judges, to hear and finally determine the controversy, so always as a major part of the judges who shall hear the cause shall agree in the determination: and if either party shall neglect to attend at the day appointed, without showing reasons, which congress shall judge sufficient, or being present shall refuse to strike, the congress shall proceed to nominate three persons out of each state, and the secretary of congress shall strike in behalf of such party absent or refusing; and the judgment and sentence of the court to be appointed, in the manner before prescribed, shall be final and conclusive; and if any of the parties shall refuse to submit to the authority of such court, or to appear or defend their claim or cause, the court shall nevertheless proceed to pronounce sentence, or judgment, which shall in like manner be final and decisive, the judgment or sentence and other proceedings being in either case transmitted to congress, and lodged among the acts of congress for the security of the parties concerned: provided that every commissioner, before he sits in judgment, shall take an oath to be administered by one of the judges of the supreme or superior court of the state where the cause shall be tried, "well and truly to hear and determine the matter in question, according to the best of his judgment, without favour, affection or hope of reward:" provided also, that no state shall be deprived of territory for the benefit of the united states.

All controversies concerning the private right of soil claimed under different grants of two or more states, whose jurisdictions as they may respect such lands, and the states which passed such grants are adjusted, the said grants or either of them being at the same time claimed to have originated antecedent to such settlement of jurisdiction, shall on the petition of either party to the congress of the united states, be finally determined as near as may be in the same manner as is before prescribed for deciding disputes respecting territorial jurisdiction between different states.

The united states in congress assembled shall also have the sole and exclusive right and power of regulating the alloy and value of coin struck by their own authority, or by that of the respective states—fixing the standard of weights and measures throughout the united states—regulating the trade and managing all affairs with the Indians, not members of any of the states, provided that the legislative right of any state within its own limits be not infringed or violated—establishing and regulating post-offices from one state to another, throughout all the united states, and exacting such postage on the papers passing thro' the same as may be requisite to defray the expences of the said office—appointing all officers of the land forces, in the service of the united states, excepting regimental officers—appointing all the officers of the naval forces, and commissioning all officers whatever in the service of the united states—making rules for the government and regulation of the said land and naval forces, and directing their operations.

The united states in congress assembled shall have authority to appoint a committee, to sit in the recess of congress, to be denominated "A Committee of the States," and to consist of one delegate from each state; and to appoint such other committees and civil officers as may be necessary for managing the general affairs of the united states under their direction—to appoint one of their number to preside, provided that no person be allowed to serve in the office of president more than one year in any term of three years; to ascertain the necessary sums of money to be raised for the service of the united states, and to appropriate and apply the same for defraying the public expences—to borrow Money, or emit bills on the credit of the united states, transmitting every half year to the respective states on account of the sums of money so borrowed or emitted,—to build and equip a navy—to agree upon the number of land forces, and to make requisitions from each state for its quota, in proportion to the number of white inhabitants in such state; which requisition shall be binding, and thereupon the legislature of each state shall appoint the regimental officers, raise the men and cloath, arm and equip them in a soldier like manner, at the expence of the united states; and the officers and men so cloathed, armed and equipped shall march to the place appointed, and within the time agreed on by the united states in congress assembled: But if the united states in congress assembled shall, on consideration of circumstances judge proper that any state should not raise men, or should raise a smaller number than its quota, and that any other state should raise a greater number of men than the quota thereof, such extra number shall be raised, officered, cloathed, armed and equipped in the same manner as the quota of such state, unless the legislature of such state shall judge that such extra number cannot be safely spared out of the same, in which case they shall raise, officer, cloath, arm and equip as many of such extra number as they judge can be safely spared. And the officers and men so cloathed, armed and equipped, shall march to the place appointed, and within the time agreed on by the united states in congress assembled.

The united states in congress assembled shall never engage in a war, nor grant letters of marque and reprisal in time of peace, nor enter into any treaties or alliances, nor coin money, nor regulate the value thereof, nor ascertain the sums and expences necessary for the defence and welfare of the united states, or any of them, nor emit bills, nor borrow money on the credit of the united states, nor appropriate money, nor agree upon the number of vessels of war, to be built or purchased, or the number of land or sea forces to be raised, nor appoint a commander in chief of the army or navy, unless nine states assent to the same: nor shall a question on any other point, except for adjourning from day to day, be determined, unless by the votes of a majority of the united states in congress assembled.

The congress of the united states shall have power to adjourn to any time within the year, and to any place within the united states, so that no period of adjournment be for a longer duration than the space of six Months, and shall publish the Journal of their proceedings monthly, except such parts thereof relating to treaties, alliances or military operations, as in their judgment require secrecy; and the yeas and nays of the delegates of each state on any question shall be entered on the Journal, when it is desired by any delegate; and the delegates of a state, or any of them, at his or their request shall be furnished with a transcript of the said Journal, except such parts as are above excepted, to lay before the legislatures of the several states.

Article X

The committee of the states, or any nine of them, shall be authorized to execute, in the recess of congress, such of the powers of congress as the united states in congress assembled, by the consent of nine states, shall from time to time think expedient to vest them with; provided that no power be delegated to

the said committee, for the exercise of which, by the articles of confederation, the voice of nine states in the congress of the united states assembled is requisite.

Article XI

Canada acceding to this confederation, and joining in the measures of the united states, shall be admitted into, and entitled to all the advantages of this union: but no other colony shall be admitted into the same, unless such admission be agreed to by nine states.

Article XII

All bills of credit emitted, monies borrowed and debts contracted by, or under the authority of congress, before the assembling of the united states, in pursuance of the present confederation, shall be deemed and considered as a charge against the united states, for payment and satisfaction whereof the said united states, and the public faith are hereby solemnly pledged.

ARTICLE XIII

Every state shall abide by the determinations of the united states in congress assembled, on all questions which by this confederation are submitted to them. And the Articles of this confederation shall be inviolably observed by every state, and the union shall be perpetual; nor shall any alteration at any time hereafter be made in any of them; unless such alteration be agreed to in a congress of the united states, and be afterwards confirmed by the legislatures of every state.

And Whereas it has pleased the Great Governor of the World to incline the hearts of the legislatures we respectively represent in congress, to approve of, and to authorize us to ratify the said articles of confederation and perpetual union. Know Ye that we the undersigned delegates, by virtue of the power and authority to us given for that purpose, do by these presents, in the name and in behalf of our respective constituents, fully and entirely ratify and confirm each and every of the said articles of confederation and perpetual union, and all and singular the matters and things therein contained: And we do further solemnly plight and engage the faith of our respective constituents, that they shall abide by the determinations of the united states in congress assembled, on all questions, which by the said confederation are submitted to them. And that the articles thereof shall be inviolably observed by the states we respectively represent, and that the union shall be perpetual. In Witness whereof we have hereunto set our hands in Congress. Done at Philadelphia in the state of Pennsylvania the ninth day of July, in the year of our Lord one Thousand seven Hundred and Seventy-eight, and in the third year of the independence of America.

[Names omitted]

Appendix C

■ INDEX GUIDE TO THE CONSTITUTION

Preamble

Article I: The Legislative Department. Organization of Congress and terms, qualifications, appointment, and election of Senators and Representatives.

Procedure in impeachment.

Privileges of the two houses and of their members.

Procedure in lawmaking.

Powers of Congress.

Limitations on Congress and on the States.

Article II: The Executive Department.

Election of President and Vice-President.

Powers and duties of the President.

Ratification of appointments and treaties.

Liability of officers to impeachment.

Article III: The Judicial Department.

Independence of the judiciary.

Jurisdiction of national courts.

Guarantee of jury trial.

Definition of treason.

Article IV: Position of the States and territories.

Full faith and credit to acts and judicial proceedings.

Privileges and immunities of citizens of the several States.

Rendition of fugitives from justice.

Control of territories by Congress.

Guarantees to the States.

Article V: Method of amendment.

Article VI: Supremacy of the Constitution, laws, and treaties of the United States.

Oath of office prohibition of a religious test.

Article VII: Method of ratification of the Constitution.

Amendments

 I. Freedom of religion, speech, press and assembly; right of petition.

 II. Right to keep and bear arms.

 III. Limitations in quartering soldiers.

 IV. Protection from unreasonable searches and seizures.

 V. Due process in criminal cases. Limitation on right of eminent domain.

 VI. Right to speedy trial by jury, and other guarantees.

 VII. Trial by jury in suits at law.

 VIII. Excessive bail or unusual punishments forbidden.

 IX. Retention of certain rights by the people.

 X. Undelegated powers belong to the States or to the people.

 XI. Exemption of States from suit by individuals.

 XII. New method of electing President.

 XIII. Abolition of slavery.

 XIV. Definition of citizenship. Guarantees of due process and equal protection against State action. Apportionment of Representatives in Congress. Validity of public debt.

 XV. Voting rights guaranteed to freedmen.

 XVI. Tax on incomes "from whatever source derived."

 XVII. Popular election of Senators.

 XVIII. Prohibition of intoxicating liquors.

 XIX. Extension of suffrage to women.

 XX. Abolition of "lame duck" session of Congress. Change in presidential and congressional terms.

 XXI. Repeal of 18th Amendment.

 XXII. Limitation of President's terms in office.

 XXIII. Extension of suffrage to District of Columbia in presidential elections.

 XXIV. Abolition of poll tax requirement in national elections.

 XXV. Presidential succession and disability provisions.

 XXVI. Extension of suffrage to eighteen-year-olds.

 XXVII. Allows congressional pay raises but only "until an election of Representatives shall have intervened."

Appendix D

■ THE CONSTITUTION OF THE UNITED STATES OF AMERICA

Preamble

We the people of the United States, in order to form a more perfect union, establish justice, insure domestic tranquility, provide for the common defense, promote the general welfare, and secure the blessings of liberty to ourselves and our posterity, do ordain and establish this Constitution for the United States of America.

Article I

Section I

All legislative powers herein granted shall be vested in a Congress of the United States, which shall consist of a Senate and House of Representatives.

Section 2

The House of Representatives shall be composed of members chosen every second year by the people of the several states, and the electors in each state shall have the qualifications requisite for electors of the most numerous branch of the state legislature.

No person shall be a Representative who shall not have attained to the age of twenty five years, and been seven years a citizen of the United States, and who shall not, when elected, be an inhabitant of that state in which he shall be chosen.

Representatives and direct taxes shall be apportioned among the several states which may be included within this union, according to their respective numbers, which shall be determined by adding to the whole number of free persons, including those bound to service for a term of years, and excluding Indians not taxed, three fifths of all other Persons. The actual Enumeration shall be made within three years after the first meeting of the Congress of the United States, and within every subsequent term of ten years, in such manner as they shall by law direct. The number of Representatives shall not exceed one for every thirty thousand, but each state shall have at least one Representative; and until such enumeration shall be made, the state of New Hampshire shall be entitled to chuse three, Massachusetts eight, Rhode Island and Providence Plantations one, Connecticut five, New York six, New Jersey four, Pennsylvania eight, Delaware one, Maryland six, Virginia ten, North Carolina five, South Carolina five, and Georgia three.

When vacancies happen in the Representation from any state, the executive authority thereof shall issue writs of election to fill such vacancies.

The House of Representatives shall choose their speaker and other officers; and shall have the sole power of impeachment.

Section 3

The Senate of the United States shall be composed of two Senators from each state, chosen by the legislature thereof, for six years; and each Senator shall have one vote.

Immediately after they shall be assembled in consequence of the first election, they shall be divided as equally as may be into three classes. The seats of the Senators of the first class shall be vacated at the expiration of the second year, of the second class at the expiration of the fourth year, and the third class at the expiration of the sixth year, so that one third may be chosen every second year; and if vacancies happen by resignation, or otherwise, during the recess of the legislature of any state, the executive thereof may make temporary appointments until the next meeting of the legislature, which shall then fill such vacancies.

No person shall be a Senator who shall not have attained to the age of thirty years, and been nine years a citizen of the United States and who shall not, when elected, be an inhabitant of that state for which he shall be chosen.

The Vice President of the United States shall be President of the Senate, but shall have no vote, unless they be equally divided.

The Senate shall choose their other officers, and also a President pro tempore, in the absence of the Vice President, or when he shall exercise the office of President of the United States.

The Senate shall have the sole power to try all impeachments. When sitting for that purpose, they shall be on oath or affirmation. When the President of the United States is tried, the Chief Justice shall preside: And no person shall be convicted without the concurrence of two thirds of the members present.

Judgment in cases of impeachment shall not extend further than to removal from office, and disqualification to hold and enjoy any office of honor, trust or profit under the United States: but the party convicted shall nevertheless be liable and subject to indictment, trial, judgment and punishment, according to law.

Section 4

The times, places and manner of holding elections for Senators and Representatives, shall be prescribed in each state by the legislature thereof; but the Congress may at any time by law make or alter such regulations, except as to the places of choosing Senators.

The Congress shall assemble at least once in every year, and such meeting shall be on the first Monday in December, unless they shall by law appoint a different day.

Section 5

Each House shall be the judge of the elections, returns and qualifications of its own members, and a majority of each shall constitute a quorum to do business; but a smaller number may adjourn from day to day, and may be authorized to compel the attendance of absent members, in such manner, and under such penalties as each House may provide.

Each House may determine the rules of its proceedings, punish its members for disorderly behavior, and, with the concurrence of two thirds, expel a member.

Each House shall keep a journal of its proceedings, and from time to time publish the same, excepting such parts as may in their judgment require secrecy; and the yeas and nays of the members of either House on any question shall, at the desire of one fifth of those present, be entered on the journal.

Neither House, during the session of Congress, shall, without the consent of the other, adjourn for more than three days, nor to any other place than that in which the two Houses shall be sitting.

Section 6

The Senators and Representatives shall receive a compensation for their services, to be ascertained by law, and paid out of the treasury of the United States. They shall in all cases, except treason, felony and breach of the peace, be privileged from arrest during their attendance at the session of their respective Houses, and in going to and returning from the same; and for any speech or debate in either House, they shall not be questioned in any other place.

No Senator or Representative shall, during the time for which he was elected, be appointed to any civil office under the authority of the United States, which shall have been created, or the emoluments whereof shall have been increased during such time: and no person holding any office under the United States, shall be a member of either House during his continuance in office.

Section 7

All bills for raising revenue shall originate in the House of Representatives; but the Senate may propose or concur with amendments as on other Bills.

Every bill which shall have passed the House of Representatives and the Senate, shall, before it becomes a law, be presented to the President of the United States; if he approve he shall sign it, but if not he shall return it, with his objections to that House in which it shall have originated, who shall enter the objections at large on their journal, and proceed to reconsider it. If after such reconsideration two thirds of that House shall agree to pass the bill, it shall be sent, together with the objections, to the other House, by which it shall likewise be reconsidered, and if approved by two thirds of that House, it shall become a law. But in all such cases the votes of both Houses shall be determined by yeas and nays, and the names of the persons voting for and against the bill shall be entered on the journal of each House respectively. If any bill shall not be returned by the President within ten days (Sundays excepted) after it shall have been presented to him, the same shall be a law, in like manner as if he had signed it, unless the Congress by their adjournment prevent its return, in which case it shall not be a law.

Every order, resolution, or vote to which the concurrence of the Senate and House of Representatives may be necessary (except on a question of adjournment) shall be presented to the President of the United States; and before the same shall take effect, shall be approved by him, or being disapproved by him, shall be repassed by two thirds of the Senate and House of Representatives, according to the rules and limitations prescribed in the case of a bill.

Section 8

The Congress shall have power to lay and collect taxes, duties, imposts and excises, to pay the debts and provide for the common defense and general welfare of the United States; but all duties, imposts and excises shall be uniform throughout the United States;

To borrow money on the credit of the United States;

To regulate commerce with foreign nations, and among the several states, and with the Indian tribes;

To establish a uniform rule of naturalization, and uniform laws on the subject of bankruptcies throughout the United States;

To coin money, regulate the value thereof, and of foreign coin, and fix the standard of weights and measures;

To provide for the punishment of counterfeiting the securities and current coin of the United States;

To establish post offices and post roads;

To promote the progress of science and useful arts, by securing for limited times to authors and inventors the exclusive right to their respective writings and discoveries;

To constitute tribunals inferior to the Supreme Court;

To define and punish piracies and felonies committed on the high seas, and offenses against the law of nations;

To declare war, grant letters of marque and reprisal, and make rules concerning captures on land and water;

To raise and support armies, but no appropriation of money to that use shall be for a longer term than two years;

To provide and maintain a navy;

To make rules for the government and regulation of the land and naval forces;

To provide for calling forth the militia to execute the laws of the union, suppress insurrections and repel invasions;

To provide for organizing, arming, and disciplining, the militia, and for governing such part of them as may be employed in the service of the United States, reserving to the states respectively, the appointment of the officers, and the authority of training the militia according to the discipline prescribed by Congress;

To exercise exclusive legislation in all cases whatsoever, over such District (not exceeding ten miles square) as may, by cession of particular states, and the acceptance of Congress, become the seat of the government of the United States, and to exercise like authority over all places purchased by the consent of the legislature of the state in which the same shall be, for the erection of forts, magazines, arsenals, dockyards, and other needful buildings; And

To make all laws which shall be necessary and proper for carrying into execution the foregoing powers, and all other powers vested by this Constitution in the government of the United States, or in any department or officer thereof.

Section 9

The migration or importation of such persons as any of the states now existing shall think proper to admit, shall not be prohibited by the Congress prior to the year one thousand eight hundred and eight, but a tax or duty may be imposed on such importation, not exceeding ten dollars for each person.

The privilege of the writ of *habeas corpus* shall not be suspended, unless when in cases of rebellion or invasion the public safety may require it.

No bill of attainder or ex post facto Law shall be passed.

No capitation, or other direct, tax shall be laid, unless in proportion to the census or enumeration herein before directed to be taken.

No tax or duty shall be laid on articles exported from any state.

No preference shall be given by any regulation of commerce or revenue to the ports of one state over those of another: nor shall vessels bound to, or from, one state, be obliged to enter, clear or pay duties in another.

No money shall be drawn from the treasury, but in consequence of appropriations made by law; and a regular statement and account of receipts and expenditures of all public money shall be published from time to time.

No title of nobility shall be granted by the United States: and no person holding any office of profit or trust under them, shall, without the consent of the Congress, accept of any present, emolument, office, or title, of any kind whatever, from any king, prince, or foreign state.

Section 10

No state shall enter into any treaty, alliance, or confederation; grant letters of marque and reprisal; coin money; emit bills of credit; make anything but gold and silver coin a tender in payment of debts; pass any bill of attainder, ex post facto law, or law impairing the obligation of contracts, or grant any title of nobility.

No state shall, without the consent of the Congress, lay any imposts or duties on imports or exports, except what may be absolutely necessary for executing its inspection laws: and the net produce of all duties and imposts, laid by any state on imports or exports, shall be for the use of the treasury of the United States; and all such laws shall be subject to the revision and control of the Congress.

No state shall, without the consent of Congress, lay any duty of tonnage, keep troops, or ships of war in time of peace, enter into any agreement or compact with another state, or with a foreign power, or engage in war, unless actually invaded, or in such imminent danger as will not admit of delay.

Article II

Section 1

The executive power shall be vested in a President of the United States of America. He shall hold his office during the term of four years, and, together with the Vice President, chosen for the same term, be elected, as follows:

Each state shall appoint, in such manner as the Legislature thereof may direct, a number of electors, equal to the whole number of Senators and Representatives to which the State may be entitled in the Congress: but no Senator or Representative, or person holding an office of trust or profit under the United States, shall be appointed an elector.

The electors shall meet in their respective states, and vote by ballot for two persons, of whom one at least shall not be an inhabitant of the same state with themselves. And they shall make a list of all the persons voted for, and of the number of votes for each; which list they shall sign and certify, and transmit sealed to the seat of the government of the United States, directed to the President of the Senate. The President of the Senate shall, in the presence of the Senate and House of Representatives, open all the certificates, and the votes shall then be counted. The person having the greatest number of votes shall be the President, if such number be a majority of the whole number of electors appointed; and if there be more than one who have such majority, and have an equal number of votes, then the House of Representatives shall immediately choose by ballot one of them for President; and if no person have a majority, then from the five highest on the list the said House shall in like manner choose the President. But in choosing the President, the votes shall be taken by States, the representation from each state having one vote; A quorum for this purpose shall consist of a member or members from two thirds of the states, and a majority of all the states shall be necessary to a choice. In every case, after the choice of the President, the person

having the greatest number of votes of the electors shall be the Vice President. But if there should remain two or more who have equal votes, the Senate shall choose from them by ballot the Vice President.

The Congress may determine the time of choosing the electors, and the day on which they shall give their votes; which day shall be the same throughout the United States.

No person except a natural born citizen, or a citizen of the United States, at the time of the adoption of this Constitution, shall be eligible to the office of President; neither shall any person be eligible to that office who shall not have attained to the age of thirty five years, and been fourteen years a resident within the United States.

In case of the removal of the President from office, or of his death, resignation, or inability to discharge the powers and duties of the said office, the same shall devolve on the Vice President, and the Congress may by law provide for the case of removal, death, resignation or inability, both of the President and Vice President, declaring what officer shall then act as President, and such officer shall act accordingly, until the disability be removed, or a President shall be elected.

The President shall, at stated times, receive for his services, a compensation, which shall neither be increased nor diminished during the period for which he shall have been elected, and he shall not receive within that period any other emolument from the United States, or any of them.

Before he enter on the execution of his office, he shall take the following oath or affirmation: "I do solemnly swear (or affirm) that I will faithfully execute the office of President of the United States, and will to the best of my ability, preserve, protect and defend the Constitution of the United States."

Section 2

The President shall be commander in chief of the Army and Navy of the United States, and of the militia of the several states, when called into the actual service of the United States; he may require the opinion, in writing, of the principal officer in each of the executive departments, upon any subject relating to the duties of their respective offices, and he shall have power to grant reprieves and pardons for offenses against the United States, except in cases of impeachment.

He shall have power, by and with the advice and consent of the Senate, to make treaties, provided two thirds of the Senators present concur; and he shall nominate, and by and with the advice and consent of the Senate, shall appoint ambassadors, other public ministers and consuls, judges of the Supreme Court, and all other officers of the United States, whose appointments are not herein otherwise provided for, and which shall be established by law: but the Congress may by law vest the appointment of such inferior officers, as they think proper, in the President alone, in the courts of law, or in the heads of departments.

The President shall have power to fill up all vacancies that may happen during the recess of the Senate, by granting commissions which shall expire at the end of their next session.

Section 3

He shall from time to time give to the Congress information of the state of the union, and recommend to their consideration such measures as he shall judge necessary and expedient; he may, on extraordinary occasions, convene both Houses, or either of them, and in case of disagreement between them, with respect to the time of adjournment, he may adjourn them to such time as he shall think proper; he shall receive ambassadors and other public ministers; he shall take care that the laws be faithfully executed, and shall commission all the officers of the United States.

Section 4

The President, Vice President and all civil officers of the United States, shall be removed from office on impeachment for, and conviction of, treason, bribery, or other high crimes and misdemeanors.

Article III

Section 1

The judicial power of the United States, shall be vested in one Supreme Court, and in such inferior courts as the Congress may from time to time ordain and establish. The judges, both of the supreme and inferior courts, shall hold their offices during good behavior, and shall, at stated times, receive for their services, a compensation, which shall not be diminished during their continuance in office.

Section 2

The judicial power shall extend to all cases, in law and equity, arising under this Constitution, the laws of the United States, and treaties made, or which shall be made, under their authority; to all cases affecting ambassadors, other public ministers and consuls; to all cases of admiralty and maritime jurisdiction; to controversies to which the United States shall be a party; to controversies between two or more states; between a state and citizens of another state; between citizens of different states; between citizens of the same state claiming lands under grants of different states, and between a state, or the citizens thereof, and foreign states, citizens or subjects.

In all cases affecting ambassadors, other public ministers and consuls, and those in which a state shall be party, the Supreme Court shall have original jurisdiction. In all the other cases before mentioned, the Supreme Court shall have appellate jurisdiction, both as to law and fact, with such exceptions, and under such regulations as the Congress shall make.

The trial of all crimes, except in cases of impeachment, shall be by jury; and such trial shall be held in the state where the said crimes shall have been committed; but when not committed within any state, the trial shall be at such place or places as the Congress may by law have directed.

Section 3

Treason against the United States, shall consist only in levying war against them, or in adhering to their enemies, giving them aid and comfort. No person shall be convicted of treason unless on the testimony of two witnesses to the same overt act, or on confession in open court.

The Congress shall have power to declare the punishment of treason, but no attainder of treason shall work corruption of blood, or forfeiture except during the life of the person attainted.

Article IV

Section 1

Full faith and credit shall be given in each state to the public acts, records, and judicial proceedings of every other state. And the Congress may by general laws prescribe the manner in which such acts, records, and proceedings shall be proved, and the effect thereof.

Section 2

The citizens of each state shall be entitled to all privileges and immunities of citizens in the several states.

A person charged in any state with treason, felony, or other crime, who shall flee from justice, and be found in another state, shall on demand of the executive authority of the state from which he fled, be delivered up, to be removed to the state having jurisdiction of the crime.

No person held to service or labor in one state, under the laws thereof, escaping into another, shall, in consequence of any law or regulation therein, be discharged from such service or labor, but shall be delivered up on claim of the party to whom such service or labor may be due.

Section 3

New states may be admitted by the Congress into this union; but no new states shall be formed or erected within the jurisdiction of any other state; nor any state be formed by the junction of two or more states, or parts of states, without the consent of the legislatures of the states concerned as well as of the Congress.

The Congress shall have power to dispose of and make all needful rules and regulations respecting the territory or other property belonging to the United States; and nothing in this Constitution shall be so construed as to prejudice any claims of the United States, or of any particular state.

Section 4

The United States shall guarantee to every state in this union a republican form of government, and shall protect each of them against invasion; and on application of the legislature, or of the executive (when the legislature cannot be convened) against domestic violence.

Article V

The Congress, whenever two thirds of both houses shall deem it necessary, shall propose amendments to this Constitution, or, on the application of the legislatures of two thirds of the several states, shall call a convention for proposing amendments, which, in either case, shall be valid to all intents and purposes, as part of this Constitution, when ratified by the legislatures of three fourths of the several states, or by conventions in three fourths thereof, as the one or the other mode of ratification may be proposed by the Congress; provided that no amendment which may be made prior to the year one thousand eight hundred and eight shall in any manner affect the first and fourth clauses in the ninth section of the first article; and that no state, without its consent, shall be deprived of its equal suffrage in the Senate.

Article VI

All debts contracted and engagements entered into, before the adoption of this Constitution, shall be as valid against the United States under this Constitution, as under the Confederation.

This Constitution, and the laws of the United States which shall be made in pursuance thereof; and all treaties made, or which shall be made, under the authority of the United States, shall be the supreme law of the land; and the judges in every state shall be bound thereby, anything in the Constitution or laws of any State to the contrary notwithstanding.

The Senators and Representatives before mentioned, and the members of the several state legislatures, and all executive and judicial officers, both of the United States and of the several states, shall be

bound by oath or affirmation, to support this Constitution; but no religious test shall ever be required as a qualification to any office or public trust under the United States.

Article VII

The ratification of the conventions of nine states, shall be sufficient for the establishment of this Constitution between the states so ratifying the same.

Done in convention by the unanimous consent of the states present the seventeenth day of September in the year of our Lord one thousand seven hundred and eighty seven and of the independence of the United States of America the twelfth. In witness whereof We have hereunto subscribed our Names,

G. Washington	- Presidt. and deputy from Virginia
New Hampshire:	John Langdon, Nicholas Gilman
Massachusetts:	Nathaniel Gorham, Rufus King
Connecticut:	Wm. Saml. Johnson, Roger Sherman
New York:	Alexander Hamilton
New Jersey:	Wil. Livingston, David Brearly, Wm. Paterson, Jona. Dayton
Pennsylvania:	B. Franklin, Thomas Mifflin, Robt. Morris, Geo. Clymer, Thos. FitzSimons, Jared Ingersoll, James Wilson, Gouv Morris
Delaware:	Geo. Read, Gunning Bedford jr, John Dickinson, Richard Bassett, Jaco. Broom
Maryland:	James McHenry, Dan of St Thos. Jenifer, Danl Carroll
Virginia:	John Blair, James Madison Jr.
North Carolina:	Wm. Blount, Richd. Dobbs Spaight, Hu Williamson
South Carolina:	J. Rutledge, Charles Cotesworth Pinckney, Charles Pinckney, Pierce Butler
Georgia:	William Few, Abr Baldwin

Amendments to the Constitution of the United States

Amendment I (1791)

Congress shall make no law respecting an establishment of religion, or prohibiting the free exercise thereof; or abridging the freedom of speech, or of the press; or the right of the people peaceably to assemble, and to petition the government for a redress of grievances.

Amendment II (1791)

A well regulated militia, being necessary to the security of a free state, the right of the people to keep and bear arms, shall not be infringed.

Amendment III (1791)

No soldier shall, in time of peace be quartered in any house, without the consent of the owner, nor in time of war, but in a manner to be prescribed by law.

Amendment IV (1791)

The right of the people to be secure in their persons, houses, papers, and effects, against unreasonable searches and seizures, shall not be violated, and no warrants shall issue, but upon probable cause,

supported by oath or affirmation, and particularly describing the place to be searched, and the persons or things to be seized.

Amendment V (1791)

No person shall be held to answer for a capital, or otherwise infamous crime, unless on a present-ment or indictment of a grand jury, except in cases arising in the land or naval forces, or in the militia, when in actual service in time of war or public danger; nor shall any person be subject for the same offense to be twice put in jeopardy of life or limb; nor shall be compelled in any criminal case to be a witness against himself, nor be deprived of life, liberty, or property, without due process of law; nor shall private prop-erty be taken for public use, without just compensation.

Amendment VI (1791)

In all criminal prosecutions, the accused shall enjoy the right to a speedy and public trial, by an impartial jury of the state and district wherein the crime shall have been committed, which district shall have been previously ascertained by law, and to be informed of the nature and cause of the accusation; to be confronted with the witnesses against him; to have compulsory process for obtaining witnesses in his favor, and to have the assistance of counsel for his defense.

Amendment VII (1791)

In suits at common law, where the value in controversy shall exceed twenty dollars, the right of trial by jury shall be preserved, and no fact tried by a jury, shall be otherwise reexamined in any court of the United States, than according to the rules of the common law.

Amendment VIII (1791)

Excessive bail shall not be required, nor excessive fines imposed, nor cruel and unusual punish-ments inflicted.

Amendment IX (1791)

The enumeration in the Constitution, of certain rights, shall not be construed to deny or disparage others retained by the people.

Amendment X (1791)

The powers not delegated to the United States by the Constitution, nor prohibited by it to the states, are reserved to the states respectively, or to the people.

Amendment XI (1798)

The judicial power of the United States shall not be construed to extend to any suit in law or equity, commenced or prosecuted against one of the United States by citizens of another state, or by citizens or subjects of any foreign state.

Amendment XII (1804)

The electors shall meet in their respective states and vote by ballot for President and Vice-President, one of whom, at least, shall not be an inhabitant of the same state with themselves; they shall name in

their ballots the person voted for as President, and in distinct ballots the person voted for as Vice-President, and they shall make distinct lists of all persons voted for as President, and of all persons voted for as Vice-President, and of the number of votes for each, which lists they shall sign and certify, and transmit sealed to the seat of the government of the United States, directed to the President of the Senate; The President of the Senate shall, in the presence of the Senate and House of Representatives, open all the certificates and the votes shall then be counted; the person having the greatest number of votes for President, shall be the President, if such number be a majority of the whole number of electors appointed; and if no person have such majority, then from the persons having the highest numbers not exceeding three on the list of those voted for as President, the House of Representatives shall choose immediately, by ballot, the President. But in choosing the President, the votes shall be taken by states, the representation from each state having one vote; a quorum for this purpose shall consist of a member or members from two-thirds of the states, and a majority of all the states shall be necessary to a choice. And if the House of Representatives shall not choose a President whenever the right of choice shall devolve upon them, before the fourth day of March next following, then the Vice-President shall act as President, as in the case of the death or other constitutional disability of the President. The person having the greatest number of votes as Vice-President, shall be the Vice-President, if such number be a majority of the whole number of electors appointed, and if no person have a majority, then from the two highest numbers on the list, the Senate shall choose the Vice-President; a quorum for the purpose shall consist of two-thirds of the whole number of Senators, and a majority of the whole number shall be necessary to a choice. But no person constitutionally ineligible to the office of President shall be eligible to that of Vice-President of the United States.

Amendment XIII (1865)

Section 1. Neither slavery nor involuntary servitude, except as a punishment for crime whereof the party shall have been duly convicted, shall exist within the United States, or any place subject to their jurisdiction.

Section 2. Congress shall have power to enforce this article by appropriate legislation.

Amendment XIV (1868)

Section 1. All persons born or naturalized in the United States, and subject to the jurisdiction thereof, are citizens of the United States and of the state wherein they reside. No state shall make or enforce any law which shall abridge the privileges or immunities of citizens of the United States; nor shall any state deprive any person of life, liberty, or property, without due process of law; nor deny to any person within its jurisdiction the equal protection of the laws.

Section 2. Representatives shall be apportioned among the several states according to their respective numbers, counting the whole number of persons in each state, excluding Indians not taxed. But when the right to vote at any election for the choice of electors for President and Vice President of the United States, Representatives in Congress, the executive and judicial officers of a state, or the members of the legislature thereof, is denied to any of the male inhabitants of such state, being twenty-one years of age,

and citizens of the United States, or in any way abridged, except for participation in rebellion, or other crime, the basis of representation therein shall be reduced in the proportion which the number of such male citizens shall bear to the whole number of male citizens twenty-one years of age in such state.

Section 3. No person shall be a Senator or Representative in Congress, or elector of President and Vice President, or hold any office, civil or military, under the United States, or under any state, who, having previously taken an oath, as a member of Congress, or as an officer of the United States, or as a member of any state legislature, or as an executive or judicial officer of any state, to support the Constitution of the United States, shall have engaged in insurrection or rebellion against the same, or given aid or comfort to the enemies thereof. But Congress may by a vote of two-thirds of each House, remove such disability.

Section 4. The validity of the public debt of the United States, authorized by law, including debts incurred for payment of pensions and bounties for services in suppressing insurrection or rebellion, shall not be questioned. But neither the United States nor any state shall assume or pay any debt or obligation incurred in aid of insurrection or rebellion against the United States, or any claim for the loss or emancipation of any slave; but all such debts, obligations and claims shall be held illegal and void.

Section 5. The Congress shall have power to enforce, by appropriate legislation, the provisions of this article.

Amendment XV (1870)

Section 1. The right of citizens of the United States to vote shall not be denied or abridged by the United States or by any state on account of race, color, or previous condition of servitude.

Section 2. The Congress shall have power to enforce this article by appropriate legislation.

Amendment XVI (1913)

The Congress shall have power to lay and collect taxes on incomes, from whatever source derived, without apportionment among the several states, and without regard to any census of enumeration.

Amendment XVII (1913)

The Senate of the United States shall be composed of two Senators from each state, elected by the people thereof, for six years; and each Senator shall have one vote. The electors in each state shall have the qualifications requisite for electors of the most numerous branch of the state legislatures.

When vacancies happen in the representation of any state in the Senate, the executive authority of such state shall issue writs of election to fill such vacancies: Provided, that the legislature of any state may empower the executive thereof to make temporary appointments until the people fill the vacancies by election as the legislature may direct.

This amendment shall not be so construed as to affect the election or term of any Senator chosen before it becomes valid as part of the Constitution.

Amendment XVIII (1919)

Section 1. After one year from the ratification of this article the manufacture, sale, or transportation of intoxicating liquors within, the importation thereof into, or the exportation thereof from the United States and all territory subject to the jurisdiction thereof for beverage purposes is hereby prohibited.

Section 2. The Congress and the several states shall have concurrent power to enforce this article by appropriate legislation.

Section 3. This article shall be inoperative unless it shall have been ratified as an amendment to the Constitution by the legislatures of the several states, as provided in the Constitution, within seven years from the date of the submission hereof to the states by the Congress.

Amendment XIX (1920)

The right of citizens of the United States to vote shall not be denied or abridged by the United States or by any state on account of sex.

Congress shall have power to enforce this article by appropriate legislation.

Amendment XX (1933)

Section 1. The terms of the President and Vice President shall end at noon on the 20th day of January, and the terms of Senators and Representatives at noon on the 3d day of January, of the years in which such terms would have ended if this article had not been ratified; and the terms of their successors shall then begin.

Section 2. The Congress shall assemble at least once in every year, and such meeting shall begin at noon on the 3d day of January, unless they shall by law appoint a different day.

Section 3. If, at the time fixed for the beginning of the term of the President, the President elect shall have died, the Vice President elect shall become President. If a President shall not have been chosen before the time fixed for the beginning of his term, or if the President elect shall have failed to qualify, then the Vice President elect shall act as President until a President shall have qualified; and the Congress may by law provide for the case wherein neither a President elect nor a Vice President elect shall have qualified, declaring who shall then act as President, or the manner in which one who is to act shall be selected, and such person shall act accordingly until a President or Vice President shall have qualified.

Section 4. The Congress may by law provide for the case of the death of any of the persons from whom the House of Representatives may choose a President whenever the right of choice shall have devolved upon them, and for the case of the death of any of the persons from whom the Senate may choose a Vice President whenever the right of choice shall have devolved upon them.

Section 5. Sections 1 and 2 shall take effect on the 15th day of October following the ratification of this article.

Section 6. This article shall be inoperative unless it shall have been ratified as an amendment to the Constitution by the legislatures of three-fourths of the several states within seven years from the date of its submission.

Amendment XXI (1933)

Section 1. The eighteenth article of amendment to the Constitution of the United States is hereby repealed.

Section 2. The transportation or importation into any state, territory, or possession of the United States for delivery or use therein of intoxicating liquors, in violation of the laws thereof, is hereby prohibited.

Section 3. This article shall be inoperative unless it shall have been ratified as an amendment to the Constitution by conventions in the several states, as provided in the Constitution, within seven years from the date of the submission hereof to the states by the Congress.

Amendment XXII (1951)

Section 1. No person shall be elected to the office of the President more than twice, and no person who has held the office of President, or acted as President, for more than two years of a term to which some other person was elected President shall be elected to the office of the President more than once. But this article shall not apply to any person holding the office of President when this article was proposed by the Congress, and shall not prevent any person who may be holding the office of President, or acting as President, during the term within which this article becomes operative from holding the office of President or acting as President during the remainder of such term.

Section 2. This article shall be inoperative unless it shall have been ratified as an amendment to the Constitution by the legislatures of three-fourths of the several states within seven years from the date of its submission to the states by the Congress.

Amendment XXIII (1961)

Section 1. The District constituting the seat of government of the United States shall appoint in such manner as the Congress may direct:

A number of electors of President and Vice President equal to the whole number of Senators and Representatives in Congress to which the District would be entitled if it were a state, but in no event more than the least populous state; they shall be in addition to those appointed by the states, but they shall be considered, for the purposes of the election of President and Vice President, to be electors appointed by a state; and they shall meet in the District and perform such duties as provided by the twelfth article of amendment.

Section 2. The Congress shall have power to enforce this article by appropriate legislation.

Amendment XXIV (1964)

Section 1. The right of citizens of the United States to vote in any primary or other election for President or Vice President, for electors for President or Vice President, or for Senator or Representative in Congress, shall not be denied or abridged by the United States or any state by reason of failure to pay any poll tax or other tax.

Section 2. The Congress shall have power to enforce this article by appropriate legislation.

Amendment XXV (1967)

Section 1. In case of the removal of the President from office or of his death or resignation, the Vice President shall become President.

Section 2. Whenever there is a vacancy in the office of the Vice President, the President shall nominate a Vice President who shall take office upon confirmation by a majority vote of both Houses of Congress.

Section 3. Whenever the President transmits to the President pro tempore of the Senate and the Speaker of the House of Representatives his written declaration that he is unable to discharge the powers and duties of his office, and until he transmits to them a written declaration to the contrary, such powers and duties shall be discharged by the Vice President as Acting President.

Section 4. Whenever the Vice President and a majority of either the principal officers of the executive departments or of such other body as Congress may by law provide, transmit to the President pro tempore of the Senate and the Speaker of the House of Representatives their written declaration that the President is unable to discharge the powers and duties of his office, the Vice President shall immediately assume the powers and duties of the office as Acting President.

Thereafter, when the President transmits to the President pro tempore of the Senate and the Speaker of the House of Representatives his written declaration that no inability exists, he shall resume the powers and duties of his office unless the Vice President and a majority of either the principal officers of the executive department or of such other body as Congress may by law provide, transmit within four days to the President pro tempore of the Senate and the Speaker of the House of Representatives their written declaration that the President is unable to discharge the powers and duties of his office. Thereupon Congress shall decide the issue, assembling within forty-eight hours for that purpose if not in session. If the Congress, within twenty-one days after receipt of the latter written declaration, or, if Congress is not in session, within twenty-one days after Congress is required to assemble, determines by two-thirds vote of both Houses that the President is unable to discharge the powers and duties of his office, the Vice President shall continue to discharge the same as Acting President; otherwise, the President shall resume the powers and duties of his office.

Amendment XXVI (1971)

Section 1. The right of citizens of the United States, who are 18 years of age or older, to vote, shall not be denied or abridged by the United States or any state on account of age.

Section 2. The Congress shall have the power to enforce this article by appropriate legislation.

Amendment XXVII (1992)

No law varying the compensation for the services of the Senators and Representatives shall take effect until an election of Representatives shall have intervened.

Appendix E

■ *THE FEDERALIST* NO. 10

The Utility of the Union as a Safeguard Against Domestic Faction and Insurrection *Daily Advertiser*
Thursday, November 22, 1787
[James Madison]

To the People of the State of New York:

Among the numerous advantages promised by a well constructed Union, none deserves to be more accurately developed than its tendency to break and control the violence of faction. The friend of popular governments never finds himself so much alarmed for their character and fate, as when he contemplates their propensity to this dangerous vice. He will not fail, therefore, to set a due value on any plan which, without violating the principles to which he is attached, provides a proper cure for it. The instability, injustice, and confusion introduced into the public councils, have, in truth, been the mortal diseases under which popular governments have everywhere perished; as they continue to be the favorite and fruitful topics from which the adversaries to liberty derive their most specious declamations. The valuable improvements made by the American constitutions on the popular models, both ancient and modern, cannot certainly be too much admired; but it would be an unwarrantable partiality, to contend that they have as effectually obviated the danger on this side, as was wished and expected. Complaints are everywhere heard from our most considerate and virtuous citizens, equally the friends of public and private faith, and of public and personal liberty, that our governments are too unstable, that the public good is disregarded in the conflicts of rival parties, and that measures are too often decided, not according to the rules of justice and the rights of the minor party, but by the superior force of an interested and overbearing majority. However anxiously we may wish that these complaints had no foundation, the evidence, of known facts will not permit us to deny that they are in some degree true. It will be found, indeed, on a candid review of our situation, that some of the distresses under which we labor have been erroneously charged on the operation of our governments; but it will be found, at the same time, that other causes will not alone account for many of our heaviest misfortunes; and, particularly, for that prevailing and increasing distrust of public engagements, and alarm for private rights, which are echoed from one end of the continent to the other. These must be chiefly, if not wholly, effects of the unsteadiness and injustice with which a factious spirit has tainted our public administrations.

By a faction, I understand a number of citizens, whether amounting to a majority or a minority of the whole, who are united and actuated by some common impulse of passion, or of interest, adversed to the rights of other citizens, or to the permanent and aggregate interests of the community.

There are two methods of curing the mischiefs of faction: the one, by removing its causes; the other, by controlling its effects.

There are again two methods of removing the causes of faction: the one, by destroying the liberty which is essential to its existence; the other, by giving to every citizen the same opinions, the same passions, and the same interests.

It could never be more truly said than of the first remedy, that it was worse than the disease. Liberty is to faction what air is to fire, an aliment without which it instantly expires. But it could not be less folly

to abolish liberty, which is essential to political life, because it nourishes faction, than it would be to wish the annihilation of air, which is essential to animal life, because it imparts to fire its destructive agency.

The second expedient is as impracticable as the first would be unwise. As long as the reason of man continues fallible, and he is at liberty to exercise it, different opinions will be formed. As long as the connection subsists between his reason and his self-love, his opinions and his passions will have a reciprocal influence on each other; and the former will be objects to which the latter will attach themselves. The diversity in the faculties of men, from which the rights of property originate, is not less an insuperable obstacle to a uniformity of interests. The protection of these faculties is the first object of government. From the protection of different and unequal faculties of acquiring property, the possession of different degrees and kinds of property immediately results; and from the influence of these on the sentiments and views of the respective proprietors, ensues a division of the society into different interests and parties.

The latent causes of faction are thus sown in the nature of man; and we see them everywhere brought into different degrees of activity, according to the different circumstances of civil society. A zeal for different opinions concerning religion, concerning government, and many other points, as well of speculation as of practice; an attachment to different leaders ambitiously contending for pre-eminence and power; or to persons of other descriptions whose fortunes have been interesting to the human passions, have, in turn, divided mankind into parties, inflamed them with mutual animosity, and rendered them much more disposed to vex and oppress each other than to co-operate for their common good. So strong is this propensity of mankind to fall into mutual animosities, that where no substantial occasion presents itself, the most frivolous and fanciful distinctions have been sufficient to kindle their unfriendly passions and excite their most violent conflicts. But the most common and durable source of factions has been the various and unequal distribution of property. Those who hold and those who are without property have ever formed distinct interests in society. Those who are creditors, and those who are debtors, fall under a like discrimination. A landed interest, a manufacturing interest, a mercantile interest, a moneyed interest, with many lesser interests, grow up of necessity in civilized nations, and divide them into different classes, actuated by different sentiments and views. The regulation of these various and interfering interests forms the principal task of modern legislation, and involves the spirit of party and faction in the necessary and ordinary operations of the government.

No man is allowed to be a judge in his own cause, because his interest would certainly bias his judgment, and, not improbably, corrupt his integrity. With equal, nay with greater reason, a body of men are unfit to be both judges and parties at the same time; yet what are many of the most important acts of legislation, but so many judicial determinations, not indeed concerning the rights of single persons, but concerning the rights of large bodies of citizens? And what are the different classes of legislators but advocates and parties to the causes which they determine? Is a law proposed concerning private debts? It is a question to which the creditors are parties on one side and the debtors on the other. Justice ought to hold the balance between them. Yet the parties are, and must be, themselves the judges; and the most numerous party, or, in other words, the most powerful faction must be expected to prevail. Shall domestic manufactures be encouraged, and in what degree, by restrictions on foreign manufactures? Are questions which would be differently decided by the landed and the manufacturing classes, and probably by neither with a sole regard to justice and the public good. The apportionment of taxes on the various descriptions of property is an act which seems to require the most exact impartiality; yet there is, perhaps, no legislative act in which greater opportunity and temptation are given to a predominant party to trample

on the rules of justice. Every shilling with which they overburden the inferior number, is a shilling saved to their own pockets.

It is in vain to say that enlightened statesmen will be able to adjust these clashing interests, and render them all subservient to the public good. Enlightened statesmen will not always be at the helm. Nor, in many cases, can such an adjustment be made at all without taking into view indirect and remote considerations, which will rarely prevail over the immediate interest which one party may find in disregarding the rights of another or the good of the whole.

The inference to which we are brought is, that the *causes* of faction cannot be removed, and that relief is only to be sought in the means of controlling its *effects*.

If a faction consists of less than a majority, relief is supplied by the republican principle, which enables the majority to defeat its sinister views by regular vote. It may clog the administration, it may convulse the society; but it will be unable to execute and mask its violence under the forms of the Constitution. When a majority is included in a faction, the form of popular government, on the other hand, enables it to sacrifice to its ruling passion or interest both the public good and the rights of other citizens. To secure the public good and private rights against the danger of such a faction, and at the same time to preserve the spirit and the form of popular government, is then the great object to which our inquiries are directed. Let me add that it is the great desideratum by which this form of government can be rescued from the opprobrium under which it has so long labored, and be recommended to the esteem and adoption of mankind.

By what means is this object attainable? Evidently by one of two only. Either the existence of the same passion or interest in a majority at the same time must be prevented, or the majority, having such coexistent passion or interest, must be rendered, by their number and local situation, unable to concert and carry into effect schemes of oppression. If the impulse and the opportunity be suffered to coincide, we well know that neither moral nor religious motives can be relied on as an adequate control. They are not found to be such on the injustice and violence of individuals, and lose their efficacy in proportion to the number combined together, that is, in proportion as their efficacy becomes needful.

From this view of the subject it may be concluded that a pure democracy, by which I mean a society consisting of a small number of citizens, who assemble and administer the government in person, can admit of no cure for the mischiefs of faction. A common passion or interest will, in almost every case, be felt by a majority of the whole; a communication and concert result from the form of government itself; and there is nothing to check the inducements to sacrifice the weaker party or an obnoxious individual. Hence it is that such democracies have ever been spectacles of turbulence and contention; have ever been found incompatible with personal security or the rights of property; and have in general been as short in their lives as they have been violent in their deaths. Theoretic politicians, who have patronized this species of government, have erroneously supposed that by reducing mankind to a perfect equality in their political rights, they would, at the same time, be perfectly equalized and assimilated in their possessions, their opinions, and their passions.

A republic, by which I mean a government in which the scheme of representation takes place, opens a different prospect, and promises the cure for which we are seeking. Let us examine the points in which it varies from pure democracy, and we shall comprehend both the nature of the cure and the efficacy which it must derive from the Union.

The two great points of difference between a democracy and a republic are: first, the delegation of the government, in the latter, to a small number of citizens elected by the rest; secondly, the greater number of citizens, and greater sphere of country, over which the latter may be extended.

The effect of the first difference is, on the one hand, to refine and enlarge the public views, by passing them through the medium of a chosen body of citizens, whose wisdom may best discern the true interest of their country, and whose patriotism and love of justice will be least likely to sacrifice it to temporary or partial considerations. Under such a regulation, it may well happen that the public voice, pronounced by the representatives of the people, will be more consonant to the public good than if pronounced by the people themselves, convened for the purpose. On the other hand, the effect may be inverted. Men of factious tempers, of local prejudices, or of sinister designs, may, by intrigue, by corruption, or by other means, first obtain the suffrages, and then betray the interests, of the people. The question resulting is, whether small or extensive republics are more favorable to the election of proper guardians of the public weal; and it is clearly decided in favor of the latter by two obvious considerations:

In the first place, it is to be remarked that, however small the republic may be, the representatives must be raised to a certain number, in order to guard against the cabals of a few; and that, however large it may be, they must be limited to a certain number, in order to guard against the confusion of a multitude. Hence, the number of representatives in the two cases not being in proportion to that of the two constituents, and being proportionally greater in the small republic, it follows that, if the proportion of fit characters be not less in the large than in the small republic, the former will present a greater option, and consequently a greater probability of a fit choice.

In the next place, as each representative will be chosen by a greater number of citizens in the large than in the small republic, it will be more difficult for unworthy candidates to practice with success the vicious arts by which elections are too often carried; and the suffrages of the people being more free, will be more likely to centre in men who possess the most attractive merit and the most diffusive and established characters.

It must be confessed that in this, as in most other cases, there is a mean, on both sides of which inconveniences will be found to lie. By enlarging too much the number of electors, you render the representatives too little acquainted with all their local circumstances and lesser interests; as by reducing it too much, you render him unduly attached to these, and too little fit to comprehend and pursue great and national objects. The federal Constitution forms a happy combination in this respect; the great and aggregate interests being referred to the national, the local and particular to the State legislatures.

The other point of difference is, the greater number of citizens and extent of territory which may be brought within the compass of republican than of democratic government; and it is this circumstance principally which renders factious combinations less to be dreaded in the former than in the latter. The smaller the society, the fewer probably will be the distinct parties and interests composing it; the fewer the distinct parties and interests, the more frequently will a majority be found of the same party; and the smaller the number of individuals composing a majority, and the smaller the compass within which they are placed, the more easily will they concert and execute their plans of oppression. Extend the sphere, and you take in a greater variety of parties and interests; you make it less probable that a majority of the whole will have a common motive to invade the rights of other citizens; or if such a common motive exists, it will be more difficult for all who feel it to discover their own strength, and to act in unison with each other. Besides other impediments, it may be remarked that, where there is a consciousness of unjust or

dishonorable purposes, communication is always checked by distrust in proportion to the number whose concurrence is necessary.

Hence, it clearly appears, that the same advantage which a republic has over a democracy, in controlling the effects of faction, is enjoyed by a large over a small republic, is enjoyed by the Union over the States composing it. Does the advantage consist in the substitution of representatives whose enlightened views and virtuous sentiments render them superior to local prejudices and schemes of injustice? It will not be denied that the representation of the Union will be most likely to possess these requisite endowments. Does it consist in the greater security afforded by a greater variety of parties, against the event of any one party being able to outnumber and oppress the rest? In an equal degree does the increased variety of parties comprised within the Union, increase this security? Does it, in fine, consist in the greater obstacles opposed to the concert and accomplishment of the secret wishes of an unjust and interested majority? Here, again, the extent of the Union gives it the most palpable advantage.

The influence of factious leaders may kindle a flame within their particular States, but will be unable to spread a general conflagration through the other States. A religious sect may degenerate into a political faction in a part of the Confederacy; but the variety of sects dispersed over the entire face of it must secure the national councils against any danger from that source. A rage for paper money, for an abolition of debts, for an equal division of property, or for any other improper or wicked project, will be less apt to pervade the whole body of the Union than a particular member of it; in the same proportion as such a malady is more likely to taint a particular county or district, than an entire State.

In the extent and proper structure of the Union, therefore, we behold a republican remedy for the diseases most incident to republican government. And according to the degree of pleasure and pride we feel in being republicans, ought to be our zeal in cherishing the spirit and supporting the character of Federalists.

PUBLIUS

Appendix F

■ THE MONROE DOCTRINE

December 2, 1823

Message to Congress from President James Monroe

. . . At the proposal of the Russian Imperial Government, made through the minister of the Emperor [the Russian Tsar] residing here, a full power and instructions have been transmitted to the minister of the United States at St. Petersburg to arrange by amicable negotiations the respective rights and interests of the two nations on the northwest coast of this continent. A similar proposal had been made by His Imperial Majesty to the Government of Great Britain, which has likewise been acceded to. The Government of the United States has been desirous by this friendly proceeding of manifesting the great value which they have invariably attached to the friendship of the Emperor and their solicitude to cultivate the best understanding with his Government. In the discussions to which this interest has given rise and in the arrangements by which they may terminate, the occasion has been judged proper for asserting, as a principle in which the rights and interests of the United States are involved, that the American continents, by the free and independent condition which they have assumed and maintain, are henceforth not to be considered as subjects for future colonization by any European powers. . .

It was stated at the commencement of the last session that a great effort was then making in Spain and Portugal to improve the condition of the people of those countries, and that it appeared to be conducted with extraordinary moderation. It need scarcely be remarked that the result has been so far very different from what was then anticipated. Of events in that quarter of the globe, with which we have so much intercourse and from which we derive our origin, we have always been anxious and interested spectators. The citizens of the United States cherish sentiments the most friendly in favor of the liberty and happiness of their fellow-men on that side of the Atlantic. In the wars of the European powers in matters relating to themselves we have never taken any part, nor does it comport with our policy so to do. It is only when our rights are invaded or seriously menaced that we resent injuries or make preparation for our defense. With the movements in this hemisphere we are of necessity more immediately connected, and by causes which must be obvious to all enlightened and impartial observers. The political system of the allied powers is essentially different in this respect from that of America. This difference proceeds from that which exists in their respective Governments; and to the defense of our own, which has been achieved by the loss of so much blood and treasure, and matured by the wisdom of their most enlightened citizens, and under which we have enjoyed unexampled felicity. . . . We owe it, therefore, to candor and to the amicable relations existing between the United States and those [allied] powers to declare that we should consider any attempt on their part to extend their system to any portion of this hemisphere as dangerous to our peace and safety. With the existing colonies or dependencies of any European power we have not interfered and shall not interfere. But with the [Latin American] Governments who have declared their independence and maintained it, and whose independence we have, on great consideration and on just principles, acknowledged, we could not view any interposition for the purpose of oppressing them, or controlling in any other manner their destiny, by any European power in any other light than as the manifestation of any unfriendly disposition toward the United States. In the war between those new

Governments and Spain we declared our neutrality at the time of their recognition, and to this we have adhered, and shall continue to adhere, provided no change shall occur which, in the judgment of the competent authorities of this Government, shall make a corresponding change on the part of the United States indispensable to their security.

The late events in Spain and Portugal show that Europe is still unsettled. Of this important fact no, stronger proof can be adduced than that the allied powers should have thought it proper, on any principle satisfactory to themselves, to have interposed by force in the internal concerns of Spain. To what extent such interposition may be carried, on the same principle, is a question in which all independent powers whose governments differ from theirs are interested, even those most remote, and surely none more so than the United States. Our policy in regard to Europe, which was adopted at an early stage of the wars which have so long agitated that quarter of the globe, nevertheless remains the same, which is, not to interfere in the internal concerns of any of its powers; to consider the government de facto as the legitimate government for us; to cultivate friendly relations with it, and to preserve those relations by a frank, firm, and manly policy, meeting in all instances the just claims of every power, submitting to injuries from none.

But in regard to those continents circumstances are eminently and conspicuously different. It is impossible that the allied powers should extend their political system to any portion of either continent without endangering our peace and happiness; nor can anyone believe that our southern brethren, if left to themselves, would adopt it of their own accord. It is equally impossible, therefore, that we should behold such interposition in any form with indifference. If we look to the comparative strength and resources of Spain and those new [Latin American] Governments, and their distance from each other, it must be obvious that she can never subdue them. It is still the true policy of the United States to leave the parties to themselves, in the hope that other powers will pursue the same course

Appendix G

■ WOMEN'S RIGHTS

The Declaration of Sentiments and Resolutions

Women's Rights Convention

Seneca Falls, New York, 1848

Declaration of Sentiments

The Declaration of Sentiments and Resolutions was drafted by Elizabeth Cady Stanton for the women's rights convention at Seneca Falls, New York in 1848. Based on the American Declaration of Independence, the Sentiments demanded equality with men before the law, in education and employment. Here, too, was the first pronouncement demanding that women be given the right to vote.

Sentiments

When, in the course of human events, it becomes necessary for one portion of the family of man to assume among the people of the earth a position different from that which they have hitherto occupied, but one to which the laws of nature and of nature's God entitle them, a decent respect to the opinions of mankind requires that they should declare the causes that impel them to such a course.

We hold these truths to be self-evident: that all men and women are created equal; that they are endowed by their Creator with certain inalienable rights; that among these are life, liberty, and the pursuit of happiness; that to secure these rights governments are instituted, deriving their just powers from the consent of the governed. Whenever any form of government becomes destructive of these ends, it is the right of those who suffer from it to refuse allegiance to it, and to insist upon the institution of a new government, laying its foundation on such principles, and organizing its powers in such form, as to them shall seem most likely to effect their safety and happiness.

Prudence, indeed, will dictate that governments long established should not be changed for light and transient causes; and, accordingly, all experience has shown that mankind are more disposed to suffer, while evils are sufferable, than to right themselves by abolishing the forms to which they were accustomed. But when a long train of abuses and usurpations, pursuing invariably the same object, evinces a design to reduce them under absolute despotism, it is their duty to throw off such government and to provide new guards for their future security. Such has been the patient sufferance of the women under this government, and such is now the necessity which constrains them to demand the equal station to which they are entitled.

The history of mankind is a history of repeated injuries and usurpations on the part of man toward woman, having in direct object the establishment of an absolute tyranny over her. To prove this, let facts be submitted to a candid world.

He has never permitted her to exercise her inalienable right to the elective franchise.

He has compelled her to submit to law in the formation of which she had no voice.

He has withheld from her rights which are given to the most ignorant and degraded men, both natives and foreigners.

Having deprived her of this first right as a citizen, the elective franchise, thereby leaving her without representation in the halls of legislation, he has oppressed her on all sides.

He has made her, if married, in the eye of the law, civilly dead. He has taken from her all right in property, even to the wages she earns.

He has made her morally, an irresponsible being, as she can commit many crimes with impunity, provided they be done in the presence of her husband. In the covenant of marriage, she is compelled to promise obedience to her husband, he becoming, to all intents and purposes, her master-the law giving him power to deprive her of her liberty and to administer chastisement.

He has so framed the laws of divorce, as to what shall be the proper causes and, in case of separation, to whom the guardianship of the children shall be given, as to be wholly regardless of the happiness of the women-the law, in all cases, going upon a false supposition of the supremacy of man and giving all power into his hands.

After depriving her of all rights as a married woman, if single and the owner of property, he has taxed her to support a government which recognizes her only when her property can be made profitable to it.

He has monopolized nearly all the profitable employments, and from those she is permitted to follow, she receives but a scanty remuneration. He closes against her all the avenues to wealth and distinction which he considers most honorable to himself. As a teacher of theology, medicine, or law, she is not known.

He has denied her the facilities for obtaining a thorough education, all colleges being closed against her.

He allows her in church, as well as state, but a subordinate position, claiming apostolic authority for her exclusion from the ministry, and, with some exceptions, from any public participation in the affairs of the church.

He has created a false public sentiment by giving to the world a different code of morals for men and women, by which moral delinquencies which exclude women from society are not only tolerated but deemed of little account in man.

He has usurped the prerogative of Jehovah himself, claiming it as his right to assign for her a sphere of action, when that belongs to her conscience and to her God.

He has endeavored, in every way that he could, to destroy her confidence in her own powers, to lessen her self-respect, and to make her willing to lead a dependent and abject life.

Now, in view of this entire disfranchisement of one-half the people of this country, their social and religious degradation, in view of the unjust laws above mentioned, and because women do feel themselves aggrieved, oppressed, and fraudulently deprived of their most sacred rights, we insist that they have immediate admission to all the rights and privileges which belong to them as citizens of the United States.

In entering upon the great work before us, we anticipate no small amount of misconception, misrepresentation, and ridicule; but we shall use every instrumentality within our power to effect our object. We shall employ agents, circulate tracts, petition the state and national legislatures, and endeavor to enlist the pulpit and the press in our behalf. We hope this Convention will be followed by a series of conventions embracing every part of the country.

Resolutions

Whereas, the great precept of nature is conceded to be that "man shall pursue his own true and substantial happiness." Blackstone in his Commentaries remarks that this law of nature, being coeval with mankind and dictated by God himself, is, of course, superior in obligation to any other. It is binding over all the globe, in all countries and at all times; no human laws are of any validity if contrary to this, and

such of them as are valid derive all their force, and all their validity, and all their authority, mediately and immediately, from this original; therefore,

Resolved, That such laws as conflict, in any way, with the true and substantial happiness of woman, are contrary to the great precept of nature and of no validity, for this is superior in obligation to any other.

Resolved, that all laws which prevent woman from occupying such a station in society as her conscience shall dictate, or which place her in a position inferior to that of man, are contrary to the great precept of nature and therefore of no force or authority.

Resolved, that woman is man's equal, was intended to be so by the Creator, and the highest good of the race demands that she should be recognized as such.

Resolved, that the women of this country ought to be enlightened in regard to the laws under which they live, that they may no longer publish their degradation by declaring themselves satisfied with their present position, nor their ignorance, by asserting that they have all the rights they want.

Resolved, that inasmuch as man, while claiming for himself intellectual superiority, does accord to woman moral superiority, it is preeminently his duty to encourage her to speak and teach, as she has an opportunity, in all religious assemblies.

Resolved, that the same amount of virtue, delicacy, and refinement of behavior that is required of woman in the social state also be required of man, and the same transgressions should be visited with equal severity on both man and woman.

Resolved, that the objection of indelicacy and impropriety, which is so often brought against woman when she addresses a public audience, comes with a very ill grace from those who encourage, by their attendance, her appearance on the stage, in the concert, or in feats of the circus.

Resolved, that woman has too long rested satisfied in the circumscribed limits which corrupt customs and a perverted application of the Scriptures have marked out for her, and that it is time she should move in the enlarged sphere which her great Creator has assigned her.

Resolved, that it is the duty of the women of this country to secure to themselves their sacred right to the elective franchise.

Resolved, that the equality of human rights results necessarily from the fact of the identity of the race in capabilities and responsibilities.

Resolved, that the speedy success of our cause depends upon the zealous and untiring efforts of both men and women for the overthrow of the monopoly of the pulpit, and for the securing to woman an equal participation with men in the various trades, professions, and commerce.

Resolved, therefore, that, being invested by the Creator with the same capabilities and same consciousness of responsibility for their exercise, it is demonstrably the right and duty of woman, equally with man, to promote every righteous cause by every righteous means; and especially in regard to the great subjects of morals and religion, it is self-evidently her right to participate with her brother in teaching them, both in private and in public, by writing and by speaking, by any instrumentalities proper to be used, and in any assemblies proper to be held; and this being a self-evident truth growing out of the divinely implanted principles of human nature, any custom or authority adverse to it, whether modern or wearing the hoary sanction of antiquity, is to be regarded as a self-evident falsehood, and at war with mankind.

Appendix H

■ THE CONSTITUTION OF THE CONFEDERATE STATES OF AMERICA MARCH 11, 1861

Preamble

We, the people of the Confederate States, each State acting in its sovereign and independent character, in order to form a permanent federal government, establish justice, insure domestic tranquillity, and secure the blessings of liberty to ourselves and our posterity invoking the favor and guidance of Almighty God do ordain and establish this Constitution for the Confederate States of America.

Article I

Section 1

All legislative powers herein delegated shall be vested in a Congress of the Confederate States, which shall consist of a Senate and House of Representatives.

Section 2

(1) The House of Representatives shall be composed of members chosen every second year by the people of the several States; and the electors in each State shall be citizens of the Confederate States, and have the qualifications requisite for electors of the most numerous branch of the State Legislature; but no person of foreign birth, not a citizen of the Confederate States, shall be allowed to vote for any officer, civil or political, State or Federal.

(2) No person shall be a Representative who shall not have attained the age of twenty-five years, and be a citizen of the Confederate States, and who shall not when elected, be an inhabitant of that State in which he shall be chosen.

(3) Representatives and direct taxes shall be apportioned among the several States, which may be included within this Confederacy, according to their respective numbers, which shall be determined by adding to the whole number of free persons, including those bound to service for a term of years, and excluding Indians not taxed, three-fifths of all slaves. The actual enumeration shall be made within three years after the first meeting of the Congress of the Confederate States, and within every subsequent term of ten years, in such manner as they shall by law direct. The number of Representatives shall not exceed one for every fifty thousand, but each State shall have at least one Representative; and until such enumeration shall be made, the State of South Carolina shall be entitled to choose six; the State of Georgia ten; the State of Alabama nine; the State of Florida two; the State of Mississippi seven; the State of Louisiana six; and the State of Texas six.

(4) When vacancies happen in the representation from any State the executive authority thereof shall issue writs of election to fill such vacancies.

(5) The House of Representatives shall choose their Speaker and other officers; and shall have the sole power of impeachment; except that any judicial or other Federal officer, resident and acting solely

within the limits of any State, may be impeached by a vote of two-thirds of both branches of the Legislature thereof.

Section 3

(1) The Senate of the Confederate States shall be composed of two Senators from each State, chosen for six years by the Legislature thereof, at the regular session next immediately preceding the commencement of the term of service; and each Senator shall have one vote.

(2) Immediately after they shall be assembled, in consequence of the first election, they shall be divided as equally as may be into three classes. The seats of the Senators of the first class shall be vacated at the expiration of the second year; of the second class at the expiration of the fourth year; and of the third class at the expiration of the sixth year; so that one-third may be chosen every second year; and if vacancies happen by resignation, or other wise, during the recess of the Legislature of any State, the Executive thereof may make temporary appointments until the next meeting of the Legislature, which shall then fill such vacancies.

(3) No person shall be a Senator who shall not have attained the age of thirty years, and be a citizen of the Confederate States; and who shall not, then elected, be an inhabitant of the State for which he shall be chosen.

(4) The Vice President of the Confederate States shall be president of the Senate, but shall have no vote unless they be equally divided.

(5) The Senate shall choose their other officers; and also a president pro tempore in the absence of the Vice President, or when he shall exercise the office of President of the Confederate states.

(6) The Senate shall have the sole power to try all impeachments. When sitting for that purpose, they shall be on oath or affirmation. When the President of the Confederate States is tried, the Chief Justice shall preside; and no person shall be convicted without the concurrence of two-thirds of the members present.

(7) Judgment in cases of impeachment shall not extend further than to removal from office, and disqualification to hold any office of honor, trust, or profit under the Confederate States; but the party convicted shall, nevertheless, be liable and subject to indictment, trial, judgment, and punishment according to law.

Section 4

(1) The times, places, and manner of holding elections for Senators and Representatives shall be prescribed in each State by the Legislature thereof, subject to the provisions of this Constitution; but the Congress may, at any time, by law, make or alter such regulations, except as to the times and places of choosing Senators.

(2) The Congress shall assemble at least once in every year; and such meeting shall be on the first Monday in December, unless they shall, by law, appoint a different day.

Section 5

(1) Each House shall be the judge of the elections, returns, and qualifications of its own members, and a majority of each shall constitute a quorum to do business; but a smaller number may adjourn from day to day, and may be authorized to compel the attendance of absent members, in such manner and under such penalties as each House may provide.

(2) Each House may determine the rules of its proceedings, punish its members for disorderly behavior, and, with the concurrence of two-thirds of the whole number, expel a member.

(3) Each House shall keep a journal of its proceedings, and from time to time publish the same, excepting such parts as may in their judgment require secrecy; and the yeas and nays of the members of either House, on any question, shall, at the desire of one-fifth of those present, be entered on the journal.

(4) Neither House, during the session of Congress, shall, without the consent of the other, adjourn for more than three days, nor to any other place than that in which the two Houses shall be sitting.

Section 6

(1) The Senators and Representatives shall receive a compensation for their services, to be ascertained by law, and paid out of the Treasury of the Confederate States. They shall, in all cases, except treason, felony, and breach of the peace, be privileged from arrest during their attendance at the session of their respective Houses, and in going to and returning from the same; and for any speech or debate in either House, they shall not be questioned in any other place. No Senator or Representative shall, during the time for which he was elected, be appointed to any civil office under the authority of the Confederate States, which shall have been created, or the emoluments whereof shall have been increased during such time; and no person holding any office under the Confederate States shall be a member of either House during his continuance in office. But Congress may, by law, grant to the principal officer in each of the Executive Departments a seat upon the floor of either House, with the privilege of discussing any measures appertaining to his department.

Section 7

(1) All bills for raising revenue shall originate in the House of Representatives; but the Senate may propose or concur with amendments, as on other bills.

(2) Every bill which shall have passed both Houses, shall, before it becomes a law, be presented to the President of the Confederate States; if he approve, he shall sign it; but if not, he shall return it, with his objections, to that House in which it shall have originated, who shall enter the objections at large on their journal, and proceed to reconsider it. If, after such reconsideration, two-thirds of that House shall agree to pass the bill, it shall be sent, together with the objections, to the other House, by which it shall likewise be reconsidered, and if approved by two-thirds of that House, it shall become a law. But in all such cases, the votes of both Houses shall be determined by yeas and nays, and the names of the persons voting for and against the bill shall be entered on the journal of each House respectively. If any bill shall not be returned by the President within ten days (Sundays excepted) after it shall have been presented to him, the same shall be a law, in like manner as if he had signed it, unless the Congress, by their adjournment, prevent its return; in which case it shall not be a law. The President may approve any appropriation and disapprove any other appropriation in the same bill. In such case he shall, in signing the bill, designate the appropriations disapproved; and shall return a copy of such appropriations, with his objections, to the House in which the bill shall have originated; and the same proceedings shall then be had as in case of other bills disapproved by the President.

(3) Every order, resolution, or vote, to which the concurrence of both Houses may be necessary (except on a question of adjournment) shall be presented to the President of the Confederate States; and before the same shall take effect, shall be approved by him; or, being disapproved by him, shall be repassed by two-thirds of both Houses, according to the rules and limitations prescribed in case of a bill.

Section 8

The Congress shall have power

(1) To lay and collect taxes, duties, imposts, and excises for revenue, necessary to pay the debts, provide for the common defense, and carry on the Government of the Confederate States; but no bounties shall be granted from the Treasury; nor shall any duties or taxes on importations from foreign nations be laid to promote or foster any branch of industry; and all duties, imposts, and excises shall be uniform throughout the Confederate States.

(2) To borrow money on the credit of the Confederate States.

(3) To regulate commerce with foreign nations, and among the several States, and with the Indian tribes; but neither this, nor any other clause contained in the Constitution, shall ever be construed to delegate the power to Congress to appropriate money for any internal improvement intended to facilitate commerce; except for the purpose of furnishing lights, beacons, and buoys, and other aids to navigation upon the coasts, and the improvement of harbors and the removing of obstructions in river navigation; in all which cases such duties shall be laid on the navigation facilitated thereby as may be necessary to pay the costs and expenses thereof.

(4) To establish uniform laws of naturalization, and uniform laws on the subject of bankruptcies, throughout the Confederate States; but no law of Congress shall discharge any debt contracted before the passage of the same.

(5) To coin money, regulate the value thereof, and of foreign coin, and fix the standard of weights and measures.

(6) To provide for the punishment of counterfeiting the securities and current coin of the Confederate States.

(7) To establish post offices and post routes; but the expenses of the Post Office Department, after the 1st day of March in the year of our Lord eighteen hundred and sixty-three, shall be paid out of its own revenues.

(8) To promote the progress of science and useful arts, by securing for limited times to authors and inventors the exclusive right to their respective writings and discoveries.

(9) To constitute tribunals inferior to the Supreme Court.

(10) To define and punish piracies and felonies committed on the high seas, and offenses against the law of nations.

(11) To declare war, grant letters of marque and reprisal, and make rules concerning captures on land and water.

(12) To raise and support armies; but no appropriation of money to that use shall be for a longer term than two years.

(13) To provide and maintain a navy.

(14) To make rules for the government and regulation of the land and naval forces.

(15) To provide for calling forth the militia to execute the laws of the Confederate States, suppress insurrections, and repel invasions.

(16) To provide for organizing, arming, and disciplining the militia, and for governing such part of them as may be employed in the service of the Confederate States; reserving to the States, respectively, the appointment of the officers, and the authority of training the militia according to the discipline prescribed by Congress.

(17) To exercise exclusive legislation, in all cases whatsoever, over such district (not exceeding ten miles square) as may, by cession of one or more States and the acceptance of Congress, become the seat of the Government of the Confederate States; and to exercise like authority over all places purchased by the consent of the Legislature of the State in which the same shall be, for the erection of forts, magazines, arsenals, dockyards, and other needful buildings; and

(18) To make all laws which shall be necessary and proper for carrying into execution the foregoing powers, and all other powers vested by this Constitution in the Government of the Confederate States, or in any department or officer thereof.

Section 9

(1) The importation of negroes of the African race from any foreign country other than the slaveholding States or Territories of the United States of America, is hereby forbidden; and Congress is required to pass such laws as shall effectually prevent the same.

(2) Congress shall also have power to prohibit the introduction of slaves from any State not a member of, or Territory not belonging to, this Confederacy.

(3) The privilege of the writ of habeas corpus shall not be suspended, unless when in cases of rebellion or invasion the public safety may require it.

(4) No bill of attainder, ex post facto law, or law denying or impairing the right of property in negro slaves shall be passed.

(5) No capitation or other direct tax shall be laid, unless in proportion to the census or enumeration hereinbefore directed to be taken.

(6) No tax or duty shall be laid on articles exported from any State, except by a vote of two-thirds of both Houses.

(7) No preference shall be given by any regulation of commerce or revenue to the ports of one State over those of another.

(8) No money shall be drawn from the Treasury, but in consequence of appropriations made by law; and a regular statement and account of the receipts and expenditures of all public money shall be published from time to time.

(9) Congress shall appropriate no money from the Treasury except by a vote of two-thirds of both Houses, taken by yeas and nays, unless it be asked and estimated for by some one of the heads of departments and submitted to Congress by the President; or for the purpose of paying its own expenses and contingencies; or for the payment of claims against the Confederate States, the justice of which shall have been judicially declared by a tribunal for the investigation of claims against the Government, which it is hereby made the duty of Congress to establish.

(10) All bills appropriating money shall specify in Federal currency the exact amount of each appropriation and the purposes for which it is made; and Congress shall grant no extra compensation to any public contractor, officer, agent, or servant, after such contract shall have been made or such service rendered.

(11) No title of nobility shall be granted by the Confederate States; and no person holding any office of profit or trust under them shall, without the consent of the Congress, accept of any present, emolument, office, or title of any kind whatever, from any king, prince, or foreign state.

(12) Congress shall make no law respecting an establishment of religion, or prohibiting the free exercise thereof; or abridging the freedom of speech, or of the press; or the right of the people peaceably to assemble and petition the Government for a redress of grievances.

(13) A well-regulated militia being necessary to the security of a free State, the right of the people to keep and bear arms shall not be infringed.

(14) No soldier shall, in time of peace, be quartered in any house without the consent of the owner; nor in time of war, but in a manner to be prescribed by law.

(15) The right of the people to be secure in their persons, houses, papers, and effects, against unreasonable searches and seizures, shall not be violated; and no warrants shall issue but upon probable cause, supported by oath or affirmation, and particularly describing the place to be searched and the persons or things to be seized.

(16) No person shall be held to answer for a capital or otherwise infamous crime, unless on a presentment or indictment of a grand jury, except in cases arising in the land or naval forces, or in the militia, when in actual service in time of war or public danger; nor shall any person be subject for the same offense to be twice put in jeopardy of life or limb; nor be compelled, in any criminal case, to be a witness against himself; nor be deprived of life, liberty, or property without due process of law; nor shall private property be taken for public use, without just compensation.

(17) In all criminal prosecutions the accused shall enjoy the right to a speedy and public trial, by an impartial jury of the State and district wherein the crime shall have been committed, which district shall have been previously ascertained by law, and to be informed of the nature and cause of the accusation; to be confronted with the witnesses against him; to have compulsory process for obtaining witnesses in his favor; and to have the assistance of counsel for his defense.

(18) In suits at common law, where the value in controversy shall exceed twenty dollars, the right of trial by jury shall be preserved; and no fact so tried by a jury shall be otherwise reexamined in any court of the Confederacy, than according to the rules of common law.

(19) Excessive bail shall not be required, nor excessive fines imposed, nor cruel and unusual punishments inflicted.

(20) Every law, or resolution having the force of law, shall relate to but one subject, and that shall be expressed in the title.

Section 10

(1) No State shall enter into any treaty, alliance, or confederation; grant letters of marque and reprisal; coin money; make anything but gold and silver coin a tender in payment of debts; pass any bill of attainder, or ex post facto law, or law impairing the obligation of contracts; or grant any title of nobility.

(2) No State shall, without the consent of the Congress, lay any imposts or duties on imports or exports, except what may be absolutely necessary for executing its inspection laws; and the net produce of all duties and imposts, laid by any State on imports, or exports, shall be for the use of the Treasury of the Confederate States; and all such laws shall be subject to the revision and control of Congress.

(3) No State shall, without the consent of Congress, lay any duty on tonnage, except on seagoing vessels, for the improvement of its rivers and harbors navigated by the said vessels; but such duties shall not conflict with any treaties of the Confederate States with foreign nations; and any surplus revenue thus derived shall, after making such improvement, be paid into the common treasury. Nor shall any State keep

troops or ships of war in time of peace, enter into any agreement or compact with another State, or with a foreign power, or engage in war, unless actually invaded, or in such imminent danger as will not admit of delay. But when any river divides or flows through two or more States they may enter into compacts with each other to improve the navigation thereof.

ARTICLE II

Section 1

(1) The executive power shall be vested in a President of the Confederate States of America. He and the Vice President shall hold their offices for the term of six years; but the President shall not be reeligible. The President and Vice President shall be elected as follows:

(2) Each State shall appoint, in such manner as the Legislature thereof may direct, a number of electors equal to the whole number of Senators and Representatives to which the State may be entitled in the Congress; but no Senator or Representative or person holding an office of trust or profit under the Confederate States shall be appointed an elector.

(3) The electors shall meet in their respective States and vote by ballot for President and Vice President, one of whom, at least, shall not be an inhabitant of the same State with themselves; they shall name in their ballots the person voted for as President, and in distinct ballots the person voted for as Vice President, and they shall make distinct lists of all persons voted for as President, and of all persons voted for as Vice President, and of the number of votes for each, which lists they shall sign and certify, and transmit, sealed, to the seat of the Government of the Confederate States, directed to the President of the Senate; the President of the Senate shall, in the presence of the Senate and House of Representatives, open all the certificates, and the votes shall then be counted; the person having the greatest number of votes for President shall be the President, if such number be a majority of the whole number of electors appointed; and if no person have such majority, then from the persons having the highest numbers, not exceeding three, on the list of those voted for as President, the House of Representatives shall choose immediately, by ballot, the President. But in choosing the President the votes shall be taken by States, the representation from each State having one vote; a quorum for this purpose shall consist of a member or members from two-thirds of the States, and a majority of all the States shall be necessary to a choice. And if the House of Representatives shall not choose a President, whenever the right of choice shall devolve upon them, before the 4th day of March next following, then the Vice President shall act as President, as in case of the death, or other constitutional disability of the President.

(4) The person having the greatest number of votes as Vice President shall be the Vice President, if such number be a majority of the whole number of electors appointed; and if no person have a majority, then, from the two highest numbers on the list, the Senate shall choose the Vice President; a quorum for the purpose shall consist of two-thirds of the whole number of Senators, and a majority of the whole number shall be necessary to a choice.

(5) But no person constitutionally ineligible to the office of President shall be eligible to that of Vice President of the Confederate States.

(6) The Congress may determine the time of choosing the electors, and the day on which they shall give their votes; which day shall be the same throughout the Confederate States.

(7) No person except a natural-born citizen of the Confederate States, or a citizen thereof at the time of the adoption of this Constitution, or a citizen thereof born in the United States prior to the 20th of December, 1860, shall be eligible to the office of President; neither shall any person be eligible to that office who shall not have attained the age of thirty-five years, and been fourteen years a resident within the limits of the Confederate States, as they may exist at the time of his election.

(8) In case of the removal of the President from office, or of his death, resignation, or inability to discharge the powers and duties of said office, the same shall devolve on the Vice President; and the Congress may, by law, provide for the case of removal, death, resignation, or inability, both of the President and Vice President, declaring what officer shall then act as President; and such officer shall act accordingly until the disability be removed or a President shall be elected.

(9) The President shall, at stated times, receive for his services a compensation, which shall neither be increased nor diminished during the period for which he shall have been elected; and he shall not receive within that period any other emolument from the Confederate States, or any of them.

(10) Before he enters on the execution of his office he shall take the following oath or affirmation:

Section 2

(1) The President shall be Commander-in-Chief of the Army and Navy of the Confederate States, and of the militia of the several States, when called into the actual service of the Confederate States; he may require the opinion, in writing, of the principal officer in each of the Executive Departments, upon any subject relating to the duties of their respective offices; and he shall have power to grant reprieves and pardons for offenses against the Confederate States, except in cases of impeachment.

(2) He shall have power, by and with the advice and consent of the Senate, to make treaties; provided two-thirds of the Senators present concur; and he shall nominate, and by and with the advice and consent of the Senate shall appoint, ambassadors, other public ministers and consuls, judges of the Supreme Court, and all other officers of the Confederate States whose appointments are not herein otherwise provided for, and which shall be established by law; but the Congress may, by law, vest the appointment of such inferior officers, as they think proper, in the President alone, in the courts of law, or in the heads of departments.

(3) The principal officer in each of the Executive Departments, and all persons connected with the diplomatic service, may be removed from office at the pleasure of the President. All other civil officers of the Executive Departments may be removed at any time by the President, or other appointing power, when their services are unnecessary, or for dishonesty, incapacity, inefficiency, misconduct, or neglect of duty; and when so removed, the removal shall be reported to the Senate, together with the reasons therefor.

(4) The President shall have power to fill all vacancies that may happen during the recess of the Senate, by granting commissions which shall expire at the end of their next session; but no person rejected by the Senate shall be reappointed to the same office during their ensuing recess.

Section 3

(1) The President shall, from time to time, give to the Congress information of the state of the Confederacy, and recommend to their consideration such measures as he shall judge necessary and

expedient; he may, on extraordinary occasions, convene both Houses, or either of them; and in case of disagreement between them, with respect to the time of adjournment, he may adjourn them to such time as he shall think proper; he shall receive ambassadors and other public ministers; he shall take care that the laws be faithfully executed, and shall commission all the officers of the Confederate States.

Section 4

(1) The President, Vice President, and all civil officers of the Confederate States, shall be removed from office on impeachment for and conviction of treason, bribery, or other high crimes and misdemeanors.

ARTICLE III

Section 1

(1) The judicial power of the Confederate States shall be vested in one Supreme Court, and in such inferior courts as the Congress may, from time to time, ordain and establish. The judges, both of the Supreme and inferior courts, shall hold their offices during good behavior, and shall, at stated times, receive for their services a compensation which shall not be diminished during their continuance in office.

Section 2

(1) The judicial power shall extend to all cases arising under this Constitution, the laws of the Confederate States, and treaties made, or which shall be made, under their authority; to all cases affecting ambassadors, other public ministers and consuls; to all cases of admiralty and maritime jurisdiction; to controversies to which the Confederate States shall be a party; to controversies between two or more States; between a State and citizens of another State, where the State is plaintiff; between citizens claiming lands under grants of different States; and between a State or the citizens thereof, and foreign states, citizens, or subjects; but no State shall be sued by a citizen or subject of any foreign state.

(2) In all cases affecting ambassadors, other public ministers and consuls, and those in which a State shall be a party, the Supreme Court shall have original jurisdiction. In all the other cases before mentioned, the Supreme Court shall have appellate jurisdiction both as to law and fact, with such exceptions and under such regulations as the Congress shall make.

(3) The trial of all crimes, except in cases of impeachment, shall be by jury, and such trial shall be held in the State where the said crimes shall have been committed; but when not committed within any State, the trial shall be at such place or places as the Congress may by law have directed.

Section 3

(1) Treason against the Confederate States shall consist only in levying war against them, or in adhering to their enemies, giving them aid and comfort. No person shall be convicted of treason unless on the testimony of two witnesses to the same overt act, or on confession in open court.

(2) The Congress shall have power to declare the punishment of treason; but no attainder of treason shall work corruption of blood, or forfeiture, except during the life of the person attainted.

ARTICLE IV

Section 1

(1) Full faith and credit shall be given in each State to the public acts, records, and judicial proceedings of every other State; and the Congress may, by general laws, prescribe the manner in which such acts, records, and proceedings shall be proved, and the effect thereof.

Section 2

(1) The citizens of each State shall be entitled to all the privileges and immunities of citizens in the several States; and shall have the right of transit and sojourn in any State of this Confederacy, with their slaves and other property; and the right of property in said slaves shall not be thereby impaired.

(2) A person charged in any State with treason, felony, or other crime against the laws of such State, who shall flee from justice, and be found in another State, shall, on demand of the executive authority of the State from which he fled, be delivered up, to be removed to the State having jurisdiction of the crime.

(3) No slave or other person held to service or labor in any State or Territory of the Confederate States, under the laws thereof, escaping or lawfully carried into another, shall, in consequence of any law or regulation therein, be discharged from such service or labor; but shall be delivered up on claim of the party to whom such slave belongs, or to whom such service or labor may be due.

Section 3

(1) Other States may be admitted into this Confederacy by a vote of two-thirds of the whole House of Representatives and two-thirds of the Senate, the Senate voting by States; but no new State shall be formed or erected within the jurisdiction of any other State, nor any State be formed by the junction of two or more States, or parts of States, without the consent of the Legislatures of the States concerned, as well as of the Congress.

(2) The Congress shall have power to dispose of and make all needful rules and regulations concerning the property of the Confederate States, including the lands thereof.

(3) The Confederate States may acquire new territory; and Congress shall have power to legislate and provide governments for the inhabitants of all territory belonging to the Confederate States, lying without the limits of the several States; and may permit them, at such times, and in such manner as it may by law provide, to form States to be admitted into the Confederacy. In all such territory the institution of negro slavery, as it now exists in the Confederate States, shall be recognized and protected by Congress and by the Territorial government; and the inhabitants of the several Confederate States and Territories shall have the right to take to such Territory any slaves lawfully held by them in any of the States or Territories of the Confederate States.

(4) The Confederate States shall guarantee to every State that now is, or hereafter may become, a member of this Confederacy, a republican form of government; and shall protect each of them against invasion; and on application of the Legislature (or of the Executive when the Legislature is not in session) against domestic violence.

ARTICLE V

Section I

(1) Upon the demand of any three States, legally assembled in their several conventions, the Congress shall summon a convention of all the States, to take into consideration such amendments to the Constitution as the said States shall concur in suggesting at the time when the said demand is made; and should any of the proposed amendments to the Constitution be agreed on by the said convention, voting by States, and the same be ratified by the Legislatures of two-thirds of the several States, or by conventions in two-thirds thereof, as the one or the other mode of ratification may be proposed by the general convention, they shall thenceforward form a part of this Constitution. But no State shall, without its consent, be deprived of its equal representation in the Senate.

ARTICLE VI

Section I

(1) The Government established by this Constitution is the successor of the Provisional Government of the Confederate States of America, and all the laws passed by the latter shall continue in force until the same shall be repealed or modified; and all the officers appointed by the same shall remain in office until their successors are appointed and qualified, or the offices abolished.

(2) All debts contracted and engagements entered into before the adoption of this Constitution shall be as valid against the Confederate States under this Constitution, as under the Provisional Government.

(3) This Constitution, and the laws of the Confederate States made in pursuance thereof, and all treaties made, or which shall be made, under the authority of the Confederate States, shall be the supreme law of the land; and the judges in every State shall be bound thereby, anything in the constitution or laws of any State to the contrary notwithstanding.

(4) The Senators and Representatives before mentioned, and the members of the several State Legislatures, and all executive and judicial officers, both of the Confederate States and of the several States, shall be bound by oath or affirmation to support this Constitution; but no religious test shall ever be required as a qualification to any office or public trust under the Confederate States.

(5) The enumeration, in the Constitution, of certain rights shall not be construed to deny or disparage others retained by the people of the several States.

(6) The powers not delegated to the Confederate States by the Constitution, nor prohibited by it to the States, are reserved to the States, respectively, or to the people thereof.

ARTICLE VII

Section I

(1) The ratification of the conventions of five States shall be sufficient for the establishment of this Constitution between the States so ratifying the same.

(2) When five States shall have ratified this Constitution, in the manner before specified, the Congress under the Provisional Constitution shall prescribe the time for holding the election of President and Vice President; and for the meeting of the Electoral College; and for counting the votes, and inaugurating the President. They shall, also, prescribe the time for holding the first election of members of Congress under this Constitution, and the time for assembling the same. Until the assembling of such Congress, the Congress under the Provisional Constitution shall continue to exercise the legislative powers granted them; not extending beyond the time limited by the Constitution of the Provisional Government.

Adopted unanimously by the Congress of the Confederate States of South Carolina, Georgia, Florida, Alabama, Mississippi, Louisiana, and Texas, sitting in convention at the capitol, the city of Montgomery, Ala., on the eleventh day of March, in the year eighteen hundred and sixty-one.

HOWELL COBB, President of the Congress.

South Carolina: R. Barnwell Rhett, C. G. Memminger, Wm. Porcher Miles, James Chesnut, Jr., R. W. Barnwell, William W. Boyce, Lawrence M. Keitt, T. J. Withers.

Georgia: Francis S. Bartow, Martin J. Crawford, Benjamin H. Hill, Thos. R. R. Cobb.

Florida: Jackson Morton, J. Patton Anderson, Jas. B. Owens.

Alabama: Richard W. Walker, Robt. H. Smith, Colin J. McRae, William P. Chilton, Stephen F. Hale, David P. Lewis, Tho. Fearn, Jno. Gill Shorter, J. L. M. Curry.

Mississippi: Alex. M. Clayton, James T. Harrison, William S. Barry, W. S. Wilson, Walker Brooke, W. P. Harris, J. A. P. Campbell.

Louisiana: Alex. de Clouet, C. M. Conrad, Duncan F. Kenner, Henry Marshall.

Texas: John Hemphill, Thomas N. Waul, John H. Reagan, Williamson S. Oldham, Louis T. Wigfall, John Gregg, William Beck Ochiltree.

Appendix I

■ THE EMANCIPATION PROCLAMATION

January 1, 1863

By the President of the United States of America:

A Proclamation.

Whereas, on the twenty-second day of September, in the year of our Lord one thousand eight hundred and sixty-two, a proclamation was issued by the President of the United States, containing, among other things, the following, to wit:

"That on the first day of January, in the year of our Lord one thousand eight hundred and sixty-three, all persons held as slaves within any State or designated part of a State, the people whereof shall then be in rebellion against the United States, shall be then, thenceforward, and forever free; and the Executive Government of the United States, including the military and naval authority thereof, will recognize and maintain the freedom of such persons, and will do no act or acts to repress such persons, or any of them, in any efforts they may make for their actual freedom.

"That the Executive will, on the first day of January aforesaid, by proclamation, designate the States and parts of States, if any, in which the people thereof, respectively, shall then be in rebellion against the United States; and the fact that any State, or the people thereof, shall on that day be, in good faith, represented in the Congress of the United States by members chosen thereto at elections wherein a majority of the qualified voters of such State shall have participated, shall, in the absence of strong countervailing testimony, be deemed conclusive evidence that such State, and the people thereof, are not then in rebellion against the United States."

Now, therefore I, Abraham Lincoln, President of the United States, by virtue of the power in me vested as Commander-in-Chief, of the Army and Navy of the United States in time of actual armed rebellion against the authority and government of the United States, and as a fit and necessary war measure for suppressing said rebellion, do, on this first day of January, in the year of our Lord one thousand eight hundred and sixty-three, and in accordance with my purpose so to do publicly proclaimed for the full period of one hundred days, from the day first above mentioned, order and designate as the States and parts of States wherein the people thereof respectively, are this day in rebellion against the United States, the following, to wit:

Arkansas, Texas, Louisiana, (except the Parishes of St. Bernard, Plaquemines, Jefferson, St. John, St. Charles, St. James Ascension, Assumption, Terrebonne, Lafourche, St. Mary, St. Martin, and Orleans, including the City of New Orleans) Mississippi, Alabama, Florida, Georgia, South Carolina, North Carolina, and Virginia, (except the forty-eight counties designated as West Virginia, and also the counties of Berkley, Accomac, Northampton, Elizabeth City, York, Princess Ann, and Norfolk, including the cities of Norfolk and Portsmouth), and which excepted parts, are for the present, left precisely as if this proclamation were not issued.

And by virtue of the power, and for the purpose aforesaid, I do order and declare that all persons held as slaves within said designated States, and parts of States, are, and henceforward shall be free; and that the Executive government of the United States, including the military and naval authorities thereof, will recognize and maintain the freedom of said persons.

And I hereby enjoin upon the people so declared to be free to abstain from all violence, unless in necessary self-defence; and I recommend to them that, in all cases when allowed, they labor faithfully for reasonable wages. And I further declare and make known, that such persons of suitable condition, will be received into the armed service of the United States to garrison forts, positions, stations, and other places, and to man vessels of all sorts in said service.

And upon this act, sincerely believed to be an act of justice, warranted by the Constitution, upon military necessity, I invoke the considerate judgment of mankind, and the gracious favor of Almighty God.

In witness whereof, I have hereunto set my hand and caused the seal of the United States to be affixed.

Done at the City of Washington, this first day of January, in the year of our Lord one thousand eight hundred and sixty-three, and of the Independence of the United States of America the eighty-seventh.

By the President: ABRAHAM LINCOLN

WILLIAM H. SEWARD, Secretary of State.

Index

Collins College OUTLINES

Fully Revised and Updated

Written by professors, teachers, and experts in various fields, the titles in the Collins College Outlines series provide students with a fast, easy, and simplified approach to the curricula of important introductory courses, and also provide a perfect preparation for AP exams. Each title contains a full index and a "Test Yourself" section with full explanations for each chapter.

Published in the United States of America by Star Bright Books, Inc.,
30-19 48th Avenue, Long Island City, NY 11101.

The name Star Bright Books and the Star Bright Books logo are
registered trademarks of Star Bright Books, Inc.
Please visit www.starbrightbooks.com.
For bulk orders, contact: orders@starbrightbooks.com, or call
customer service at: (718) 784-9112.

Hardback ISBN-13: 978-1-59572-278-2
Paperback ISBN-13: 978-1-59572-299-7

Star Bright Books / NY / 00103110
Printed in China (WKT) 10 9 8 7 6 5 4 3 2 1

Library of Congress Cataloging-in-Publication Data

Jenkins, Emily, 1967-
Small, medium, large / by Emily Jenkins ; illustrated by Tomek Bogacki.
 p. cm.
ISBN 978-1-59572-278-2
1. Vocabulary--Juvenile literature. I. Bogacki, Tomasz, ill. II. Title.
PE1449.J37 2011
428.1--dc22
 2010050853

A BOOK ABOUT RELATIVE SIZES

 Small

 Medium

 Large

By Emily Jenkins

Illustrated by Tomek Bogacki

Star Bright Books
New York

And this one is **extra large.**

This one is **huge.**

And this one is

enormous!

This one is simply

colossal.

There's not even enough room for it.